IMPRESSIONISM

Reflections and Perceptions

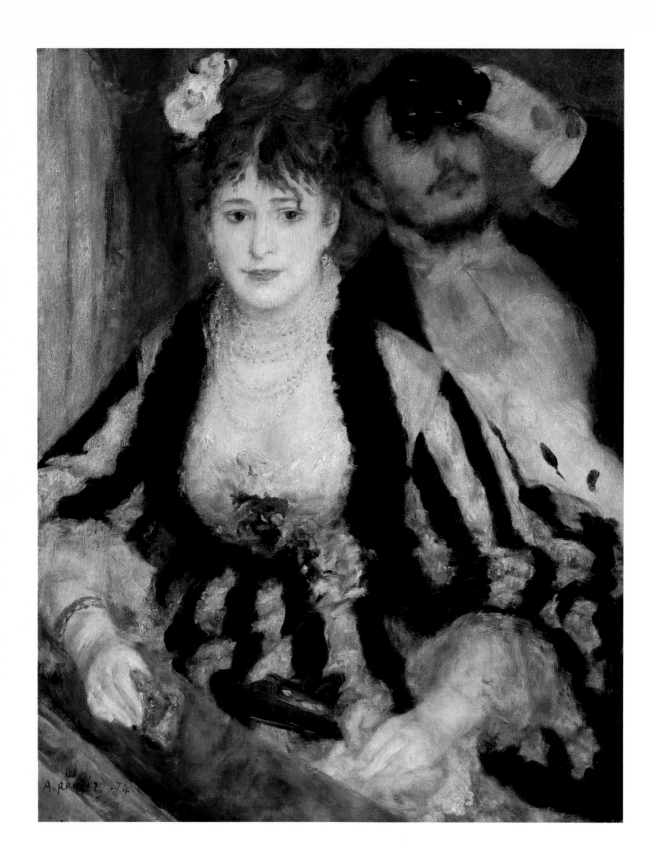

MEYER SCHAPIRO

IMPRESSIONISM

Reflections and Perceptions

GEORGE BRAZILLER

NEW YORK

First published in 1997 by George Braziller, Inc.
Text © The Estate of Meyer Schapiro.

For information, please address the publisher:
George Braziller, Inc., 171 Madison Avenue, New York, New York 10016

LIBRARY OF CONGRESS CATALOGING-IN-PUBLICATION DATA:

Schapiro, Meyer, 1904-96
 Impressionism : reflections and perceptions / Meyer Schapiro.
 p. cm.
 Includes index.
 ISBN 0-8076-1420-3
 1. Impressionism (Art)—France. 2. Arts, French. 3. Arts.
Modern—19th century—France. I. Title.
NX549.A1S32 1997 97-10632
700'.944'09034—dc21 CIP

Frontispiece: Pierre-Auguste Renoir, *The Theatre Box (La Loge)*, 1874, oil on canvas, 80 x 63.5 cm, Courtauld Gallery, London.

Design: Philip Grushkin

Printed and bound by G. Canale, Italy

FIRST EDITION

CONTENTS

Prefatory Note 7

INTRODUCTION: The Seer, the Seeing, and the Seen 9

I. The Concept of Impressionism 21

II. The Aesthetic and Method of Impressionism 43

III. Nature and the Environment 79

IV. The Railroad 96

V. The City 108

VI. The Performers 123

VII. The Crowd, the Stroller, and Perspective as Social Form 144

VIII. Portraiture and Photography 153

IX. The Exemplary Impressionist: Claude Monet 179

X. Impressionism and Science 206

XI. Impressionism in History 230

XII. Impressionism and Literature 268

CONCLUSION: The Reaction to Impressionism 299

Notes 325

List of Names 345

List of Illustrations 348

Index 353

PREFATORY NOTE

PROFESSOR MEYER SCHAPIRO (1904-1996) first wrote on Impressionism in 1928 in an essay entitled "Modern Art" published in *An Introduction to Contemporary Civilization in the West: A Syllabus,* 7th edition, (New York: Columbia University Press, pp. 270-322). He gave courses on Impressionism at Columbia University over the following decades, as well as at New York University in 1935 and the New School for Social Research, and lectures at Vassar College (1944) and in Minneapolis (1957). This volume is an expansion of the six Pattin Lectures that he delivered at Indiana University, Bloomington, in 1961. While lecturing, Professor Schapiro spoke extemporaneously, with slides as his primary guideline, allowing himself to be inspired anew by each painting. The Pattin Lectures were taped and their transcription provided Schapiro with his first complete manuscript on Impressionism.

During later years, Schapiro returned to his manuscript to amplify and clarify his ideas. His wife, Dr. Lillian Milgram, assisted him throughout this process by carefully retyping each page and saving each version for future reference. Under Professor Schapiro's direction, two of his students, Robin Sand and John Klein, researched and assembled the basic lists of illustrations for each chapter.

While reviewing the galleys of the fourth volume of his Selected Papers (*Theory and Philosophy of Art: Style, Artist, and Society,* George Braziller, 1994), Schapiro, then age 89, turned his attention again to Impressionism. He continued to revise his manuscript and the lists of illustrations. Well aware of his mortality, he asked me to serve as editor for the project of publishing the manuscript. I thank George Braziller for the opportunity to do so.

Schapiro died soon after the publication of the fourth volume of his Selected Papers. Since her husband's death, Dr. Milgram has been of immeasurable and unfailing assistance as the various chapters were assembled and typeset. Furthermore, she has graciously overseen the process of organizing the chapters and determining the final list of illustrations. We warmly thank her for her tireless help and commitment to this project. I would also like to thank Sarah Faunce and Petra Chu, Jim McLachlan and Nan Watkins of Western Carolina University, and Phil Rees and Rachel Frew of the University of North Carolina–Chapel Hill for their help in finding references. Adrienne Baxter singlehandedly pulled the book together.

Professor Schapiro drafted a general Table of Contents for this volume, which I have generally followed. The full texts of the completed chapters, somewhat amplified according to Professor Schapiro's marginal notations, have been reprinted in their entirety. Outlines for chapters on Raffaëlli, Impressionism and Japanese art, Impressionism and the Rococo, and Impressionism and Architecture have not been included. Because the texts began as transcriptions of lectures, some additional editing was needed to accommodate the new printed format. I hope, however, that the mellifluous tone and inspired cadences of Professor Schapiro's spoken lecture style have been retained.

<div align="right">

JAMES THOMPSON
Associate Professor
Western Carolina University

</div>

INTRODUCTION:

The Seer, the Seeing,
and the Seen

"Impressionism" has become a vaguer term as the works of the painters who are called the "Impressionists" have become better known. After first designating the style of a small band of French artists of the last third of the nineteenth century—perhaps no more than eight or nine painters—Impressionism was soon applied to novels, poems, and music, and even to a point of view in science.

If common features lead us to bracket these painters rigidly as a group, we will fail to recognize their great differences from each other, even in the 1870s when they chose to exhibit together under one name. It seemed then to the Italian painter and art critic Diego Martelli (fig. 1) that, among those whom he knew personally in Paris, Édouard Manet and Edgar Degas were the "artists of modernity," while Claude Monet, Pierre-Auguste Renoir, and Camille Pissarro were the "true Impressionists who represent the dawn of the future."[1] By the mid-1880s certain of them had diverged enough to raise doubts as to the rightness of the common label, with its connotations of the sketchy and formless in art.[2]

Paul Cézanne, who had been a disciple of Pissarro and who exhibited with the group, can appear accordingly not truly Impressionist because of his constructive form. Renoir, too, was occupied with modeling and volume and therefore seems an atypical member, while Degas's life-long pursuit of the contour was opposed in principle to the dissolution of line seen in so much of Monet's work. Even Pissarro and Alfred Sisley, who were closer to Monet, never carried pictorial novelty of color and stroke as far as he did.

From these observations there might seem to have been only one true and thorough Impressionist: Claude Monet. But Monet's art, too, changed radically in the course of fifty years, so that his later work still looks new, with a prophetic conception of space and surface related to that of artists of the following generations.

Impressionism eludes strict definition by aesthetic features. The term arose as the name of an exhibiting group at a unique moment in the course of 1870s art and had less aptness for the same painters a decade later. One can argue that the name is misleading and has no place in serious

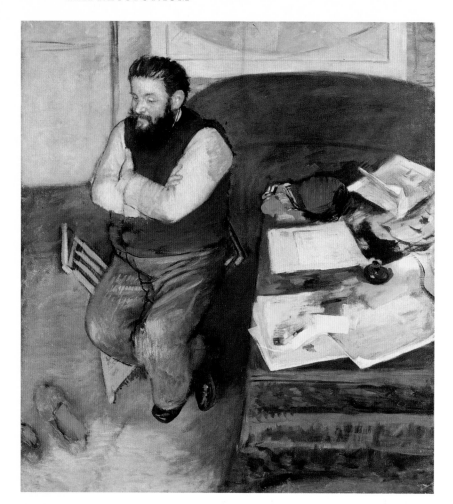

FIGURE 1. Edgar Degas, *Portrait of Diego Martelli*, 1879, 110 x 100 cm, oil on canvas, National Gallery of Scotland, Edinburgh

criticism and history. At least one ought not to infer from its original sense the constant traits binding certain individual innovative artists or reflecting the consistent practice of a school.

Yet in examining the art of the nineteenth century as a whole and in considering the work before and after the phase called Impressionist, viewers have come to recognize how important were these few painters as a group. What they shared was not just a single trait, but a set of related aims, which individual members realized in different degrees—all of them were devoted to an ideal of modernity that included the imaging of the actually seen as part of the common inclusive world of the spectacle, in opposition to the then-current official taste for history, myth, and imagined worlds. To treat their works together as an epoch-making unit remains illuminating mainly because of their relationships to what preceded and to what followed them. Their connections with earlier and later art are so significant that their originality is better understood by attending to their achievement as a collective growth.

Among these artists Monet stands out as an exemplar, the clearest and most far-reaching in

accomplishing certain broadly shared goals. Such an assessment, however, does not place him above all the others. In fact, these painters, while so distinct as personalities, were at one time conscious of a community of radical aims. They chose to exhibit together under the same banner, they had common opponents in the supporters of official art—already a ground for association—and they stimulated each other in the development of their personal styles.

These painters were strong individuals who absorbed more from each other at certain moments than from any other contemporaries. Despite their great differences and despite the difficulty in describing Impressionism so that the designation applies clearly to all of its practitioners in the same way, these artists can instructively be perceived as a group and considered in terms of common qualities, however elusive such affinities might turn out to be and however different may be the weight of those features. If the Impressionists were not a distinct class in the logical sense through those qualities, they were a family by virtue of their ancestors and descendants and by virtue of their relations to one another.

The aim of these reflections has not been to deal, as in a monograph, with each painter separately. Several broad aspects of their art have been considered here in general and illustrated by examples from all of their works. Only Monet has been isolated in a separate chapter to show the distinctive life-course and continuing growth and fertility of an exemplary Impressionist painter's art. Readers may regret that less attention has been given to the others. This focus was not originally planned; but the characteristic Impressionist features that appeared in this study turned out to be most evident and sustained in Monet's work.

More might well have been said about Manet, generally seen as the mentor of the young artists, the leader of those on their way to a new art. Though younger than Pissarro and only slightly older than Degas, Manet is often separated from the Impressionists because of the nature of his art in the 1860s, with its residue of earlier realism and imaginative painting, his interest in novelistic, even journalistic, themes, and his distinctive palette of blacks and grays, as well as his rare neutralized tones applied in large, clearly defined masses.

Manet's art was advanced and powerfully challenging in its time, and it helped free the young Impressionists from the banality of the academic schools. But if in the 1860s his work was a liberating example, his art of the 1870s and 1880s, with its new luminosity of color and freer brushstrokes, was in its turn stimulated by the younger men and especially by his sister-in-law Berthe Morisot. The provocative subject matter that had made Manet's *Olympia* (1863) and the *Déjeuner sur l'herbe* (fig. 2) scandalous in the 1860s gave way in the next decade to more typically Impressionist themes, with less comment and irony.

In treating the group as a whole, I have proceeded from the subject matter of the paintings as images. This approach may seem inapt for a movement that initiated the modern conception of painting as an art of color and was reputedly indifferent to the content of representation. In its own time, Impressionism was reproved for its drastic break with those traditional programs of imagery, noble in subject and rich in allusion, that called for decipherment and understanding.[3]

The painters themselves spoke of the themes of their pictures as merely "pretexts" of a painterly art. If a painting is viewed as a text to be deciphered, interpreted, and understood, then the elements of the text are the tones, brushstrokes, and light in their order and harmony, while the subject is only a "pre-text" that has suggested to the painter certain of those elements and relations. But the painters' choices of objects to represent, even the most trivial or obvious like those of still life, sprang from interests, from personal affinities that must be considered.

If the Impressionists spoke of their objects as merely incidental to the chromatic tones, one may yet ask whether the commitment to such themes was without significance for the character of their art. Theirs was still an art of image making, and the aspects of the subjects attractive to those painters—color, light, and atmosphere, as well as physiognomy, once called the "moral nature" of a landscape—were important for the artists' concept of the picture as an expressive whole. The unity of the picture itself is felt at the same time as the unity of the specific site it represents, although in a particular mode of attention one of these different aspects may be ignored by the viewer.

Study of the Impressionists' choices discloses a distinctive attitude, as significant for certain qualities and for the originality of their art as were the themes of medieval painters for their aesthetic and style. The purely visual in experience is no less a cultural phenomenon and choice than action, religion, or myth.4 Impressionism is visual art not just in terms of abjuring the literary but also in that its principal themes belong to the perceptual. In the chapters following those that characterize the Impressionists' subject matter, I have tried to bring out connections between various features and values of the subjects as well as between the theory and practice of the artists.

More than previous collective styles, with their constant features of the imagined or remembered, Impressionism took as its themes of representation only scenes and objects beheld directly by the painter.5 The experience of seeing, at a particular moment in time and from what later became the spectator's position, was a felt content of the work. One can object that such a difference was unimportant, since painting by its nature has always been an art of the visible, and modern notions that define style as a way of seeing have been applied to visual art in general. As early as 1803 the philosopher François-Pierre Maine de Biran wrote that "the whole secret of the fine arts" lies in "their creation of new ways of seeing."6 On this concept of "seeing" have been built interpretations of particular styles and even reconstructions of the mind or outlook of a people through their art.

The idea of seeing appears strongly rooted and self-evident in the literature of art. It is especially important for Impressionism, an art committed so fully to the directly perceived object. Notions of seeing and outlook are not to be taken as physiological concepts, as if they pertained only to the visual cortex or the eye. They refer to mental and pictorial representations as expressions of attitudes and interests, as well as to representation as an actual technique. Applying the same word both to the common perception of things and to the artist's envisioning of his painted image can often result in ambiguity.

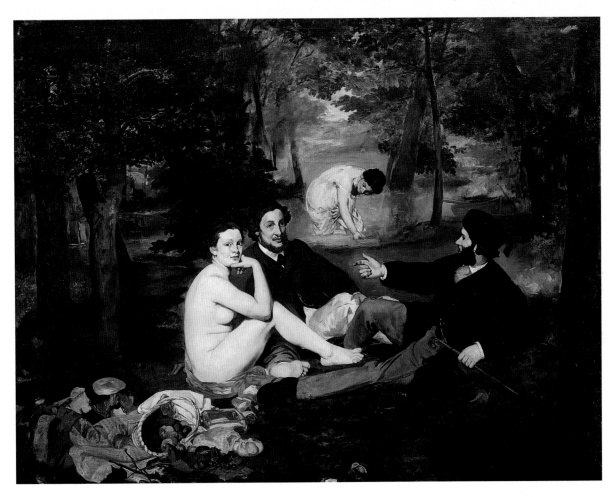

FIGURE 2. Édouard Manet, *Le Déjeuner sur l'herbe*, 1863,
oil on canvas, 208 x 264 cm, Musée d'Orsay, Paris

Ancient Egyptian artists did not actually see profile heads as they invariably drew them, with the eyes viewed full face, nor did the world appear to them shallow, flat, and shadowless, as in their paintings. They must have distinguished near and far and recognized how the eye looked in real heads seen in profile. These distinctions can be deduced from the Egyptian sculptures in the round, where the rules of painting and relief did not apply. Egyptian artists would have been alarmed to see a real human head in which the profile presented a complete frontal eye. Knowing how eyes appeared, Greek viewers, even without instruction, would have recognized at once what the complete eyes in Egyptian drawings of heads in profile represented: a customary artistic device, as in certain Archaic Greek works.

Artists have different ways of looking at objects in a practical sense. They employ techniques of observation, especially with instruments. Landscape painters often carried outdoors with them

little frames through which they could isolate a potential picture, as photographers today look through their viewfinders. Drawing from models, students have traditionally held up sticks of charcoal as vertical lines in order to observe better the relation of various points on the figure by referring them to a common axis. On another level of artistic practice, painters have half shut one eye or squinted to see tones in abstraction from finer detail. Manet used a small reducing glass to sight his canvas as if from a distance. A common way of testing the unity and balance of a work has been to look at it upside down so that familiarity with the represented objects will not interfere with judging the colors and relations of shapes for their harmony or coherence as parts of a composition.

More generally, painters' practices of figurative painting, organized as personal methods, have included habits of selective attention in scrutinizing their objects. They have sought certain elements and neglected others in their models. They have arranged the lighting of their studios, much like the old portrait photographers, and have set their models in positions that determined a particular play of light and shadow required by the norms of their styles of representation. With all these devices of seeing, the projective optical process and the cues for distance, volume, and relative size in the field of the object remain much the same. However, that which has been noticed and that which has been screened and held for finer discrimination as an element of the picture have varied. For the Impressionist painters, seeing a landscape meant intently scanning its light and colors as well as the reactions of these on each other. It meant discovering with elation a multiplicity of tones and pairings of tones that great painters in the past had ignored.

In general, to speak of a style as a way of seeing is to apply a figure of speech. Taken literally, it may induce the false idea that in every style artists reproduced what was impressed on their eyes precisely as their minds recorded it. Just as the verbs "see," "perceive," "view," and the associated "discern," "illuminate," "enlighten," "clarify," together with words for touch—"grasp," "comprehend," "feel"—have come to be applied to modalities in knowing, so "to see" may refer to selecting, imagining, shaping, and composing in art.

Yet no representation, however fantastic, is possible in art without components matched, directly or indirectly, with the visual experience of objects or their parts. The same object, though, can be recognized in pictures drawn in quite different styles, and no account of the process of representation is adequate that ignores the fact of recognizability as a whole. Certain relations of a complex whole in a drawn figure—for example, the invariant positions and symmetry of the facial features and their transformations in movement and perspective—have been responses to a perception of the real object and can be recognized in a picture not simply because the viewers have learned the same methods of representation, but because they have retained in memory of visual experience enough of what is constant or typical in the changing appearance of the object, even ones as elusive as clouds and smoke. Without knowledge of a convention, four dots properly placed in a circle can be seen as a face no less quickly than a modeled and subtly toned painting of a face by Diego Velázquez. For animals a remote resemblance of a pattern of

circles or dots to eyes is enough to release a response to real eyes: such a spotting on the wings of a moths offers survival value for the creatures by frightening off their natural predators.7

Nevertheless, artists have differed in the degree to which they have explored perception and represented elements from visual experience. There have been styles without perspective, styles that did not render lights and reflections or cast shadows, styles without modeling by contrast or gradation of light and shade. Although these devices are essential signs in the judgment of shapes, volume, size, and distance, and are shared by all eyes, they appear in only a few traditions of painting. Styles differ in the extent to which the artists search and incorporate the features of experience as well as in their way of representing them. Much that is seen and handled in everyday life does not appear in art, and much appears in art that was never beheld in nature by the painter.

If all seeing is governed by the same organic apparatus and process, individuals differ in the conditions and selected objects of vision—what they attend to, with what interest and feeling, and with what powers of discrimination, native and acquired. They differ even more in their representations of what they see. For representing, like recognizing and remembering, is an act that calls into play the creators' experiences, their culture, learning, and artistic skills, their thoughts, states of mind, and emotional dispositions.

How in time artists' seeing, with an eye to the painting, changes its objectives, while the physiological conditions of seeing remain the same, is the historian's problem—a problem that cannot be solved without attention to the artists' ideas, knowledge, and values in a field larger than painting. These considerations include the effects of their social milieux upon them since childhood, throughout the course of growth and during maturity.

For the Impressionists it was practically a rule that whatever was represented in their pictures—objects, light, atmosphere, colors, induced contrasts—had been perceived directly by them, whether painted at the moment as they looked at their chosen subjects or afterward in their studios. This quality of observation does not mean that the pictures were to be understood as replicas of what the artists saw—there was much they ignored in their views—but rather that, with a style already formed, the painters' projects as a whole, and not just in details, depended on specific occasions of seeing and called for acute perception. Certain visual conditions in their encounters with scenes, such as the mode of appearance in light and atmosphere, were for them necessary factors of their paintings. From these requirements flowed various consequences for the artistic structure of these works, the choice of elements, and the technique of representation, all of which would have been unlikely in art committed to imagined objects, even if that imagination were supported by careful study of living figures who served as models in the rendering of ideal imaginary beings.

If an Impressionist landscape also appears as a fixed site with constant features, the painter has approached it with an eye to its momentary aspect, its light, atmosphere, and traffic. This radical commitment to the visible as the freshly encountered and continuously changing

distinguished the Impressionist choice of objects from that of the older painters, whose portrait subjects and still lifes had been more obviously prearranged and set for the act of painting: their landscapes had been composed with a formality that seems a permanent attribute of the stable site, independent of a moving observer.

Visual experience consists not only of ever-changing colors, lights, shadows, and forms. More plainly, we perceive and respond to objects as recognizable entities, even when they appear blurred or incomplete. The different kinds of objects we have looked at, as well as their individual qualities—the isolated and the continuous, the near and the far, the unique and the repeated, the small and large, the stable and moving—all suggest different possibilities in art. The habitual rendering of sky, sea, meadow, forest, and desert, of day and night, of the weather and the seasons, of plants and animals, has been the ground of a range of forms and colors on the canvas, less likely in an art that represented only the human body.

The changing choice of objects to depict and the accompanying attention to the qualities of these objects have been essential aspects of the history of art. These selections have concerned more than the technique and style of representation; they have brought into play (and are in turn influenced by) the directing conceptions of humanity and nature and the affect-charged interest in the creation of enduring images. An art of painting that has presented figures with a volume and a freedom of movement in space made possible by a study of light and shade and perspective not only has distinctive structures of forms connected with those perceptions but also can convey a different idea of the span of human qualities from an art in which the outlined figure has been portrayed as flat and set against a neutral ground without depth. Correspondingly, the study of the subject matter of these two styles and of the concepts and feelings governing the choice can lead to further insights concerning the associated styles of representation.

In this history of the investigation of visual experience in art, Impressionism has a unique and epochal place. More than any previous style of painting it explored and pictured everyday objects and occasions that we enjoy with our eyes and value for their sensuous qualities. Certain of its themes had appeared earlier, mainly in Dutch and Venetian art, as secondary subject matter and even with painterly forms approaching the modern. For the Impressionists, however, these commonplace subjects formed the basis of representation; the restriction to them meant a program inseparable from various features of the style.

Just as religious themes furnished the main objects of medieval Christian representation and as the imagined figures of history and myth were major themes of later art, so the Impressionists created an imagery of their own, valued, everyday environment. As the problem of bringing more effectively to view the dominant meanings of their subjects elicited from earlier painters over time new forms appropriate to those themes, so did the Impressionists, in painting their chosen subjects, find their way to a new order of color and a new painterly substance and composition.

Yet it would be wrong to speak of the Impressionists' style as only an expressive vehicle of the themes and attitudes underlying their choices. There were also the artistic interests, the

problems of integration arising in the course of work, and the painters' reactions to previous art, which, together with larger ideas and values of the time, modified by the individual personality, generated in an obscure process new conceptions of painting that in many features corresponded to attitudes arising outside of art.

The visual in Impressionism should be considered not only in the metaphoric sense in which all styles are "ways of seeing," but also more literally as a distinctive subject matter. Impressionism arose shortly after the time when the French poet and critic Théophile Gautier declared: "My whole value lies in the fact that I'm a man for whom the visible world exists."[8] To be sure,

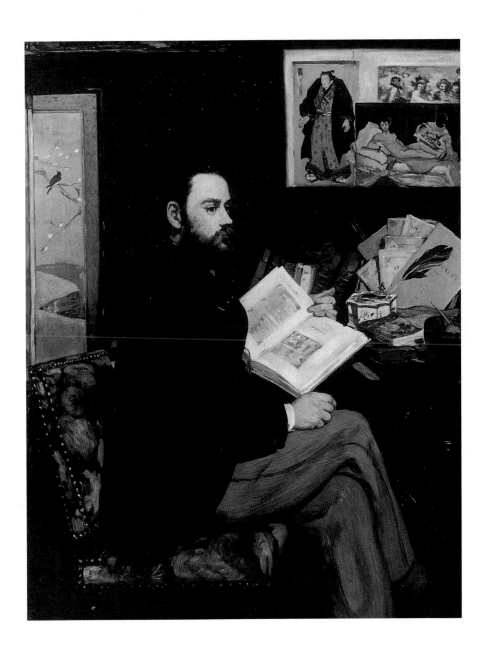

FIGURE 3. Édouard Manet, *Portrait of Emile Zola*, 1868, oil on canvas, 146 x 114 cm, Musée d'Orsay, Paris

the visible world has always existed for painters, even for the primitives, who ignored the environment altogether in their flat and shadowless pictures. But Gautier was proclaiming a new interest in the visual, evidenced in his own poetic art by the abundant use of a rich painterly language with rare color words in picturesque descriptions.[9]

Besides the obvious affinity of his writing with painting, a more essential point for Gautier was that joy in the visible was part of a program of self-fulfillment, as well as a major source of poetic themes and a stimulus to creation. The instant of apprehension of the visible as the discovery of a unique essence was for him the occasion of a perfect experience. By the "visible world" the poet did not mean all that one could see, but only what one saw with delight in its colors, shapes, textures, and motions, and without involvement in practical and moral connotations of the object; his term implied both a mode and a content of seeing.

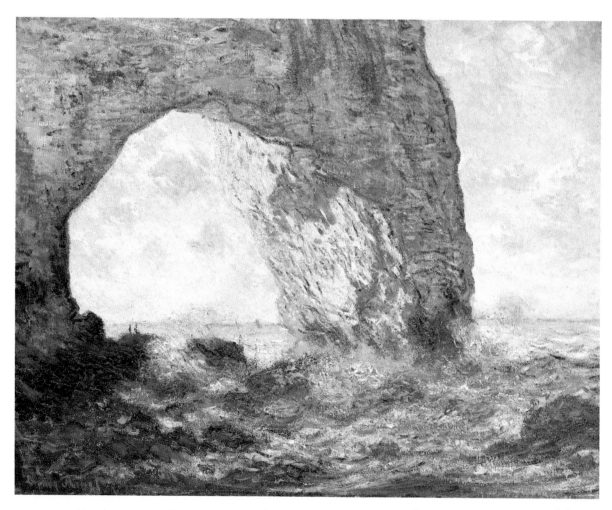

FIGURE 4. Claude Monet, *The Manneporte, Étretat I*, 1883, oil on canvas, 65 x 81 cm, The Metropolitan Museum of Art, New York

Though Impressionism was an art that appeared to abandon subject matter as conceived in earlier art and that gave first importance to an aesthetic of painting—to light, to the harmony of tones, to the vibrant pattern of light brushstrokes, and to a novel freedom of composition—it had its own distinctive body of themes. Its growth and character as an art would have been inconceivable without its chosen fields of representation. This choice can be categorized no more rigidly for Impressionist painting than for medieval art. There, besides the dominant theological content, we find scenes from secular history and figures of fable, fantasy, and work, even though the art of that period has been portrayed by historians and philosophers as a model of an integrated collective imagery submitted to a guiding religious attitude. So, inversely, we may look for a principal theme in varied Impressionist subjects, for their relationship on the one hand to the contexts and functions of that domain in social life and on the other to the artists' aesthetic, to forms and expressive effects.

It used to be a commonplace that with Impressionism the subject disappeared as a factor and what the artist depicted was unimportant. The subject was only a pretext for an accord of tones, with certain favored qualities of color, atmosphere, and light. This view was maintained in the 1860s—for example by Émile Zola, who may have spoken for some of his painter-friends (fig. 3). It corresponded then to a new attitude of artists in their choice of themes as well as to the nature of the theme itself as an encountered rather than prescribed or imagined subject. The new image was an abstracted bit of the familiar visible world, which required no special knowledge or literary culture for its recognition, unlike the historical, mythical, and poetic subjects of the Neoclassical and Romantic Schools. Those works had taken their content from books and had to be deciphered with the help of a title and sometimes a wordy explanation in the printed guide to the Salon.

Despite a declared indifference to subject matter, Impressionist art manifested a high degree of constancy in its choice of themes. Chosen subjects were not pretexts of the painters, but favored texts of perception, which they undertook to transpose into painterly substance. These subjects would hardly have been so recurrent had they been no more than accidentally found motifs offering a model of preferred tones and shapes. In the literature of this time the repeated themes of the painters—sunlight, the open air, moving clouds and water, the spectacle of the city streets—appeared often as deeply stirring, even liberating moments in the life of a character. Evoking the sensibility of the heroine in his tragic 1883 novel *Une Vie* (*A Life*), Guy de Maupassant had her say that "only three things were beautiful in creation: light, space, and water." The occasion of this avowal was her approach from the sea to Étretat,[10] a site that Monet later made familiar by his many paintings of its strange, arched rock (fig. 4).

In advance of a more detailed description, the Impressionist choice of themes can be generalized. These paintings possess, for the most part, an imagery of the environment as a field of freedom of movement and an object of sensory delight in everyday life. Especially in the 1860s and 1870s, during the first fifteen years of this art, scenes with both a spectator and a spectacle

were common. Painters were attracted by those real-life situations in which individuals enjoyed the surroundings and especially their visual impact. But the original experience was more than the purely visual. It included the feel of the sun and the air—warm, cool, dry, windy, or still; the tactile qualities of water, sand, soil, grass, and rock; the bodily sensations of walking, rowing, or dancing; listening to music, plays, and conversation; and, together with sound and sight, the stimuli of taste and smell at the café, the dining table or in the garden.[11]

Impressionist pictures were often of resorts, recreation, and travel, of the open country as a place for strolling or rest. Besides cultivated nature, they represented the promenade, the city streets, the parks, the beaches, the waters of river and ocean close to the shore; the races, the theater, the concert hall, and circus; the conviviality of the café, the picnic, and the table; and the individual human person as an engaging, unproblematic presence—beautiful, loved, friendly, intimate, depicted without critical scrutiny of either character or role. This body of unepisodic themes from actual life predominated in early Impressionist paintings. Even where spectators did not appear, or where the image was of an uninhabited segment of nature, the viewpoints of the painter-observers were often like those of strollers or travelers, whose relations to their surroundings were not those of small-townspeople or farmers, but of holiday or vacation spectators who enjoyed in the landscape refreshment of the senses, expansive feelings of freedom and attunement. Impressionist painters represented a freshly met world of open paths and bright skies, with changing, informal views and horizons.

One unifying term encompasses, at least in the major part, their varied choice of subject matter: the environment. It does not embrace all the subjects listed, but it includes enough of them to call for the closer consideration of its significance that takes place in chapter 3. The environment, to be sure, had occupied painters since the fifteenth century, first as extended setting or background of scenes of action and then as a field complete in itself. The fact that it entered painting as a theme during the centuries of a new secular humanism, when thought became more self-observing and self-critical, as well as more objective and scientific in the study of nature, suggests that the painting of landscape was not independent of the general movement of ideas but was closely tied to the broader trend of critical reflection and interests in which self-knowledge grew with knowledge of the external world and with sharpened, more exacting criteria or truth.

The Impressionists' interest in the environment as the main object of painting thus continued an already common and old practice. But their choice appears as a new commitment, when viewed in the context of their contemporaries and of the official art of their time, which favored historical and dramatic subjects. Besides, the Impressionists conceived of figure painting as people in a natural setting and as subject to the same conditions of visibility—of light and air—as landscape. Finally, and most important, is the new conception of environment that permeates their works.[12]

The Concept of Impressionism

THE NAME "IMPRESSIONIST" was probably coined in 1874 by Louis Leroy, an artist, art critic, and playwright who, in reviewing the first joint exhibition of the new painters, was struck by the title of one of Monet's pictures: *Impression, soleil levant (Impression, Sunrise)* (fig. 5). Though the name was conceived by some critics as a derogatory term, the artists accepted it willingly: a magazine set up by Renoir with his friend Georges Rivière to defend them during their third show in April 1877 was called "*L'Impressionniste.*" The critic may have had a pun in mind, for the phrase "*peinture d'impression*" once meant house painting—the plain coat of color on a wall. In the painting of pictures as well as in the printing of wallpaper, the ground coat was called the "*impression.*"

To a public accustomed to the slick finish of Salon paintings, built up in layers with much glazing and blending, the *alla prima* sketchy execution of many of the new Impressionist works, sometimes featuring unpainted, exposed areas of canvas, must have looked no better than that first stage of a housepainter's craft. And for philistine minds, the suffix designation of the new group of exhibitors as "*-istes*" retained something of the stigma of the eccentrically doctrinaire and subversive, as in "*réalistes,*" "*socialistes*" or "*anarchistes.*" But these suggestions are merely conjectural; the comparison with the housepainter might never have entered the mind of the writer responsible for the label "*Impressionniste,*" though Leroy did say about one of Monet's pictures: "[W]allpaper in its early stages is much more finished than that seascape."[1]

The name was already in the air. In other reviews of that exhibition of 1874, "impression" and "impressionism" were frequent terms, and several years before, in 1865, Léon Lagrange had spoken of the landscape painter Charles-François Daubigny as the leader of "the school of impression."[2] The painters were all the more ready to adopt the name, since "impression" had for them a decidedly positive value. The term appeared often in their letters and in statements by other artists in the decade before. Manet, whom they admired, defended himself from hostile critics by saying in a foreword to the catalogue of his exhibition in 1867 that he sought only "to render [my] impression."[3] This goal was for him the stimulus and starting point of his work, and perhaps its essential ground.[4]

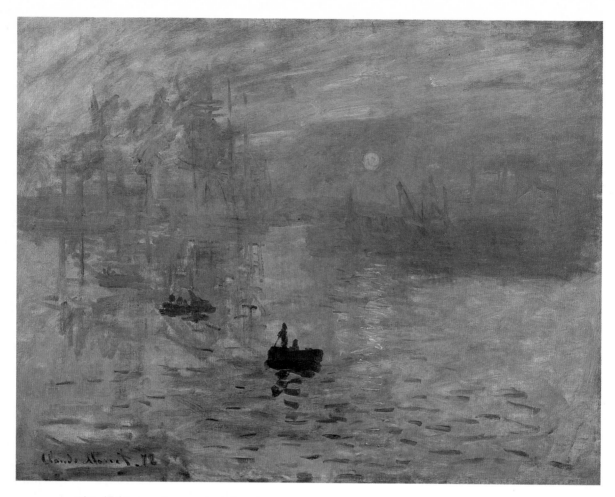

FIGURE 5. Claude Monet, *Impression, Sunrise*, 1872,
oil on canvas, 48 x 63 cm, Musée Marmottan, Paris

Whatever the origin of the name, Monet, in calling his painting of the sunrise *"Impression,"* was explaining himself to the public. He was saying that the picture was not just an image of the dawn over a harbor, but an effect of the scene on the eye of an artist-observer. The painting expresses a perception and, while less fully descriptive than the usual picture, it has its own validity—a truth to an experience. *"Impression"* added to the title of the picture is like labeling a canvas: *"esquisse," "étude,"* or *"morceau"* to induce understanding of a seemingly unfinished or preparatory work. These subtitles, taken from the language of the studio, directed attention to the painter's process. But unlike the expected incompleteness of the sketch and study, which could be admired for qualities of dashing spontaneity or for close searching in an isolated part, *"impression"* in this special context meant also the misty and vague in nature rendered with truth to their momentary aspect.

Monet used the term in the title of another picture, this one painted in 1874, *Fumées dans le brouillard: Impression* (*Smoke in the Fog: An Impression*), and in 1879 in a picture called *Vétheuil dans le brouillard: Impression* (*Vétheuil in the Fog: An Impression*). Monet was, of course, no less an Impressionist in painting bright sunlight than in realizing those images of smoke and fog. The word *"impression"* in his titles was a tactic for educating the public to see that the method of the new art was founded on the reality of the unclear and atmospheric in nature and had its own objectivity and refined precision. He was justifying his approach by pointing to the naturalness and poetic beauty of examples that rendered familiar perceptions. The public was not easily convinced. Fog was considered a disagreeable state of nature, an absurd if not perverse subject, like an ugly nude. Three years later the public's resistance and mockery were exploited for comic effect in a play by Henri Meilhac, *La Cigale*, in which an artist inserted in the foreground of his painting, featuring an impenetrable coat of gray, a clearly rendered knife to indicate his subject: a fog thick enough to slice.

In adding *"impression"* to his titles, Monet perhaps counted on the sanctioned use of the term in titles of books, mainly of travel, as a caution or modest avowal of naive experience. *"Impression"* in a title appealed to the reader who wished to relive in an account of travel the authentic perceptions and feelings of the traveler as a candid, freshly responding mind; it promised the reader the vicarious delight of a first encounter with new sites and people. In ordinary speech, *"impression"* had acquired long before the sense of the personal in perception; it softened the assertive by acknowledging the subjective and tentative in a speaker's descriptions and judgments. But while this common usage enabled one to grasp at least some part of the meaning of *"impression"* in Monet's titles, the commitment to the impression as a value in painting was part of a deeper conviction about the artist's practice. The concept of impression shared by Manet and younger painters in the 1860s and 1870s had both an aesthetic and a philosophic sense and implied a moral and social standpoint. The word *"impression"* belonged to the vocabulary of science as well as to everyday speech, and the obscure and conflicting ideas about impression in the first appear also in the second.

Beside the concept of impression as a feeling-toned experience of the quality of an object or scene there was the meaning, on a quasi-physiological level, that was also conveyed by *"sensation,"* a term often used interchangeably with *"impression"* as an effect on the senses.

The Impressionist painters introduced into their pictures—of trees, let us say—notes of color that to a lay observer looked bizarre and untrue to nature. But the artists could justify these tones as truly perceived in the object. When represented properly on the canvas, they harmonized with the rest and contributed to the liveliness of the whole; they corresponded to their sensations in observing the trees in strong sunshine, and the painters explained them as reflections of neighboring objects or as subjective effects of interacting colors or lights, including complementary contrasts: a bright green induced sensations of red, while yellows induced blues and violets.

The term *"sensation,"* like *"impression,"* came to be applied not only to perceptions of a single surprising note of color, unlike an object's familiar identifying hue, but also to an entire scene. One had a *"sensation"* of a place, a person, a work of art, a whole milieu, even of a life situation, as a unique nonverbal quality, a distinctive essence that seemed to pervade the complex whole and could be sensed in an immediate intuition. The *"sensation"* was the ground of a feeling in the receptive observer, an effect of that directly perceived whole on mood and sensibility. One also characterized a state of feeling, apart from its cause, as a *"sensation"*; in Leo Tolstoy's *War and Peace*, Prince Andrei in battle "felt that some unseen force was drawing him forward, and he had a sensation of great happiness."[5]

The nature of these perceptions was clear from their contrast with habit-bound, practical seeing in which an object was recognized through a bare sign or a cue; one responded then to an invariant characteristic, a fixed form or patterning of parts, and ignored the subtle or unstable in the object and the effects on feeling. The interest in the more variable and elusive qualities— what Cézanne called his *"petit sensation"*—may be described as the aesthetic moment *par excellence*, though such an interest may also be scientific. Even aesthetic perception, in the enjoyment of the qualities of an object in nature, may be focused on its more constant features, much as in the close observation of the work of art itself as an enduring external ordered whole.

In the period before Impressionism, philosophers were concerned with sense experience as a ground of knowledge. The empiricists tried to show how knowledge had been built up from sensory perceptions and from reflection on such perceptions. They criticized the notion of innate ideas independent of sensations. But in time it was assumed increasingly that the mind reshaped, ordered, and organized perceptions through its inherent mode of framing or relating perceptions and that, too, certain concepts, like time and space, were not built on sensations or reasoning but were prior and necessary modes in perception, as Immanuel Kant explained. There was also a greater attention to the personal-affective and the volitional in the qualities of sensation and in the selection of the stimuli for response. The mind was seen as set, through its nervous organizations and its previous experience, for certain perceptions and responses.

For the understanding of the intellectual foundations of the Impressionist style the question of the experienced and the innate—the perceived and the *a priori* in knowledge—is less important than the exploration of the sensory and perceptual in contemporary literature and the increased awareness of the subtlety and complexity of visual experience. I shall discuss briefly certain ideas that are expressed in this literature and that seem pertinent to Impressionist aesthetics and method.

In summarizing the ideas of philosophers and psychologists, I do not mean to suggest that the painters had read the writers or were even influenced by them indirectly through the permeation of common thinking by the philosophers' ideas. The painters could have arrived at similar views through their own experiences, views that were not generalized in a precise language but were implicit in the new problems of representation and in the values given to recently studied

aspects of the visual in a context of moral and social meanings. To determine the extent to which philosophy and science contributed to the artists' attitudes would require more of a painstaking examination of the history of words in both technical and everyday usage.

An account of the history of the concept of impression, even a brief one, will help us to enter into the artists' thought and to better understand contemporary reactions to their work. To certain philosophers and psychologists, the sense impression was the first stage in the process of knowing. It was already an ancient maxim that there was nothing in the mind that was not first in the senses. In France since the mid-eighteenth century, in the writings of Étienne Bonnet de Condillac and Denis Diderot, and at the beginning of the nineteenth among the so-called *idéologues* or ideologists—Antoine Destutt de Tracy, Maine de Biran, and others—it held a central place in the analysis of knowledge. French thinkers followed for the most part the British empiricists (John Locke, George Berkeley, and David Hume), who had analyzed acutely the dependence of ideas on the senses. The tracing of knowledge to a source in sense impressions was directed at times against the notion of innate ideas and served as an argument in the criticism of dogmatic beliefs. It challenged the confidence that reasoning from supposedly self-evident principles could guide one in matters of fact and practical decisions.

Significant in the empiricist view, at least for everyday thinking, was the idea that impressions are first experiences, not yet reworked and overlaid by thought. Impressions are the immediate impacts on the mind in its encounter with objects and therefore more genuine/authentic and reliable than abstract notions that have been shaped by reflection, schooling, fantasy, and tradition and are thus further removed from their concrete sources. Or, in judging the more complex ideas, one distinguished between those that could be traced ultimately to impressions of sense, though processed by reflection, and others—in metaphysics, religion, and popular belief—that had been implanted without direct experience of their objects. To trust one's impressions, then, seemed the part of common sense and promoted self-reliance in testing ideas by experience. Some empiricists, however, while supposing that all ideas depend on sense impressions, admitted with Francis Bacon that the "sense both fails us and deceives us." There were serious writers, too, Jean-Jacques Rousseau and Johann Wolfgang von Goethe among them, who held that errors of perception arose from judgment: sensation itself never deceives us.

An opposing line of thought, stemming from Plato, has regarded sense impressions as fallible, even illusory, the sources of the notorious instability of opinion. True knowledge, it has been argued, comes from ideas as innate possessions of the mind. In Plato's dialogue, *Theatetus*, Socrates replied to the empiricists and pragmatists of his time: "knowledge does not consist in impressions of sense, but in reasoning about them; in that only, and not in the mere impression, truth and being can be attained. . . . perception . . . can never be the same as knowledge or science."[6]

In commenting on the English philosopher John Locke, the German philosopher and mathematician Gottfried Wilhelm Leibnitz, challenged the conception of mind as a passive recipient of impressions from without, though Locke, it must be said, gave to reflection on impressions an

active role in knowledge. The mind, according to Leibnitz, had its inherent disposition and forms that sifted and organized the impressions. Later, Immanuel Kant's analysis of the concepts of time, space, and cause as *a priori* forms of or constituents of thought, necessary for the connecting and ordering of impressions, started a modern tradition critical of the old empiricists. While restricting knowledge of the external world to the phenomenal, in distinction from things in themselves, Kant also gave a new weight to the empirical.

In a parallel line of thought in the laymen's view of impression, which seems to have been affected by the philosophers and was a term in everyday speech, an aura of approval or disapproval surrounds the concept, according to the place assigned to impressions as grounds of knowledge and conduct. In the hundred years before the new art, unphilosophical lay thinkers differed markedly in judging the role and value of the sense impression in both knowledge and moral life.

Sensation, then, was a theoretical concept in the reconstructing of a process of perception beginning with impacts of stimuli mainly below the level of awareness; it was also a term for effects in consciousness, like those of pain, taste, smell, pressure, heat, or sound, not all of which are referred to external objects. So perceived, colors, lights, and movements discriminated in the visual field were also described as sensations, and this description seemed especially appropriate where the perception was of a sense quality rather than of a distinct object.

In the scientist's view, a light ray (or band of rays) produces an impression on the retina, exciting other nerve cells and paths and determining a sensation of color in the cortical region. The light ray arouses a perception of an externally localized state of affairs judged to be a particular object or color presence. This last state is called an "impression" when the judgment is of a quality of that object or presence, that is, when the observer can say "it is a soft gray-blue," instead of, "it is a car." But in both instances he refers the perception to an external cause, whether a distinct object or a localized quality.

In the scientific and philosophical literature there have been two uses of the term "impression." One was for the bodily impact of a stimulus, from outside or within, as in the somatic sensations. A distinction was made between that impact as a local, unnoticed physical effect on a sensory nerve and as an effect in consciousness, though both were called "impressions." Blue and yellow lights produce different effects on the retina, but when these lights are mixed, the resulting sensation is of white and is also termed an impression. A second use is for an effect on feeling and thought. Impression here is a diffuse conscious state that refers to a stimulating object that may be a complex whole. It may be described as a tone of feeling, an awareness of a pervading quality of the perceived object or state, and implies a feeling, sensing, estimating rather than accurately judging or reasoning subject. Yet impression as distinguished from sensation may retain, especially for the painter, a nuance of reflective or precisely discerning attention, a more active moment in perception. So if asked to characterize my sensation of blue, I become observant of its peculiarity and try to distinguish it analytically from other blues, placing it in a

spectrum of graded qualities of blue, according to its specific shade, intensity, brightness, transparency, depth, filminess, and so on; in other words, judging and classifying the particular blue as a subspecies of the large class of all blues.

While owing in part to the vagueness of a language in which "impression," "perception," and "sensation" were applied interchangeably—ideas were called sensations and Hume spoke of emotions and passions as sensations—uncertainty arose from the varied contexts and loose observations on which these concepts were built and from the difficulties in distinguishing the interacting and inseparably interwoven factors in perception and judgment. Thus, "unnoticed sensations" are "impressions" (Locke), and ideas, memories, mental images, too, are "impressions" (Stendhal). That to which "impression" referred could not be demarcated clearly from "sensation" and the objects attended to in "perception." One could even deny, as did German philosopher Franz Brentano, that sensations can be experienced without a judgment; the concept of impression as an effect of an external stimulus applied alike to the subconscious impact of light and sound and to consciously discriminated colors and tones, but also to perceptions of complex qualities of objects and even to thoughts, ideas, and mental images. The subconscious automatizing of early connections in the bodily system underlying memory, thought, and motor behavior makes it difficult to isolate the parts and stages in the process of perception knowledge, particularly for an introspective observer. Besides, the irreducibly distinct character of the sensations of touch, taste, pain, heat, sight, and sound with respect to the external character of objects of usual perception and to the relations of part and whole adds to the perplexities arising from a language that covers all these modalities with a single word. And the accompanying concepts of "passive" attached to both "sensation" and "impression" and of "active" to "perception" are still other sources of vagueness and inconsistency, since we observe and discriminate colors, isolate them in a field, and experience their qualities in relation to neighboring hues and tones.

These terms for sensory effects have changed their meanings in the course of time, acquiring and shedding connotations that will escape us if we ignore their history. An instance is the reversal in the sense of the word "perceptive." Now familiar as a cliché for designating acute insight, it once meant a commonplace seeing without thought or high imagination. In his prose poem *Eureka* (1848), on the origin of the universe, Edgar Allan Poe talked with scorn of the empiricist philosophers, disciples of Aristotle and Francis Bacon, whom he called "Hog," as "merely perceptive men" who failed to rise above the sensed and obvious.[7] Poe was perhaps influenced by the phrenologists, who located the bump of "perceptiveness" lower on the brow than the noble zone of "reflection." A similar disparagement of the empirical was expressed at the same time by the pioneering English mathematical logician George Boole, who contrasted "the merely perceptive knowledge of the world and of ourselves" with "the secret laws and relations of those higher faculties of thought" by which a deeper knowledge is "attained or matured."[8]

But Boole's contemporary John Ruskin, who despised Aristotle as a baneful influence on art,

celebrated the "perceptive" as the true domain of the artist, his mode of truth to appearance. Attacking science as a guide to art in his *Stones of Venice*, Ruskin answered his reader who pleaded that "one of the great uses of knowledge is to open the eyes":

> Not so. This could only be said or believed by those who do not know what the perceptive faculty of a great artist is, in comparison with that of other men. . . . God has given to the man whom He means for a student, the reflective, logical, sequential faculties; and to the man whom He means for an artist, the perceptive, sensitive, retentive faculties.[9]

All these modalities were covered by the word "impression," with its varied connotations of the active and passive, the immediate and the processed, the simple and the complex. Also its use for the directly sensed, the felt, and the discriminated, gave to that word a confusing richness. Yet from the context one could recognize which of those meanings was intended or primary, even when some nuance of another was also connoted. In writings from the period of early Impressionism in the 1860s and 1870s, we can read "impression" as the term for the comprehensive effect, personal and toned by feeling, of a complex whole given directly to perception. In the later period, though to some extent already in the 1870s, the term "sensation" prevailed, even when the idea of the whole was present. Thus, one spoke of the "sensation" of a site, an event, or a human face. In that first stage the impression in painting was linked with the broad brushstrokes and the large field of objects; atmosphere was no less important than light in fixing on the canvas the felt qualities of a directly observed scene.

In the later, more deliberately methodical stage, which may be called that of analytic Impressionism, the tiny point of strong color or of nuance and the single isolated or even fragmentary motif—as in Monet's Grainstacks series and Cathedrals (fig. 6)—prevailed. One was likely then to call Impressionism an art of sensation, though "sensation" had already become a habitual term in describing the genesis of any work of art and of an artist-personality. "Impression" and "sensation" were applied here in both a physiological and a psychological sense. "Sensation" was, in common use, also a term for extreme effects in perception, whether of great and shocking impacts—the "sensational"—or of the delicate and barely perceptible. Thus Maupassant wrote the following in describing a winter scene: "nothing was audible but this faint, fluttering, and indefinable rustle of falling snow—more a sensation than a sound."[10]

From the centuries-long philosophical debate came several ideas that reappear in the theory and criticism of Impressionist painting. One cannot say, of course, that a notion common to painters, poets, and critics on the one side and to philosophers and psychologists on the other had the same connotations for all these minds with their dissimilar perspectives. Nor can one be sure that the artists owed their concept of "impression" to philosophy and science, though the term itself and certain of its meanings probably entered the layperson's vocabulary from these fields. In the literature on art since the middle of the century one is struck by references to

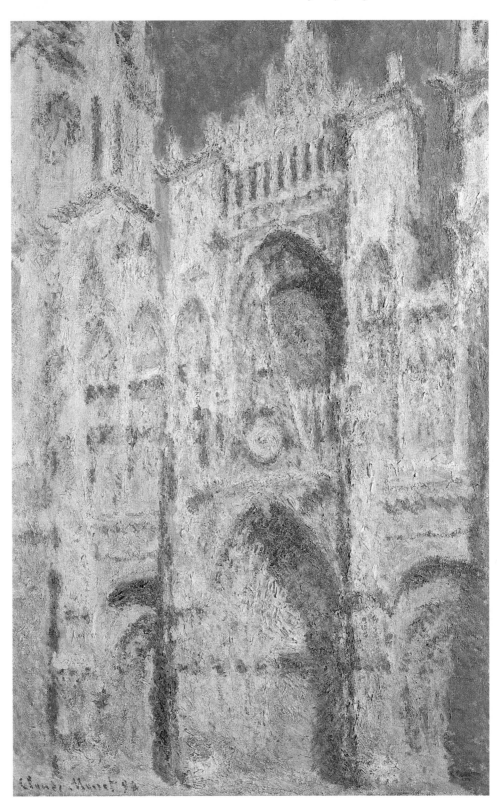

FIGURE 6. Claude Monet, *Rouen Cathedral: The Portal in the Sun*, 1894, oil on canvas, 100 x 65 cm, The Metropolitan Museum of Art, New York

painting as a "retinal" art. But in some instances, at least, the artists understood the concept of "impression" differently from the theorists of knowledge.

Granting their possible independence from each other in applying the same terms, we can isolate some features ascribed earlier by philosophers and psychologists to impressions or sensations as primitive elements in the process of knowledge and to consider the place of these elements in painting. Visual sensations, in their view, are of color and light, not of lines, solid bodies, and three-dimensional space. This view is often credited to Bishop George Berkeley, who wrote in his *New Theory of Vision* (1709): "There is no other immediate object of sight beside light and colours." He explained the perception of space and volume by the correlation of impressions of the eye with sensations of the hand and muscles in bodily movement.[11]

In 1694, Locke had argued that visual impressions are of colors and light alone; the boundaries of different neighboring colors came to be interpreted as the outline of objects and as signs of their solid form only after they had been connected with experiences of touch and bodily action or motion. A man born blind, on acquiring sight, could not distinguish at first a cube from a sphere, even though he had handled both. Before Locke, scientists had reached the same conclusion. The astronomer Galileo Galilei, in a June 26, 1612, letter to the painter and architect Lodovico Cordi da Cigoli, affirmed that the specifically visual quality is color, in opposition to those who spoke of lines and solid forms as the elementary visual perceptions.[12] But Galileo's view was old Greek doctrine and had appeared in the teaching of Aristotle, among others.

The fact that the eye receives only color and light was a basic argument of the Impressionists for the validity of their method. Theorists of art had known this since the sixteenth century without its affecting the confident practice of painters in drawing clear outlines and rendering the apparent solidity of objects. Scientific knowledge did not lead them to suppose that lines were unreal, artificial, and secondary to color as the native domain of vision. Ruskin, who asserted with strong conviction the absence of lines in nature, could still regard drawing as the foundation of the art of painting. Besides, we do perceive sharply bounded colors, graded in light and shade and standing out clearly against a surrounding tone. In choosing to represent these effects of light within distinctively shaped areas, painters have re-created the appearance of definitely bounded objects. If, in the time of the Impressionists and in the decades before, the primacy of line in Neoclassic painting was challenged as untrue to the nature of the visual,[13] it was not because of a recent scientific theory but rather because of a change in aesthetic sensibility and in the aims of artists who found in a freer use of color a new and congenial expressiveness.

The justification by physics and physiology accorded also with the prestige of the original and the primitive in the theory of art. The argument of the Impressionists rationalized their painterly goal, their taste for the luminous, the colorful, the vibrant, the indistinct, and the broken, all of which they sought out in nature and transferred to the canvas in visible brushstrokes. What they opposed essentially was the hardness of outline and darkness of shadow in older art as untrue to the observed play of light and unsuited to the picturing of atmosphere and the

interactions of colors in the aesthetically enjoyed outdoor world. When Cézanne, a disciple of Pissarro, undertook in a classic spirit to represent objects as distinct and voluminous, he shaped their contours through discontinuous strokes and modeled the forms with a shading of relatively high-key and richly varied tones.

The consequences drawn for art from the notions of scientists and philosophers depended also, as we shall see, on a *parti pris* of the painter as of the moralist and social critic. Both sensations and impressions were regarded as resultants or summations of the impacts of an immense number of tiny indiscernible components in the stimulus. In this way an impression was some effect we take account of, a quality given in perception, but one that has not by itself always permitted us to judge the ground of the effect. This had been noticed already by Leibnitz when he spoke of "minute" and "confused perceptions" and gave as an example of those the sound of the ocean. This sound as a whole depends on a sum of infinitesimals, the indistinguishable separate effects of innumerable waves; no one of these can be isolated, but without each there would not be the sound we hear. It was for Leibnitz a model of aesthetic experience in art. With its decided impression of a totality, a whole rich in concordant sounds or colors, the sound of the sea is something that we recognize afterward; yet, as with a familiar face, we are unable to describe the parts from memory.

In the time of the Impressionists, the example of the roar of the ocean was cited by the French philosopher, historian, and aesthetician Hippolyte Taine in his book *De l'intelligence* (1870). The same idea appeared earlier in an observation by the English poet and critic Samuel Taylor Coleridge about a Gothic building. Perhaps paraphrasing an architectural critic, Coleridge wrote of York Cathedral that the "whole is altogether a feeling in which several thousand distinct impressions lose themselves as in a universal solvent." This concept of visual experience had been expressed long before by Saint Teresa of Ávila in her remarkable book of meditations, *The Interior Castle*.[14] To illustrate by analogy her vision of God as an indescribable light given in one dazzling perception, she compared Him to a treasure chamber she had once seen where the numerous precious objects overwhelmed her by their luminous splendor yet could not be recalled and described singly.[15]

For the painters, the impression founded on the summating of minute sensations or impacts of light was a practical as well as theoretical concept. They were creating pictures in which every point in a web of pigment rendered a sensation of color, though not all could be referred strictly to a distinct object (or part) in the scene to which the picture as a whole corresponded. Among them were tones arising from interactions of neighboring colors; but all in concert produced an affective quality true to an "impression" and to an ideal of tonal harmony. The notion of the confused, indiscernible components of the unique impression was also applied to the external world. Nature itself appeared to the painter as a field of infinite mutability in which the minuteness of the elements made these difficult to distinguish or even inaccessible to direct perception. The physical sciences provided analogies for characterizing the psychic sphere of perception; just

as bodies are composed of molecules, and molecules of invisible atoms, so sensations and impressions are formed of tiny units, some of them indiscernible directly and connected by psychological and physiological laws. And on an expanding scale, from the elementary sensation, through the experience of their regular recurrence together, and through comparison of sensations as like and unlike are formed ideas, and through reflection upon these ideas, more general notions. In this account by empiricist philosophers, ideas were traced to sensation as the original core of cognition, though for Leibnitz and Kant, there was a prior constituting mind that imposed its innate categories and forms on the input for the sense organs and made possible the perception of an order and coherence of phenomena in space and time.

Coupled with this view of sensation as an effect based on more elementary impacts of stimuli—impressions below the threshold of awareness—was the theory that visual sensations fail to give us an exact report of the world; they do not resemble strictly the constant forms or qualities of things but are signs for the different objects that elicit these varied sensations by emitting or reflecting light that reaches the eye. This view, expounded in Locke's and Berkeley's writings and elaborated by the German scientist Hermann von Helmholtz in the 1860s during the early years of Impressionism, had been well established in French philosophy since René Descartes and Nicolas de Malebranche. The notion is important for understanding the critical attitude of certain painters, as well as philosophers, to the objectivity of representations. If visual sensations are not faithful pictures or copies of things by psychic effects that function as signs of the stimulating physical objects—signs that can be coordinated with each other and with our positions in space relative to those objects in their varying perspective form and that permit us to direct and control our actions effectively in adapting them to the surrounding world and our needs and bodily structure—then the required correspondence between pictures and what is regarded as the independent world of objects can only be a correspondence between the natural signs (or clues) and the represented ones on the canvas. The latter are recognized as similar to the former in sufficient respects and can serve in identifying the objects, like a good map in a navigator's hands. The idea of a picture as a "likeness" is not at all discredited or weakened by the interpretation of sensory qualities as "signs" or "appearance." Only instead of resembling an "object" in the fullness of its known physical properties, it resembles the signs through which we habitually recognize that object and its relative position in space; the picture thereby produces the same, or a sufficiently similar, effect on the eye as does the object. And just as we identify an object that is only partly visible by a familiar visual cue for that part, so even a schematic drawing that exhibits the distinctive relations or a certain invariant pattern of a few pronounced features of an object will be enough for our recognition of the latter.

From this account of sense impressions as "signs," and particularly signs coordinated in the course of experience and action, it follows that a thoughtful modern painter, accustomed to scrutinize both nature and his own pictures, will not feel bound to a naive view of his art as an exact replication of objects as we have come to know these in our practical engagement with the milieu.

If he, nevertheless, has an ideal of fidelity to the objects and sets himself the task of scrupulous representation of its details, he knows this to be a personal choice that entails for him an individual style with consequences for his own approach to painting and a search for harmony of tones and coherence of forms through arbitrary adjustments or deviations from the model.

The analysis of experience and knowledge into elementary sensations, impressions, and perceptions, and their coordination, and the belief that these elements are signs rather than faithful copies or replicas of things, were accompanied in the period just before Impressionism by a revived critique of the classic notion of substance as the substrate or carrier of the qualities of things and as characterized by bulk and weight and definite form. The physicists now described the natural world as a system of ideal points with measurable charges and velocities, or of particles, each in principle possessing a definite momentum and position. This newer physics supported the notion of the empiricist philosophers that substance or matter in the old sense is a fiction, though it may be a useful one, and though scientists continued to speak of the mass and configuration of the invisible molecules and atoms, just as did the old speculative materialists in defining matter. In any case, the concept of substance now appeared to be less well founded than the concept of directly experienced sensations or impressions. Matter, as Berkeley had argued more than a hundred years before, is not disclosed in perception but is an arbitrary construction of philosophers and metaphysicians. Taine in 1870 wrote that "substance" and "force" are merely verbal entities; there are not substances in nature, only series of connected events.

The Austrian physicist-philosopher Ernst Mach held a still more radical view. "Properly speaking the world is not composed of 'things' as its elements but of colors, tones, pressures, spaces, times, in short what we ordinarily call individual sensations." Not only is matter or substance a fiction, but things too are ideal constructions. In accord with this view of things, Mach restated their relation to signs: "Sensations are not signs of things; but, on the contrary, a thing is a thought-symbol for a compound sensation of a relative fixedness." Only sensations are admitted to the primitive category of experience.[16] Impressionist painting could then be described as an art in which colors, the represented discrete sensation-elements, are more pronounced than the "relatively fixed compound sensations," which are symbolized by "things." Yet the canvas itself, covered with flecks of paint in such a style, would take its place among "things" as a "relatively fixed compound sensation," a distinct, identifiable picture-thing, like the paintings in a style with definite outlines and local color. And translating our common language of things into Mach's language of sensations, one could also say that what are depicted most frequently in Impressionist art are light and air and states that we call weather, things that are thought-symbols for relatively less stable, less constant compounds of sensations.

If sensations are signs, not all are cues for recognizing an object. The sensation may be of a color reflected from a neighboring object and mixed with another colored light or of an "accidental" color induced by contrast. And if we understand that seemingly anomalous color through our knowledge of optics, we may still disregard it, even subtract it, in identifying the

object. But are not these "accidental" colors also signs through which we know other aspects of the object and its surroundings, though less constant or frequent? So blue shadows on snow, while no attribute of snow, are part of a complex of signs that evoke for us the brightness of sunlight in a clear sky above the snow. Painted a dark gray, the shadows on the snow would reduce the brightness of sunlight throughout the scene.

Even if we regard the perceived colors as signs, pictures differ in their fullness of such sign content, that is, the range of qualities of the objects signified by the color. In a primitive work we find no signs for light, air, or shadow; there is no indication of deep space, nor of clouds and sky. The theory of sensations as signs rather than copies of nature is not incompatible with, nor does it exclude, the program of realism in art. On the contrary, it is in accord with realism as a project of exploring our experience of phenomena. The study of those "accidental" sense-impressions may enlarge and deepen our awareness of the variable qualities of things.

Even the "self," which once seemed so clearly present to the introspective mind and possessed the distinctness that older metaphysics and theology attributed to the soul as a substance, was reduced by philosophers to a sequence or memory of sensations. In France those who came after Condillac—particularly Maine de Biran—analyzing the organic (or proprioceptive) sensations, those from within the body, viewed the self as no substance, or distinct entity, but as a recurrent pattern of sensations, some of which arise from internal organic stimuli and others from the surroundings. Before these French philosophers, Hume had described the self as "nothing but a bundle or collection of different perceptions." At the time of the Impressionists, Hippolyte Taine, following Hume, spoke of the self as a fragmentary series of, or continuity among, certain sensations. The self, like substance, was a "metaphysical illusion."[17] This turn of thought was paralleled by the ideas of poets and novelists who, in a doubting mood, described the self as a phantom entity, an illusion; all that one truly knows is a flux of sensations with some recurrent features. The sensations were finally viewed as the whole of experience; one gave less importance to the other components and to the different levels in the construction of knowledge; thought, feeling, will, and ideas were all treated as sensations. "Consciousness" was the name for a certain mode or occasion of sensation—without sensation, there would be no consciousness.

That view of mind and of human activity in general as immersed in sensation, penetrated by it, always tied to it, and constantly building on it, was congenial to this tradition of French thought, even at a time when the will was regarded as primary for characterizing personality. For these thinkers the will is the feeling of effort, mediated by the somatic muscular and kinesthetic sensations. The conviction that the self exists as a distinct entity or center of action was explained by the regularly associated characteristics of sensations. Ideals, intentions, and goals were described then as bundles or complexes of sensations. In the 1860s, the zoologist Pierre Gratiolet, in his public lectures at the Collège de France on physiognomics and bodily expression in the animal and human world—a book from which Charles Darwin was to quote extensively in his work on the expression of the emotions (1873)—implied that all is sensation and appealed to the

experience of his Parisian audiences in confirming his principle. "When the sentient being loves, desires, pursues a thing, he pursues not so much this thing as the sensations that it determines." "The sensations are the determining causes of action." In his theory of expression, the body as a whole responds to a sensation directly or by means of symbols.[18]

How limited and crude was this psychology we may judge from other related statements of Gratiolet, closer to the context of Impressionism and painting: "Thus we imagine that we perceive visible things and in an infinite perspective and at a distance from us, when in reality we are only contemplating a microscopic picture presented on the retina."[19] Gratiolet's formulation, which is a physicalizing of Descartes's idea that we do not perceive the object itself, but an image of it in the mind, is a gross misuse of language, of the words "contemplate" and "perceive." Clearly one is not aware of, nor does one experience, the retina when one sees an object. What we perceive, we perceive as outside us, extended or distributed in three-dimensional space, and we cannot tell from that seeing what is the pattern of an impression on our retinal fields, unless by inference from the laws of optics. Yet scientists, as well as philosophers of that time, often spoke like Gratiolet. His error will reappear in the later judgments of Impressionism as a superficial art of the retina, which ignores the reality of nature and the self.

Although this account of ideas about sensations may suggest that the painters have followed, directly or indirectly, the thought of the philosophers, that their practice may have been dependent on those writings, nevertheless those ideas are not sufficient to account for Impressionism. Berkeley's and Hume's critique of the concept of substance does not by itself entail a style of representation in which modeling and clear outlines are replaced by a mosaic of shapeless color. Berkeley would surely have been shocked or puzzled by such painting; an important part of his thought was in fact addressed to explaining our ideas of space, outline, and solidity by sensations of touch and bodily movement, coordinated with visual impressions. In his *Treatise Concerning the Principles of Human Knowledge* (1710), he did not deny the existence of external objects but was concerned rather with our knowledge of that existence, which he believed was founded on sensation. He also believed firmly in what he called "the Clockwork of Nature," and he assumed the necessity of "a particular size, figure, motion, and disposition of parts" for "producing any effect . . . according to the standing mechanical laws of nature."[20] For his inclination in art, as a man of his time, one may cite a passage from his *Second Dialogue* between Hylas and Philonous (1713): "At the prospect of the wide and deep ocean, or some huge mountain whose top is lost in the clouds, or of an old gloomy forest, are not our minds filled with a pleasing horror? Even in rocks and deserts is there not an agreeable wildness?"[21] This text brings to mind the ideas of eighteenth-century writers on the sublime and the picturesque; the taste for such rugged and massive landscapes in nature and art existed already before 1700.

With Berkeley's explanations one could still justify as true to nature the styles with modeled forms, deep space, and local color, as in the art of the Renaissance, which brought to view the "size, figure, motion, and disposition of parts" of the human body in action. What was more

distinctive for other modern empiricist philosophers, little if at all concerned with Berkeley's need to defend a spiritualist conception of mind against materialism, was the interest in sensation as the support of an outlook favorable to individuality, change, and new experience. If, for painters, sensations are signs, then their choices of objects for attention, the external things that elicit those sensations, may become the ground of different approaches to painting and of the qualities of color and their order in reconstituting those signs on the canvas.

The belief that sensation is primary for knowing the world did not by itself, however, determine an Impressionist approach to art. Painters who held that view could take as a norm of representation other aspects and stages of the process of knowledge. The philosopher Taine, writing in the 1860s as a psychologist and aesthetician with an empiricist view of sensation, defined the aim of art as "to manifest the essence of things," a fixed and impersonal essence disclosed in the typical or characteristic in the represented objects. While radical in his scientific views, Taine was conservative in his theory of art, perhaps because of a disenchanted and pessimistic social outlook as well as early adherence to the German philosopher Friedrich Hegel and to classical German aesthetics. Taine reproached his countrymen for dwelling in sensation and living only in the present—a criticism that a later generation was to address to Impressionism as both an art and a moral outlook. Yet by expanding the scope of "essence" to include all that is formless and fleeting in the visible, one could accommodate to Impressionist painting and literature that idea of art as making more manifest the essences experienced in nature and the human world. One could even regard the unstable, changing qualities of things in their mode of appearance as more characteristic and aesthetically satisfying than the enduring entities of both idealistic thought and common sense.

If, in the nineteenth century, physical theory accustomed observers to think of nature as a vast, randomly distributed aggregate of continually varying, interacting bodies and particles—with forces throughout space producing new forms in both the inorganic and organic systems—distinct from the older picture of nature as a stable universe with substantial objects of well-defined form in a spatial void, practical life required both views for coping with objects of different scale and duration. In practice, we do rely on the constancies of objects; we devise and trust maps, plans, and pictures as guides, and we count on their stability as well as on that of the environment they represent. The painting is itself a concrete material thing that we view as a fixed and well-ordered complex of qualities; the colored pigments on the canvas and palette, like sculptures in stone and clay, are seen and manipulated by the artist as distinct objects, formed of substances with precisely noted physical properties of mass, thickness, and viscosity, though known incompletely and selectively like the natural objects they are designed to represent. The painter perceives the patch of colored paint on the tangible surface of his canvas as a material entity of a definite size, relief, and position, much as he knows the objects around him, even if in representing these he will strive to see them as colors disengaged from a supporting substance or strict boundary. For certain ends, for things and events of another scale, a philosophy that

recognizes time, change, and the interaction of bodies will be more appropriate. Particular interests or problems, the support of a social outlook or ideology, will incline us to one or another view of nature or to a reconciling concept of their relationship.

For scientists as for laymen, sensation was more than a controlled phenomenon elicited in the laboratory. Certain values ascribed to sensation, particularly in the enjoyment of the outdoor world, also affected the thinking of scientists and especially their outlook on nature. A revealing instance is found in the influential book of Ernest Mach, *The Analysis of Sensations and the Relation of the Physical to the Psychical.* Tracing the development of his ideas, he tells how he had read Kant at fifteen and had been deeply impressed by his notions, especially of the thing-in-itself that was inaccessible to knowledge. But "[s]ome two or three years later the superfluity of the role played by the 'thing-in-itself' [the so-called noumenon as distinguished from the phenomenon, the apparent object of sense-experience] abruptly dawned on me. On a bright summer day in the open air, the world with my ego suddenly appeared to me as *one* coherent mass of sensations, only more coherent in the ego. Although the actual working-out of this thought did not occur until a later period, yet this moment was decisive for my whole view."[22] Mach's account of his conversion recalls the experience of mystics who describe a moment of startling illumination that changes for them the large meaning of the world—for example, the German mystic Jakob Boehm's observing the highlight on a polished pewter dish in his room and at once enjoying an intuition of divinity.[23]

Let us consider the concept of impression as it appeared to novelists, poets, and painters. To appreciate its significance to artists it is useful to keep in mind that for traditional theory of art the impression had been discounted as an inferior moment of experience and was often equated with the merely apparent and illusory. In the older view, a true painter or sculptor strives to present the forms of enduring nature or an ideal form through which the observer is freed from the accidents, imperfections, and chaos of the natural; what belongs to the phenomenal, the world of sense, was regarded, in terms of an influential Platonic view, as no proper object of true knowledge or of representation in art—it lacks the stability and beauty of ideal forms, those mysterious, imagined, immutable entities that are discovered by thought. Above the contingencies of nature and sense perception, they disclose the constancy, the eternal order of being, and the archetypes residing in mind. Even if one accepted the visible world as a veil of phenomena, one could distinguish in the sphere of sensation certain more stable appearances as leading to knowledge of that order. That, broadly speaking, was the approach to representation during the Renaissance and in the seventeenth and eighteenth centuries. It has survived to our own time and was evident not long ago in a theory of abstract painting that justified, by a dualistic metaphysics of appearance and reality, the rejection of imagery and the choice of geometrical forms, the reality underlying appearance being most adequately expressed through the qualities or pure forms of the "abstract" elements.

Thus impression, and with it sensation, were seen as untrustworthy for art, since they

introduced into art the impermanent, the subjective, and illusory, or at best belonged to the lowest level in the hierarchy of knowledge and spirit. This view, however, had lost much of its cogency before Impressionism arose. We see that Mach's conversion from Kant's philosophy to an empiricist philosophy of sensation is connected here with an occasion typical in Impressionist painting: the experience of the outdoor summer world as "a mass of sensations coherent in the self" to which the Impressionist spectator is particularly attached rather than as an external structure of (definite) subsisting objects grasped as wholly independent of ourselves.

A younger contemporary of Mach who is unlikely to have read him and would perhaps have found his outlook distasteful, the novelist Maurice Barrès, wrote: "I no longer existed, I was simply the sum of all that I was seeing." This feeling that the self has been wholly dissolved by the world or the world has been absorbed into oneself, so that the boundary between self and world has been erased or blurred in sensation, is an experience often described in the literature of the nineteenth century. It has its positive and negative aspects, according to the place of this feeling in the larger field of an individual's goals and activities. But it is almost coeval with the philosophical view, for Maine de Birain around 1800 expressed the same feeling of existence as an inversion in sense experience. By the end of the nineteenth century, writers are as likely to speak of their sensations as of their impressions; the sensation is nearer to the source, the first stage of knowledge, hence more authentic and veridical than the impression that is already subject to the manifold influences of thought and past experience. Moreover, the sensation has the sanction of science; in studying the organism, the physiologist proceeds from sensations as primordial ultimate events, the ultimate constituent of consciousness in the ceaseless, vigilant process of interaction with the surroundings.

Earlier, Delacroix had believed that if the mind builds from sensations to the higher forms of knowledge, the impression in itself is the starting point of the creative personality. "Artists and poets," he wrote, "are men in whom a strange mobility of impressions is at the same time the source of their talent and also of their cruelest pains or dissatisfactions" ("*les plus cruels déplaisirs*"). Impression meant for him, as for the Romantic artist in general, impressibility. The true artist is one who responds intensely and constantly to qualities in the appearance of things, while the ordinary or mediocre man is content to recognize things through codified, familiar qualities as signs and merely applies names to objects. There is no freshness, no frequent stirring of sensibility in his experience of the world; he does not stop to savor the sensations and to dwell in them and distinguish their finer modalities. The conception of the artist, therefore, as one whose root of creative practice is a native sensitivity to colors, lights, and sounds replaces the notion that the artist is fundamentally a man gifted with power of imagination and skill of the hand. There appear, more and more, in the literature of art, statements to the effect that an artist's work is the result of strong "impressions" and that because it is based on impression or sensation it is good. England's premier academician Sir Joshua Reynolds compared the work of his recently deceased rival Thomas Gainsborough to the polished efforts of Pompeo Battoni and

Anton Raphael Mengs: "I take more interest in and am more captivated with the powerful impressions of nature, which Gainsborough exhibited. . . . "[24] But this view of the roots of the work of art did not have the same weight for writers at the beginning of the nineteenth century that it acquired later.

In the course of time, the impression as the effective ground of art gives way to the sensation as the elementary term, the physiological concept replacing the psychological with the interest in fine differences and their control and measure. Cézanne, who had been with the Impressionists and learned from Pissarro, could speak of his "*petit sensation*," as earlier one had spoken of impressions; more specifically it is the delicate elusive appearance, whether of color or shape, arising from the momentary, intermittent fixations of the eye upon an object or even an extensive landscape, as in a sensation of its pervading luminosity. The painting built of such sensations became no longer an equivalent of the impression, but something more deliberated and constructed. Common to Cézanne and Monet is the sensation as a consciously pursued and cultivated experience. Cézanne wrote to Zola in 1878: "When I see you again I shall ask if your opinion on painting as a means of expressing sensation is not the same as mine"; and almost twenty years later (1899) in a letter to another old friend, Henri Gasquet, recalling their boyhood days, he said: "[T]here still vibrate in us the sensations aroused in this good Provence sun, our old youthful memories of these horizons, these landscapes, these marvelous lines, which leave such deep impressions. . . ."[25]

Among artists of the earlier generation before Impressionism, the interest in impressions as the embryonic stage in the unfolding of the painter's sensibility was still subordinate to the idea of a higher creative process that operates upon old perceptions, sifting impressions, and on combining them and shaping them into a new form in the complete work of art.

Charles Baudelaire, who thought, like the Romantics, that one becomes a poet through the impressions of childhood—"*le cerveau féconde d'enfance*,"[26] as he wrote in his essay on Poe—was, nevertheless, not wholly receptive to the new tendency of art; he believed that what the advanced painters regarded as the painter's impressions had first to be reworked and completed by a controlling memory and imagination. When in 1859 he saw the pastel sketches of Monet's teacher, Eugène-Louis Boudin, each rendering a study/perception of clouds and atmosphere at a recorded instant of the day, Baudelaire praised the beauty of those sketches, but insisted, too, that they were only a raw material that had yet to be reworked. Boudin himself, he wrote, "knows well that all that has yet to become a picture by means of the poetic impression recalled at will."[27] For Baudelaire, it is clear: "impression" meant the *original* emotional impact of a scene or experience that colors the memory of an object and is a stimulus to imagination, not the immediate "retinal," the sensation *vécu*.

This was also the view of Baudelaire's contemporary, the painter, writer, and critic Eugène Fromentin. In his novel *Dominique* (1863), in distinguishing the hero from the peasants around him, Fromentin wrote that "he was an artist by nature through a singular aptitude for allowing

himself to be penetrated by impressions";[28] but he spoke of this trait as a fatality that cut off Dominique from practical life and easy social relations with others. To dwell on one's impressions has an inhibiting effect on action and understanding, both of which require that the impressions be elaborated into logically connected, coherent thoughts. The same Fromentin as a young painter had written in 1844: "I lead a rather active interior life. I absorb enormously through the eyes."[29] The idea that an artist is not just a man of distinctive and superior imagination but a visual or auditory genius anticipates the explanation by psychologists who, in studying character, classified individuals as visual, auditory, and motor types, or according to other specialized organic dispositions. (As early as 1800, however, the physician and philosopher Georges Cabanis, of the school of *idéologues*, thought to account for individual differences in general by differences both in the milieu and in the mode of experiencing sensations.)[30] Apart from the philosophers' tradition concerning the process of knowledge, artistic theory and naive psychology of art in the second third of the century—the period of the Romantics, the Realists, and the beginning of the Impressionists—ascribe to the painter a particularly impressionable nature with an innate gift of acute visual perception; his character and destiny as an artist are set by that initial sensitivity.

FIGURE 7. Eugène Boudin, *Approaching Storm*, 1864,
oil on panel, 36.6 x 57.9 cm, The Art Institute of Chicago

If a strong, immediate aesthetic response to sensations and impressions is the first requirement in the forming of an artist, there follows for the mature painter an attitude toward daily visual experience very different from that of the classicisizing or Romantic painter, who works largely from imagination in representing scenes suggested by literature. The belief that there resides in the impression as such an intrinsic virtue, a source of creative power, disposes him then to cultivate his impressions.

Camille Corot, who was formed by teachers of the classic school committed to strict principles of drawing and composition, left instructive jottings on the impression. Already in devoting himself to landscape, with its relatively indistinct and fused shapes, he appeared as a deviant in the conservative school. In his own time he was admired as both a composer with stable, clearly balanced forms and as a poet of delicate moods expressed through subtle relations of tones. His written notes and the conversations published by friends demonstrate that for him fidelity to impressions is a practical imperative in art. Corot admonished, "Let us submit to our first impression. If we are really touched, the sincerity of our emotion will be transmitted to others."[31]

How deeply rooted this concept of impression in landscape painting of the first half of the nineteenth century was can be seen in the frequent use of the term by the English art critic and writer John Ruskin. He came to it through his study of the work of the English landscape painter Joseph Mallord William Turner and the native empirical tradition in philosophy, independently of French art and thought. In volume five of his *Modern Painters* (1856), contrasting the painting of impression with the "portrayal of actuality in a faithful spirit, modified by a sentiment of beauty," he wrote:

> If a painter has inventive power he is to treat his subject in a totally different way: giving not the actual facts of it, but the impression it made on his mind.
>
> First, he receives a true impression from the place itself, and takes care to keep hold of that as his chief good; . . . the distinction of his mind from that of others consists in his instantly receiving such sensations strongly, and being unable to lose them; and then he sets himself as far as possible to reproduce that impression on the mind of the spectator of his picture.

Ruskin had spoken earlier of "the sacredness of the truth of impression." If the artist tried "to compose something prettier than he saw, and mightier than he felt, it is all over with him. Every such attempt at composition will be utterly abortive."[32]

The painter Boudin, a disciple of Corot and a primary influence in turn on his own young pupil Monet, wrote that it was essential to retain "one's first impression in making the picture. . . . Everything that is painted directly on the spot has always a force, a power, a vivacity of touch that cannot be re-created in the studio" (fig. 7). Committed to this principle, the painters were to work from nature face-to-face; they were no longer to be satisfied with constructing their pictures from repeated studies of the model or from sketches of the landscape and preliminary

drawings of the composition. Sincere artists must confront their objects, armed with a method of seeing and rendering that preserved the freshness and wholeness of the impact experienced in that encounter. Trust in this principle could be a tormenting challenge to young painters who were often discouraged by its difficulties and deceptions. Renoir's struggles with these pictorial problems have been cited as a cause of his departure from the Impressionist method in the 1880s.

Degas, who, after a long discipline and practice in the traditional method, had come to a realistic program of painting the directly seen, counseled emphatically against the practice of painting from the object; but he strove by other means to achieve the aspect of the momentarily seen in pictures he composed and finished in the studio. He is said even to have painted portraits in the absence of the model. At least in a note in a sketchbook he recommends this practice to himself: "For a portrait, pose the sitter on the *rez-de-chaussée* and then work upstairs in order to get used to retaining the forms and expressions in memory and never draw or paint directly,"[33] meaning directly from the model. But the sitter was then the object of a prolonged scrutiny, a close searching of her appearance, her forms and tones, her characteristic mood and bearing, which he strove, like J.-A.-D. Ingres, to preserve in the painting done from memory. Degas's struggle to realize his "impression" of a figure or a scene, his ceaseless corrections of the contours, spring from that authority of direct perception. There were no formulas to guide him, only the vivid traces of the impression.

The demand for truth to feeling that earlier painters had identified with the impression did not lead them to a sustained program of direct painting from nature. That had to wait for a new content, a subject matter that called for more direct participation. Living among peasants in Barbizon, Jean-François Millet wrote in a letter of 1850: "If I could only do what I like . . . I would paint nothing that was not the result of an impression directly received from nature, whether in landscapes or in figures."[34] Eugène Delacroix, who said "I consider the impression transmitted by nature to the artist the most important thing to be translated," painted little from nature, though he drew constantly from the living model in preparing large historical and mythological pictures. At the same time, he recommended drawing from imagination and memory as a means of freeing oneself from the imperfections of the individual model. In his finished work, he sought the qualities of rapid, impulsive execution stimulated and directed by the force of his imaginative impressions of the subjects, which were often taken from great literary works by Dante, Shakespeare, and Byron. In the complex process of transposing the experience of the written word and the images it has aroused to an equally stirring picture, the painter's enthusiasm for the imagined theme, heightened by the enthusiastic reading of a poet's dramatic or lyrical text, was the romantic counterpart of the emotion the later landscape painters experienced on their first encounters with a scene.

The Aesthetic and Method of Impressionism

CHARACTERIZING THE STYLE of a group or period, however vaguely, by distinctive formal elements and relations implies nothing about the value of particular works in that style. This discussion of the general aesthetic and method of Impressionism aims to describe a few essential aspects and features that neither exhaust the character of the art nor determine sufficiently a judgment of individual works. This chapter advances an account of habitual Impressionist practices and features, which are valid not only for the most prized and pathbreaking works of the original masters but also for the less successful results, for their failures, copies, and imitations.

In the use of these common forms there is an important difference between the art of the leaders—Manet, Degas, Renoir (fig. 8), Monet, Sisley, Pissarro—and that of their most accomplished followers. It is the difference between the inventor and the less original mind that has applied the invention. The artists who conceived what became in time a model for others, a new style or norm, were more likely to exhibit in the course of the process that passion for its development and perfection that usually accompanies high artistic quality. The architects who originated Gothic forms were aware of problems and possibilities not envisioned by others, and that awareness was itself a stimulus and fertilizing moment. The fact that a particular range of tones and a mode of breaking up colors and stroking the surface of Impressionist art became a cliché in the art of the later nineteenth and the twentieth centuries—just as the innovative devices of contemporary abstraction can be practiced today in day-care centers—does not diminish the fertile ideas of the first Impressionists, which emerged and were elaborated in paintings of high quality and marked artistic power.

The aesthetic of Impressionism comprises at first a new attitude, a new way of seeing. This fresh perspective was implied in the name, in what was called the "impression," which the artists sometimes referred to as the "sensation." This attitude in perception is present in common experience as well as in art, though not with the same intensity or with the same practical effect. In the image world of the Impressionists—in their picturing of the environment, whether city or country, the distinctive occasions of spectacle, play, performance, recreation, and enjoyment—

FIGURE 8. Pierre-Auguste Renoir, *Claude Monet Reading*, 1872, oil on canvas, 61 x 50 cm, Musée Marmottan, Paris

their subjects issue from the aesthetic moments in everyday life. Even people who were not artists and who rejected Impressionist painting as unnatural and bizarre enjoyed the sites and occasions pictured by those painters and frequented them for their own sake. For that common enjoyment of nature, sport, and spectacle was the result of a city designed with an eye to aesthetic and recreational effect, producing the thousand and one facilities that made Paris and its suburban sites the capital of pleasure in the middle of the nineteenth century.

Valuing the mode of perception called the "impression," a summary term for a way of thinking and feeling as well as perceiving, the new artists differed from the psychologists and philosophers in isolating and exploring the impression as a prized experience and not just as one stage among others in the process of knowledge or as an item in laboratory experiments on the relationships between stimuli and perceptions. The painters singled out the impression as a fertile

ground of art that they opposed to analytical thought and observation, to fantasy and memory as traditional sources of art. These sources were seen as abstractions associated often with deforming constraints and illusions in personal and social life, while the impression, with its component sensations, was viewed as a basic primitive experience, an occasion in which we are most sincere, responsive, and capable of grasping totalities as aesthetic values. The occasions of impression and sensation became for art and also for moral and social thought the experiences believed to be most progressive and emancipating in society and personal relations, particularly during the last third of the nineteenth century, when for many in the educated middle class political thought and activity had lost much of their urgency and passion. With economic expansion and prosperity a balance had been achieved for a larger number of people in the relations of individuals to their social milieux, through the new opportunities for relaxation, pleasure, and freedom of movement. Such a view of the nourishing attitudes and elements in experience has continued in our own time and still figures in the reflections of psychologists, moralists, and social thinkers about the importance of the instinctive, freely reacting, and spontaneous, of the intuitive and felt, in our thinking and behavior.

At the time of the Impressionists, when this view was widespread, not all artists who believed in the broader values of the impression tried to build upon it in practice. Many held these notions as intellectual formulae without exploring them in their art. The Impressionists were distinctive in attempting to create art on this foundation. Accordingly, they invented new means and introduced into painting a domain of subjects and qualities that, through the particularity of artistic substance, made it possible for them to realize on canvas the content of this otherwise elusive moment of the impression. The value of Impressionist paintings did not lie simply in the fact that an idea was given a material embodiment, as philosophers suppose when they speak of art as the sensuous communication of otherwise private institutions or abstract ideas. While their new practice required the support of general principles, the sense of these emerged in the course of the work. In the painting as a concrete, individual object the Impressionists were able to discover and to realize these fresh artistic qualities and to create a new mode of appearance in painting.

The notion of the primary place of the impression is a contradiction for psychologists, who believe that the Impressionists have misunderstood the nature of perception. For the scientists, perception is a biological process through which we find our way in the world and learn to handle objects as well as direct our own bodies. For scientists and also for philosophers since the eighteenth century, visual sensations have been understood as physiological effects, with components that lie below the threshold of ordinary awareness.[1] According to this view, we experience objects rather than sensations. Sometimes isolated in experience, the sensation is a sophisticated procedure, resting on knowledge and reflection.

Yet there is a large sector of daily experience in which we respond naively and attentively, like the painter, to fine differences in sensation, differences that affect our well-being and our action. We react, for example, with delight and sometimes with depression to the aspect of the

large environment we call weather. Our feelings for its relative brightness, warmth, airiness, or moisture—qualities that we do not designate as properties of distinct objects and that we cannot isolate as we specify the qualities of objects set in a definite field or against a ground—reflect the weather as an extensive unbounded totality, determining our mood and inducing our awareness of or our dependence on small changes in our surroundings as a whole. For these vitally important variations in quality, we have only a few imprecise words.

A rich range of reactions occurs not only in our relations with the environment as a source of feeling—a source that is infinitely complex and that calls into play more than one sense—but also in our responses to small isolated objects, such as our aesthetic judgment of costume or our reaction to faces where a slight change in the expected color makes us sense a shift in the mood, even a disturbance in the state of a person. Differences in paling and blushing, in signs of health or discomfort, for example, are not understood as constant properties of an object but as subtle mutations caused by passing experiences, which call for a discernment attentive to fine gradients of sensation. The Impressionists built resolutely, not so much on the knowledge of the more stable properties of objects that can be clearly singled out as on those elusive features that make up the "physiognomic" of our surroundings and to which we react with feeling, no less than to more distinct and valued objects.

Perception is, therefore, not just a passive, optic relationship; it also shapes our behavior, our mood, even our considered action, whether for a moment or a longer period. Long ago painters were aware that one can practice a mode of seeing in which one pays little attention to things, while treating their qualities as if they are distinct entities. Psychologists have said that this is a special attitude of the laboratory or studio, which is unsuited to everyday life. Some even regard it as highly artificial, a risky ground for drawing conclusions about normal human behavior or the psychic process.

Yet we see in the Impressionists' pictures that their paintings are about a common world; they imaged the kind of objects to which they often reacted spontaneously and with pleasure and to which we, a century later, respond similarly, whether we are artists or not, whether in a laboratory or at home. The Impressionist painters, however, were able to make of this experience the grounds of a new art in devising a technique for its controlled representation, a method of matching and ordering tones adjusted to that field of sensation. Hence, if the sensation as elicited by Impressionist pictures is truly a perception in that it refers to a definite, concrete source in the tangible field of the canvas, we must ask what artistic means were invented for these perceptions to be stabilized and organized into a system of graded qualities with respect to which the painters could make their artistic practice consistent.

How were the Impressionists able to distinguish and measure those newly invented means as qualities? How were they able to use them as components, like the tones in music, and foresee their interaction, their behavior in concert? This important visual and intellectual discipline was achieved, not through the reading of scientific books, but by practical study and reflection; it

required, besides inventive imagination, a painstaking, searching effort to refine the process and to test the means in successive works. The imitators of Impressionism inherited the results and could practice the art without having to undergo the trials of discovery and testing, losing, in the process, the rough power of the revelation.

Though not inclined to theorize, the Impressionists and their predecessors left some instructive remarks about their procedures and thought. When asked what object he had painted in a corner of his realistic picture some years before them, Gustave Courbet, an older contemporary, was reported to have said that he did not know—he painted only what he saw.[2] That answer is suspect to philosophers and psychologists, who suppose that you cannot represent an object unless you know what it is. Perhaps it is more correct to say that you can draw an object before you quite distinctly without recognizing it as one of a species, if you know how to draw objects in general—that is, how to reproduce shapes and colors through a disciplined coordination of hand and eye. Similarly, you can describe an unfamiliar thing in words if you have a language for specifying forms and colors and their relations in space; even gestures can simulate a shape.

To represent a strange object so that others will recognize it in the depiction requires experience in matching its colors and outlines, in isolating its form, in bringing out the object's volume through light and shadow, in blurring its edges where these recede, and in making parts look properly near or far. For all this you need not be able to name, that is, to classify, what it is that you are drawing. You can, in such a way, represent with fair accuracy some very complex, unfamiliar objects indeed. The astronomers who noted with care and recorded in words and diagrams the spots and colors on the surface of a planet before they could interpret them were like the Impressionist painters in their attitude. Conjectural explanations of the colored spots on Mars as canals or natural structures or as induced subjective contrast colors rest on the presumed reliability of the recording of uninterpreted sensations. Although appearance is often rendered more fully and correctly when the objects are known, to represent conjecturally those perceived Martian colors precisely as a band of vegetation, canal, or rock edge as we know such things look on Earth would be to falsify the appearance,

Ordinarily we see an extended green in a landscape as grass, a blue overhead as sky, a red below it as a roof, a point of yellow as a flower. Colors may trigger our recognition of these objects, but not as do the specific words for colors and objects. These are, in the linguist's sense, culturally inherited, arbitrary signs that vary with the language of a social group. We say that colors are natural signs as features or effects of the objects; the sensations of color are so connected with particular things and their positions in space, relative to the observer's, that in experiencing the color in a landscape we recognize the object or class of objects as components of the site. The Impressionist painters, too, knew these colors as signs, perhaps more precisely than we do, since without reflection they distinguished fine differences as indicators of form and distance and position. But for the moment they suspended that knowledge of the colors as signs and

considered them as colors alone, just as a linguist (and sometimes a poet) can study the sounds of words and attend to their component elements without regard to the object that the word designates—the same sounds may be shared by words of unrelated meaning. In abstracting the colors from their function as signs, the Impressionist painters did not ignore all signification. Latent in the design of the pictures, indeed necessary for the ordered construction of the whole, was their experience and recognition of objects in space, their knowledge of characteristic differences between the near and far and between the object and its ground or surroundings.

The painters' long practice and habit in scanning things in space cannot be suspended completely (even the poets or linguists who isolate the single elements of speech as pure sounds alone must sometimes know the whole word as a sign and distinguish it from other words in properly defining these meaningless components). But as artists they discovered in these colors, which had been stripped of sign-content (while they painted), another order of significance: their varying roles in a corresponding system of pigment tones and their places in the picture as an ordered whole. The yellow they picked out in the landscape and transposed to a place on their painted canvases was brighter or duller than another yellow elsewhere, or contrasted as a tone with a lavender beside it.

In the painters' discriminations and choices was meaning, a pictorial intention, and a fitness. Not at issue was the color's ordinary function as a sign but rather its position in a scale of qualities, often in several coordinated scales. This meaning was not arbitrary or coded, like the meaning of a word, but was a relationship that had been discovered intuitively by the artists through study of their medium; their color convinces us without reflection or memory as rightly chosen because of its effect in the whole. Like a tone in music that contributes to a distinct melody or harmony by virtue of its perceptible quality in the enveloping context, the color has a character that is itself affected by the neighboring tones.

To speak of Impressionist colors as "uninterpreted sensations" or to refer to those Impressionist sensations as being conveyed by "uninterpreted colors," is to indicate first that the colors have been taken from that complex of perceptions in which colors are in fact signs; but they have been isolated or abstracted without much regard to their particular function as signs. In disregarding the more constant color signs of the object, the painters discovered a new set of signs for features of the world that had not been closely observed before: the various modalities of light and atmosphere. This new approach to color was one root of the public's uneasiness with Impressionist paintings. Yet for the Impressionists themselves their color was truly more exact in representation than the accepted color of the traditional painters. For example, shadows were colored, and color is a sign of sunlight even in shadows; formerly, dark shadows, brown and black, were signs for volume and for the position of an object with respect to light, atmosphere, and distance.

In their study and pursuit of color, the Impressionists sought the kind of qualities not normally noticed. They were keenly attentive to uninterpreted sensations, qualities of colors and

light that referred to a point or region in space but that did not distinguish among a tree limb, a rock, or a living creature. The sensations were uninterpreted in the sense that, although they were not identified with a specific object or a distinct part of an object—they were, in short, not taken as signs—still they were understood as characterizing some kind of object. They belonged also to the light and to the observer as a sensing, searching "eye." Seeing a patch of color on the canvas, one can say that it is a yellow lying distinctly between two other tones, that it is in value near to or between tones in different parts of the work, that it establishes a certain interval or produces an effect of intensity, harmony, assimilation, or contrast at that point, and that it has certain expressive properties. The habit of dealing with colors in this way as uninterpreted sensations was one of the basic approaches of the Impressionist painters. Later it was also essential for the development of abstract painting, though not in as obvious a manner, since so many distinguished practitioners were not representing objects.

Monet once explained to an American interviewer how he looked at the scene he was painting: "Merely think, here is a little square of blue, here is an oblong of pink, here is a streak of yellow; now paint, just as it looks to you, the exact color and shape until it gives you your own naive impression of the scene before you."[3] Monet connected this way of looking at things in terms of distinct uninterpreted sensations as the means of building up the effect of the whole scene, of reproducing what psychologists call the "proximal stimulus." But in speaking as he did, Monet was going beyond Courbet. He was not simply explaining an incidental or partial effect in a picture that rendered a great number of indistinct recognizable objects; he was creating a new method that constituted an overall attempt to capture the pervading qualities of light and atmosphere at a given time and place.

John Ruskin, Turner's great advocate, had written, "until you are quite fearless of your faithfulness to the appearance of things, the less you know of their reality, the better, and it is precisely in this passive, naive simplicity that art becomes not only great in herself, but most useful to science." But Ruskin did not approve of Impressionist paintings when he saw them; he could not tell what was painted there, and warned his readers against accepting their own sensations without knowing in detail what objects they were seeing. He probably also found their subjects—the paintings of the Paris environment—repugnant to his moral outlook.

The Impressionists were convinced that uninterpreted color referred to a sensation rather than to an object. It was thus an ultimate element of both art and the experience of nature. Their pursuit of uninterpreted color was directed, then, to the development of a new fertile method, though not a method governed by strict rules. They pursued it according to their sensibility, their observations, experiences, and goals; and in the course of their work, they often varied the approach. If they were concerned with an object of which the singular form attracted them, they modified or adapted their approach to the demands of their feeling for the object, as, for example, in painting a portrait.

The relationship here set forth is not as simple as it appears from this account. It varied with

individual artists, their past experiences, their temperaments, their momentary situations in looking at scenes, and the energy with which they conceived and pursued the task at hand. Among the Impressionists, the uninterpreted color presents itself with a broad range of properties and applications.

To this unit of visual experience corresponds a material element of the painting: the tangible stroke or distinct patch of paint. It is a fundamental feature of Impressionist painting, as can be seen even in a black-and-white photograph. A hundred years before, commentators noted as characteristic of their styles that Gainsborough painted with patches and Jean-Baptiste Chardin in little dots. Examination of their works today may indeed yield some patches and dots, but each painting as a whole has not been conceived accordingly. These small units have been submerged in larger, more distinct object-forms. For the Impressionist, the stroke of color was a more basic, decisive element, determining many qualities and relationships of the work.

Chardin's touch was not as perfectly discrete and was often blended with overlaid, scumbled touches, crisscrossed and directionless as a group, as if they had been heaped up on a spot to produce a dense patch of rich coloring. In the painting of rocks and formless mixed vegetation this technique is most strikingly evident. In time, Chardin also manifested a gradual tendency to reduce all strokes to one kind, with every object emerging as if suspended in a pure medium with a characteristic weave, like a tapestry.

Cézanne in the late 1870s used Chardin's method in painting fully modeled objects, perhaps as a means of control and of a more compact unity. An outcome of these attempts to create a distinctive brushwork independent of and often submerging the forms of the objects—and in Cézanne's modeling the strokes are fairly uniform—can be found in Georges Seurat's more fully emancipated, universal stroke: the tiny directionless touch of pigment, a particle with a charge of color.

In the older practice, the artist's stroke was often valued as a personal script and adapted to the forms of the objects represented. But however spontaneous in filling an area or shaping a contour, it belonged to drawing and served to effect the modeling. In praising Delacroix for his rare brushwork, the critic Théophile Thoré wrote in 1847 that "his touch, or his way of placing color and conducting the brush, is always regulated by the forms on which it is employed, and helps to mark their relief. As the modeled form turns, his brush turns with it in the same direction." There were, Thoré noted, painters who ignored the structure of objects in their strokes, which often proceeded in disregard of the forms. This approach was admissible in representing a flat wall without relief; "but one doesn't caress the face of a mistress by starting with the chin."[4]

By reducing modeling and sometimes eliminating it altogether, the Impressionists gradually freed themselves from the stroke guided by the voluminous form of the object. Their own *parti pris* was anticipated in earlier painting of distinct objects in landscape. The rendering of light and atmosphere as pervasive, affecting every corner of the picture alike, and the choice of distant

objects on a small canvas, tended to minimize, even eliminate, all modeling. This effect, complementary to the predominance of the small, discontinuous stroke, reinforced the mosaic or molecular aspect of the work.

But the stroke of the Impressionists was bound to their objects in other ways. Their tree trunks, painted flat, were formed of vertical strokes; the masses of unmodeled foliage, of mottled tones of color, were built of touches that move upward and outward as if responding to the apparent directions of growth; the sea has been laid down in horizontal strokes, shrubs and hedges in vertical ones; the clouds were painted in curved and horizontal patches that recreate the main axes of these shapeless fields. All these conformations of stroke to the object added to the liveliness of the works, their contrasts and effects of movement.

In early Impressionist painting, as it advanced toward a freer and more luminous color, areas were filled by their neighbors in helping to suggest virtual objects that do not appear to be characterized by the properties of the stroke, just as the objects on a human scale, that we see and handle in everyday life, are not visibly patterned like the molecules and atoms of which they are constituted in the scientists' constructed models. The Impressionists formed a whole in which light, atmosphere, movement, shapes, and colors were all discernibly constituted by the stroke. We can reverse the relation (as is possible when we deal with part-whole relationships) and say that in that kind of whole, that particular combination of light, atmosphere, movement, and color, the unit had to be the small stroke. A passage in either direction is conceivable. But from the historian's point of view, observing the order of development, the conception of the stroke as an ultimate unit is essential for the way in which the various features of the work—its rendering of objects, its aesthetic, light, atmosphere, color, movement and composition, arabesque, and decorativeness—were realized by these painters, though each artist has obvious individual characteristics.

The stroke in Impressionist painting is not only felt as the property of a single region or point in the picture; the strokes seen together fabricate a surface web—a film or crust of pigment that here, more than in earlier art, exists as distinct in texture from the image-object. In painting trees, water, and sky, the Impressionist produced two modes of appearance. First, there is the image aspect—the scene that you make out in the fictive space of the painting. But you are also made aware that the layer of the paint is thick, and composed of small doses of color, a dense substance, which has more relief than anything you discern in the things imaged, and that the texture of what is rendered—water, sky, clouds, and buildings—is rather unlike the natural texture of these things. All these things or areas have a somewhat hazy, filmy appearance. They have been modified by atmosphere, or the light shining on them is so brilliant that we see the light rather than the thing itself.

Before Impressionism, artists who wished to give a vivid effect of the objects they were imaging understood the need for a smooth, shiny surface or picture field. The canvas became transparent, an invisible plane, like a mirror. One looked through it as through a perfectly clear window, without awareness of the glass; but if the glass were irregular or stained, one would see

the pattern of those irregularities and only vaguely the object-world behind them. The Impressionists tried to make both aspects—the stroke pattern and the "world"—more or less distinct. They wished to make visible both the illusive image-appearance of a scene in deep space and the tangible substance of the painting as effects produced by the artist on the framed surface of the canvas. Out of this duality arose problems of coherent design that have attracted artists of the twentieth century, though such problems have been solved in different ways.

In organizing this relationship between surface and representation, the Impressionists painters achieved what is enjoyed today as a true, yet evocative image; but in striving to make the painted layer itself as attractive and harmonious as possible with all the marks of the brush, they had to contend with the spectator's older habits of vision. The first viewers of Impressionist pictures, attuned to a smoother and more minutely detailed rendering, could not make much of them from close up; they saw nothing but an unfamiliar pattern of colored brushstrokes. Stepping back ten feet, they might be charmed by the effect. Something new had happened; they discovered that by moving their own bodies and shifting their points of vision they had magically brought into existence a recognizable image. But in this reassuring view they could not experience the beauty of tones and texture or the rhythm of the brushstrokes. When asked from what distance one should view his pictures, Renoir peremptorily replied: "*Parbleu*, at arm's length."

To experience intimately an Impressionist work as ordered color and stroke you must hold it in your hands. Only then can you sense the rhythmic, graphic play of the brush, the fine differences and accords of tone in neighboring touches, and the passages of colors in ever varied chords on that surface. All these disappear as you step back in order to bring into focus the mirrored landscape. And yet, even at a distance an effect of the constant interplay between the two aspects remains. The painters were aware, too, that this effect is not something inherent in the art of painting, in the adaptation of the deep image-space to the tangible surface of the canvas; it belongs also to a specific way of experiencing the visible world.

In everyday life, when we attend to the light falling on an object, we sometimes cannot determine its so-called local color. If we try to discern this constant color, we abstract it from the concentration of lights, reflections, shadows, and nuances that belong to it uniquely; we also tie the object to its surroundings. Nature itself presents us with these alternatives in perception, above all when we look at the sky or still water. In observing reflections in a quiet pond we enjoy the smoothness and color of the surface. By a slight shift of attention we also perceive the reflected trees and sky inverted in the water. All these qualities of light and atmosphere, of reflection and movement, not only determine paradoxes of space and conflicts with the painted picture and with the image on the canvas; these conflicts appear in our vision of the world itself.

A beautiful description of Paris by Henry James corresponds with uncanny aptness to the complex Impressionist vision of both nature and painting. James wrote of the city in *The Ambassadors*:

It hung before him this morning, the vast, bright Babylon, like some huge iridescent object, a jewel brilliant and hard, in which parts were not to be discriminated nor differences comfortably marked. It twinkled and trembled and melted together, and what seemed all surface one moment seemed all depth the next.[5]

James's word picture did not arise only from his awareness of the new art.[6] Rather his observation was of nature itself, of the phenomenon of Paris, which the Impressionist painters had envisioned triply: first, as the city, in its stirring aspect of atmosphere, light, and movement; then, as a picture that could exhibit in its color and structure certain qualities corresponding to those of the city; and finally, as the interrelation between the two, the source of the beautiful web of brushstrokes—the unstable duality of depth and surface, of reality and appearance, described by James—that came vividly into being as an artistic unity. The painted canvas is the reality, the represented city an appearance that was a part or aspect of the city's attractive, engaging reality.

How did the stroke, as an element, build the whole into a totality? Applied as a unit throughout, the stroke made for a special kind of surface, a material layer with definite properties of a texture different from the objects represented by the painting. The touches of color, put on in subtle and unequal relief, themselves reflect light variably; a luminosity of the canvas was distinct from the light represented in the picture. That luminosity could even be a disturbing factor; it often troubled the painters. They wished to reconcile the devices by which the light falling on trees, clouds, and water in nature was vividly realized with the devices through which paint and brushwork made the canvas surface itself become as alive with reflected light as the scene or object it represented. The resolution of this conflict involved compromises, notably in certain paintings by Renoir in which his desire to suggest the smoothness of human skin led him to sacrifice the textural unity of his surface.

In a small segment from *La Grenouillière* (figs. 9a and 9b), a painting by Monet of a bathing place on the Seine, with figures on a barge and an artificial island, we note between them large, distinct horizontal strokes of blue and yellow, firm and strong, that are opposed to the darker blue and whites of the figures. These patches summarize distant water, though they cannot be translated directly or specifically as visual detail. Monet did not outline the figures but applied his brush directly in a single broad curved stroke (or a few patches) to build a layer of color. At this early stage of Monet's practice, he would find a tone and set it down boldly—no simple reflex of mimicry but a reflective procedure, a matching that called for a subtle adjustment of relative values, as the scale of pigment colors could not reproduce exactly the scale of brightness in nature and had to be adapted to the latter through a system of proportionate correspondences.

Consider another example: a small detail, a few inches wide, from Monet's painting *Rouen Cathedral: The Portal in the Sun* (fig. 10). Our knowledge of the building itself—its forms and the texture of its masonry—cannot account directly for the fine or gross variations in the picture's brushwork. The painter has introduced many touches that translate intense sensations of

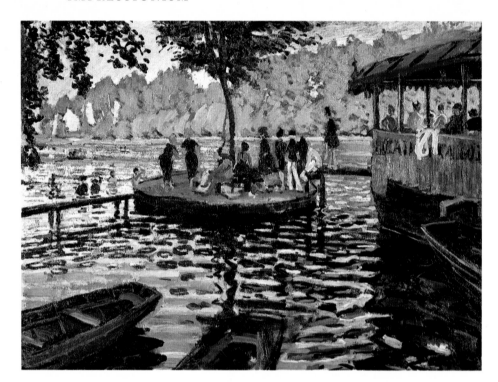

FIGURE 9a.
Claude Monet,
La Grenouillière,
c. 1869, oil on
canvas, 75 x 100 cm,
The Metropolitan
Museum of Art,
New York

below:
FIGURE 9b.
Claude Monet,
La Grenouillière,
detail

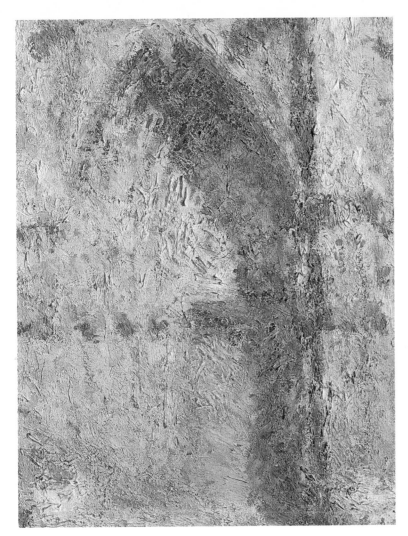

FIGURE 10. Claude Monet, *Rouen Cathedral: The Portal in the Sun*, detail

color. They have been adroitly selected to produce effects like those of uninterpreted sensation; taken together, these elements form a whole that has the vague semblance of the cathedral but also an uncannily precise semblance of a specific aspect of the façade at a particular time of day and at a certain distance. (Or is it perhaps its harmony as a work of art that disposes us to accept the image as true to a subtle poetic appearance of the object?) In this detail especially we can see how pronounced is the painting as compared with the imaged object. The latter—the cathedral facade—is filmy, suspended, without a localizable position in depth. We cannot judge how near or far from us are the parts. But the pigment persistently is more definite, an irregular, richly kneaded and broken surface.

Turning to a canvas with plants, water, and shore, and reflections in the water, we can see again how the unity of the work and, above all, the more minute pattern of the whole depends

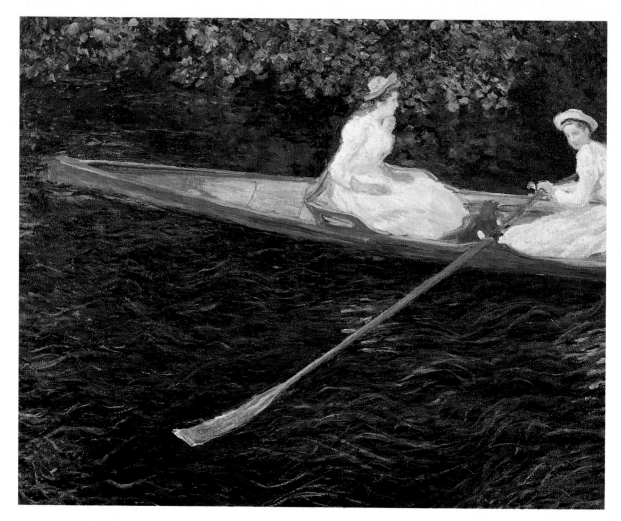

FIGURE 11. Claude Monet, *Boating on the River Epte, Blanche and Marthe Hoschedé*, 1890, oil on canvas, 133 x 145 cm, Museu de Arte, São Paulo, Brazil

on the brushstrokes (fig. 11). Here, more than in other works, the large articulation of Monet's flecked surface replaces the microstructure of the represented objects, while retaining a broad correspondence of an aggregate of strokes to a single, vaguely summarized object. In a view of the whole, these seemingly shapeless and arbitrary notations of color make a simple, isolated silhouette. But even this pattern presents a phantasmal appearance—a result of the priority given to the uninterpreted sensation and its material counterparts: the accented touch, the stroke of color.

A detail of *River Scene at Bennecourt* (figs. 12a and 12b) demonstrates how the construction of the whole is a web of patterned strokes bringing to view the pigment surface as a palpable layer on the canvas. The woman's head—and in the imaged space she is the object closest to us—has

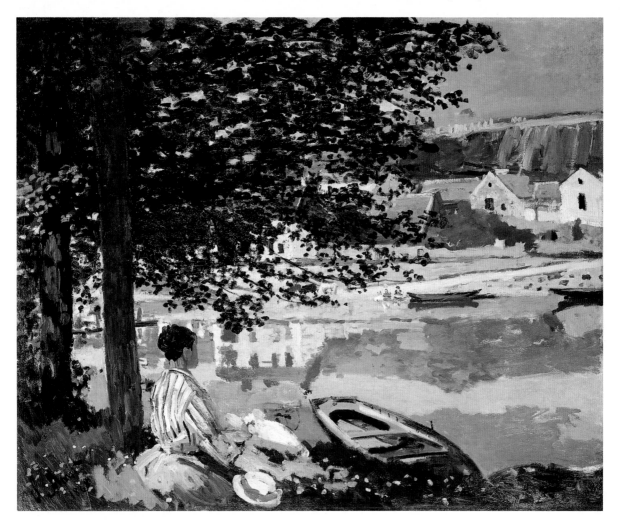

FIGURE 12a. Claude Monet, *River Scene at Bennecourt*, 1868, oil on canvas, 81 x 100 cm, The Art Institute of Chicago

at left:
FIGURE 12b. Claude Monet, *River Scene at Bennecourt*, detail

FIGURE 13. Claude Monet, *La Gare Saint-Lazare*, 1877, oil on canvas, 75 x 100 cm, Musée d'Orsay, Paris

been painted in a tone very similar to the patch that renders the roof of a reflected building inverted beside her. Though nearest to her on the surface of the canvas and matching her color most closely, that reflection cannot be located clearly in the depth of the landscape. It is not in the water, nor on the opposite shore. The series of tones that are most like the flesh color may be picked out on the canvas both as tone and as patch qualities, distinct units that make up the whole. They are vague and vibrant, they overlap and are scattered irregularly, though mainly vertically and horizontally. Notice, too, that the white areas on her striped blouse and at her knee, the patches on the boat and in the reflected building, all work together; they reinforce the reality of the pigment surface as much as they contribute to the effect of an image with reflections in the water.

The painting *La Gare Saint-Lazare* (fig. 13) is an especially clear example of Monet's frequent use of what is already painterly in the landscape—smoke, vapors, clouds, the vagueness of distant and moving objects. The turbulence and vibration of the steam and smoke are brought

out by means of the same rhythms and textures of paint as the human figures, the sign, the posts, and the ground below, with the vaporous, phantasmal blue at the left. Monet's was not a systematic stroke, such as appeared soon after in the work of Seurat, who belonged to a younger generation. Yet compared with older painting, Monet's art was an amazingly radical approach to a homogeneous effect. Before his time one spoke of color and the brushstroke in a language that would apply to Monet's more advanced work, but nothing was produced then that approached the thoroughness of his practice. In his work the same kind of material unit appears everywhere as a motor trace—something visibly impressed on the canvas, with its own rhythm of the working hand—and as the vaguely suggestive yet often uncannily precise semblance of all shapes and colors, all qualities and textures of the imaged field in nature.

That suspension of the image in the substantive material web of strokes is equally evident in Monet's view of a distant town (fig. 14). The painter gave to the near parts of the scene the same qualities of reduced contrast, fusion, and vagueness that appeared in the distant space. Already in paintings of the fifteenth and sixteenth centuries the remote planes along the horizon and the reflections in water had anticipated features of Impressionist rendering; but the picture as a whole owed its character to a strict definition of the major objects by distinct contours.

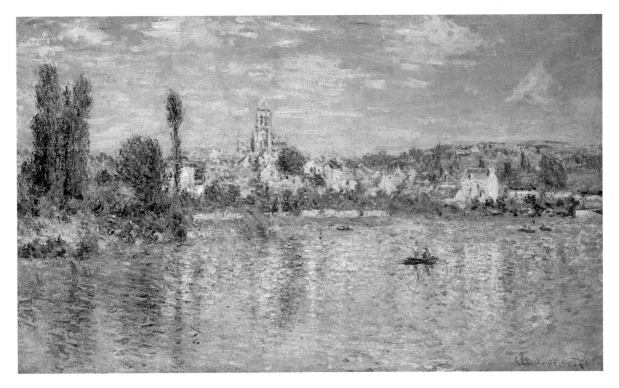

FIGURE 14. Claude Monet, *Vétheuil in Summer*, 1880,
oil on canvas, 60 x 100 cm, The Metropolitan Museum of Art, New York

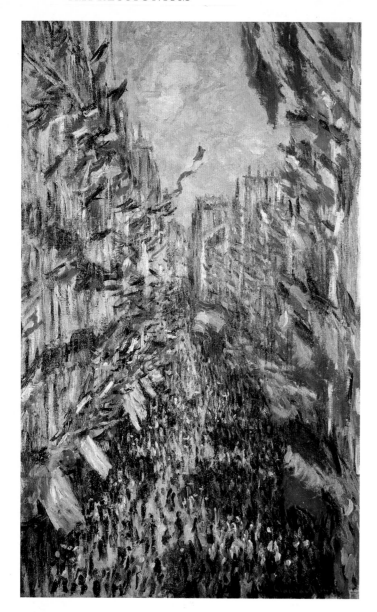

FIGURE 15. Claude Monet, *The Rue Montorgueil, 30th of June, 1878*, 1878, oil on canvas, 80 x 48.5 cm, Musée d'Orsay, Paris

In Impressionism the mode of appearance of distant objects has been transferred to the near. Whether far or near, the world is often characterized in much the same stroke-bound, loosened manner; a type of brushmark was invented that gave to the painted canvas the same relief and appearance as it gave to the represented objects. This method led to qualities that affected the appearance of the objects and particularly to an effect of vibrancy throughout the painting. By virtue of the sustained and legible brushstrokes, any segment may seem to belong to the same picture as any other on the same canvas. Whatever the subject represented, the parts show not only a similar density in the number of strokes per unit of surface but also a similar relief

texture overlaying the successive strokes, as well as patches with a noticeable rhythm and relief. In consequence, an effect of fine vibration is produced throughout, a flicker of the painted surface of the canvas that enhances the luminosity depicted through it.

The Impressionists' stroke, however, was more than a technical device for simulating subtle qualities of light and atmosphere and movement. It differed from painter to painter as personal marks. Like handwriting, strokes also had an expressive, even gestural, sense and were often bound to a momentary intensity of the painters' feelings or moods in their lyrical engagement with certain scenes. We recognize this in the variation of stroke from picture to picture and its correspondences to qualities of the scene. At the time of early Impressionism, the first treatise that aspired to a systematic interpretation of handwriting—a book by Jean-Hippolyte Michon— maintained that handwriting expressed a momentary impression that acted on a writer's feelings, although the graphologist also discerned in writing the signs of constant features of personality.[7]

The peculiarities of Monet's stroke seemed to change more than those of the other Impressionists with the conditions of his feelings, whether elated or more coolly observant in emphatic response to a subject before him. Both states could well have sprung from his effort to re-create objectively a quality of the original scene before him. So the ecstatic, rapid brushstrokes, forceful and swift, in the picture of the festive holiday crowd on the rue Montorgueil may be read as true to both the actuality and to the artist's own enjoyment as an enthusiastic participant in the collective mood of the moment (fig. 15). In the series of paintings of the railroads, Monet greeted the sight with rapture; the spectacle of the incoming and outgoing trains, of the smoke, steam, and crowds exalted him.

The new atmosphere and environment were for Monet a rousing example of modernity. His paintings of the railroads anticipated in their energy and boldness Fauve pictures at the beginning of our own century. They show the most passionate, impulsive streaking, scribbling, crossing, and hatching of strokes that in concert evoke the original exciting phenomenon. Nothing was rendered as a distinct object in closed, drawn lines, though the execution has graphic qualities. Every touch possessed an uncanny rightness and power of suggestion, as in the best French writing of the time, in which the evocative word or phrase or the rhythm of a verse or sentence was so often a discovery, an outcome of the will to realize in language the qualities of unique, unnameable sensation.

That fury of the brush was a personal reflex and in the final building of the whole was directed by feelings and energies aroused by the contemplated scene. The execution of the work seemed to mimic the repeated shocks of the stimulus from which the painting had proceeded. There was little or no separation in time between the vision of the encounter with the object and its rendering on the spot. The abrupt rhythms and the vehemence of the brush expressed a vital personal reaction besides imaging keenly observed features of the site.

A text by the contemporary novelist Alphonse Daudet, who displayed Impressionist features in his syntax as well as in his choice of episodes, offers an instructive parallel to the work of the

painters. In the preface to a volume of short stories from the early 1870s, he tells the reader that he is presenting "notes written from day to day. It is a leaf from my notebook that I tear out while the siege of Paris is still hot. It is all chopped up, banged, tossed off on one knee, fragmented like a burst of shrapnel, but I give it as it is, changing nothing, not even re-reading it." The image of the shrapnel was just; Daudet was describing a moment of war. In a similar vein, the Impressionists re-created for the imagination a crowd or turbulence of nature with a burst of brushstrokes—an expressive equivalent of the movement and force in the world they saw, not in a photographic sense, but more inventively and freely. Through its execution as a material object, the painting presented a vibrancy or flicker that the smooth impersonal surface of a photograph could not achieve.

In Monet's painting *Le Boulevard des Capucines* (fig. 16), the crowd in the street appears as a dense aggregate of small staccato patches. Such rapid irregular strokes, in a random order, could not be planned precisely in advance. They were not designed and corrected in preliminary drawings. Their effects were begotten either directly or not at all. But that spontaneity was paid for by long study and by many trials and failures.

Before they arrived at what may be called a fully Impressionist style, with the surface web of fine touches and its unique patterning, those painters had already chosen to paint from nature its congruent quasi-Impressionist moments and situations: its appearances, sites, and sights. They often chose scenes that, apart from the method of execution, would have, if rendered in a more traditional realistic manner or even in a photograph, offered at least some qualities of the Impressionist picture. Monet, for example, spoke of Venice as an Impressionist city, though its architecture is largely in the Gothic and Renaissance styles. He loved to paint it as a spectacle of façades in sunlight, broken repeatedly by arcades and windows, and reflected in the water. Earlier artists, we have seen, who were attracted by this kind of world, could not have created such an effect. They not only lacked the painterly means, but they had not come to appreciate those qualities in the scene itself. They had not seen it as a stimulating milieu that could fully awaken and sustain the mode of perception that underlay the Impressionists' approach.

Among other special Impressionist moments was the falling and fallen snow—a dosage of white dots in the sky, an accumulated blanket of white covering the dark winter ground. In Monet's pictures of ice breaking up in the river, nature has done the fragmention and scattering that he and other Impressionists would seek by other means in their pictures of perfectly smooth snow, finding within the whiteness many points of contrasted color. In Renoir's painting of the park in winter, the crowds skating, the trees, and the buildings produce an allover pattern of contrasts to produce a typical Impressionist surface.[8]

We associate the Impressionists more with the nature rebirth of spring, despite their proficiency with winter scenes. For one of his compositions, Pissarro selected a group of houses fronted by trees, a scene congenial to him in the openwork screening of the colors and shapes of the buildings by the lacy net of branches before them (fig. 17). He did not paint this scene by first

drawing the buildings and then imposing the trees upon them; he patched the contrasted forms of near and far elements beside each other to form a mosaic of which we can hardly say whether certain tones represent objects behind or in front. Yet they take their places easily in the plane of pigment tones.

Impressionist pictures were, in their day, often described as madly arbitrary because the painters gave to familiar objects in the pictures of landscapes colors that others had not yet perceived in nature. Scientists, exploiting their authority, supported the hostile, often philistine, reactions, by asserting that a defect of the artist's eye, lens, or retina was responsible for the tones

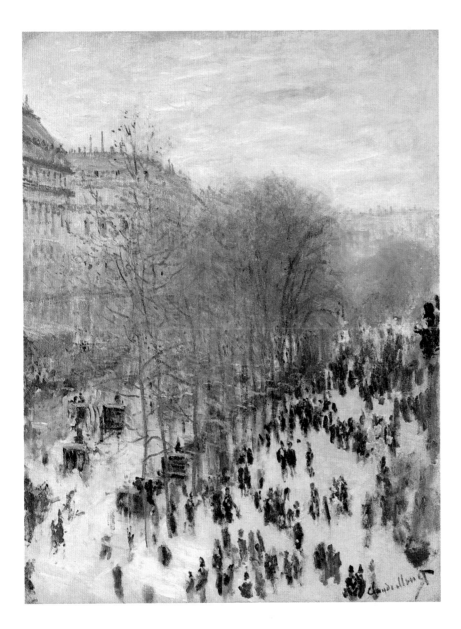

FIGURE 16. Claude Monet, *Le Boulevard des Capucines*, 1873-74, oil on canvas, 80 x 60 cm, The Nelson-Atkins Museum of Art, Kansas City, Missouri

FIGURE 17. Camille Pissarro, *The Red Roofs in the Village, Winter Effects*, 1877, oil on canvas, 54.5 x 65.6 cm, Musée d'Orsay, Paris

of violet in their canvases, much as a doctor later accounted for El Greco's elongated figures by his supposed astigmatism. Turner's colors had also been explained by an ophthalmologist a few decades earlier as the result of a defect of the eye. Although the Impressionists shocked their contemporaries by introducing into landscape certain tones and relationships of colors that looked unreal, they were later acclaimed as the acute observers of a true coloring that we now take for granted.

At the beginning of the nineteenth century, it had been noticed by artists who were observing nature freshly that traditional landscape painting was dominated by a convention of brownness, greenness, or grayness for the sake of harmony, which reduced the richness of color experienced in nature. In fact, the painter's commitment to a fixed local color was an obstacle for his

perceiving correctly even that local color. Local color refers to the constant, natural color of an object—the defining red of an apple, the brown of wood, the blue of the sky, as a permanent attribute. The "correct" color was the matching color that would appear like the other under varying illumination.

Around 1830, Charles-Augustin Sainte-Beuve, a poet and novelist as well as the most eminent literary critic of the century, remarked in his journal:

> There is in nature, strictly speaking, neither green, nor blue, nor red, in the usual sense of the word. The natural colors of things are nameless colors, but according to the spectator's disposition, according to the season, the hour of the day, the play of light, these colors undulate perpetually, and permit the painter and poet also to invent constantly while seeming to copy them faithfully. Vulgar painters do not grasp these distinctions. For them a tree is green; quick—some fine green. The sky is blue—quick, some fine blue. But under these crude, superficial colors, a Bonington, a Louis Boulanger, divines and reproduces the rarest, the newest, the most piquant, intimate color. They disengage what belongs to the time and place, what harmonizes best with the idea of the whole, and they bring out that *je ne sais quoi* by an admirable idealization.

Looking at the work of Richard Parkes Bonington and Louis Boulanger today, we may be surprised that Sainte-Beuve should have found such novelty and truth of color in paintings whose qualities of idealization today seem more apparent. Seen in comparison to the art that preceded them, however, their small increment of unfamiliar tones made these men stand out as daring innovators.

When we examine the works of the Impressionists—those "five madmen and a woman"—in the 1860s and early 1870s, we discover that their color was often surprisingly grayed, atmospheric, subdued, and subtly modulated: not at all what we would be led to expect from the shocked reaction of the public that denounced as aberrations the intensity and untruth of their tones. Brighter, more saturated Impressionist colors belong to the later 1870s and 1880s. They prepared the way for the still franker hues of Vincent van Gogh and of twentieth-century artists.

Impressionist color had several distinct aspects. One was the quest for the greater fullness of the palette: the Impressionists were on the hunt for tones. Maupassant described Monet as *"le chasseur."* Meeting Monet in 1886 in the north of France, Maupassant was astonished by the painter's ardent sportsman's energy in discovering the places, times, and weather in which color emerged with most startling freshness.[9] Monet searched for novelty and diversity of color. He wished to apply his entire palette to the picture, not merely by painting objects of many different colors but also by endowing an object ordinarily seen as of one color, like the green of foliage, with a large range of spectral hues within that green. That tree discloses to scrutiny much blue, warm and cold green, yellow, touches of red, and violet. All those colors together, in small points,

give to the green of the tree its luminous flicker, its tie with the surroundings, and its spectral richness. Monet aspired, at certain times in his career, to a spectralization of every part of the work. That is one distinctive trait of Impressionist color.

On the other hand, the Impressionists were convinced that there was a pervading quality of the color of an entire scene—a tonality of specific luminosity that in its prevalence corresponded to the pronounced brushstroke that seems to build all things with one kind of unit. The Impressionists divined those unique prevailing tonalities in relation to atmosphere and light. Into a scene that is predominantly gray or lavender or warm in color, they introduced a refined nuancing and subdivision of grays; where an older painter found only three or four intervals between two values of brightness, the Impressionists discovered a dozen.

In the 1860s, "tones" was the magic word among young French painters. Not "line" or "color," as among the classicists and Romantics, but "tones," a term often coupled with "patches" ("*taches*"), "impressions," and "sensations." The concept of tones, adopted from music, referred to the color as an element in a graded series. Red is a hue, but a tone of red is a note or point

FIGURE 18. Jean-Baptiste-Camille Corot, *Ville d'Avray*, 1870, oil on canvas, 54.9 x 80 cm, The Metropolitan Museum of Art, New York

in a scale of hues, a scale of intensity or saturation, a scale of relative brightness called the value scale.

The tone as a unique value owes its special quality to its place in such scales. It is not an isolated element but a term in a series, with a consequent relationship to other series, a relationship of distance or proximity, contrast or accord, differences in some respects like those among members of a family. The search for tones is a search for colors separated by small intervals, yet perceived as distinct notes. Tone refers not only to the obvious variation that appears in a smooth, soft passage from the light to a dark of the same color, but also to the series of neutral tones, nearly gray, and varying in degree of warmth and coolness: yellowish grays, bluish grayish, lavender grays, with slight differences also in degree of brightness and in degree of saturation of the hues in the gray.

In all painting, whatever the style, there are tones, if there are colors; but in earlier art we see a large mass of red against a large mass of blue; in each the local color passes from a light to a dark value. There is a value of red, a degree of relative brightness, that is quite equal (in brightness) to the same variant of the blue; but we do not see them only as a pair, a chord; each is seen also as a step in its own scale of red or blue.

Painting in a dominant green or gray tonality, Corot offered a rich series between the lightest and darkest gray (fig. 18). He also included touches of warm and cool gray. But the span of hue in the grays is quite limited; it is hardly as rich as the value scale in the variety of tones and their intervals.

Coming after Corot, the Impressionists wished to give to the value scale the variety and distinctiveness possible in the local colors of things, and to local colors the variety found in the scales of brightness and saturation. There was in their aesthetic search an aspect of realism, an exploring of the richness of the phenomenal world, though one could also apply this richer scale in abstract painting without regard to representation. The gray scale, narrowed to a particular segment is the carrier of feeling, of mood; the hue and saturation scales correspond more to sensations of things and of distances, of space.

There is also the condition called tonality. A scale of values may be a span of a single color, as in a painting that is mainly blue. Gray may be such a local color in which a hundred fine distinctions are discovered. All the hues may appear within a narrow middle range of brightness that corresponds to gray or all the hues may be neutralized by graying, whitening, or blackening. These are different potentialities of color; they are not simply found in nature but emerged gradually, as painters arrived at a concept of a scale, an order based on the series of elements graded in quality, and subject to modifications in a dominant hue.

While earlier artists effected the same span of contrast in the large and the small parts—a large red area contrasted with a large green mass, and a similar passage from light to shadow in each, or just a contrast of light and shadow in a small red patch—the Impressionists painted in a small red portion a contrast of light and shadow beside a large area of green adjoining

another mass of blue-green or near green. But within each green they applied touches of red, yellow, orange, and violet. The strongest contrasts of color are often found in the smallest touches. The observer must attend to fine differences in the large areas and not expect energy of contrast in large masses of color as in Romantic or older Venetian art. Impressionist color was new both in the variety of frank hues throughout the canvas and in the refinement of tones in small intervals; it admitted many hues within a narrow range of values or brightness.

An original painter of the preceding generation, Théodore Rousseau—an important artist still too little known—almost approached Impressionism in painting with dots; but his tiny touches of color with little variation of hue were a means of rendering the multiplicity of leaves. We see them as anatomical elements of the tree, though he aimed also at breadth of effect while searching for the form and individuality of the tree and the rock. Rousseau's skies were painted in another manner, in smoothly blended strokes to convey the airiness and translucency of the sky. Rocks in the foreground were rendered by still another kind of stroke. The whole not only lacked the Impressionist near homogeneity of stroke; the color, too, was submerged in a prevailing brownness or greenness. All was filtered through a colored lens that toned the whole canvas with its own standard hue. Yet there is in the grain of Rousseau's pictures a vibrancy and minuteness that suggests the infinitesimal in nature.

The Impressionists sought out attentively the subtler colors in reflections and light not simply for scientific truth but because such colors offered new accords and contrasts. In Monet's painting *The Magpie* (fig. 19), the blue shadow on the snow is closest to the blue of the roof. The latter, a constant local color, is in nature a body or surface color, while the blue of the shadow has another mode of appearance, arising as it does from reflection of the sky, and is intensified by the contrast—blue induced by the yellow sunlight. This play with blues is varied by a second shadow on the snow, a blue tone of another brightness. There are then three kinds of blue, and a fourth appears far off in the haze on the trees. The blues are contrasted with the warm tones of the building—the yellow, the darker brown of wood, and the scattered touches of sunny yellow in the white of the snow. Everywhere blue and white have been treated as if they belonged together on both the tiniest and the largest scale; a new music of colors emerged from this freedom in selecting and coupling tones.

This visual music was not based just on fidelity to nature. The Impressionists applied the joyfully discovered uncommon notes—colors of nature—as elements of fresh harmonies with a new structure of intervals and of rhythmic grouping of colors throughout the pictures, as well as of a greater luminosity. All modes of appearance of color in nature were rendered as modalities of the same paint substance. Shadow colors, local colors, reflections, atmospheric distance colors, induced contrast colors were all alike as pigment, equally prominent and strong and with the same texture, unlike in previous painting.

The Impressionists first accepted frankly the large irregular masses of color in nature, in flowers, skies, sunsets, shadows, and other reflection phenomena as a matter for their art.

68

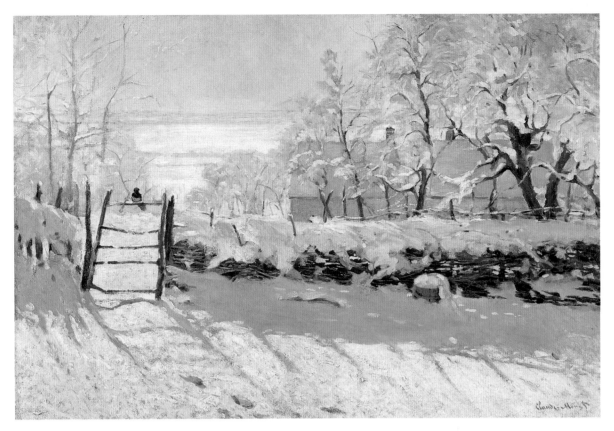

FIGURE 19. Claude Monet, *The Magpie*, 1869, oil on canvas, 89 x 130 cm, Musée d'Orsay, Paris

Impressionist painting has in this respect a considerable element of frank and fresh realism. It affirmed a renewed vision of nature and interest in appearances; the Impressionists were convinced that, despite all their inventions and arbitrariness, their art was rooted in the direct observation of things.

Monet's *The Beach at Sainte-Adresse* (fig. 20) shows more clearly an Impressionist principle of color; the large areas are closer to each other in tone and are related through short-stepped nuances. The strongest blue is the boat, and the strongest red is a highlight on the seated figure to the left. On the large areas of the sky is an extremely subtle mottling of warm and cool—a gray cloud, the sky seen intermittently through the cloud, and the shadows of the cloud—an irregular patterning unified through the texture and common flicker and through the similar densities of the scattered elements. Below is the sand—a warm area in which the painter found tones of gray, beige, off-yellow, near-pink, and white, and mingled them to produce an even more random mottling of small touches of color. The difference between sky and sand in texture and pattern is striking, but their niceties of color call for an especially attentive eye. Correspondingly, the water is a dilute bluish-green, with fine markings of a still different order. The horizon is deftly

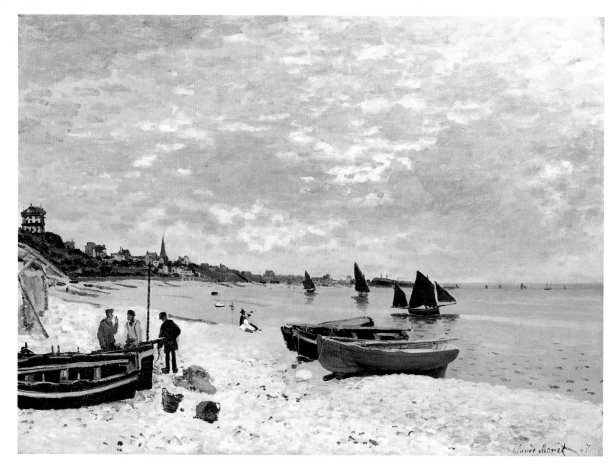

FIGURE 20. Claude Monet, *The Beach at Sainte-Adresse*, 1867,
oil on canvas, 75 x 101 cm, The Art Institute of Chicago

painted with tiny touches that build no forms but only suggest vague objects. In the costume of the figures are spottings of red, blue, and white, which pick up the notes of the larger elements.

Here, then, the color system follows an order in which the large areas—sky, water, beach—differ from each other only slightly in value and intensity, while varying in warmth and coolness; the major areas form relatively closed fields of uniform brushwork, with a patterning of tiny contrasts that also characterize the objects, irregular and scattered spots that we cannot bind as easily into a definite order like the larger fields.

Monet's painting *River Scene at Bennecourt* (see fig. 12a) is another brilliant example of visual translation. What appears to be acutely observed in the rendering of the sky, trees, water, and plants owes its recognizability to a rich variation in the brushstrokes as equivalences of different kinds of objects. The painter does not distinguish particular types of flowers; he disregards morphology but delights above all in the play of colors as an independent and sufficient

phenomenon. Only these sensations matter; they may evoke the presence of particular plants, but even as signs they have their own strongly marked qualities and relations to each other; you attend to these marks directly without recognizing what they represent.

Color bound to a mood of feeling is superbly embodied in Monet's snow scene at Vétheuil (fig. 21). The cold wintriness, the veiling of nature and suspension of life, excite in Monet new rhythms of the brush. Considered in themselves, the strokes appear shapeless and casual; the coloring, too, seems at first unrelated to objects; the segments of the picture are astonishing to contemplate for the rare tones, the diversity and interplay of grays and warm touches, the undirected strokes, chaotic in form, but together weaving this coherent, striking whole.

Impressionist color and stroke had important consequences for the patterning and coherence of elements. Earlier painterly artists had still drawn, even when they avowed themselves to be colorists. Artists of the Venetian School laid out the large masses of color broadly, only after

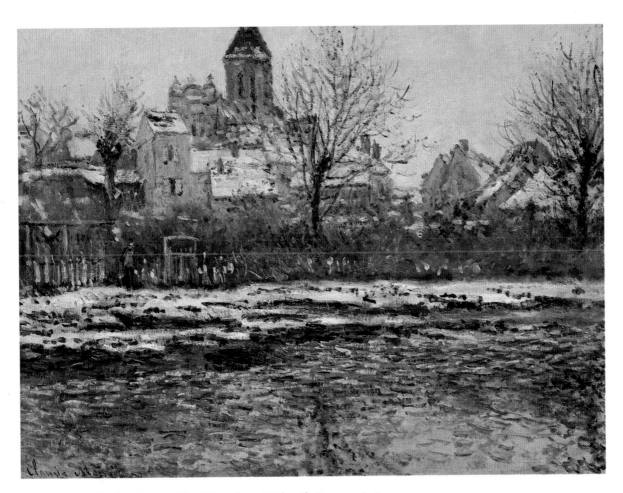

FIGURE 21. Claude Monet, *The Church at Vétheuil, Snow,* 1878-79, oil on canvas, 53 x 71 cm, Musée d'Orsay, Paris

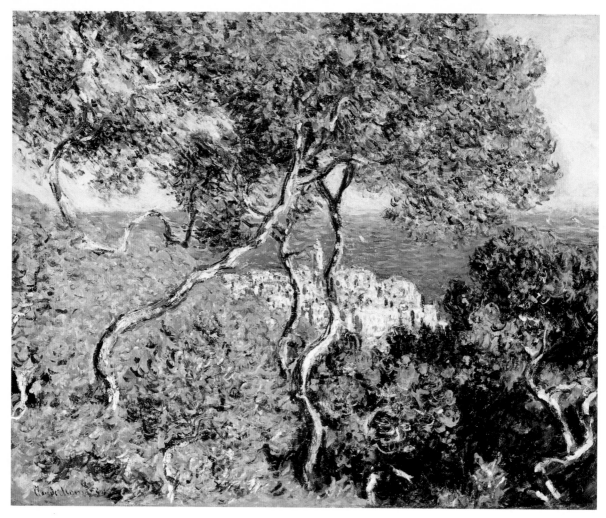

FIGURE 22. Claude Monet, *Bordighera*, 1884,
oil on canvas, 64.8 x 81.3 cm, The Art Institute of Chicago

having prepared the pictures through studied drawings and having laid for each object a ground of uniform local color on which other tones were to be set for distinct light and shadow. The Impressionists painted directly, drawing and composing with the brush at the same time, often from the scenes before them. Guided by that method, which was adapted to their goal, they sought out those groupings that maximized the effect of fusion on the surface, as if all things were embedded in the same primordial substance, like the pigment crust itself, and they composed so as to heighten the appearance of vibrancy and movement. The articulation of figures and trees transmuted into a decorative continuity of rippling, repeatedly curved forms without a distinct axis.

In Monet's painting of trees, the trunks and stems wind through the picture, as if

unconnected with the mass of vegetation (fig. 22). The foliage is so involved through the brush-work with the ground, earth, buildings, and the neighboring areas, that we can scarcely distin-guish the mass of one tree from another. Merging, they seem to share parts of a common sil-houette; and if some distinct lines appear, they crisscross or are broken, as if there were no well-defined objects in nature, possessing closed forms. Above all, we feel the strength of brushstrokes as elements in relief and also the richness of point contrasts—the red, blue, and yellow touches on the green are more pronounced than the contrast of the large area of green below against the upper green, or even of the green with the blue. The distant city, which is the brightest area and looks more yellowish against the blue sky, is happily and capriciously in silhouette, so broken by vegetation and patches of color that we cannot extricate the city from the landscape and see its internal structure; it takes its place in the whole through the grain, relief, and color of brush-strokes that have their own analogies. Where line has survived, as in the silhouetted trees, it is a vagrant trailing line, a decorative arabesque close to the plane of the canvas, not an enclosing, organically articulated contour distinct from the outline of neighboring counterpoised objects.

Another Impressionist procedure was to treat distinct objects as floating spots; they were often painted as if transparent, with an overlay of area upon area, as in *Water Lilies (I)* (fig. 23) of Monet. Sometimes, many distinct objects—buildings, trees, water, and so on—have been set

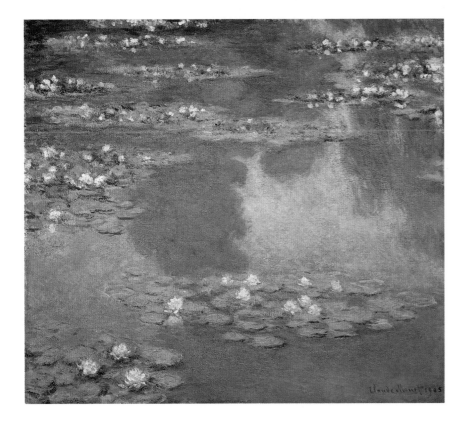

FIGURE 23. Claude Monet, *Water Lilies (I)*, 1905, oil on canvas, 89.5 x 100 cm, Museum of Fine Arts, Boston

in an atmosphere that, at their points of contact with one another or with supporting ground, melted them into one large mass of color; we see this not as the local color but as a prevailing tonality peculiar to the state of sunlight and atmosphere. Where Monet did isolate elements of the landscape, like the Belle-Île rocks in the sea, he viewed them from the side or as a group so that no matter how well-defined they are they look incomplete; the isolated elements of the landscape are marginal or cut by the frame rather than set in the center of the field of vision.

In the view of a Paris street and park seen from above, painted by Gustave Caillebotte, the figures were beheld either from the side or in a perspective that deformed the shapes (fig. 24). We cannot distinguish the foreshortened standing figures from posts, and a tree that is normally a centralized radial form is seen as a tangle, an incomplete object.

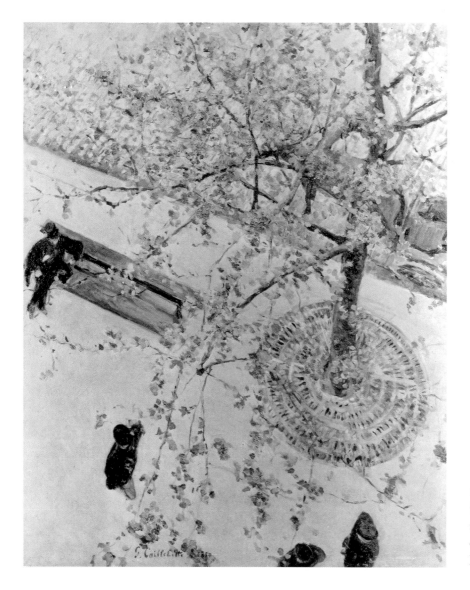

FIGURE 24. Gustave Caillebotte, *Boulevard vu d'en haut*, 1880, oil on canvas, 65 x 54 cm, Private collection, Paris

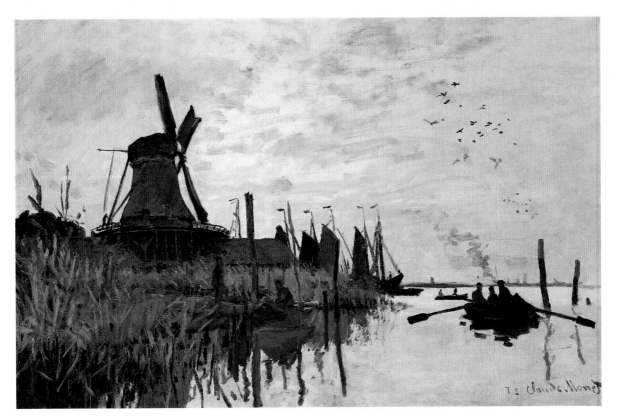

FIGURE 25. Claude Monet, *Windmill at Zaandam*, 1872,
oil on canvas, 48 x 73.5 cm, Ny Carlsberg Glyptothek, Copenhagen

If an Impressionist painter composed a symmetrical group, balancing as Monet did the boats and the shore, an abrupt opposition still appears unreconciled, except through the affinities of color, the common vigor of patching, and the decorative repetition of a few triangular elements. Compositions were no longer concentrated scenes in the old manner. The strokes became a daring and arbitrary means of organizing the whole. In Monet's picture of the windmills, the great vanes have been formed of powerful, broad strokes that dominate the sky (fig. 25). He painted the separate clouds with equally large patches of the brush—much larger than the strokes of the foreground—and in contrast to the architecture of the windmills. The stroke has been absorbed into the composition of the objects and the objects into the composition of strokes. This radical freedom in the correspondences of the units of execution and of representation, of image and paint structure, was developed further in the late pictures, with more minute elements.

Another type of unity depended on a scattering of units that, though random, preserved the same overall effect from part to part, or an unstressed balancing of the elements in one part against those in another. The recurrence of similar densities of repeated elements throughout— so many windows above so many branches, figures, buses, and trees, maintained with few

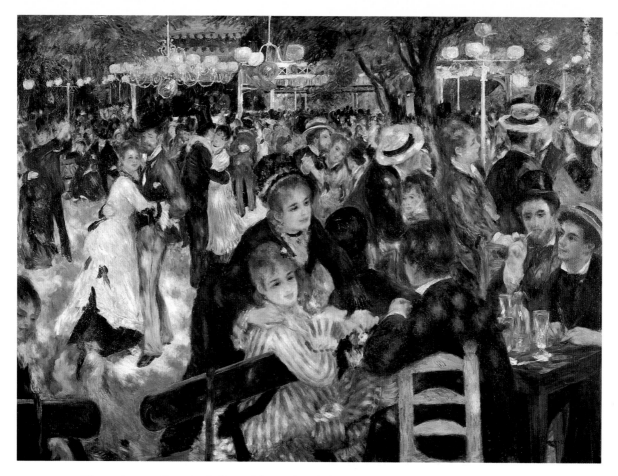

FIGURE 26. Pierre-August Renoir, *Ball at the Moulin de la Galette*, 1876,
oil on canvas, 131 x 175 cm, Musée d'Orsay, Paris

deviations—permitted the painter to hold together what at first looked accidental and disordered.

More committed to formal composition in the classical sense, Renoir continued to study the old masters, composing with an inherited norm of grouping, usually of a closed type. As an Impressionist, he tried to reconcile this traditional attitude with the new taste for a free diffuse composition. If you isolate the figures in his *Ball at the Moulin de la Galette* (fig. 26), outlining them with a pencil, you discover features out of Paolo Veronese, Peter Paul Rubens, and other composers—a triangular grouping and centering. But Renoir loosens and conceals these devices through the overlapping of objects of the same color; he also breaks them up by carrying the colors of the more formalized group into a less formalized one beside it; finally, he multiplies small units that are similar in touch and color in all parts of the composition. We see this procedure most obviously in the lamps above, in the patches of sunlight falling on the dancing figures and the

ground, in the decoration of the costumes and hats, and in the still life at the right. Through this work, we discover how the stroke and sensation patterns enter into aspects of the Impressionist picture that ordinarily seem to be closed to these elements, even in a highly formalized composition.

Another important device of Impressionist design—and one that was most cultivated by Degas, though brilliant examples appear in work by Monet, Renoir, and Pissarro, and in the late pictures of Manet—is the practice of segmentation, either within the picture or at the frame. The principle is that no object shall be complete. An object must be cut by neighboring objects or by the frame as if seen by a peripheral or partly obstructed eye, through which the quality of a casual, unprepared perception is affirmed. Besides, segmentation brings the scene closer to the spectator.

In Degas's *Place de la Concorde (Le Vicomte Lepic and His Daughters)*, there is a formality in the grouping of a large figure beside two smaller ones in what appears to be a classic triangular

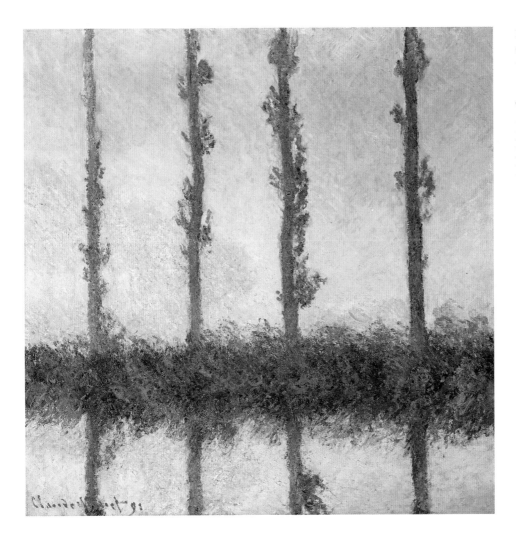

FIGURE 27.
Claude Monet,
The Four Trees,
1891, oil on
canvas, 81.9 x
81.6 cm, The
Metropolitan
Museum of Art,
New York

design. Yet the elements of the group are not figures who look toward the center or communicate with one another as in the older compositions. They are passing each other in the street, and each will have another position in the next instant; they are so near you as a passerby that you cannot see the whole figure; but they hardly take notice of you, and your own awareness of them is no more than a passing attention. The man at the left has been wittily drawn—he walks yet seems to stand perfectly still—drawn as a segment of a figure caught by your eye as he enters your field of vision. In the distance are some blurred moving objects. In other works, where the contact of a figure with the ground is visible, the figure is probably moving; and in the same picture if a figure is standing still, you cannot see its contact with the ground. It is a principle applied by Degas with subtle effect in many pictures of rehearsing dancers. The artist strove to break up the notion of fixity, of definiteness of position, and to invent forms of grouping that were related to the qualities of stroke and color that could produce a heightened, uncanny effect of movement and emergence, yet correspond to a momentary attention.

One of Monet's paintings in his series of poplar trees (fig. 27) appears more formalized and has even been described as a sample of the French "geometric spirit." These poplar trees seem to be only a segment of a larger row, just as their reflections are cut by the lower border of the frame. The regularity here is only an accident of nature, an uncharacteristic excerpt; if we saw the landscape as a whole, it would appear far less regular. Monet is able to present it as regular only by sacrificing its completeness. Here again we observe that the greatest regularity occurs where there is some indefiniteness—we see these objects far off, but through their contact with the frame, they also seem close to us.

A final aspect of Impressionism that has often been misunderstood is its sketchiness. Impressionist paintings were frequently disparaged as merely sketches without compositional order. Precisely because they have been made so quickly, sketches are recognized as abbreviated renderings of things that could be rendered more fully. Impressionist pictures share with sketches the quality of direct, rapid execution and expression. But unlike earlier sketches that were conceived as preparatory efforts, as a step toward a more complete and studied whole, Impressionist paintings were final works; more often every bit of their surface has been filled, and every valid possibility that the artist envisioned at the moment has been realized in the work. Where a painter left parts of the canvas bare, it was with the consciousness of an achieved accord and unity in which the tone of the canvas is a proper note and functions as such in the whole.

Impressionist pictures were not reduced or concise versions of a more complete type of drawn form; they were a new kind of painting that, in employing some techniques of sketching, was removed from sketchiness, not only in its goal of completeness but in its far-reaching consistency in different aspects—paint surface, qualities of the object seen, mode of composing, structure of intervals in the color, and the rhythm, shape, and relief of brushwork. All these sustained each other; none was sacrificed for the sake of rapidity in execution.

III

Nature and the Environment

OFTEN EXPLAINED AS THE CULMINATION of four centuries of depicting "nature," the imagery of Impressionism can also be described as the depiction of an ideal enjoyed environment. In Western thought "environment" has not always meant the same as "nature." Nature is all-embracing, yet boundless, a totality without axis or center; whereas environment, less comprehensive, implies a sensing, responding creature as its point of reference, its enclosed object. It presupposes man as an inhabitant set in a limited surrounding field, a milieu.

Environments are many, even within the same space, each relative to a being, human or animal, on whom it acts directly and who reshapes it or adapts to it. Nature, on the other hand, is one, universal, and absolute; it envelopes and permeates all environments. The concept of nature can also be applied in a restrictive or ideal sense, in contrast to the artificial or the constructed, while the environment can comprise, in addition to the local segment of earth and air, the reshaped second nature of cultivated land, of cities and streets, roads and houses, boats and harbors. Environment can be more inclusive than nature but also less so, according to the scale and aspect considered.

In earlier art, the environment was most often a backdrop or stage for a pronounced human presence. In the nineteenth century, it was more prominent, an inseparable part of what was human, both a source and a product of feelings, moods, and actions. For the man in the street, the crowd, together with the dwellings, shops, and vehicles, became a felt part of his own existence. All these appeared in Impressionist art as a spectacle enjoyed without strain or conflict.

Impressionism gave to the environment a new kind of unity in fusing the appearance of the natural and human spheres. A subtly rendered light and atmosphere permeated their images; there was in pictures of both worlds the same flicker of colored strokes, with a constant interchange of qualities. The theme was often a momentary state of the artificial environment, influenced by nature, or of nature modified by man: the unstable weather, with its favored moments of bright sunshine; the landscape changing with the light and with the position of the moving

79

spectator; the railroad train speeding through the countryside and transforming it by smoke and steam while disclosing ever new vistas to the traveler.

Time in this art was marked by the rhythms both of the man-made milieux and of nature. The variable aspects of the city streets, the parks, the railroad stations, the poplars, the cathedrals, the haystacks—all things set up and spaced by man—were, like those of natural landscapes, the effect of intangible pervading forces of light and air, but also of the changing human presence and the moving viewers. The span of themes reflected the paramount actuality of the environment as a common field of pleasure. Their appeal in images may be gauged from the growing attraction of that portrayed milieu as a collective sphere significant for norms of personal life and well-being.

The subjects of Impressionist painting were in their time model occasions of freedom. They released spectators for a moment from constricting habit, routine, and domestic order, and revitalized them through the stimulus of the novel beauties of the visual. This art celebrates the mobility of urban strollers, travelers, and sportsmen; the receptivity of eager, alert spectators; and the richness and indeterminate aspect of the surroundings, open, changing, and offering a multitude of captivating views and sensations. Viewers were central here as more than focusing eyes who shaped the perspective of a scene; the paintings depict sites enjoyed by the artists themselves as more attentive fellow observers who shared the happy immersion of casual spectators, moving or sedentary, in these same milieux. The scenes, both outdoor and indoor, were, in feeling, the contrary of the regulated in practical life; they were congenial to an outlook that anticipated the moment of aesthetic seeing as an end in itself, to be savored without thought of cause or consequence. In their time, the urban subjects, above all, were attractive to minds that found in that changing environment a stirring symbol of modernity, and enjoyed, in the surprises of an awakened perceptiveness in the outdoor world, a mood of freedom and expansion.

In previous art since the fifteenth century, religious subjects, especially paintings from the great towns of Florence and Venice, included many portrayals of seeing: unengaged figures looking out of windows or on balconies and parapets, observers at ceremonies and processions; later, contemplative figures in landscapes, on heights or below; artists drawing in the open air; scenes with spectators of performance and sport. These were usually minor motifs on the margins of more favored subjects with a religious or dramatic meaning. Yet they occur often enough to show that the aesthetic moment was prized as such and had become a valued recurrent occasion in everyday life. No doubt, at all times the novel sight, whether of art or nature, breaking the monotony of a stagnant existence or relieving the strains of anxiety and conflict was an irresistible attraction—even for happier souls. Festivities, religious and secular, excited the keenest interest by their appeal as visual show and often sparked the invention of new costumes, emblems, and masquerade. But in their representation that experience was secondary to the picturing and symbolizing of the religious, folkloric, and civic concepts that underlay the festive moment. Compared with the older examples, the Impressionist imagery appears more frankly and fully devoted to the delights of the

vagrant eye in the actual world, with all that this implies for the individual's freedom of move-
ment. Veronese's giant canvas in the Louvre, a stupendous image of a public banquet with an end-
less profusion of participants and onlookers, contains single figures and groups that might have
served as models for Renoir's pictures of luncheon parties and canoers, of crowds in the dance
hall and at the circus and opera. But the Italian's festive spectators are attendants at a ceremony—
the Wedding at Cana (fig. 28)—and witness a miracle, while Renoir, a true son of his time, is able
to picture the pleasures of a holiday as a recurring secular occasion and to render that liberty of
movement through the choice of a boating party without a focus, a center, or prescribed group-
ing. Other religious artists of his day who chose to represent the Marriage at Cana would likely
have felt the incongruity of the sacramental meaning of the gospel subject and the all-absorbing
elaboration of a civic festival in Veronese's picture; they would have brought back to the image of
the wedding dinner its original core of the miraculous and reduced or excluded the distracted and
distracting company of the enjoying crowd.

In the middle of the nineteenth century, the onlooker was an indispensable feature of the true

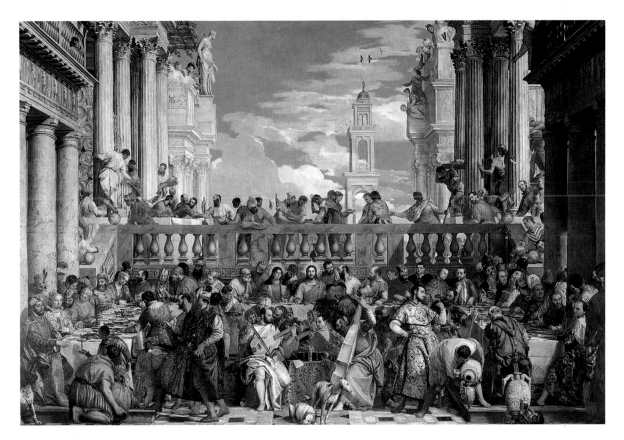

FIGURE 28. Paolo Veronese, *The Wedding at Cana*, 1562-63,
oil on canvas, 666 x 990 cm, Musée du Louvre, Paris

FIGURE 29. Eugène Delacroix, *Murder of the Bishop of Liège*, 1829,
oil on canvas, 91 x 116 cm, Musée du Louvre, Paris

image of a dramatic event. The painter Ernest Meissonier, whose frequent goal it was to re-create
for the viewer the late Napoleon I and his past battlefield triumphs as a credible spectacle, could
deprecate Delacroix's picture *Murder of the Bishop of Liège* (fig. 29) because the spectators in
that scene were not straining to see. Even for academic artists the instant of vision had become
an absorbing theme; and just as they hoped to attract to their pictures at the Salon the eyes of
the crowd and make them marvel at the minuteness and veracity of painted detail, so they con-
firmed for the viewer the corresponding itch to see the crowd inside the picture. Seeing was
prompted by curiosity about the powerful and great and by the fascination of violence; at the
Salon the visitors were drawn by the visible miracle of the painter's skill and by the piquant or
the sensational in his story.

Academic painters before the Impressionists had also a taste for the theme of aesthetic

seeing in which the contemplation and judging of works of art and the shared intimacy of the painter at work in his studio were favored themes. But these were generally given a historical or exotic flavor as in Meissonier's 1860 picture of a Dutch seventeenth-century artist before his easel with an admiring patron,[1] or in *The Rug Merchant* (fig. 30), a canvas by Jean-Léon Gérôme, where buyers inspect the great suspended carpet like a jury screening works for the Salon.

In another popular theme of academic painting in the mid-nineteenth century—visitors at the museum or Salon—one recognizes a descendant of older pictures representing the interior of a collector's palace or gallery crowded with dozens of framed paintings on the walls. What distinguishes the modern versions is the prominence of the spectator, whether an isolated viewer, as in

FIGURE 30. Jean-Léon Gérôme, *The Rug Merchant*, 1887, oil on canvas, 83 x 65 cm, The Minneapolis Institute of Arts

Degas's or Renoir's examples, or one of a crowd. The occasion of seeing, private or public, the intimate and personal in the experience of art, and sometimes the spectacle of the crowd itself, inspired the conception of the subject. Honoré Daumier, more than any other artist, has brought to view this large preoccupation with art in his time. Though he is held up as the great example of an artist who confronted in his art the social and political realities of the day—in contrast to those who practiced an idealizing art—no one else depicted so often and so vividly the visitors at the Salon, the individual passion for art, the emotions and pleasures of the art lover, the connoisseur, and the collector, as of the theatergoer and amateur of music, in a span from ecstatic enjoyment to philistine curiosity and bewilderment. From his pictures of scenes of the world of art, we can document that actuality of art in public and private life during his time.

The Impressionists possessed a significant and coherent body of themes, just as the painters of the Middle Ages and the Renaissance had their commissioned canonical subjects in which we recognize common beliefs and interests of their time. The novelty of the new art, to be sure, was not simply in the choice of those scenes that consisted of a complex of spectacle and spectator that may also be found, though to less extent, in contemporary paintings in a conservative style. What made it a unique art was the new mode of conceiving the work as an object for the eye; the painterly substance as a fabric of colored strokes revives for the imagination qualities of the artist's original experience of the subject that incited him to represent it on his canvas. However firmly one held to the principle that only the tones and brushstrokes matter for the value of a painting, something of the attitude that governed a spectator's response to those real sites and moments entered into the sympathetic experience of the picture. In defending this still unaccepted art in 1877, the art critic and writer Georges Rivière, a close friend of the painters, who was fully aware of their originality as artists and noted their search for a novel harmony of tones as a primary goal in their art, pointed also to the freshness of the subjects, their contemporary Parisian flavor, their actuality as a characteristic and valued part of a modern way of life. Some years later Marcel Proust—a supremely conscious artist—writing with admiration about Monet's landscapes, saw in them an ideal evocation of the beauties of light and color that he himself enjoyed most keenly in nature.

In some respects, Impressionism was like the prime innovations in the art of Christian antiquity, which came about in stages—after long reliance on older forms created for a pagan outlook and subjects—through the will of successive artists—eventually Christians themselves and increasingly dependent on Christian patronage—to achieve a style infused with qualities more consonant with the new religious faith. It was a process of many generations during which imagery with a Christian content was often hardly distinguishable in style from pagan works; while in the nineteenth century, in a remarkably short time, perhaps no more than ten years, artists developed with a congenial subject matter of living interest new qualities of color, form, and surface that soon after won acceptance and became a world style. (Rapid in its growth, and drastic as that style first appeared, it was preceded by an older practice that had approached in

essential respects the Impressionists' aesthetic and content.) These new features of art recall the inventions of the contemporary novelists who, in striving to realize for a radically naturalistic outlook appropriate qualities in their own medium, devised a new syntax, vocabulary, and texture of language as well as new patterns of description and narration: in short, a new literary art.

I shall deal in another chapter with the artistic innovations. But to see what is distinctive in the Impressionists' conception of the subject—which belongs to the aesthetic of life, of the spectacle and spectator in nature and the constructed environment—let us compare it with older ones of the same or similar subjects. I shall begin with Monet's early pictures representing a landscape with a viewing figure that seems to embody much of the painter's own relation to the surroundings.

Monet's canvas called *River Scene at Bennecourt* (see fig. 12a) is set near a resort on the Seine where the Impressionists often worked in the late 1860s and the 1870s. His spectator, the woman resting in the shade of a tree, is not from the local community of villagers or peasants but a vacationer from the city who enjoys in a holiday mood the light and air and the well-being of relaxation in the country. From the point of view of the older painters what she contemplates is scarcely defined, though recognizable as a whole. With the same degree of vagueness Monet renders the farmhouses in the distance and their inverted reflections in the water. To the woman the mirrored landscape in the river is much like her vision of the real objects on the other shore. The reflection and its source are both picturelike to her eye—distant phenomena, wavering forms, broken and blurred in the flicker of small neighboring spots of color.

On the canvas her shadowed face is a patch we barely distinguish as a tone from one beside it of a house reflected in the water; the inverted image has no clear location in the space of the landscape. Parts of this scene, if not the whole, are a colorful mirage. For the woman, too, one may suppose, the landscape owes much of its charm to the many separate notes of color and the fascinating reflections that would hardly hold her eye if she were merely recognizing the site or scanning the landscape for a path or landmark.

In the same spirit Monet pictured a terrace beside the ocean (fig. 31). The visitors, his own family, among motley flowers under bright flags—intense bands of red, blue, and white against the sky—bask in the sunlight and vista. Far off, as transposed equivalents of the flowers and the light on the parasol, the hat, and clothes, are the boats and waves—vaguely formed objects for the viewer. Shifting points in the traffic of the landscape, with no great meaning in themselves, they are part of its charm for a spectator who, without need to act or to learn, savors the quietly changing show of nature in the warm sunlight. The scattered elements of the original scene seem to elicit and sustain a way of seeing and a method of painting; they supply the artist with notes of color for his informal composition. Viewing the canvas, we pick out the more pronounced spots, the singular contrasts and brushstrokes, as the eye of the spectator at the seashore is arrested momentarily and in turn by the wavelets, the boats, and flowers, and by the people promenading before him—a soothing moment without stress or drama. He has no need to connect them firmly, to build of them a larger, more compact and focused order, or to interpret them

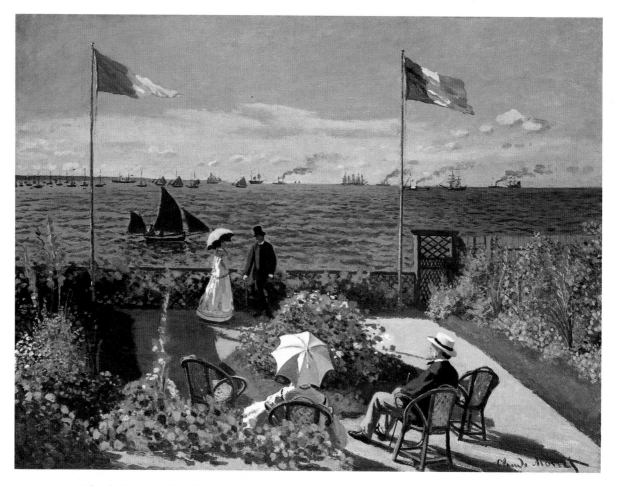

FIGURE 31. Claude Monet, *Garden at Sainte-Adresse*, 1867,
oil on canvas, 98 x 130 cm, The Metropolitan Museum of Art, New York

further, once he has distinguished the separate kinds of objects; the oneness of the whole with its many scattered parts springs largely from the common light and atmosphere in which every element has its place as a point of interest, fully satisfying to a disburdened holiday viewer. It is a unity of site and of mood sustained for a time by the bright sunshine that has brought the strollers to the open seashore and might be ignored by a more practical eye.

Not long before, Baudelaire, in describing the beauty of a Channel port from a Parisian's point of view, dwelt on the sky, the clouds, the changing color of the sea, the unfailing attraction of the boats, and the rhythm of the waves, the scintillation of a lighthouse—together a marvelously delightful and amusing prism for the eye. "And then there is, above all, a kind of mysterious and aristocratic pleasure for one who is neither curious nor ambitious, to contemplate, while reclining in a belvedere or leaning against a mole, all movements of those who depart and those who return. . . ."[2]

86

Monet's image of landscape and spectator embodies a prevailing idea of the aesthetic in his time. Long before that notion was framed in theory by Kant in a classic statement, one had understood that in aesthetic experience, whether of nature or works of art, one attends in an enjoying spirit to a harmony and order of color and form without referring overtly in thought to the import of things—their use, their cause and effect. It is the qualities apprehended as beautiful (or ugly) in themselves, it is their instant impact on feeling without the stimulus of self-interest, utility, or desire for knowledge, that sets the aesthetic moment apart from the practical and intellectual. From that point of view Delacroix had written in his journal that the aim of painting is "the delectation of the eye," an idea Nicolas Poussin had expressed two centuries before in an often-quoted letter. Both had in mind then the sensuous powers of their art, not just the appeal of its intelligible imagery, although they would not have failed to select and compose the forms and colors with an eye to the expression of the subject. Yet Delacroix would have judged the Impressionist pictures to be insufficiently imaginative, and Poussin would have rejected them as trivial for want of a noble theme.

While it is true that in the experience of art, in Kant's sense, we are attentive to "inherent" qualities of a painting, these are often inseparable in our perception and response from qualities of the real or imaginary world, which is recognized and enjoyed as a distinctly integrated matter represented in the work of art and which excites feelings other than the supposedly pure pleasure in color and forms. Kant spoke also of "adequacy to the imagination"[3] as a factor in aesthetic judgment—a concept he left unexplained. That "adherent" matter, too, has a more or less identified structure and is grasped through memory and associations that further understanding of its significance. We are not fully absorbed by the picture of a tragic subject unless we discern something of the action, motives, and feelings of the figures as conceived by the painter. We respond with a vague unease of compassion or horror to a scene of violence depicted by Delacroix; and in a dimmed Arcadian landscape by Corot, the idyllic note revives a dream of happiness in solitude. Even where man is absent and a purely phenomenal aspect of nature is held in view, as in the enchanted contemplation of a sunset, Baudelaire could say in a prose poem on the evening sky that its surprising colors "imitate all the complicated feelings that struggle in man's heart at the solemn moments of life."[4]

In Impressionist pictures, the agreeable aesthetic occasions of life in the common environment, with their connotations of pleasure and freedom, have become the chief subjects of art. The common pursuit of these moments is itself a significant social fact, like the interests that once determined the choice of religious, dramatic, or moral subjects of painting. It is not simply the fact that exceptional, sensitive personalities, the artists, responded to surprising nuances of the sky's color, finding them poignantly beautiful; still more: in the second half of the nineteenth century an increasing part of the public's personal lives was allocated to the enjoyment of nature and urban spectacle. The aesthetic attitude became for many an indispensable ingredient of their way of life, a symbol and even the support of an ideology that, in affirming the individual's freedom, had a

critical and sometimes polemical edge, asserting the value of the senses and their pleasures against a traditional moral or religious view of their inferior worth. Certain times were reserved periodically for that enjoyment, and in response to the growing demand, there were constructed for common use, together with means of travel, the new parks, boulevards, roads, beaches, and belvederes as ideal sites of collective recreation where the delight in the surroundings was a primary goal.

In depicting the everyday aesthetic moments, the Impressionist painters shared a contemporary popular passion, however bizarre and even absurd their works appeared then because of the shock of their strange execution. Those subjects consist not only of nature encountered in the open countryside as in earlier landscape painting, where it is often a secure and agreeable solitude, but also of what was most public and modern: the streets, parks, resorts, railroads, cafés, amusements, outdoor sports, and other attractions of the holiday world. Like the accompanying modes of vision, the instrumentalities of pleasure entered often into the Impressionists' conception of their scenes. The spectator who enjoys these sights in pictures may be unaware of or insensitive to the painter's choice of tones and the painter's refined expression of light in representing that world, but the spectator's own response to the original scene is also an aesthetic one. Like the painter the spectator delights in the colors and brightness of the landscape, its vistas and paths, its openness and traffic, and he remembers afterward the charm of performers and the multiple sensations of the summer day in the country or at the beach. And if in time the style of the art loses its disturbing strangeness, the viewer may come to recognize in the painting the enjoyed familiar scenes and react to them accordingly. How different is this unreflective response from the pious reactions to religious art in the past? The believer was moved by human qualities of the sacred figures, their physical beauty and nobility, and by the threat and ugliness of demons, often attending little to the distinctively artistic in the work, though something of its character was effective in the realization of those imagined holy or demonic figures through the shapes, colors, and composition.

The modern spectator, in a holiday or vacation mood, is, of course, not the only kind of viewer of nature and environment. Earlier artists, inheriting an old tradition of landscape painting freed from its original function as a setting for themes of action, had produced memorable pictures of the spectator in the landscape. Besides these were scenes without a represented viewer, where singularities of the perspective viewpoint bring to mind a virtual presence. Once established as a theme for itself, landscape was open to varied selections and interpretations and could serve a wide range of personal outlooks through qualities of space and light that seem to intimate a philosophy or worldview. Comparison of such older works with Impressionist pictures brings to still clearer light what is novel in the modern choice and conception.

In the middle of the painting *Monk Before the Sea* (fig. 32), the inspired Romantic Caspar David Friedrich sets before us a model contemplative figure in his ideal landscape. This solitary man is no artist or vacation traveler, but a religious, metaphysically minded spectator withdrawn from the common world. Clothed in black, with a contrasting white tonsure on his head that serves as an isolated focus in the whole, his tiny vertical form is submerged in the vastness of the

FIGURE 32. Caspar David Friedrich, *Monk Before the Sea*, 1808-10,
oil on canvas, 110 x 171.5 cm, Schloss Charlottenburg, Berlin

horizon and the lifeless strata of ocean, sky, and sandy earth. There is nothing else here of the human or suggestive of man. One may interpret the bald spot as the thinking point contrasted with matter as pure extension; but it is better understood, I believe, as spirit apprehending spirit in the mysterious light rising from the darkness. The visible world appears in its enduring primordial aspect through the stark constants of earth, sky, and water. The earth is a pedestal from which the monk views the great void. Nature is keyed in a scale of black and white, with some grays and faintly bluish tones; for the sensual eye it is colorless and cold like the the ascetic figure. In Monet's painting *River Scene at Bennecourt* (see fig. 12a), the woman with her striped blouse of white, green, and yellow, harmoniously sits in the surrounding fertile landscape dappled in bright sunlight. Friedrich's monk beholds the immensity of ocean and sky at a climactic instant of thought, undated in terms of season or year, an ahistorical point in God's endless time; it is not the Impressionist instant, no spell of sunshine among other moments agreeable to the roving eye. In this somber scene, the monk dwells rather in a state of inner illumination. Light advances in the sky from the distant horizon above the darkness of the ocean and in its slowly expanding sway guides the monk's reflections about a vaster immanent power.

FIGURE 33. Gustave Courbet, *Marine, The Waterspout*, 1870,
oil on canvas, 68.9 x 99.7 cm, The Metropolitan Museum of Art, New York

Even when Friedrich pictured a less grandiose spectacle, he still retained the solitude and portentous mystery of the *Monk Before the Sea*. In another canvas, a single spectator contemplates a rainbow in a wild mountain landscape, spanning the sky like the first spectral arch after the Deluge—a sign from God.[5] Or three figures sit on a rugged boulder at the seashore, watching the receding boats in a mist.[6] The men are in black like the rocks; the seascape and vessels are a hazy gray; from the darkness one man looks out into a half-light. Nothing in this solemn, brooding scene suggests harbors, towns, belvederes, roadways, or seasonal places of habitual spectators.

Nearer to the Impressionists in time and place is a painting by Courbet (fig. 33), which in its breadth and solitude recalls Friedrich's ocean. But here water, sky, and earth have been represented as grandly massive. The clouds roll, grave and menacing; the giant waves seem to have grown as they advance and display their immense power. Strewn rocks in the foreground, remnants of old catastrophes, complete the series of the voluminous clouds, the weighty ocean, and the solid earth; and all these, together with the dense substance of paint, so unlike the seamless

and smooth film of Friedrich's gray surface, proclaim the painter's joy in the universality of matter. From the varied states of the sea, Courbet does not select a mild summer aspect that would draw the city dweller to the beach, but a sublime view. Nature here is an overwhelming presence, the elemental ground of Courbet's native materialism; it is a conception of matter as the eternal moving substrate of existence, as the existent itself. In this smaller image, which has a metaphysical grandeur like the German painter's, there is also something of the artist's dream of strength and craving for immortality. In an apocryphal letter to the novelist Jules Vallès, recounting a visit to the ocean, Courbet told his friend how he cried out: "Oh sea, your voice is tremendous, but it will never succeed in drowning out the voice of fame as it shouts my name to the whole world."[7] As his critics noted with amusement, the immense signature of the proud Courbet was the largest of any painter's in his time.

Neither Friedrich nor Courbet was likely to have pictured the sandy coast of vacationers at home by the ocean, with their little cabins, their city clothes and fashions, strolling and conversing, seen in the charming views lightly sketched in the 1850s and 1860s by Monet's teacher, Boudin (see fig. 7).

In Monet's early canvas of *The Jetty at Le Havre in Rough Weather* (fig. 34), the spectacular rainbow and turbulent sea, dear to Romantic painters, are scaled down and the wildness of the scene is tamed by the human elements of the site—the promenaders on the mole, the lampposts, and the lighthouse with its iron balcony, all of which together suggest a city street in the ocean. Even in Monet's later pictures of the trackless sea, strange and spectacular rocks rise in the sunlit water like inhabitants and buildings, sunken Stonehenges of nature, monumental landmarks for an eye bred in the spaces of the city and the country roadway (fig. 35). Yet something of the perceptions of Friedrich and Courbet survived in Monet's later art—the sublimity of the ocean—and the most frivolous visitor could respond with awe to its grandeur and endless motion.

If Monet's wave-beaten rocks at Belle-Île and Étretat were closer in aspect to the ruggedness and dynamism of Courbet's subject, he also chose also to paint calmer sites with a filminess of sky and water that could intimate, like Friedrich's *Monk Before the Sea*, an abiding immaterial essence in phenomena. Yet here, too, Monet's engaging views of the Seine flowing through Paris and Rouen, and of the nearby seaports and resorts, noted the casually encountered and momentary, a seasonal and hourly light and color. In his great series of London scenes, the city, a silhouetted phantom, became fused with sky and river in a veiling tonality. In the most animated and weightiest, as in the most rarefied, of those pictures, Monet remained faithful to an Impressionist sighting, the strolling spectator's delight in a surprisingly spotted or nuanced milieu. In his later works the water was often an isolated segment of nature, without sky or horizon, a few yards of a pond with flowers on the surface, transposed life-size onto a large canvas, still further from the cosmic span of the small pictures of Friedrich and Courbet, though Monet aspired to grandeur through the expanse of the canvas and the mysterious richness of a single hue. Despite

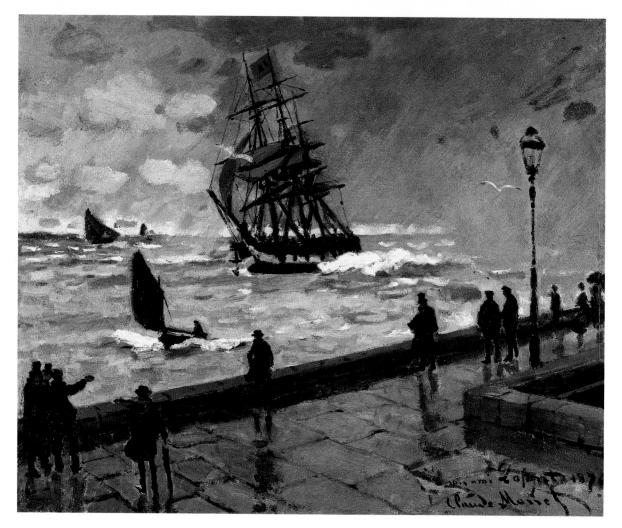

FIGURE 34. Claude Monet, *The Jetty at Le Havre in Rough Weather*, 1867,
oil on canvas, 50 x 61 cm, Private collection

their breadth, the conception of the "subject" in these pictures—bits of gardened nature close to
the viewer—has nothing of that magniloquent scale that once made the ocean the inevitable
object of brooding or exalted meditations on cosmos and eternity.

Within less than fifty years, between the seascapes of the early nineteenth century, among them
Gericault's and Delacroix's dramatic pictures of extreme situations on the ocean waters, and
Monet's paintings of safe harbors and vacation resorts on the Normandy coast, the sea had lost
for artists its sublime dimensions and stress of feeling. Monet may have delighted in the water and
great rocks at Étretat and Belle-Île; but in his art he showed little concern with the experience of
a boundless totality that had possessed Friedrich, Courbet, and the Romantic poets.

In the mid-nineteenth century, the taste for landscape was explained as the expression of a

pantheistic outlook. A direct apprehension of the infinity of nature, sensed above all in the limitless ocean, replaced or complemented the devout awareness of a supernatural personal God. The "oceanic" experience, the "cosmic consciousness" awakened in that encounter, became a model of religious feeling or of the agnostic's piety toward the ever-mysterious natural universe. Monet's art, too, had been described as pantheistic in temper; but his sky and ocean are most often parts of a local bit of nature, a site for play or relaxing contemplation, as familiar and accessible as the resorts along the sea coast and belonging with them. Following the Trinity of God, Nature, and Man that Victor Hugo matched with the triumvirate of sky, ocean, and earth, it is the earthly human that prevails over the sweeping seascapes of Monet, though not without occasions of self-transcending rapture.

How differently the same ocean sites in Normandy were viewed in the preceding generation by a positivist mind imbued with the poetry of cosmic feeling we may learn from the fervent descriptions of young writers. The critic Théophile Thoré, a politically radical advocate of an "art for man," who shared the sense of nature that he admired in the advanced landscape painting of his time, left in the preface to his Salon of 1844, done as a letter addressed to his friend the Barbizon painter Théodore Rousseau, a stirring account of his own first glimpse of the ocean:

> When I reached the summit of the dunes where I hovered over the immensity, there was a silvery effect in the sky and on the sea. Never again have I seen it so brilliant. The sea and sky appeared to me fused in a supernatural radiance. I wondered

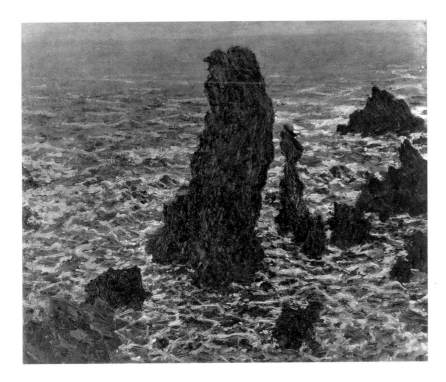

FIGURE 35. Claude Monet, *Rocks at Belle-Île,* 1886, oil on canvas, 60 x 73 cm, Ny Carlsberg Glyptothek, Copenhagen

where the sea was. It seemed to me that I was transposed far above the sea and
earth to a more luminous sphere. I was gripped by an uncontainable enthusiasm
that clutched me by the throat. Unable to fly, I allowed myself to slide down along
the earth, no longer feeling my own body. Unable to cry out the glory of nature
with the force of the tempests, I began to weep softly, very softly, without a sound,
in order to hear the great harmonious voice of the boundless immensity.[8]

Three years later the young Gustave Flaubert, traveling with a friend along the coast, was to
experience before the Atlantic at Belle-Île another kind of "cosmic emotion," inspired perhaps
by Hindu ideas. He wrote:

And while we were under the spell of that contemplative effusion, we wished that
our souls, radiating everywhere, might live all these different lives, assume all these
different forms, and, varying unceasingly, accomplish their metamorphoses under
an eternal sun![9]

Such mystical immersion in nature as Thoré's and Flaubert's was foreign to the Impression-
ist painters, who, even when under the sway of the moving vastness of sky and ocean, are never
transported beyond the local scene, the here and now of its ever changing colors and parts, into
another dimension of being. We learn from these texts, as from the paintings, how the experi-
ence of nature has changed in the course of the half century between the Romantics and Monet.
Not only have different aspects of nature, and accordingly different sites and moments, been cho-
sen for picturing, but the spectator's point of view, his emotion before the scene, and his mode
of contemplation, have been radically transformed.[10]

In the nineteenth century, perceptions of nature, enriched by travel and the experiences of
generations of poets, painters, and naturalists, were more open and varied than at any time
before. One enjoyed many newly seen aspects but continued to respond to others that had been
profoundly moving discoveries of the past. The grand and the intimate, the wild and cultivated,
forest and meadow, ocean and still pond, were alike attractive, though a painter might find a
particular segment of nature most promising for his art. In trudging on country roads or along
riverbanks, painters hunting for a subject were most likely to stop at sites before which they
anticipated a desired pictorial result—the views that suggested the contrasts, asymmetries,
rhythms, colors, silhouettes, spotting, and lines that marked their style. The attraction may
also have been grounded unconsciously in old fantasies and memories revived by a scene. The
artists might have welcomed, too, the landscapes that promised a change from their habitual
choices—in a desired direction, remedial, invigorating, or challenging to their art. But painters
were inspired as well, as can be judged from their statements, by the irresistible beauty of
places that prompted a desire to translate arresting visions into works that had their own
concordant beauty as art.

It was not just a pictorial need for brighter notes of color in solving a problem of the canvas that led painters to select sunlit places with a scattering of flowers and vegetation, white houses with red rooftops beside blue water. These were elements of a common taste in the enjoyment of the outdoor world, responding to an appetite for brightness, openness, and freedom. In the mid-nineteenth century, writers before the Impressionists noted the same features of landscape in their novelistic descriptions and diaries of travel. Writing later on Monet, Proust dwelled with joy on the actual sites of his landscapes, happy with their colors and atmosphere and light as if he were viewing the original scenes. Proust also loved art and travel for the sake of art, especially in the picturesque old Italian cities and the medieval towns and villages of France that preserved Gothic buildings, which he described with the same delight as the surrounding flowery meadows and hillsides.

There is a mystery in the process of change and contagion of taste. A new quality of nature seemed to come unannounced as a mutation of feeling in the perception of aspects and beauties of the surroundings, unnoticed before and now appealing instantaneously to the eye with an unquestioned force. Whence came for painters and others in 1870 the attraction of particular colors of the environment little remarked before? In what experiences and situations were rooted the needs or impulses that were fulfilled in these new perceptions? One may conjecture for a class of spectators a secret accord of the attracting colors, lights, and patterns of space with an emerging way of life, and with fantasies and subconscious desires in a shared reaction to social life. Are these always reactions to constraints and thereby symbolic of liberation? Are there not also new possibilities of enjoyment discovered in the course of social development through enlarged experience and freedom in an ongoing process of domestication of the environment, as in the technology that has transformed travel and the range of vision through the railroad, the auto, and the plane?

Though industrialization by itself did not call forth the Impressionist landscape painting, no doubt the love of nature that inspired so many works of art in the early nineteenth century was often a reaction to an unease people felt, a sentiment, acute in the more advanced nations, that in urban society people are not fully themselves, that they have lost something wholesome and precious that they can recover, if only for a moment, in the unspoiled landscape. But this concept of the natural changed with the new conditions and goals of modern life. Resenting speed, congestion, and clatter in the city, though still attached to the system of life that begat them, and at times even delighting in these as manifestations of energy and progress, people also welcomed movement in nature and found in the novel variety of landscape, with its perpetual mutability of light and atmosphere, a revitalizing release from the dullness of habit or from the urgency of affairs. Though they also valued in nature its moving aspects, the counting of work hours was suspended; in its undemanding presence, people breathed without the strain of projects and concerns about the future.

IV

The Railroad

THAT MONET AND PISSARRO, who pictured riversides, harbors, and crowded Paris streets, should have also chosen to represent the railroad is no surprise. In this taste they shared the feelings of the thousands who flocked to the stations; the world of the railroad was itself a spectacle and offered, besides, an enthralling sedentary experience of motion. As artists on the hunt for painterly sights, they were frequent travelers, especially to and from the Channel ports, and they knew the joy of arriving at a station and emerging in the middle of the bustling city. The new facility of travel first appeared as a factor in art in the generation of the Impressionists, who owed to it their range of landscape sites offering an enchanting variety of seasonal color and light. The frequent change of locations depicted by Monet—his scenes of England, Holland, Norway, Italy, and the provinces of France—are inconceivable without the railroad.

Impressionist art, while stimulated by the new subject and the ease of travel it offered, was not simply its outcome. Other painters had responded to the railroad without bringing to it as novel a vision of the familiar scene as did Monet. Among the Impressionists, he alone dwelled in the subject, immersed himself in it, and created a series on the big city station, years before he later painted the cathedral, the poplars, the grainstacks, and water lilies. Even before that, he and Pissarro, in a poetic mood, had pictured trains standing in country stations (fig. 36).

Representing a smoking train in the Gare Saint-Lazare in the early 1870s, Édouard Manet reduced it to a background setting for a portraitlike figure of a woman reading; inattentive to the traffic behind her, she looks up from her book at the viewer, while at her side a little girl, an innocent eye, turns her back to us and peeps over a balcony to watch the arriving train (fig. 37). Renoir, whose first and last subject in art was the female body, was not one to admire the iron machine and its shapeless emanations. In an early enthusiasm for modernity, Degas had included the locomotive in his program of exploring the varied phenomena of smoke; but he never painted the train or station as a central subject. Instead, Degas noted the smoke of distant factory chimneys on the suburban horizon in his pictures of the race track (fig. 38) and found equivalents of the smoky and vaporous in the delicate scale of grays in other contexts—the neutralized tones in his *Blanchisseuses* are comparable in finesse to those of Monet's Gare Saint-Lazare series.

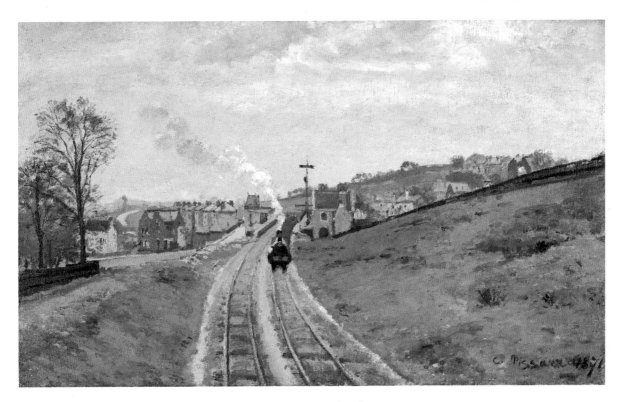

FIGURE 36. Camille Pissarro, *Lordship Lane Station, Dulwich*, 1871,
oil on canvas, 45 x 74 cm, Courtauld Gallery, London

Already in the 1830s and 1840s people enjoyed the sheer sight of the railroad and beheld from the moving train the swiftly changing colors and forms of the landscape with an exhilaration that seems to foretell the later Impressionist pictures. In elated descriptions the oldest reports of railroad journeys convey through new perceptions the overwhelming impact of speedy mechanical travel. The railroad made people dream and imagine a new world, a different future, and made them sense that life had been radically transformed, so profound was the effect of this increased velocity on their outlook. In his novel *Une Vie*, Maupassant described the thoughts of a young woman during her first train ride:

> She sat and watched the fields and farms and villages rush past. She was frightened at the speed at which she was going, and the feeling came over her that she was entering a new phase of life, and was being hurried towards a very different world from that in which she had spent her peaceful girlhood and her monotonous life.[1]

Victor Hugo left a classic account of his first railroad trip in 1835:

> A magnificent motion, one cannot describe it unless one has experienced it directly. The speed is unbelievable. The flowers on the road are no longer flowers, they are

FIGURE 37. Édouard Manet, *Saint-Lazare Station*, 1873,
oil on canvas, 93.3 x 111.5 cm, National Gallery of Art, Washington, D.C.

spots or rather red and blue stripes. No more points, everything is striped. The ears of wheat are great yellow tresses, the green blades are long green bands; towns, towers, and trees dance and mingle madly on the horizon; from time to time a shadow, a form, a specter rises up, appears and disappears like flashes of lightning at your window; it is a road-guard in uniform. People say in the coach: it is three leagues off, we'll be there in ten minutes.[2]

One might discern in that account—and it was surely of a common perception—the germs of future painting and poetry. In reviewing the Salon of 1846 Théophile Gautier wrote: "The modern Pegasus will be a locomotive." What he had in mind, however, was not a new style of art inspired by the railroad but a broadened range of picturesque themes, the opening of the

entire planet to the painter's eye—"in a few years the Salon will be the Panorama of the world." The new experience suggested then no surprising forms in art, though it perhaps reinforced the interest of some artists in a more realistic and timely subject matter. In 1848 the comic illustrator Bertall[3] could whimsically frame a black spot as a view in a railroad tunnel, or draw a succession of mannequin guards rigidly extending an arm, without his ever conceiving a graphic style built on the playful starkness of the first or the mechanized human forms of the second. It is extremely doubtful that the Impressionists' flecked touches and dosage of contrasted color thirty years later were inspired by the flickering fields and shaking horizon seen from the windows of speeding trains.

Yet the railroad in its first decades inspired the strongest reactions, entering deeply into popular fantasy as well as into daily life. For Romantic and wide-ranging speculative minds, it

FIGURE 38. Edgar Degas, *A Gentleman's Race, Before the Start*, 1862, partly repainted in 1882, oil on canvas, 48.5 x 61.5 cm, Musée d'Orsay, Paris

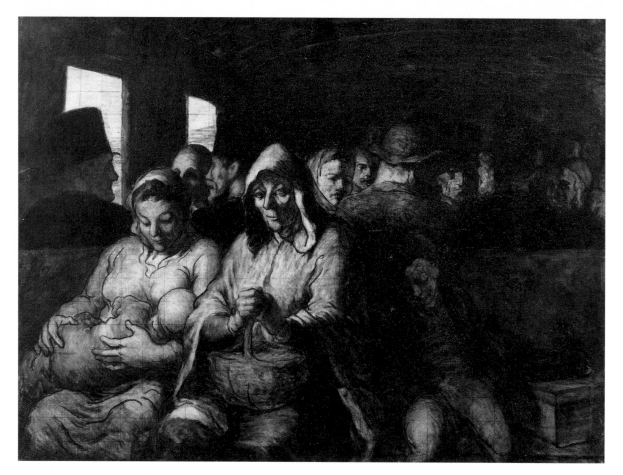

FIGURE 39. Honoré Daumier, *The Third-Class Carriage*, 1863-65,
oil on canvas, 65.4 x 90.2 cm, The Metropolitan Museum of Art, New York

marked a new stage of humanity and was celebrated as such by radical thinkers of the time. Parodying modernist enthusiasm in the 1840s, the young Flaubert coined the magniloquent phrase describing "Christ as an engineer driving the locomotive of history." For the Saint-Simonian theorists of a future rational order of society, the railroad was the great engine of progress, overcoming space, uniting far-separated peoples, and opening the markets of the world to an expanding industry. It was the vehicle of the expectant community for which the prophets of progress had written out the schedule of history as a movement on preestablished tracks with a few major stations. But men of an older generation, like Goethe, feared in the railroad a disturbing acceleration of life that would leave less time for thought and contemplative vision; or, like François-René de Chateaubriand, they saw the locomotive taking humanity to its destruction.

The painters at first represented the train, distant and small, as an element in the unchanged landscape, hardly disturbing the quiet of nature; the smoke of the engine replaced in their

idyllic pictures of the countryside the smoke of the peasant's chimney. Popular taste welcomed the engraved pictures of trains and stations, which were done, like the views of the city streets, in a blandly descriptive style and which took their place, beside the perishable, soon discarded imagery of fashions and public figures, as timely items of the day.

Daumier, always alert to the popular and eventful, pictured the railroad most often as a setting for the human drama of travel, with its expectations, arrivals, and departures.[4] He drew the interiors of trains with tired or eager people, the families of travelers, odd middle- and lower-class types in converse and reverie, the crowds in the station, hurrying anxiously to the waiting train, racing with time like the fugitives he had painted marching on the roads, driven by historic catastrophes, famine, pestilence, and war—the anonymous burdened humanity eternally on the move (fig. 39). Strong contrasts of light and deep shadow—devices of an old tenebrist art—accent the poignance of leave-takings and reunions. Ignored for the most part are the atmosphere of smoke and vapor, the noise and traffic, and the buildings beyond, veiled in the haze emanating from the station. Inside the coaches the patient passengers are borne along to an awaited destination. In the summer, they open their collars, relax, and stretch their limbs, and look out at the summarily rendered passing landscape. In winter, they huddle together, unseeing, wrapped up in their clothes, causing the modern observer to confuse seasons and classes, with the result that two pictures of the same car have been labeled "third class" in the winter scenes and "second class" in the summer.

As late as 1862 the English Victorian artist William Powell Frith painted his extremely

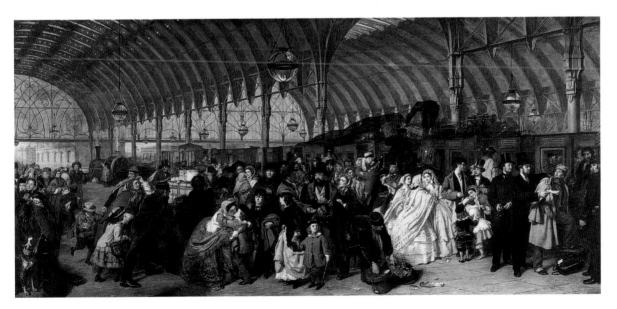

FIGURE 40. William Powell Frith, *The Railway Station*, 1862, Royal Holloway & Bedford Collection, New College, Egham, Surrey

popular picture of Paddington Station—an iron-and-glass construction responding to the new demands of its function—in sharply drawn detail, as a place of farewells and embraces in clear atmosphere, without smoke or steam (fig. 40).

By this time Champfleury (Jules Husson), the novelist-champion of Realism, could propose that Courbet be commissioned to decorate a station—in which he recognized a truly modern architecture—with murals of railroad themes, such as a *Departure of a Train*, an *Arrival*, a *Disembarking of Passengers*, a *Consecration of a New Road by the Church*, and a *Harvest of New Products Introduced to Europe by Steam*. Such a series would have resembled the old church frescoes of episodes from the life of a saint, with his beneficent acts and miracles. Champfleury, who had moved from a youthful revolutionary zeal in 1848 to a conservative acceptance of the modern state as a stabilizing yet progressive force, spoke of the "poetry of the modern machine" and recommended the formerly subversive genius of Courbet as most suited to paint the "iron mastodon" in the landscape.[5] "Iron mastodon": Champfleury's phrase has some of the same anachronistic incongruity also apparent in the detailed foliate ornament that decorated the black iron columns of the stations even as they were acclaimed as the manifestation of a distinctive modern art, founded on new materials and uses.

The powerful hold of habits of imagination is nowhere clearer than in the response of a mind as original and as intensely reactive to the new as Victor Hugo's. If he described with verve the phenomenal transmutation of the landscape for the passengers in the train—a description that remains as fresh as the first train ride—Hugo looked at the train itself from the viewpoint of a Romantic poet, fancifully contemplating a strange demonic power and assimilating its novel forms to medieval imagery. After subduing his regret that the stagecoach was replaced by a machine, he could not help but see the locomotive as an "iron horse," a "prodigious beast." As he wrote:

> One hears it breathing while at rest, sighing at the start, yapping on the way; it sweats, it trembles, it hisses, it neighs, it slows up, it bolts; all along its route it drops a dirty waste of burning coals and a urine of boiling water; enormous bursts of sparks flash at every moment from its wheels, or its feet, if you wish, and it breathes out over your heads in clouds of white smoke which are torn by the trees on the route. . . . At night when our locomotive passed near me in the dark on the way to its stable, the illusion was complete. You could hear it groan in its whirlwind of flame and smoke like a harassed steed.
>
> Of course, one ought not to *see* the iron horse; if one sees it, all its poetry vanishes. To the ear it is a monster, to the eye merely a machine. That is the tragic sickness of our time: dry utility, never beauty. If four hundred years ago those who invented gunpowder had invented steam—and they were surely capable of it—the iron horse would have been fashioned and caparisoned differently; the iron horse would have been something alive, like a horse, or terrifying, like a statue. What a

magnificent chimera our fathers would have made of what we call the boiler! Can you imagine it? Of that boiler they would have made a scaly and monstrous belly, an enormous shell; of the smokestack, a smoking horn or a long neck supporting a mouth full of embers; and they would have hidden the wheels under immense fins or great suspended wings; the cars would also have had a hundred fantastic forms, and in the evening we would have seen passing near the towns a colossal gargoyle with outspread wings, or a dragon vomiting fire, or an elephant with its high trunk panting and roaring, wild-looking, glowing, smoking, formidable, dragging after them like conquered prey a hundred other monsters in chains, and crossing the fields with the speed, the noise and the shape of lightning. It would have been grand.

But as for us, we are good businessmen, very stupid and very proud of our stupidity. We understand neither art, nor nature, nor intelligence, nor fantasy, nor beauty, and from the height of our smallness what we fail to understand we declare to be useless. That is all very well. Where our ancestors would have seen life, we see matter. There is in the steam engine a magnificent motif for a sculptor. . . .[6]

Hugo's response to the locomotive shows how the new and strange in the milieu can arouse fanciful images and exotic metaphors, especially when they excite feelings by their fearful power. In describing the interior of the iron-world at Le Creusot fifty years later, a novelist as soberly realistic in language as Maupassant resorted to the same type of demonic similes as Hugo. The factory with its furious flames, suffocating heat, and dull, incessant roar, appeared to him sinister, a confusing, terrifying labyrinth of machines that he likened to reptiles, boa constrictors, elephants, giants, and monsters. Yet he admired, too, the beauty of its products: "some as fine as the chiseled works of artists, others as monstrous as the work of giants, complicated, delicate, powerful, brutal."[7] Even the great promontory of Étretat, Monet's favored theme, is pictured by Maupassant in his story *Une Vie* as a living creature, "a rock of strange shape, rounded and flooded with light, like an enormous elephant burying its trunk in the waves."[8]

In Monet's circle, too, the locomotive in his paintings was seen as an alarming presence. In *L'Impressioniste; journal d'art,* a paper that ran for five issues between April 6 and 28, 1877, during the group's third exhibition, Monet's admirer Georges Rivière praised the "astonishing variety" and "intense life" of Monet's locomotives, "despite the monotony and aridity of the subject," further characterizing the locomotive as "an impatient and impetuous beast, animated rather than fatigued by the long pull . . . it shakes its mane of smoke. . . . Around the monster men swarm like pygmies at the feet of a giant."[9]

For Zola, by contrast, the engine, though still seen as a living organ, became a prototype of the new iron architecture of the great market, Les Halles. It "appeared as a modern machine, beyond all measure, like a steam engine . . . a gigantic metal belly, bolted and riveted, made of wood, glass, and cast iron, with the elegance and power of a mechanical motor, functioning through the heat of the boiler, the furious motion of the wheel."[10]

Hugo's two descriptions—of the locomotive and of the view from the moving train—set terms for the future developments of art, which were to include, besides the Impressionist vision of movement, color, and light, an enthusiasm for abstract constructions inspired by the machine and also a free fantasy of "super-real" hybrid organic forms. In both descriptions there is the history-marking mobility of the artist as an inventor of forms and of art as a "movement."

In Monet's works of the 1870s, the railroad appeared in painting for the first time as the inspiring theme of a new aesthetic (fig. 41). What attracted Monet were not the passengers in the cars, nor the monstrous and demonic in the looks of the locomotives, but the phantasmagoric qualities of the depots as animated milieux, unlike anything known in the past. In stations—modern ports of entry into the city, inner organs near its center of action—trains disgorged steam and smoke and brought clang and clatter to their surroundings. To render these, Monet created a new texture of brushstrokes and turbulence of tones; the spaces of the station and of

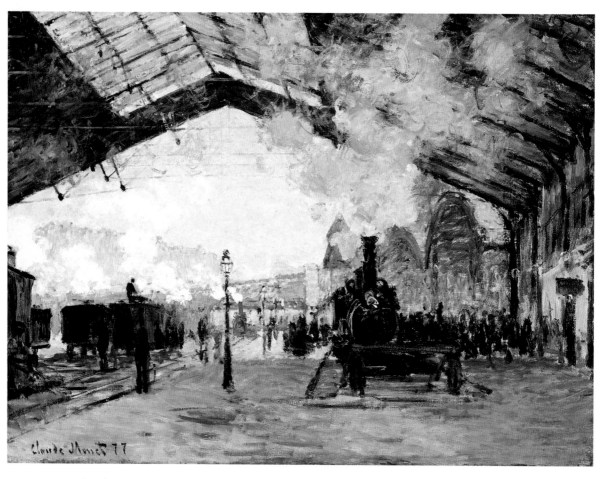

FIGURE 41. Claude Monet, *Saint-Lazare Station, the Normandy Train*, 1877, oil on canvas, 59.5 x 80 cm, The Art Institute of Chicago

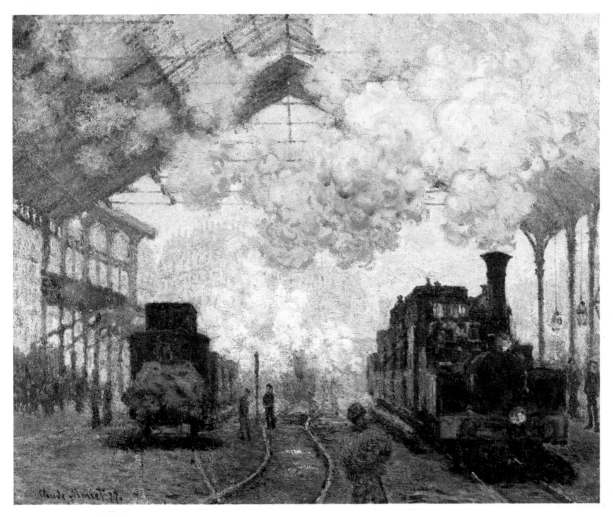

FIGURE 42. Claude Monet, *Arrival at Saint-Lazare Station*, 1877, oil on canvas, 82 x 101 cm, Fogg Art Museum, Harvard University Art Museums, Cambridge, Massachusetts

neighboring streets and skies are filled with a vaporous atmosphere released by the engines and vibrating with the energy of the ponderous machines.

There is in Monet's pictures of stations a poetry of natural forces unleashed by man, as intense and grandiose as Hugo's imagery of the beast-locomotive and his exalted account of the landscape traversed and transformed by the speeding train. Even if the painter had outlived that mythical fancy, still he was perhaps indebted to Romantic poets for the rapturous note in his image of smoke and steam. A recent enthusiastic page of Théophile Gautier on the railroad in painting and poetry might have incited Monet to undertake his great series of canvases of the Gare Saint-Lazare, bolder and more radical in conception than the pictures of trains and stations in the open countryside he and Pissarro had painted in England a few years before (fig. 42).

The occasion of Gautier's comment was the "Chant of the Locomotive" composed in a programmatic vein by Flaubert's friend Maxime Du Camp. The author was then a fervent Saint-Simonian, certain of social progress through the advance of industry and science. His poem, included in the volume *Les Chants modernes* (1855), reads today as a piece of conventional verse untouched by the heroic in its theme. The epigraph is a passage from the Apocalypse of John (9:17) about the horses' heads from which issue fire, smoke, and sulfur. We meet again in his poem that old "mastodon" who, long extinct as a species, can still serve as a metaphor of the new engine of progress. Writing about these banal verses, Gautier was reminded of Turner's picture *Rain, Steam, and Speed: The Great Western Railway* (fig. 43), which he had seen in London:

> It was a real cataclysm. Palpitating flashes, wings like great fire birds, Babels
> of cloud crumbling beneath strokes of lightning, whirlpools of rain vaporized by
> the wind: it was like a setting for the end of the world. And through it all, the

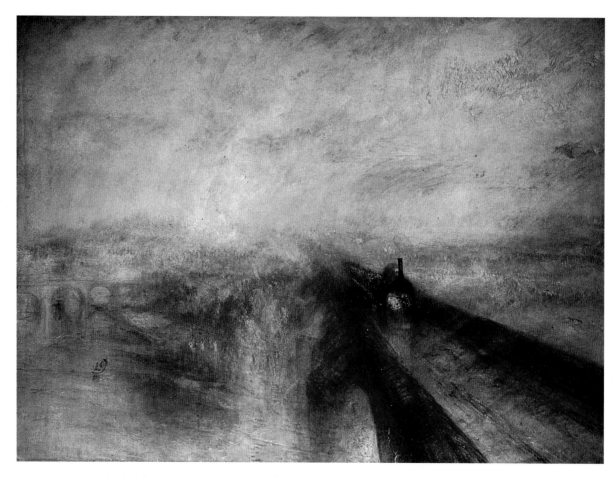

FIGURE 43. J. M. W. Turner, *Rain, Steam, and Speed: The Great Western Railway*, 1844, oil on canvas, 91 x 122 cm, National Gallery, London

locomotive twisted, like the beast of the Apocalypse, opening its red glassy eyes in the shadows and dragging behind itself the vertebrae of the wagons as an immense tail. It was undoubtedly a hurried, excited, furious sketch, confusing sky and earth in one brushstroke, a veritable extravagance, but done by a madman of genius.[11]

Gautier missed just that extravagance and intensity in Du Camp's sober and correct lines. "With fewer words one could perhaps render more poetically and picturesquely the locomotive that our writers fail to admire sufficiently. A little of Turner's disorder and fantastic effect would not do badly in the *chant* that the poet consecrates to the metal steed which is to replace Pegasus."[12]

Turner, Hugo, Gautier, and Du Camp, all born before the development of railroad travel, saw the train in mythical terms, while Monet's vision was fully at home in the new urban milieu and the now familiar aspect of iron and steel in mechanized travel. Turner transfigured the machine in a boundless cosmos of sky and sea where the long train rushes ahead as a demonic force amid the enveloping powers of a sublime nature; Monet awaited and observed the train in the security of the station, its fixed point of arrival and departure. His intense rendering was not the "sublime extravagance" of the enraptured English painter, but a no-less-impassioned response to an everyday urban phenomenon seen with wonder and delight. For Monet, the railroad was man added to nature, begetting a new human environment continuous with nature and rivaling it in power and scale.

The railroad overcame great spaces and generated astounding phenomena of light, heat, sound, and motion, creating atmospheres akin to clouds, rain, winds, and tempests. It was in the forefront of a rapidly advancing modernity and marked the direction and momentum of change, becoming an extension of the city. The railroad took its place in Monet's art in the 1870s beside the traffic of the streets and the ever moving life of the city, as an object for lyrical celebration. In his paintings of the depot we recognize a counterpart to his pictures of the boulevards (see fig. 16). In their merging of atmosphere, buildings, and crowds, suggested by scattered shapeless spots, Monet's images of the streets presented aspects of the dense, the vaporous, and chaotic also seen in his train stations.

V

The City

IN THE IMPRESSIONISTS' CHOICE of subjects, the city held an important place beside the country. Those painters' taste for sunlight and green nature has been explained as a reaction to the new growth of cities, their inhuman hardness, their factory smoke and grime. Well before, however, the preindustrial city had become a symbol of the unnatural in social life. At the end of the eighteenth century the author of the *Tableau de Paris* noted the Parisian's love of flowers and country life while dwelling in "his unvarying landscape of bricks and mortar." The crowding, shabbiness, and stifling atmosphere of major towns made the pure air and openness of the country appear more deeply stirring, like a true Eden. If at all times people have responded to the beauties of nature, the need for relief from urban routines and closeness gave to the fields and hills an added poignancy for the senses. As early as the seventeenth century, John Milton had written in *Paradise Lost*:

> *As one who, long in populous city pent,*
> *Where houses thick and sewers annoy the air,*
> *Forth issuing on a summer's morn to breathe*
> *Among the pleasant villages and farms*
> *Adjoined, from each thing met conceives delight—*
> *The smell of grain, or tedded grass, or kine,*
> *Or dairy, each rural sight, each rural sound—*[1]

Charles Dickens in 1840 described the happiness of Londoners getting out to the country:

> The freshness of the day . . . the beauty of the waving grass, the deep green
> leaves . . . —deep joys to most of us, but most of all to those whose life is in a
> crowd or who live solitarily in great cities as in the bucket of a human well—
> sank into their breasts and made them very glad.[2]

But while rural nature has long been felt with the joy of liberation by those "in populous city pent," one should not forget that the growth of cities made possible the easy and cheap transport that opened the countryside for enjoyment by all classes, and it was the standards of comfort in cities that ultimately brought such amenities to rural life. As they grew, cities themselves

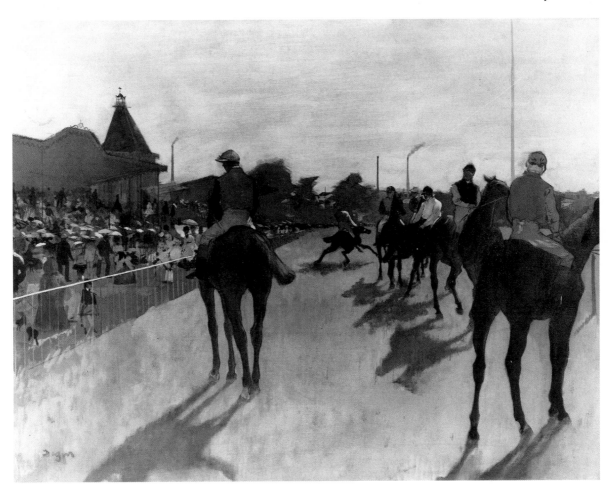

FIGURE 44. Edgar Degas, *Before the Races*, 1869-72,
oil on canvas, 46 x 61 cm, Musée d'Orsay, Paris

became more and more places of recreation and promenade. With their swarming crowds, paved streets, and showplaces, cities were as captivating a spectacle to travelers as the charms of nature in the surrounding or more distant land.

The new Paris of the 1860s and 1870s was a capital city of trees and parks and the winding Seine; a writer of the period could say that there were more trees and peasants in Paris than in the country. The fact is that Impressionism arose in Paris, which was no city of mills like Manchester and Essen—centers that produced then hardly any painting of this kind. Yet Monet and Pissarro, in their views of the railroad and the silhouettes of suburban towns, noted with pleasure the atmosphere of smoke and steam, the occasional factory chimney and the plume of dark gray rising from it against the sky. Degas proposed to himself in the early 1860s a series of paintings of the varieties of smoke: "the smoke of smokers' pipes, cigarettes, cigars; the smoke of

locomotives, of the tall factory chimneys, of steamboats, the squashing of smoke under the bridges."[3] In Degas's early paintings of the races, those smoking chimneys often surmount the horizon (fig. 44). Charles Baudelaire in 1862 could praise the young James Abbott McNeill Whistler for his discovery of the beauty of the modern metropolis with its factory buildings and traffic.[4] Before him, Antoni Deschamps, a Romantic poet, had written in a religious vein of the charms of the new industrial landscape:

> *La féconde vapeur s'élevant de l'usine*
> *Est aussi douce à Dieu dans sa maison divine*
> *Que la prière ardente ou la brise du soir.*

> *(The fecund steam rising from the factory chimney*
> *Is as sweet to God in his heavenly mansion*
> *As a fervent prayer or an evening breeze.)*

In the Paris of the 1860s and 1870s, with its traditional enjoyment of both city and country life, and its new preeminence as the city of light and capital of pleasure and chance, the Impressionists found some of their most absorbing themes. Among their works were many urban and suburban scenes no less Impressionist than their paintings of the rural landscape. Even in their pictures of the country, the converging lines of the paths and the random spotting of fields, trees, and buildings often reflect the artists' visions of towns, in sharpest contrast to the older paintings of nature, with their stately, formal groupings and air of stability, even in what seemed to artists at the time highly animated, picturesque views. Elements of city life in Monet's pictures of the beaches and ports have already been mentioned. His perspectives of both the country and the small town were formed by his experience in the long streets of the capital. For the young artist from Le Havre, they offered a rousing spectacle of movement with a promise of freedom. When Monet represented Paris—as he often did in the years before 1880—he chose crowded scenes rich in traffic and buildings.

Standing on the quay of the Louvre with the museum behind him, Monet contemplated the street on the other bank of the Seine (fig. 45). He framed the view as a segment of a larger whole, with innumerable tiny parts, endlessly aligned, each a note or two of the brush, but together shaping a coherent scene delightful to the eye. Monet multiplied the clouds, the chimneys, and roofs of the horizon with their countless flickering points. Cabs and promenaders in the foreground enter at the left from outside the frame and proceed, like the clouds and houses, to the other side. It is an original and stirring little picture of a perpetual traffic, unenclosed and without source or focus. The same magic light brightens the street, the buildings, and sky—a radiant force that lends the moment its charm. Here the urban panorama, an infinity of sights, is sampled in a random glance by a roving eye. It is the boundless, ever moving city of which Balzac had written: "Paris is an ocean."

The city had been a painters' theme for some years before the Impressionists, though it was still largely ignored by the leading masters of the Neoclassical, Romantic, and Realist Schools. Those who undertook to picture the streets were drawn then by its stable aspect—the precise lines and detail of buildings and the clear, planned order of the paths, which imposed their rule on the crowds and the wheeled traffic. In the *View of the Boulevard des Capucines about 1810* painted by Mathieu Cochereau, a talented young pupil of Jacques-Louis David in 1815, his composition has been closed at one side by a mass of trees, with balanced groups of strollers moving from left and right toward a central axis. Since the mid-eighteenth century a line of French illustrators of the Parisian scene had applied to their imagery of the streets the formalism that had been devised for composing narrative themes. In departing from such models in his early painting, while holding to the panoramic form, Monet owed much, directly or indirectly, to the pictures of Rome made by Corot forty years before, with their wide, deep views on small surfaces. Monet responded to the older painter's engaging abundance of fresh touches, to his legible strokes that condensed with sureness and grace the silhouettes of distant figures, buildings, or trees, and re-created the airy tonality and light pervading the large scene.

To isolate what was new in Monet's sensibility we may compare his early painting of Paris (see fig. 45) with a view of the Roman Forum as it appeared to the young Corot in 1826 (fig. 46). Small, refined, and broadly constructed, Corot's picture anticipates Monet's in its silhouettes and horizontal banding. Also like Monet's art is the scale of the units, whether seen as small touches of toned pigment or as objects; however, they stand out beside each other more distinctly than Monet's in shaping the foreground and the distant city. The ancient capital is beheld from behind a bank of vegetation, a dark barrier framing the Forum and separating the traveler from the enchanted world of his vista. In perceiving the Paris of Monet's picture, the viewer is inside the city and can join the strolling crowd as a promenader in the common light. The historic world of Corot's painting is seen by a solitary spectator standing at a distance—a distance in space that has been added in feeling and thought to the distance in time.

Besides the ancient structures, Corot's observer perceives also the medieval buildings and those of the Baroque age. Corot's city is a palimpsest of history in which is strangely visible a temporal sequence of uninhabited archaeological remains. All is quiet, as if set apart for meditation. Confronting the double perspective of the remote in time and space, the viewer is induced gently by the declining sun to ruminate on both the creative and the evanescent in human life. Entering the landscape horizontally at the left, the late afternoon sunshine progressively dims on the right. The reflective mood grows in part from the spectator's passive state: the spectator's position is set at a contemplative station so distant from the immobile and gradually crumbling, darkening object.

The solitude of Corot's image arises not only from the viewer's isolation but from the stillness and void of the Forum, the void of the dead past. This environment, like a work of art, exists in abstraction from the actors and events that give the old city historic significance; it is all a

spectacle of architecture, a museum in a landscape. The shadows and lights of this sunset lend a glow to the site and mark what is regular in the constructed shapes, as well as the symmetry and compactness of the whole. Devices of composition have accented the rhythms of the larger forms, softened by air and light. There is an arresting harmony and completeness in this stable image of ruins, a transfigured order in the slow course of the destructive action of time. Monet, like Corot, was sensitive to time, but the ephemeral approach of the Impressionist appears in a stirring vision of a contemporary city with its daily bustle and growth, while to the earlier artist change was a quiet process of centuries, even millennia. The reflecting minds of Corot and his viewers could brood not only on the aging and death of societies and cultures but also on their abiding presence in the arresting moments of art.

In Monet's picture of Paris—like Rome a place with a visible past that owed much of its interest to older and newer buildings, both recognized as landmarks of promenade and civic life—the large forms are broken into elements of a progressively smaller scale. Piquant notes are the contrasts from point to point and the unique, justly weighted, little touches of stronger color

FIGURE 45. Claude Monet, *Quai du Louvre*, 1867,
oil on canvas, 65 x 92 cm, Gemeentemuseum, The Hague

FIGURE 46. Jean-Baptiste-Camille Corot, *Rome: The Forum from the Farnese Gardens*, 1826, oil on paper mounted on canvas, 28 x 50 cm, Musée du Louvre, Paris

throughout; these do not unite to build distinct larger forms like Corot's but are harmonized through the apt selection of neighboring values in a dense gamut of tones. The division of the painting into tiny brushstrokes has been adapted to the scale of the smaller objects—the numberless windows, chimneys, and roof tiles, as well as the strollers in the street. It was the metropolis made visible in its true scale, a molecular world of the constructed and the living; the spectator knew himself as one of the crowd, and the house or room as a cell among thousands, like his own.

When Corot pictured a city nearly fifty years later, at the time of emerging Impressionism, he saw it as if with the eyes of a new generation formed by the intervening changes in habits and thought (fig. 47). His view of Douai, an old commercial town closer in spirit to the modern than to Rome, shows an inhabited site with people in the street. We sense the spectator's implied presence in the vertical format—one more suited to a viewer looking down a narrow street with a tall medieval belfry as the focus of his gaze—and even more decidedly in the framing of the view by buildings in the foreground, inside the picture itself. The artist looked from a point between the structures well above the street level, as in a theater loge or balcony from which a Parisian might have peered across the orchestra to the stage. The distant and the near in Corot's *Douai* are in the same direct light; we recall that in his early canvas of Rome the foreground was in

FIGURE 47. Jean-Baptiste-Camille Corot, *Le Beffroi du Douai*, 1871, oil on canvas, 46.5 x 38.5 cm, Musée du Louvre, Paris

shadow and the spectator sighted from his darkened space an ancient and inaccessible Rome illumined by the setting sun. In his late work, Corot, a Parisian but hardly a lover of crowds, has transformed the image of the city in having selected the convergent inward path, a street with its dwellers seen from above. Now a less detached observer, lacking the reverie or pathos of isolation, the spectator is closer to the space viewed and can enter it for a promenade.

Corot did not introduce this high perspective of a city street with its lively traffic into French painting. It existed already in photography and graphic art. The Impressionists chose also to picture the street from the eye level of a stroller, as in earlier popular engravings of the Paris boulevards. In these, the convergence, which revives the sensations of a swiftly moving rider or passenger, is much reduced or is masked by trees in the foreground. Scenes have been composed in the formal manner of traditional landscape painting, with large trees and buildings balancing

each other and with clusters of promenaders; each group is complete in itself and arranged more or less symmetrically. In Monet's and Pissarro's views of the boulevards from a high balcony or window (fig. 48; see fig. 16), the buildings are cut oddly by the frame and narrow the span of the observers' eyes fixed upon the long receding street and its crowds. The painters' momentary positions, the instant and objects of their gazes, have become more evident and singular through the sweeping perspective. We learn from literary descriptions that the sight of a major boulevard was a delight to many others who had looked down from the same high places, though when translated into swift, summary brushstrokes in order to become a painting by Monet or Pissarro, the scene might appear to the same enthusiastic spectators a chaotic and arbitrary image in its illegible, scattered detail.

More radical still was Monet's picture of a holiday crowd celebrating the national fête

FIGURE 48. Camille Pissarro, *Boulevard des Italiens, Morning, Sunlight*, 1897, oil on canvas, 73.2 x 92.1 cm, National Gallery of Art, Washington, D.C.

FIGURE 49. Anonymous, caricature, *Le Mardi-Gras sur le Boulevard,* from *Le Salon caricatural,* Paris: Charpentier, 1846

in 1878 (see fig. 15). The staccato strokes, insistently large for so small a canvas, render his excited vision of the promenaders below the fluttering flags and the close array of colorfully spotted windows. The happy vertigo projected in the painting corresponds, we may suppose, to the elation of the crowd. But to recognize this experience in the picture and to share the artist's enthusiasm in representing the familiar spectacle was beyond the imagination of those who had been part of the festive crowd. The novelists and poets had pictured such moments in the Paris streets, yet it would have been unlikely, if not impossible, for an earlier painter to conceive the subject as Monet did. His impassioned, still unfamiliar rendering was an obstacle to the viewers' recognition of the enjoyed sight. But even if it had been done in a more literal way, a painting of that occasion, with its chaotic movements and strident medley of colors and sounds, would almost inevitably have appeared vulgar to a conservative taste and unsuited to the dignity of art.

An 1846 engraving for an illustrated *Salon caricatural,* with poems by the young Baudelaire and his friends lampooning the pictures at that year's Salon, shows how incomprehensible a painting of a crowded Paris street could look to the public and even to artists a generation before Monet's work. This caricature of a canvas is called *Mardi Gras on the Boulevard* (fig. 49). The poet wrote:

> *Pareil aux songes creux d'un phalanstérien,*
> *Ce fouillis de chapeaux, de bonnets et de casques*
> *De titis et de bergamasques*
> *Tout ce déguisement de mannequins fantasques*
> *Est si bien déguisé que nous n'y voyons rien.*[5]

(Like the hollow dreams of a Utopian sect,
This chaos of caps and bonnets and hats
All this disguise of fantastic mannequins
Is so well concealed we see nothing at all.)

For the poet that picture of a crowd on the boulevard was an undecipherable confusion that violated the canons of clear representation. Still, if we saw the original painting today, it would doubtless seem an obvious, perhaps even veristic image of the site. Judging from the caricature, the composition does not exploit, as in Monet's and Pissarro's plunging perspectives on the street of the 1870s, a spectator's glimpse of the scene in an angular view from above, nor does it offer a distant panorama, as in Monet's *Quai du Louvre* (see fig. 45). Though designed to re-create the randomness and density of a holiday crowd, the caricaturist's image is composed in distinct bands like a relief, with buildings, trees, and strollers staged in parallel planes. This type of view was fixed in the late eighteenth century by Philibert-Louis Debucourt in his lively little pictures of Parisian promenades (fig. 50)—a model of whose authority is still felt in Manet's *Musique aux Tuileries* (*Music at the Tuileries*) of 1862 (fig. 51).

Yet even though the satirical draftsman of *Mardi Gras on the Boulevard* was partly following those conventions, he unintentionally anticipated in other respects the paintings of a later time. The delineation includes an early example of the surface-filling tangle as a form in art. One must wait nearly seventy years for the Futurists and others to produce a comparably chaotic equivalent of the shapeless crowd. Caricature, with its licensed aggressiveness, freed the artist from the usual norms of representation and conjured up surprising liberties of design, at once primitive and advanced in the playfully scribbled line. But the tangle is only a single element in a whole that is otherwise tamely regular in form. In his own painting, the caricaturist probably returned, like André Gill and Gustave Doré to the precepts of the established school.

The high point of view in the Impressionists' paintings of crowded streets is not just an ideal abstract element in the geometry of pictorial perspective. It is also a human standpoint, a spiritual post that serves an attitude to the world that includes the surroundings built by man. Landscape painters of the sixteenth century had chosen a high, unlocalized point of sight, distant from their objects, the better to unroll a maplike panorama, where figures are subordinate to the roads and buildings that mark the extended landscape, or to accommodate successive episodes of the Passion of Christ. However, all these individual scenes were represented in minute detail, as if close to the eye. The Impressionists' high view of the city, the place of an ongoing daily movement without episodes, lifted the viewer to the vantage point of an actual spectator virtually within the populated space. Such a person may be shown on a balcony in the upper foreground, as in Monet's *Boulevard des Italiens*, enjoying what is most indefinite, shifting, and vague. Even without an overt presence, his position and line of sight have been brought unmistakably to the observer's attention by the dramatic foreshortening of the street and by the long, narrowing

corridor that has framed the motion of the promenaders and vehicles in pace with the endless converging series of trees and aligned buildings and their repeated windows, doors, cornices, and chimneys. The viewer not only can take part in this movement; he can even direct and reinforce it by the convergencies in his unobstructed gaze.

An eloquent section in Flaubert's *L'Education sentimentale* (1869) recounts the impact of nature on visitors from Paris. Frédéric and Rosanette went to the forest of Fontainebleau in the late spring of 1848 after the tumult of the February revolution and just before the uprising in June. The landscape did not rinse away the visual affront caused by the ugliness and crowding of the metropolis, but rather purged the emotional grossness, passions, anxieties, and deceptions of life in the city. The woods and open spaces of the forest unfolded surprising views that awakened different feelings: terror, joy, sadness, strength, and a serene or grave contemplation. This description offers a masterly contrast to the preceding pages that describe episodes of the revolution and repeated frustrations in personal life. After a tantalizing courtship in the city, the two Parisians became lovers in the forest. Walking through the woods, "the gravity of the forest overcame them . . . they remained as if stunned in a tranquil intoxication." Earlier, Rosanette, frightened by the sight of cataclysmic, wildly strewn rocks, had remarked that "it would make

FIGURE 50. Philibert-Louis Debucourt, *Tuileries Garden, "La promenade publique,"* 1792, colored copper engraving, 35 x 58 cm, Musée de la Ville de Paris, Musée Carnavalet, Paris

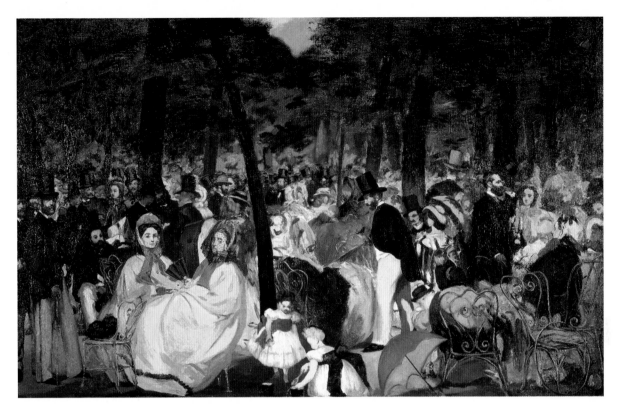

FIGURE 51. Édouard Manet, *Music at the Tuileries*, 1861,
oil on canvas, 76 x 118 cm, National Gallery, London

her go mad. . . . She turned away quickly, to avoid the dizziness, almost in fright." Rosanette "was in despair and wished to cry. But proceeding upward, her joy returned. . . . Standing beside each other on an elevated point of the terrain and breathing the wind, they felt entering their souls something of the pride of a freer life, with a superabundance of powers, a joy without cause." The forest brought out in her "a wholly new beauty which was perhaps only the reflection of the surrounding things, unless their secret virtual qualities had made it flower."[6]

The forest of Fontainebleau appears in Flaubert's pages as a natural counterpart of Paris; it was a dense world of the most varied sights. The lovers promenaded on paths among the trees; they discovered a hard, massive landscape of great superposed rocks like ancient buildings; and they enjoyed the long streetlike vistas, enclosed darkened spots, turbulent forms, shifting lights and colors, but no vast open spaces. It was a nature that enveloped the promenaders like a city and enchanted them with unexpected and continually changing views.

Certain paintings of the same woods by artists of the earlier Barbizon School also suggested a flight from the city. They represented secluded spots, low-key and brownish in tone, with deep shaded hollows and a mysterious glow in the lighted places. Nature there was a retreat, ideal for

long meditation, a haven for cenobite artists who lived in a modest tavern near the woods in Arcadian simplicity and contentment. Though other painters in the 1860s and 1870s continued to seek out the solitude of those forest sites, the Impressionists' pictures show little trace of that sentiment. Their favored landscape was the Sunday outdoors of the Parisian lower classes, an extension of the Seine, of the parks and streets of Paris, all before your eyes, in sunshine, without the mystery, seclusion, or the arresting golden light from a single spot of the forest.

The Impressionists' taste in landscape themes was, of course, not confined to those that satisfied a sensibility formed by Parisian experience alone. Such themes manifested real preoccupations of the time; they embodied a mode of life valued by a large stratum of society. Many of the same subjects had already appeared in the engraved illustrations of books published in the 1860s and earlier about the pleasures of Paris and its suburbs and the nearby countryside and beaches.

In the *Histoire des environs du nouveau Paris* (c. 1861) by Emile de Labédollière, the frontispiece drawn by Gustave Doré shows people in the open country beside a stream; it depicts a train passing on a distant bridge; the figures are fishing, picnicking, reading, painting, flying kites, even making love. "How many artists and writers flock each year to Bougival!" exclaimed the author. He quoted the verses of Fernand Desnoyers on this resort:

> *Du soleil, de l'air, de l'eau!*
> *Que Dieu me ramène*
> *Dans ce lumineux tableau*
> *Dont ma vue est pleine. . . .*
>
> *(Sun, Air, Water!*
> *God bring me back*
> *To this luminous picture*
> *That fills my eye. . . .)*

A woodcut represents the sailboats and canoes at Bougival. Canoeing had become, in the words of Edmond and Jules de Goncourt, a "passion of Parisians"—"one savored the holiday, the exertion, the speed, the free and vibrant open air, the reverberation of the water, the sun beating down on one's head." In a play, *La Cigale (The Cricket)*, by Degas's friends Henri Meilhac and Ludovic Halévy, a boating party of painters is an element of the plot. Maupassant wrote several stories around such enthusiasm for the water. Like the picnics and promenades in the *banlieue* (suburbs), the weekends and vacations on the water were a return to nature, a recharging of the self in sunshine and sportive movement. Nature was not, as with the Romantic solitaries of the previous age, a secluded spot for quiet reverie, but a world of invigorating play and promenades.

On another page of Labédollière's book, elegant figures in a carriage watch a horse race from the foreground, as in later paintings by Degas. Elsewhere (p. 77), gentlemen at the stands in

Longchamp talk to the jockeys before the race. From the terrace of St. Germain visitors enjoy the view (p. 108). A picnic at the park of Le Vésinet is spoiled by smoke from a passing freight train (p. 109)—the scene recalls a painting of 1865 by Cézanne. On page 181 the engraving entitled *Le Diner sur l'herbe*, depicting a party of bourgeois husbands and wives accompanied by five donkeys, is more informal and realistic than Manet's famous painting. The weekend pleasures of Argenteuil and Asnières, with sailboats, rowing, and canoes, are described and pictured in other chapters (pp. 135, 147, 149). There are also scenes of skating (p. 204), the races of Chantilly (p. 300), the markets and work in the fields of the neighboring villages (cf. Pissarro), and historical sites and monuments. At Fontainebleau, a painter works in the open air while the peasants watch (p. 268); a bull licks a painting as the painter sleeps, reclining in a foreshortened posture, like one of Cézanne's picnickers (p. 269).

The same Labédollière also wrote another book, *Le Nouveau de Paris* (n.d.; soon after 1850), illustrated by Gustave Doré and others, with views of the streets, the Bourse, the *café-concert*, the *coulisses* of the Opera, that recall later works by Degas. Thus were Impressionist motifs, if not the seriousness and airy finality of their presentation anticipated to some extent in popular illlustration.

Some foreign visitors, especially from Protestant countries, thought that Impressionist paintings captured the swift movement of Parisian life, a sentiment shared by the Impressionists' circle. In the magazine *L'Impressionniste*, published in 1877 in support of the third Impressionist exhibition, their defender, Georges Rivière, maintained that the painters were representing the reality of Paris with "a rigorous exactitude" as no one had done before and without Romantic illusions or theatrical display. He wrote of Renoir's *Le Bal* as an "essentially Parisian work . . . a page of history, a precious monument of Parisian life."[7] Monet's landscapes were "an agreeable, never discordant view . . . nothing that saddens the eye or the mind . . . [they are] joyous or grandiose landscapes, never with those lugubrious notes" one found in so many contemporary pictures.[8]

Those "lugubrious notes" were also common in novels about Parisian life throughout the century. A generation before the Impressionists, Balzac, who described the Parisian as an eye insatiable in the enjoyment of spectacle, could picture that society, in the prologue of his story *La Fille aux yeux d'or* (*The Girl with the Golden Eyes*),[9] through the typical pallor of Parisian faces and the exhausting effects of the routines and careers in different strata of the metropolis. A poet of more stoic temperament than Balzac's, Alfred de Vigny characterized the Parisians of 1831 as "a people without joy and without melancholy. . . . On those energetic but worn faces, alert and pallid, one could read sadness and insomnia at first glance. Each brow bore some imprint of that restless discouragement of a population without joy and without melancholy. . . . How slowly and sadly they were all going to their pleasures!"

A similar view of the city crowd in the late 1830s appeared in Fromentin's novel *Dominique* (1863), written on the eve of Impressionism: "I was struck, too, I remember, by the smell of gas,

which announced a city where one lived as much in night as in day, and by the pallor of the faces that made me think they were unwell."[10] This unhealthy mien still marked the aspect of Parisians in the late 1860s for Hippolyte Taine, who observed "the tumult of moving forms" in the streets, and the crowds at the theaters and behind the windows of the cafés: "Have you noticed how wrinkled, frowning, or pale are all these faces; how anxious are their looks, how nervous their gestures? A violent brightness falls on these shining heads; most of them are bald before thirty."

In the 1890s that ghostly pallor and passivity were to reappear in the figures of the dance halls and theaters created by Henri Toulouse-Lautrec and in the paintings of the promenaders in the streets of Oslo, for example, *Evening on Karl Johan Street* (1892), painted by Edvard Munch, which became as clear a sign of the city as the Impressionist holiday faces. It is evident that the Impressionists' happy pictures of their surroundings were not simply a reflection of actuality. Like older paintings of figures in attitudes of adoration and piety, they were a choice of optimal moments.

The Impressionists' imagery of pleasure conveyed an ideal as well as an experience and way of life. Few times have been without their amusements and festivities, and people have traditionally responded to the charm or grandeur of their surroundings. But in the Paris of the 1860s and 1870s these enjoyments had become for many a model of happiness, a cherished style of life and a fulfillment of instinctive human nature, a necessary complement to or release from work and practicality. Artists—painters above all—were the outspoken votaries of this popular hedonistic cult. The capacity to feel nature and human beauty, to respond to the qualities of things without thought of their use, is part of spiritual well-being, often in conflict with the moods of an ascetic religious sensibility. Critics of social life and moralists never tired of opposing the spontaneity and warmth of the artist as the living example of the natural man to the contracted heart and philistinism of the cold, prudent bourgeois.

In his once sensational play *Ghosts* (1881), Henrik Ibsen had the painter Oswald Alving—an afflicted victim of his father's venereal disease—say, in contrasting the dull, puritanical life of his native Norway with the Parisian "joy of life" and "joy of work":

> Over there the mere fact of being alive is thought to be a matter for exultant happiness. Mother, have you noticed that everything I have painted has turned upon the joy of life?—always upon the joy of life, unfailingly? There is light there, and sunshine, and a holiday feeling—and people's faces beaming with happiness.[11]

VI

The Performers

IMAGERY OF PERFORMERS AND PERFORMANCES, as well as of certain marginal types from the streets of Paris who were regarded with a lively interest as figures of the urban scene, occupied a significant area in the span of Impressionist subjects. In their paintings of music halls and stages, the audience was often part of the show and a sign of the vogue of the artistic in common life. So, too, the portrayal of the isolated performer, the *"artiste"* facing the viewer directly, betokened the painter's self-awareness and the public's enjoyment of the direct confrontation with the artist and his audience. Such a subject may be taken as a simile of the virtuoso painter's own performance; he is present in the brushstrokes as gestures, in the colors and forms as skilled utterance, and in the perspective as the viewpoint of his sighting and discriminating eye. Behind that choice is perhaps also the artist's longing for recognition in an everyday public world of art.

Manet, Degas, and Renoir—from the start painters of the figure—were most drawn to performers as a theme. Even Cézanne in 1886 ventured to represent actors from the *commedia dell'arte* almost life-size, though without a visible audience. The choice of performers as subjects was already distinctive in Manet's art in the decade before 1870, when he had not yet turned to direct painting outdoors with an Impressionist light and touch. A true virtuoso, confident of his uncanny power with the instruments of his art and rebuffed often by the established artists and their admirers in uncomprehending reactions to the novelty of his style, Manet was drawn to original and deviant personalities of the Parisian scene. Very early he represented in full-length portraits the *Guitarrero* or *Spanish Singer*, the *Fifer*, the *Old Musician*, the *Street Singer*, the dancer Lola de Valence, and, from his memories of the Spanish bullring, models posing as a toreador and as an espada.

Besides these Manet placed on the canvas the refractory types from the street, the outcasts of the Paris *bohème*, with whom a rejected painter of the avant-garde could feel kinship because of his own fate in a respectable philistine world. Those drunkards, rag pickers, vagabond musicians, and beggars were the native exotica of a society avowedly humane and democratic, but sharply divided into the haves and the have-nots, the ins and the outs (fig. 52). Their picturesqueness was not that of the contented provincial and peasant in the preceding art, with their traditional costume and manner, which were forms of a settled conservative culture; nor was their shabbiness due to poverty alone. It was sometimes the mark of a defiant independence in

FIGURE 52. Édouard Manet, *The Rag Picker*, c. 1869, oil on canvas, 193 x 130.5 cm, The Norton Simon Foundation, Los Angeles

sharpest contrast to the smooth banality of Monsieur Prudhomme, the right-thinking bourgeois, whose physiognomy had been fixed for all time in the writings and drawings of Henri Monnier.

Manet was not the first or only one to picture these marginal types. The urban tramp, or *clochard*, was a familiar and sympathetic figure in the art of the 1840s and 1850s through the prints of Paul Gavarni. In a collective book on the street life of Paris, *Les Rues de Paris*, published in 1844, with illustrations by artists who included Daumier, Gavarni, and Céléstin Nanteuil, a fine engraving by Pierre Zaccone shows a rag picker standing before a poster that advertises the book (fig. 53). An accompanying text by Louis Berger celebrates at length the rag picker's proud inner freedom and the habits that made him a representative Parisian figure:

FIGURE 53. Pierre Zaccone, *The Rag Picker*, etching from *Les Rues de Paris*, 1844, #205

The rag-picker is the practicing philosopher of the Paris streets. In giving up all social vanity, in his perpetual nightly walks, in this profession that does its work under the starry sky, there is a certain odd mixture of quixotic independence and carefree humility, something intermediate between the dignity of the free man and the abasement of the abject; there is finally in these contrasts something that interests us, captivates us, and makes us think; nothing is more peculiar and exceptional than this profession. . . . The rag-picker has an essentially unique place in the social hierarchy: he is *sui generi*s, there is nothing else like him; he is eternally suspended between the high and the low, between the stars and the pavement, between the sewer and the dream.

Another article, "Les Chiffonniers," in a collective volume of the series *Les Français peints par eux-mêmes*, with three accomplished illustrations by Charles-Joseph Traviès, describes a rag picker, Christophe, who was called "the philosopher" and was highly esteemed by the artist for his "probity in poverty, something so fine that in this alone there's a virtue." A talker, "he mocks, accuses, and insults the passersby and the curious while rummaging with his bare fingers in the dung heap." He is the ragpicker *par excellence*, as we would imagine him ideally. For artists, poets, and sensitive women he is the "typical personification of rag-pickers. It is this natural elevation of Christophe that has earned him the honors of painting. He has had his portrait painted, he has been represented in lithographs." Though regarded as a "dangerous class, the rag pickers are nevertheless aristocrats and very aristocratic indeed, I swear to you." They were radical pariahs.[1]

Victor Hugo thought of the rag picker as a symbol of revolutionary Paris. In a poem, "Jour de fête aux environs de Paris," he wrote:

> *Paris élève au loin sa voix,*
> *Noir chiffonnier qui dans sa botte*
> *Porte le tas sombre des rois.*
>
> *(The voice of Paris is heard afar,*
> *A black rag-man who in his bag*
> *Carries the dark heap of dethroned kings.)*[2]

In the representation of the wandering entertainers of the streets and fairs, together with the ragged *bohème*, there was a note of compassion in the recognized affinity with the artist. The most telling acknowledgment is Baudelaire's moving prose poem on the old circus acrobat, once a delight to Parisian eyes and now forgotten and friendless; Baudelaire, with choked feeling, perceived in that abandonment the fate of the old poet. At the Paris morgue the unidentified suicides found in the Seine were called "*les artistes.*"

Baudelaire also likened the rag picker to the poet in his verses, "Le Vin des chiffonniers":

> *On voit un chiffonnier qui vient, hochant la tête,*
> *Butant, et se cognant aux murs comme un poète,*
> *Et, sans prendre souci des mouchards, ses sujets,*
> *Épanche tout son coeur en glorieux projets.*
>
> *(You see a ragpicker who goes by, nodding his head,*
> *Butting and bumping the walls like a poet,*
> *And, with careless contempt for spying informers,*
> *Pours out his heart in glorious projects.)*[3]

More than any artist before him, Manet portrayed these performers and eccentric lower-class types. All stand large on the canvas and assume the prominence that portraiture had in the past conferred on the great in wealth and rank, and especially on the world of the court. In the seventeenth century, Velázquez had painted fools, dwarfs, and cretins in full-length portraits at the command of his royal employer. Prompted by the example of the Spanish master, Manet undertook on his own to picture the declassed figures life-size (fig. 54), without the nod of an approving monarch for whom the congenitally inferior creatures of his court had acted as a source of

FIGURE 54. Édouard Manet, *The Tragic Actor (Philibert Rouvière as Hamlet)*, 1866, oil on canvas, 187.2 x 108.1 cm, National Gallery of Art, Washington, D.C.

amusement, the lower steps in a visible ladder of being that culminated in his own supreme height. Manet's taste for his Parisian subjects perhaps did relate to the Spanish ruler's benign enjoyment of the abnormal, creating a parallel nineteenth-century bohemian court in which the artist was the summit. "Les rois de l'époque" was, in the 1860s, a designation of the fashionable painters of the day.

Painters of the eighteenth century had celebrated artists of the stage in large pictures like *Gilles* by Jean-Antoine Watteau and *Garrick* and *Mrs. Siddons as the Tragic Muse* by Reynolds. These were of an exceptional format for figures of their social class and reflected, beside the painters' admiration of the subjects, the recognition of outstanding artist-performers by the cultivated *habitués* of the theater, who, in England at least, admitted stars of the stage to their own exclusive company.

Manet's subjects were a consistent program of his own, a sympathetic imaging of the society of artists and others who shared their spontaneity and stigma. His elaborate portrait of Zola (see fig. 3) honors the young novelist-critic who had just risked defending Manet and the emerging Impressionist against the jibes and incomprehension of the public and its official spokesmen on the arts. In portraying the writer at his desk as in the type of miniature photographs that served then as calling cards, Manet also set up an allusive personal milieu of paintings, prints, and books; beside a reproduction of his *Olympia* are other images of works by Velázquez and a Japanese artist through which the painter commented on his own aesthetic, citing models that had inspired him. And just as the old and the new, the familiar and the exotic, are juxtaposed in works that pointedly bring the painter himself into the picture, so Manet has placed a sheaf of thin contemporary pamphlets among the old leather-bound volumes on Zola's desk.

In choosing his artist and bohemian figures, Manet was preceded by the taste of Realist painters during the 1840s and 1850s for the representation—sometimes curious and amused, sometimes partisan and compassionate—of the lower classes. The great burst of journalistic writing on the various occupations, human types, and roles in the city, in the so-called *physiologies* of that period, with their brilliant humorous woodcuts, showed that Manet's choice was neither an idiosyncrasy nor the accident of a model conveniently available for the exercise of the painter's brush. But in elevating this interest from the reportage of unframed woodcuts to the scale and formality of the large Salon canvas, Manet shifts our attention from the comprehensive social range of that miniature art with its amiable, often anecdotal, mirroring of Parisian life, to the challenging actuality of the anomalous class of independent artists and the *bohème* as intransigent individuals.

In 1855 Courbet had conceived his life-size monumental painting *The Studio* (see fig. 119) as an image of society by bringing together in his studio as two classes the contrasted representatives of the arts and the world of the uncultured. He had known or seen all these individuals in person and placed his sovereign self in the center before the easel between the two groups.

Such a conception of the divided community, an abstraction from the economic system, reappeared in the later social criticism by Matthew Arnold, Benjamin Disraeli, Friedrich Wilhelm Nietzsche, Jacob Burckhardt, and Ernest Renan.

Manet's habitual choice of subject type marks a turning point in the self-affirmation of the painter as a free social being; it must be understood also in the context of his time and place as a virile critical response to the dominant taste and outlook in French society of the Second Empire, with its cult of the chic, the pretty, and the amusing. Manet's daring pictures of contemporary history during the years of revived political insurgency in the 1860s—*The Execution of Emperor Maximilian* (1868), *The Escape of Henri Rochefort from Prison* (1880–1881), *The Battle of the "Kearsarge" and the "Alabama"* (1864)—are provocative, timely comments on the increasingly unpopular regime.

This account of Manet's subjects is not, of course, the full story of his art as imagery. I have omitted his more remarkable pictures of the sexes: the *Dejeuner sur l'herbe* (see fig. 2), the *Olympia*, and later *Nana*, pictures that point to the role of sex in his conception of society through the pairing of the undressed or partially dressed female and the clothed male, and his construction of portraits with allusive, often elliptically associated still-life objects. But his bold originality in the life-size picturing of artist-performers and pariahs is a noteworthy part of the moral and social history of Impressionism that builds on Manet's works. One painting by Manet, more than any other, unites with brilliance of execution and pictorial wit the two themes of spectator and spectacle in the imaging of the crowd at a performance: *Bar at the Folies-Bergère* (1881-82). In both a literal and symbolic sense it is a mirror of Impressionist sensibility embodied in the subject of a painting (fig. 55).

Manet has pictured the bar at the end of the great hall as the focus and reflection of the entire space. In the center is a beautiful barmaid, flanked by a profusion of colorful liqueurs and fruit, a glitter of flasks and bottles with gilt wrappers, assembled on a shiny marble slab; it is a bouquet of varied luminous tones, textures, and highlights, culminating in the charm of a woman's ornamented person and dress. We do not see the back of the man who converses with her (added in a satirical contemporary cartoon by Stop), but in the mirror behind her she reappears facing this man in reflection. The mirror spans the broad canvas, disclosing all that is in the barmaid's view as she presides over the festive hall: the lights of the vast space and the crowd seated at tables, drinking, chatting, smoking, and watching the acrobats on the trapezes, one of whose legs is caught in reflection in the upper part of the mirror. Scanning the reflected crowd, we catch sight of a woman at the front of the balcony who gazes outward through binoculars: the whole picture is alive with perceptions and reflections. The bottles and fruit of the bar are mirrored, too, and set so close to the reflecting surface that their image in the glass appears as a simple doubling of the objects, as if reality and appearance, object and mirror image, have become indistinguishable to the eye. By extending across the whole field of the canvas and appearing to exist beyond it, the mirror acquires the unbounded quality of the space of the real world; by its

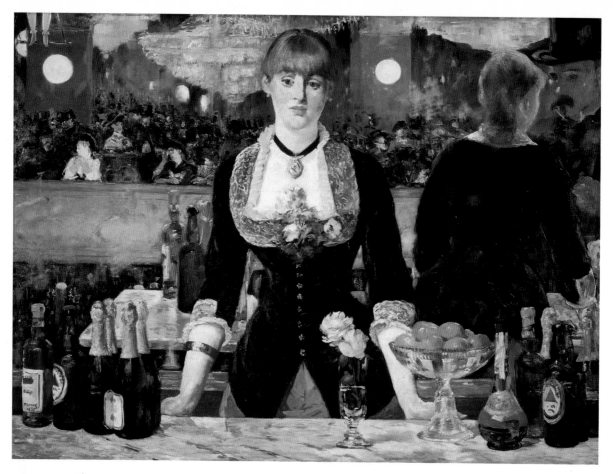

FIGURE 55. Édouard Manet, *Bar at the Folies-Bergère*, 1881-82, oil on canvas, 96 x 130 cm, Courtauld Gallery, London

closeness to the more prominent objects reflected in it—barmaid and patron, the bottles and fruit on the bar—there is effected a seeming continuity of real and mirrored space.

Ordinarily the mirror in a painting is a small, quite distant, framed object, like a picture on the wall. Such are the round mirror in the *Portrait of Giovanni Arnolfini and His Wife* (1434) by Jan van Eyck and the rectangular one in the background of Velázquez's *Las Meninas* (1656) with its reflection of the otherwise invisible king and queen, who are the objects of the glances of almost all the figures in the room and are perhaps the subjects of the large painting beside the artist in the middle ground. Closer to Manet's time is the mirror in Ingres's seated portrait of Madame Moitessier. In all these works the glass reflects a single person or couple: the artist van Eyck, who was both witness of the marriage rite and the painter of the scene, alongside another figure, probably the priest; the royal Spanish pair, who are beheld by the painter and the court; and in Ingres's picture the profiled sitter in shadowy reduction intimating a second plane of

existence, intangible and mysterious, behind the looming reality of the outer person. Earlier, in a portrait by Ingres of the Countess d'Haussonville painted in 1845 during Manet's youth, the mirror was enlarged and brought closer to the picture plane to reflect a shelf of choice objects behind the beautiful woman (fig. 56). This was perhaps the starting point and stimulus of Manet's original conception, which gives to the mirrored world—an image within an image—the openness and fullness of a real environing space.

But Manet's mirror also brings the crowd as a spectacle into the picture. Reflected in the glass is the world before the barmaid's eyes; her objects of vision are projected behind her, together with her own back and the man who speaks to her. All are spectators who have been

FIGURE 56. Jean-Auguste-Dominique Ingres, *Countess d'Haussonville*, 1845, oil on canvas, 132 x 92 cm, The Frick Collection, New York

FIGURE 57. Claude Monet, *The Coal-Dockers*, 1875,
oil on canvas, 55 x 66 cm, Musée d'Orsay, Paris

drawn to the same place and have become elements of the same spectacle. The seeing and the seen are fused here in a novel interchange of the near and far, the real and the imaged, the painted reality and the realistically painted reflection of that reality as its indistinguishable component—a spectacle within a spectacle that includes its own spectators, like a nature that contains a being whose thought contemplates and reflects nature. Soon after, the poet Jules Laforgue wrote that Impressionism was "a mirror of universal life." In that life the mirroring became a living element.

In later landscapes of Monet, this seeming equivalence and fusion of the world and its image—"reality" being an unstable reflection that nature produces in our attentive minds, a reflection changing, like the objects, with the time and viewpoint of the observer—assumed the

aspect of a doubled landscape of an upper world of trees and sky with its symmetrical counterpart inverted in the water below.

How do Impressionist pictures of work—at one time cited as tokens of their social consciousness—fit into this account of their painting as an imagery of holiday pleasures, spectacle, and the environment as an aesthetic object? Degas's laundresses yawning with fatigue and Monet's men unloading coal at a monotonous pace (fig. 57) might express another and more somber vision; later, such themes were prominent in paintings by artists of the Left.[4] If Monet felt sympathy for workmen, his picturing of labor was no protest or assertion of a political stand. Impressionist paintings of work are few and are better understood as single facets of modernity beside the spectacle of the streets, the riverside, the roads, and the beaches, which provided many more themes. Pissarro, who drew for radical publications in a partisan spirit, produced no paintings with an explicit critical edge. He did show, with evident sympathy, a peasant in the fields or a housemaid with her broom, but his scenes of industry are broad landscapes in which the boats and factories as elements of a milieu are more pronounced than the labor itself. Pissarro made many pictures of peasant labor, perhaps inspired by Jean-François Millet; some recall van Gogh, who had a similar inspiration. Sisley was attracted by scenes of construction and by the women at a stream washing clothes; here again it was the outdoor sphere, the work scene as a transitory feature of the inhabited landscape, that seemed to motivate the choice.

In all these pictures one may suppose the painter's tacit feelings of kinship with his subject. The men carrying coal at the riverside, the women scrubbing clothes at a brook, the builders setting up poles on a lot near the road, were outdoor workers like the painters themselves. The Impressionists did, in fact, choose to represent each other painting in the open. In a Sisley picture of construction work, the poles are like a giant easel. Certain canvases of labor have a more obvious analogy to the artist's effort, for example, Caillebotte's pictures of the housepainter at work outdoors in public view among the promenaders in the street. One may ask whether Caillebotte, a rich and cultivated man, was not attracted also by the sober qualities of the artisan in that craft and the likeness to his own art that, in depicting the quotidian Paris scene, aimed at both precision and frankness of touch. There is also a picture by Armand Guillaumin of Pissarro painting the shutters of his house. In another canvas, Caillebotte showed the workmen on their knees in a bare, sunlit apartment scraping or polishing the floor (fig. 58).

Perhaps in such pictures of labor, Impressionist painters avowed an affinity with those who, like themselves, worked with their hands; they challenged the official culture that addressed itself to a conservative patronage and veiled the hard, material facts of artists' lives with allegories of the beautiful and with the vague idealistic language of the aesthetics of the École des Beaux-Arts. While they were more knowing in the effective principles of their art than were the laureates of the Academy, Impressionist painters, like artisans, talked simply and plainly about their work and found in modest or blunt vernacular speech the most telling statements of their aims. It was not from indifference to ideas but in reaction against doctrinaire teaching that Manet, one of the

FIGURE 58. Gustave Caillebotte, *Floor-Scrapers*, 1875,
oil on canvas, 102 x 145 cm, Musée d'Orsay, Paris

most cultivated and rebellious of the group, summarized his incomparable, subtle practice in a few disarming words: "When it works, it works. When it doesn't, you start again. All else is nonsense."5

In none of these pictures was attention directed to the worker as victim or hero; in none was a figure idealized, as in certain paintings of the 1840s and 1850s. Yet the Impressionists' choice of themes of labor remains significant; it issued from the humane sentiment of the painters whose eyes were open to the ordinary and familiar in the living world. With the exception of the patrician Degas, they did not explore its darker sides, its miseries and latent conflicts; but there was, for some of the artists, a note of democratic feeling in that choice, though without a deliberate partisan stress.

We see this attitude also in Cézanne's pictures of simple people: peasants playing cards, a servant, a gardener—figures of an acknowledged dignity and repose. Manet, a man of the higher bourgeoisie, but also, we have seen, an opponent of the regime of the Second Empire, was often

drawn in the 1870s to plebeian types; in the cafés and bistros, the blue-bloused workman and the aproned waitress hold his attention, and he marks their contrast to an elegant silk-hatted habitué in the same room. So, too, Monet's picture of men unloading the dark cargo from a coal barge was painted in Argenteuil on the other side of the bridge that appears in his views of the vacation resort, with the sportsmen's sailboats gleaming white.

Parallel to and perhaps independent of Manet's picturing of the performer and the associated lower-class types was Degas's interest in these subjects, though he came to them somewhat later

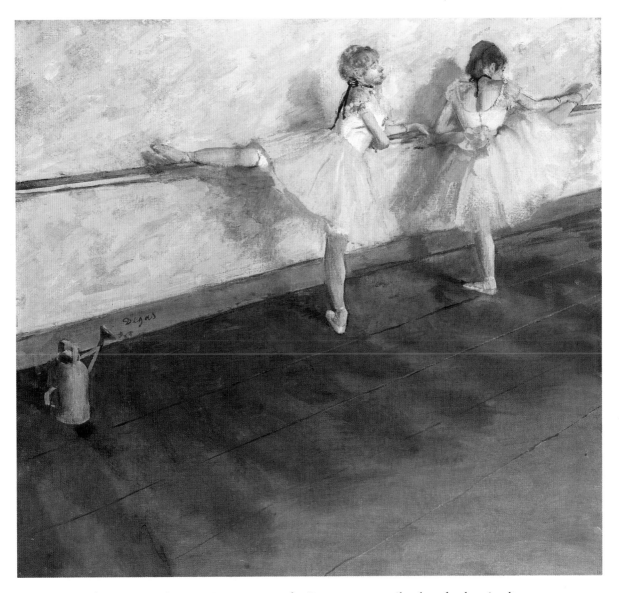

FIGURE 59. Edgar Degas, *Dancers Practicing at the Bar*, 1876-77, oil colors freely mixed with turpentine, on canvas, 75.6 x 81.3 cm, The Metropolitan Museum of Art, New York

and with a choice of figures distinctly his own. Besides the racetrack, the circus, the music hall, and opera, he represented the backstage of high life, exploring especially the *mundus muliebris,* or "women's world": ballet dancers learning and rehearsing (fig. 59), laundresses at work, milliners, and prostitutes.

Nearly the same age as his friend Manet, Degas responded like him to the innovations of the younger artists during the 1870s. While declaring himself no Impressionist, Degas showed much more readiness to promote their cause and exhibit with them, than did Manet, who consistently refused. Like Manet, Degas was a painter who frequented the museums and was steeped in important works of the past that sustained his sense of art as a noble summit of finesse. Both painters were sons of the cultivated bourgeoisie; but while Manet was confident, outgoing, sensual, at home in the cafés and street, Degas was melancholy, acerbic, repressed, a self-doubting artist tormented by a goal of perfection.

After long schooling in the Neoclassic art dominated by Ingres, and after study of the precise drawing of the older Renaissance masters, evident in his copies of Holbein and the Italians, Degas turned from historical themes—unusual choices like the *Spartan Boys and Girls in Athletic Contest, Jephthah's Daughter, The Misfortunes of the City of Orleans* (a medieval episode of torture and rape)—to a frank modernity, transposing the nudity, athletic postures, and horsemen of his historical pictures to the disciplined, elegant rites of the contemporary racetrack and ballet, which retained old, aristocratic connotations.

In both fields, Degas observed with a studious eye mainly the moments of preparation and rehearsal, though he often represented the final performance. In his choice of an imagery of racehorses and ballet dancers—creatures bred and trained for perfection in performance—we recognize subjects analogous to his own aims as an artist, his unremitting critical discipline in drawing and redrawing the active body for an elusive rightness.

Besides the beauty of the ballet as an art of bodily motion the extreme situations in performance fascinated Degas: the neck-to-neck race of straining horses, the climactic breathtaking movements of the dancer, the poise of a circus acrobat suspended dangerously from a high rope grasped with her teeth alone (fig. 60). But he notes also, in a detached and perhaps ironical spirit, the distracted or indifferent spectator who turns his eye to an insignificant or peripheral point in the spectacle or its audience. In the Museum of Fine Arts, Boston, picture of a race, the foreground is occupied by a foreshortened carriage with two horses facing the viewer; inside it a woman tends a baby, while above her a little bull dog, like a statuette, watches the distant contest with its back to us.

Degas found novel subjects as well in figures outside the arts, like milliners and laundresses, who seem remote from his interest in performers. On reflection, these, too, appear to belong to an aesthetic world; they are artists of the eye and hand, and their skills are addressed to the shaping of the beautiful costumed self.

The shop of the *modiste* attracted Degas as a milieu of artistic experiment and judgment; he

loved to accompany a friend on her visits to the shop and watch the critical trial of a hat before the mirror—an exercise of taste in color and composition and in the expressive fitting of costume to the self-imaging personality. But disavowing this interest, he is reported to have said that what had attracted him were the little red hands of the modiste holding the hat—a fractioning of the real person like his own artistic practice in drastically cropping a figure.

The laundress belonged to the sphere of art in another way. After a visit to Degas's studio, Edmond de Goncourt recorded in his *Journal* that the painter, who shared with him that curiosity about the working life of the laundress, had acquired a true connoisseurship in the skills of her craft. The painter had discoursed with a sure knowledge and in the technical jargon of the laundry about the different strokes of the iron, as he might have spoken of the movements of the painter's brush.[6] Like the young women at the milliner's shop, the laundress was an artist

FIGURE 60. Edgar Degas, *Mlle LaLa at the Cirque Fernando*, 1879, oil on canvas, 116.8 x 77.5 cm, National Gallery, London

FIGURE 61. Honoré Daumier, *The Laundress*, 1863, oil on wood, 48 x 32 cm, The Metropolitan Museum of Art, New York

of the costume to which she gave its freshness and elegance—indispensable in the refined self-display of the individual in public, an essential living part of the Parisian spectacle. In both shops the chosen scenes are intermittent moments of relaxation or trial, comparable to the rehearsals of the dancers and the arrival and practice of the horses and jockeys before the race.

Though Degas was touched also by the pathos of monotonous labor in the hot, steam-filled laundry, and caught the involuntary gesture of weariness in the woman burdened with the iron, his concern with the worker is not properly understood if taken simply as a program of naturalistic art or as a reflex of humanitarian feeling, like Daumier's in painting the laundress, with her heavy basket of clothes and with child in hand, hurrying through the darkened streets of the

big city (fig. 61). In Degas's attention to these plebeian figures, we sense also his self-consciousness as an artist with an exacting and at times taxing discipline and an eye for the aesthetics of costume in Parisian life.

Together with these subjects, one may see in Degas's many pictures of the woman's toilette, from the bath to the fitting of clothes, his attraction to the woman as the habitual, self-preoccupied creator of her perfected appearance. He himself explained his choice of the woman at her tub as the inevitable modern equivalent of the Renaissance painter's representation of the biblical Susanna. But in Degas's art the long pursuit of his theme was altogether detached from and even opposed to the sensual and idyllic in pictures of the bather in old art, whereas *Susanna and the Elders* by Tintoretto is only one of Tintoretto's many idealized biblical and pagan figures, male and female, with moral and religious as well as erotic connotations. Degas's other series with women in related contexts of specifically feminine existence seem to point to a personal affinity. The preponderance of women, clothed or naked, in hundreds of Degas's works,

FIGURE 62. Edgar Degas, *Pouting* or *Sulking*, 1869-71,
oil on canvas, 32 x 46.5 cm, The Metropolitan Museum of Art, New York

beginning with the youthful historical paintings, and continuing with so many acutely observed features of feminine roles and signs of women's burdens in his society—not only in the strains of the dancer's and the laundress's tasks, but in situations of estrangement and conflict, such as *L'Absinthe (The Glass of Absinthe)*, *Bouderie (Pouting or Sulking)* (fig. 62) and *Le Viol (The Rape)*, and in certain penetrating portraits of women, self-absorbed and neurotic—all may be seen as an expression of the feminine in Degas's own nature, an unconscious identification with women as the likeness of his hidden self. Perhaps his bold originality in dressing a bronze figure of a dancer in actual clothes stemmed from the importance that the ritual of women's dress had for Degas, as for the deliberate transvestite.

Degas's persistent interest in women as models was more complex than appears from the analogies of their roles with that of an artist. In many of his pictures, we see women as a victims, creatures subject to violence and to forced deformations of their bodies not only in life but in Degas's own art; typical is his representation of a dancer at the bar in a posture that echoes quite precisely the form of a sprinkler set prominently in the foreground (see fig. 59). In a picture once thought to be a self-portrait, Degas showed his fellow artist Henri Michel-Lèvy in shirtsleeves in the studio, shy, thoughtful, and depressed, with a small clothed female mannequin collapsed at his feet. Degas is also ingenious in finding perspective viewpoints of a woman—close-ups and odd angular sightings—that segment or distort her silhouette to give it the aspect of a cat or a strange grotesque. In a sonnet on the ballet dancer, he concludes the verses on the hypnotic, elegant motion of her performance with her final revelation as . . . a frog![7]

There is perhaps in Degas's imaging of women, so often submitted to a strenuous and deforming routine—unlike Renoir's figures who are depicted with a joyous sensuality and often in a friendly domestic milieu—an effect of his deep repression. His extraordinary undertaking in the late 1870s of the series of monotypes of the brothel—a unique portrayal of women, anticipating Toulouse-Lautrec and surpassing in sharp realism the stories of the Goncourt brothers, Zola, and Maupassant—was possible for an introverted artist who could approach women closely only as an observer; his knowledge of the flesh was bound inexorably and exclusively to the act and instrument of drawing. Degas's repression was apparently known to his fellow artists; it was remarked in a letter of van Gogh of August 1888 addressed to the young Emile Bernard.[8] Degas did not represent the sexual act—his scrutiny, without pornographic intention, was of the brothel as a feminine milieu; his impulse was to explore it intently as a professional world and to capture in unique prints the personalities, manners, and reflexes of the women. Here, too, it was the marginal and banal rather than the extreme moments that are noted: the indolent waiting, the preparations, the relaxation in solitude, and the marks of a humiliating, brutish, blasé existence in the disenchanted faces and flabby torpid bodies. His objectivity in these black-and-white monotypes, executed on glass and impressed on paper as if to simulate photography, delineated a descent into hell through which he perhaps exorcised his own desires.

Among the other Impressionist painters, themes of performance are infrequent. They are

unknown in the works of the devoted landscapists, Pissarro and Sisley. In addition to Monet's early painting of a Pierrot in a garden among women in modish costumes of the day—apparently inspired by the fashion plates of the season—he also undertook a picture of a woman in exotic dress as an artistic role, his wife Camille posing as a Japanese; it was a work destined for the Salon and later regretted as a miscalculated compromise with public taste. But from Renoir, who, like Manet and Degas, was primarily a painter of the human figure, we have several large canvases of the acrobat, the clown, the musician, the singer, and dancer, and also of women submerging their identities in exotic costumes. These belong to his earlier, more characteristically

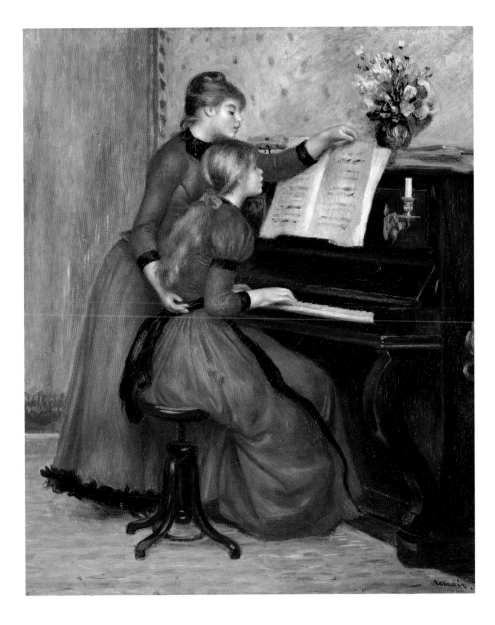

FIGURE 63. Pierre-Auguste Renoir, *Young Girls at the Piano*, c. 1889, oil on canvas, 56 x 46 cm, Joslyn Art Museum, Omaha, Nebraska

FIGURE 64. Pierre-August Renoir, *At the Milliner's*, 1878, oil on canvas, 32.4 x 24.5 cm, Fogg Art Museum, Cambridge, Massachusetts

Impressionist period. Later, the theme of art is domesticated; Renoir's composition of an interior with a woman in the foreground engaged in embroidery, while behind her men look at the pictures on the wall, may stand as his image of the arts as active and passive enjoyments in a family setting. To it we may add the adorable painting of the girls at the piano, one playing, the other listening and turning the leaves of the score (fig. 63), and also the picture of a girl decorating her younger sister's hat with flowers (fig. 64).[9]

So far I have written as if a unified aim or point of view determined the painters' choice of themes. But just as their styles differed from each other's and the works of an individual artist

varied widely in certain features, so, too, their subjects have a broader range than this analysis has disclosed. The Impressionists were artists of open sensibilities, who, like the great writers of their time, were attracted by many facets of their surroundings while shaping a dominant set of themes. Receptiveness to the visible was a prime condition of their art and a mark of their modernity.

The Impressionists were complex personalities, each with unique experiences and inclinations that entered into their art, sometimes in departure from its central themes. Impressionist painters may have explored as a personal discovery and source of fertile pictorial ideas a single sector of their milieux. But the love of this promising vein did not close their eyes to other possibilities; their spontaneous reactions to the everyday visual world may have impelled them to undertake less usual themes. Though largely landscapists, some did not hesitate to paint the nude or portraits of friends; painters of boulevard scenes, they produced still lifes during the same season.

In all these endeavors, the Impressionists continued and reinforced a tradition of painting persons, places, and things. Their conception of art as a free response to what they saw with interest and feeling, unconstrained by the requirements of commissioned tasks or by the demands of conservative officials or public taste, may have hidden from them that much in their choice belonged to the collective moment; but that choice was not therefore a limitation to a narrow field. The commitment to the visual as the actually seen was as large in its scope and results as Poussin's devotion to the painting of the imagined ideal world of history and myth for what he called "the delight of the eye."[10]

Excited by the richness of painterly spectacle in the Parisian milieu and eager for an art of reality, the young Degas, when he sought to free himself from the artificial and unlived in the historical painting for which he had been trained at school, jotted down for his new course an ambitious, far-reaching program of commonplace contemporary sights.[11] It was more than he could carry out, but the essential goal, the drive to explore the new in the visible present, is fully evident in the many pictures he later produced in his series of ballet dancers, races, music halls, cafés, bathers, and related themes. Yet he was attracted also by novelistic subjects with psychological contrasts and conflicts; and with amazing sharpness, he portrayed the business office and the Bourse as practical milieux marked by the characteristic faces, postures, and costumes of the place.

For a short time during the 1860s and 1870s, Monet also undertook portraits and still lifes, along with his more famous landscapes. To be sure, much that the Impressionists saw found no place on their canvases; but their ideas of art were realized in other subjects besides the landscape. In those less common choices that include performers and performances we recognize the same minds at work, even though the major aesthetic discoveries were made in their more famous, persistently studied treatment of the outdoors.

VII

The Crowd, the Stroller, and Perspective as Social Form

THE NINETEENTH CENTURY WITNESSED a revolution in collective and singular seeing, an acknowledgment of the unique perception of the individual as well as the complexities of interactive viewing and movement that made up the crowd. Society appeared to the observer as a swarming ant heap and the city as an ocean. These two metaphors had occurred to poets long before, but now, with the gigantic growth of the city, had acquired a more telling aptness. These analogies stressed a rhythmic, vast, and varied motion, centered, like the hole in the anthill, on the perspective of the viewer.

FIGURE 65. Isidore Grandville, *View of the Vendôme Column,* 1844, etching from "Un Autre Monde"

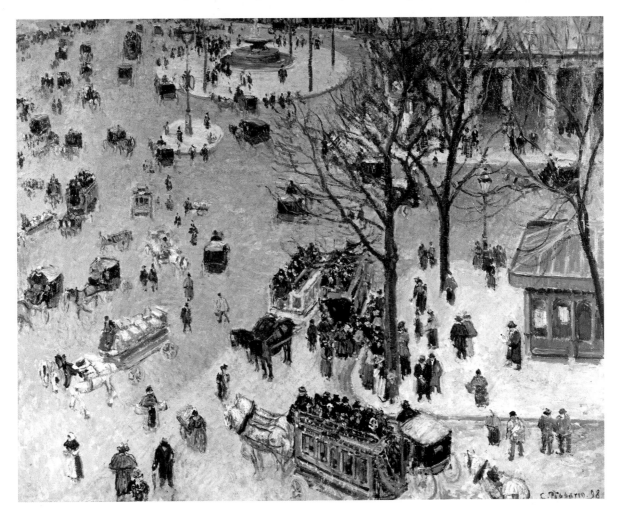

FIGURE 66. Camille Pissarro, *Place du Théâtre Français*, 1898,
oil on canvas, 72 x 93 cm, Los Angeles County Museum of Art

Compare two pictures of a Paris *place* beheld from above, one a drawing by Grandville done
in the 1840s (fig. 65) and the other by Pissaro (fig. 66). Pissarro's, painted half a century later
from a window or balcony, is without a clear center. It is a subtly balanced effect of random traf-
fic, a varied scattering of small elements with a drift in some parts; you cannot isolate a group
that is distinct from the others. The painting of the crowd scene, if expanded to show more of
the larger whole of which it is a segment, would still present the qualities of this small sample—
its apparent chaos divided by the regular grid of the planned streets. In the second picture, the
brilliant illustrator Grandville views the scene from above the Vendôme Column. A spectator
stands atop the monument, beside the statue of Napoleon—the victorious emperor for whom the
column has been erected—and from this commanding height he looks down at the traffic, which

seems to revolve around the column, the true and ideal center of the space. For Grandville, the imaging of the crowd from a high point required access to a privileged place that had been until then the exclusive station of a supreme heroic personality. By placing the spectator in the picture beside Napoleon—a poetic usurpation of the hero's lofty pedestal by an outsider, perhaps a tourist—the artist intimates the new sentiment of equality—an equality not yet realized but widely anticipated as the goal and birthright of the democratic century that had begun with the Revolution of 1789, which Napoleon carried to other nations.

For Pissarro, as for Monet, the viewer's place is one of many possible points from which he can envision the long, unending flow of the city's life. He may be high above the crowd, but looking out of one of the countless windows lining the street, he is an inhabitant of the city, at home in the boulevard like the strollers below.

Before Grandville's time, others had begun to view Paris from a height as a world of pure movement, with a Romantic exaltation as if the city were indeed an ocean, and with the pathos of man's smallness and his contrast to the vast artificial surroundings he had created for himself. Alfred de Vigny's poem "Paris," written in 1831, begins:

> *Prends ma main, Voyageur, et montons sur la tour.—*
> *(Traveler, take my hand and let us mount the tower.)*

From it we behold

> *. . . un monde mouvant*
> *Comme l'éclair, l'oiseau, le nuage et le vent. . . .*
> *Des collines, au loin, me semblent sa ceinture,*
> *Et pourtant je ne vois nulle part la nature,*
> *Mais partout la main d'homme et l'angle de sa main*
> *Impose à la matière en tout travail humain.*
> *. . . ces angles. . . .*
> *L'un sur l'autre entassés sans ordre ni sans nombre*
> *Coupent des murs blanchis pareils à des tombeaux. . . .*
> *. . . cette abîme où l'air pénètre à peine. . . .*
> *Tout fourmille et grandit, se cramponne en montant*
> *Dans un brouillard de feu, je crois voir ce grand rêve. . . .*

> *(. . . a world moving*
> *Like lightning, like a bird, a cloud, the wind.*
> *It is surrounded by distant hills. . . .*
> *And yet, nowhere do I see Nature*
> *But only man's hand and the angles his hand*
> *Imposes on matter in all human works*

. . . these angles. . . .
Piled on one another, without order or number
Cutting white walls like unto tombs. . . .
. . . this abyss where the air can hardly enter. . . .
All swarms and expands, and is cramped in ascending. . .
In a fiery fog I seem to behold this great dream. . . .)[1]

Earlier than de Vigny, Victor Hugo had written in poem 35 of "Les Soleils Couchants" (1828):

Oh! qui m'emportera sur quelque tour sublime
D'où la cité sous moi s'ouvre comme un abîme! . . .
Que je voie, à mes yeux en fuyant apparues,
Les étoiles des chars se croiser dans les rues,
Et serpenter le peuple en l'étroit carrefour. . .
Cent clartés naîtres, luire et passer tour à tour! . . .
Avec mille bruits sourd d'océan et de foule. . . .

(Oh! who will carry me up a sublime tower
From which I may behold the city opening below like an abyss! . . .
I see the starry spokes of the carriages
Cross in the streets, as if fleeing my eyes
And I see the people crawling on the narrow way. . .
A hundred flashes glisten and pass in turn! . . .
A thousand muted sounds of the ocean and the crowd. . .)[2]

It is not the chance crowd—the small cluster of observers that forms in response to a happening in the street—but the recurrent unfocused crowd, in its expected place at an expected time, like the daily traffic. It is the tide of freely moving individuals who are subject to the pattern of the streets and boulevards, with their shops, cafés, parks, public buildings, and places of amusement, scheduled to the cycle of day and night, the seasons and weather, the workdays and holidays— all the known conditions that affect the movement of an urban population and make of it a predictable phenomenon governed by constancies of interest and habit. The amorphous crowd has an order, a statistical one, but unlike the order of a parade, it is of unorganized individuals, undirected though not directionless; each follows his own desire and need in choosing a goal, a time, and a path; and all those spontaneities together maintain, week after week, the average periodic flow.

Seemingly aimless in the random motion of its members, the crowd has a distinct form as a moving ensemble. One can make out in the apparent chaos a common trend, a drift in time and place, regions of greater and lesser density or speed, fields of constant and changing force. Seen from a great distance, these regularities suggest a law-bound physical process; there is, besides

the constraints of boundaries and the attractions and repulsions of bodies, a tendency toward concentration at certain points and times, and sudden increases of density and motion, that had led Pierre-Simon Laplace in his treatise on probability to describe the behavior or movement of a crowd, the spread of an effect, as a phenomenon of *"résonance."*

While a sum of individual choices, that unorganized mass shares with the festive parade of church, state, and guild the enjoyment of a vague unison in mind and body, a reassuring collective bond. The shapeless crowd is not, as one might suppose, the negation of a cohesive special order; it is no aggregate of aimlessly moving atoms, but a mutual attraction freer than the procession and ritual assembly of the old community in the church, a set, quasi-ritual march toward a predetermined goal at a prescribed time. The crowd has its boundaries, its limiting frame, its recurring occasions and favored paths; but these are not fixed once and for all, or commanded by old authority and custom. They are the result of recent events and circumstances; they continue to evolve with new facilities and wants, and respond to unvoiced currents of feeling and common spontaneous reactions to daily events.

In the mid-nineteenth century the crowd's awareness of the novelty of its own existence as a public in motion was an outcome of recent history enacted mainly in Paris. It was an awareness heightened by the uniqueness of the great capital and the contrast with the uneventful, stagnant existence of the villagers in the rural milieu and was expressed in countless paintings, prints, feuilletons, poems, and novels. It owes to the revolutions in France between 1789 and 1871 the frequent reversals of power through collective action, that sharpened sense of self and class in the moving crowd. Those epochal events in which the unforeseen action of the people had become a history-making force—in contrast to the people as subject to the state, the church, the workplace, and the home—gave to the city a new role as the historic space of a self-conscious, alert, reacting population of citizens in a fully secular community, and also, for conservative minds, a dangerous aspect as the milieu of the mob: blind, excitable, and easily moved to violence.

The period from 1840 to 1880 is the time when the public-as-crowd discovered itself as a political and social force, and as an economic power, sustaining the prosperity of Paris in its role of critical consumer of goods. That period also had a role in reshaping manners and personal relations, in adapting the forms of sociability and speech to the new freedom of individuals in urban life. The growth of the crowd in the streets was accompanied by the vogue of democratic ideas, even under a dictatorial regime. The parts of the city that were once the preserve of the monarch and aristocracy had become public spaces. The memory of the change was still fresh and was recalled in the use of these old palaces and parks as public sites. In picturing the wondrous cathedral in his novel *Notre-Dame de Paris* as the creation of the medieval townsmen and as the city's place of assembly for a secular cause—his vision of the Paris of the fifteenth century as a city of spectacle, light, and crowds—Victor Hugo projected that consciousness of the new Paris of his time, an ideology of the mass: active, creative, spontaneous, and jealous for its liberties.

In a novel, *Les Rois en exile*, published in 1878, Alphonse Daudet described in the opening chapter the queen of a Balkan state, driven from her throne by a revolution. From the high balcony of her Parisian hotel, she contemplates the holiday crowd in the street near the Tuileries Gardens, a spectacle of color, movement, and summer sunshine that gladdens her depressed heart. On the other side, she is reminded of her misfortunes by the sight of the blackened royal palace burned during the Commune and still unrestored.

The street and especially the boulevard were the commons of the Parisian, his agora, his dearest view. Théophile Gautier, traveling in Italy, looked in every city for a place that served like the Paris boulevard for public life. In Florence, at the great medieval Piazza della Signoria, he was struck by the thought that the Greeks called such a site the "eye" of the city:

> The Greeks had a single word to express the central and important place of a country or city: *ophthalmos*. Isn't it the eye, in fact, that gives life, intelligence, and significance to the human face, that expresses its thought and seduces by the magnetism of its light? If you transpose this idea from living to inert nature, by a bold though just metaphor, has not every city a spot that summarizes the city, where movement and life culminates, where the scattered traits of its individual character become more precise and clear, where its historic memories assume a solid monumental form, so as to produce a striking unique ensemble, an eye on the face of the city? Every great capital has its eye: . . . in Paris, [it is] the Boulevard des Italiens . . . [Paris] in this privileged spot [is] more Parisian than anywhere else. . . .[3]

FIGURE 67. Isidore Grandville, *Caricature of gigantic eyes*, 1844, etching from "Un Autre Monde"

FIGURE 68.
Honoré Daumier,
The Melodrama,
c. 1860,
oil on canvas,
97.5 x 90.4 cm,
Neue Pinakothek,
Munich

When Gautier wrote this homage to the Paris boulevard, the preeminence of the eye was already a commonplace in another sense: as the organ par excellence of the Parisian. Balzac, who said of Paris, "Here all is really spectacle," wrote about the eye of the Parisian in a paragraph that sums up the cult of the visual in the arts and life of the city. In his second story of a traveling sales-man, *Gaudissart II*, Balzac speaks of the Paris stores that have been

> designed only to please the most avid and blasé organ that man has developed since Roman society, whose needs have become boundless, thanks to the efforts of the most refined civilization—this organ is the eye of the Parisian. This eye consumes one million francs worth of fireworks, palaces two kilometers long and many feet high in multi-colored glass, fourteen theaters every evening, panoramas, continual

FIGURE 69. Edgar Degas, *The Ballet from "Robert le Diable,"* 1871,
oil on canvas, 66 x 54.3 cm, The Metropolitan Museum of Art, New York

exhibitions of masterpieces, worlds of sorrows and universes of joy in promenade on the boulevard or wandering on the streets; this eye requires 15,000 francs of gas every night, and to satisfy it Paris spends every year millions in vistas and in parks.4

This luxury of the eye in its special Parisian forms was a condition (and no slight one) for the growth of a public sensibility akin to that of the Impressionists'. It was not by itself the ground of the painter's style. We shall see presently to what extent other conditions were needed. But so far as the world pictured by the Impressionist painters is in question and the weight given to the themes of seeing, we may say that in Paris more than in any other city of the time, there existed an autonomous culture of the eye, a cultivated enjoyment of the visual for its own sake, and an abundance of new means invented for its satisfaction. Among the paintings of the Impressionists are many of Parisians who live through their eyes, in a manner that reflects the painters' conception of their own pictures. The Impressionists discovered in the theaters, cafés, and streets a community whose relation to its world recalled in several respects the artists' in painting their pictures.

In popular illustrated books of the 1840s about Parisian life and amusements, the eye sometimes stood for the whole person, the visually gluttonous spectator. Grandville pictured the audience's symbolic caricatural heads as gigantic eyes in profile observing the beautiful star—a grotesque embodiment of Balzac's rhetorical metaphor of the Parisian passion for seeing. In composing this scene, Grandville followed a classic rule of balance that freezes the moment: the eyes turned to the left are answered by two eyes turned to the right. The focus of glances, all fixed upon the same object, obeys a conventional principle of form more suited to an imagery of poignant action and its witnesses (fig. 67). French artists in the middle of the century gave to the glance of spectators a powerful role in the structure of a composition. Though free from this banal compulsion, Daumier, too, in drawing an audience in the theater, rendered their intense concentration as spectators, fixed collectively on what they saw with emotion and understanding—the entire crowd responding hypnotically to the spectacle as if with one set of eyes (fig. 68).

In Degas's paintings of the less dramatic scenes of the opera, café-concert, and ballet, the eyes of the audience and performers project implicit lines that cross at different points in midspace (fig. 69). Those of the spectators follow oddly focused glances, some even turned away from the stage or directed toward each other, as if distracted or searching for another sight in the course of the performance. We are made aware of the glance as an individual's fluctuating attention, directed by vagrant impulse, caprice, or curiosity, rather than commanded by the ongoing action on the stage. By their roving eyes the spectators create their own changing spectacle; they bring it closer if they wish, isolate, and frame it with their optical instrument.

Thus did the Impressionists begin to evolve the collective Parisian culture of seeing into the greater complexity of individual ways of seeing. Personal perceptions were explored through works that aligned the distinctive vision of the artist with the varied daily visual activity of the citizen-stroller.

VIII

Portraiture and Photography

IN ADDITION TO THEORETICAL NOTIONS absorbed directly or indirectly from philosophers and psychologists, a moral and ideological sense was current among painters, poets, and novelists during the nineteenth century. How was this sense related to image content? Is there visible in the character of the landscape and urban scenes, as in the representation of the human subjects, a corresponding sense? A moral and ideological sense is evident in certain of the paintings, particularly in those with figures distinct and detailed enough to convey in posture and physiognomy and in their mutual address a state of mind or tendency of feeling, an expressive effect reinforced by the aesthetic of the painting.

The impression as a positive life-value appears especially prominent in certain of the larger portraits of human subjects. Though Impressionist painting seems to be mainly an art of landscape founded on a fresh approach to the study of atmosphere and outdoor light, its representatives produced many notable images of specific individuals, some life-size. Indeed, Renoir and particularly Degas, because of their primary interest in the human subject, and Manet in his later years (in works such as *En bateau*), seem to stand outside the usual definition of the school. But in their figure compositions they shared with the landscape painters, who at times were also attracted to human themes, an interest in the newly discovered qualities of light, air, and color, fixed through direct perception and the flicker of brushstrokes. Besides these qualities, they realized in the postures and physiognomy of the portrayed figures an expression of attitudes associated with those outdoor themes, with the impression of a *plein-air* experience.

The subjects of Impressionist paintings exhibit characteristic physiognomies of pleasure and relaxation—no tension of will or effort is evident. Presented often in sunlight, the faces have been softened and sweetened by atmospheric tones and high-key shadows that pick up the luminous color of the landscape setting. Even the rare pictures of interiors with artificial light have a look of the freshly seen, with a distinctive brightness and newly found coupling of tones. The artists' perceptions of the human, as refracted through the mode defined as the impression, are disclosed in the conception of the subject.[1]

At a time when portraiture was ruled by banal artifice, the Impressionists brought to this genre a note of simplicity and frankness, of casual everyday existence, of intimacy and goodwill that was hardly known in the trite, self-conscious poses of the Salon's worldly art. Impressionist portraits were most often of the painters' friends, their fellow artists and their families, conversing and enjoying each other's company, and were inspired by affection and respect. They convey the characteristic qualities of the community of artists as individuals. One does not look in them for penetrating characteristics. Renoir's faces, in particular, can be bland or even neutral in expression, signs of amiable, untroubled, receptive selves, which owe their charm to that air of intimacy in milieux less constrained by formalities and possessing their own custom of affable intercourse. Those looks of openness, of unaffected, unassertive bearing, owe something perhaps to the painter's idealizing vision: it is a spontaneous effect of cordiality, an appreciative view of the beauty of friendly, sensitive natures, and it continued a tradition of French eighteenth-century manners. Through the habit of the art as well as through the new personal attitude, these conventions became assimilated to the aesthetic of the Impressionist landscape, which reduced the sharpness of lines and modeling and softened that hardness of closely scrutinized detail by which older portraitists had brought out the sitter's features and the quality of skin and fabrics, just as the landscapists had once presented the anatomy and texture of rocks, trees, and clouds.

Before this time the painter of a portrait, especially life-size or nearly life-size, often aimed to convey the dignity of his subject through ennobling, enhancing attributes: costumes, postures, gestures, and accessories, the indices of rank, role, and achievement. More characteristic of the uncommissioned Impressionist portrait is the unselfconscious, frank vision and the informal, natural appearance of the private person as the man or woman in the street or at home, conversing, responding, sensing, enjoying. To be sure, there had existed earlier a bond of an artist and a friend that inspired affectionate, intimate portrayals, unrelated to the social status of the sitter, and self-portraits of many artists showed an informality and frankness that made them distinctive among the portraits of their time. But the dominant attitude toward portraiture, together with the basic conventions of established art that were shaped by the idealizing tasks of historical painting, stamped even those exceptional intimate portraits with qualities of the commissioned image of the role-bound person, with the dignity also remaining implicit in the formalisms of style, posture, and costume.

Even French portraits of the eighteenth century that show only a face—often strikingly like the Impressionists physiognomically, as in the pastels of Maurice Quentin de La Tour—include an expression of affability, candor, and good nature, as if in controlled response to a spectator, that is much more emphatic than those features when they appear in Impressionist portraiture. Yet while little concerned with character or with action other than performance in spectacles— dramatic subjects, with few exceptions, being foreign to the Impressionists—their occasional portraits and pictures of human groups fix on the canvas perceptions of the individual that are new in the art of their time.

In the first half of the nineteenth century, portraiture had served many painters as their chief means of livelihood, as it has so often done in the history of art. A secure middle class, conscious of its strength, found especially attractive in the art of painting the portrayal of its own presence; like the Dutch burghers of the seventeenth century, patrons maintained by this taste an ample assemblage of experts in portraiture. In France that vogue for the portrait, which had also aristocratic antecedents, occasioned magnificent painting of individuals by David, Ingres, Théodore Géricault, and Delacroix, artists for whom portraiture was an incidental theme. Projected in historical pictures of tragic situations and heroic action, their awareness of the human, when transferred to the imaging of a contemporary individual, yielded superb portrayals of character.

The energy and confident will of the powerful citizens were in the artists' own blood, whether they aspired to classical norms or, in an insurgent spirit, practiced Romantic styles. They could still respond to their portrait subjects as to people with whom they felt kinship. In Paris by the middle of the century and in the period of Impressionism, portraiture had become a more commonplace and indifferent art. Portraits were no longer occasions for discovering and celebrating the human; the devices of expression in portraiture became trite, empty conventional forms.

Painters, even the untalented, often looked down on their sitters—ambitious philistines whose narrowness and ignorance had been caricatured by the leading writers and comic draftsmen. Inheritors of the idealism of art from 1780 to 1840, painters of the next generations could regard complacent bourgeois with only hostility or contempt. They saw them more as types or roles than as individuals, while applying to their representation methods originally created for a searching image of individuality. Born themselves in that now inhospitable class, artists felt more keenly in the presence of a shallow, uncomprehending fellow bourgeois the problematics of their own insecure existence and the humiliating dependence on their cultural inferiors.

The decline of portraiture is a complex phenomenon that can hardly be explained by the advent of photography. Long after the camera made the portrait available at little cost to almost everyone, the painted portrait remained a superior token of the wealth or social importance of the subject, in keeping with the domestic or official decor of the place where it hung. But in Paris, by the end of the nineteenth century, and elsewhere a generation later, it became a less common object for public display in the annual Salon. What had once seemed a proper and normal expression of pride in one's family or its public role now appeared merely conventional, pretentious, or vain. A portrait of an individual was more likely to be commissioned by an official or other corporate body that wished to honor him than by the subject himself or his family. Perhaps changes in public and domestic life, less submissive now to old models of authority, manners, and speech, made conspicuous images of one's ancestors as supports of familial pieties and pedigree and the claims to social distinction seem superfluous or pretentious.

Another root of the decline of portraiture may be found in a newer conception of individuality arising from the experiences and demands of middle-lass life and from their critical exploration in literature and philosophic thought. That examination affirmed the values of aesthetic

FIGURE 70.
Paul Nadar,
*Portrait of
Claude Monet,*
1899,
photograph

feeling, of sensibility, self-knowledge, and the capacity for disinterested thought and action—qualities more truly expressive of mature personality than the signs of position and success and the externals of worldly power, wealth, and class. Nevertheless, these, too, still managed to retain some of their place as signs of spirit, and in the subtle inflections of the subjects' features there could still be recognized the marks of the individual self. The indifference to the painted portrait may be compared to the rarity of poetic drama at a time when lyric poetry and plays written in prose were favored forms, the latter adapted to an increasingly veristic concept of dramatic speech and the former to the function of poetry as concentrated phonic utterance about perceptions of nature, the self, and the human condition.[2]

Perhaps the wider practice of portraiture in the nineteenth century when it was sustained by a less educated social stratum can account for the growing banality of this art. Postures and accessories, schemata of compositions originally devised for the expression of rank and dignity, were applied to sitters who failed to win the admiration or respect of the artist, and became empty conventions. It has been supposed that the photograph killed the painted portrait as the printing press killed the handwritten book, for by 1850 the camera had made the portrait available at little cost. Some of the pioneer photographers were in fact artists, like the admirable David Octavius Hill in Scotland and Felix Nadar, the friend of Baudelaire and the Impressionists in Paris (see fig. 70 by Nadar's son Paul). Very early (c. 1854) Søren Kierkegaard noted paradoxically in his *Journal* that photography made it easy for people to have their portrait made but made them all look alike: "therefore, only one single portrait is needed."[3]

Yet the camera portraits of the midcentury often possess great strength and a fascinating candor as images; their subjects appear as unmistakable individuals, while contemporary painted portraits of individuals of the same class are more often shallow and lax. The best portrait photographs, like the first printed books, are true works of art. Their simplicity and concentration, their distinct forms and tones in the black-gray-white scale, are comparable to Ingres in his great picture of the newspaper magnate Monsieur Louis-François Bertin (fig. 71); the portraits of this master, with their keenly attentive or happily receptive faces, perhaps served as models for painter-photographers. While vastly different from Impressionist painting in result, photography with its lens, its rapid exposure, and its controlled development of a plate sensitive to light offers a technical parallel to the Impressionists' commitment to luminosity and the direct rendering of a confronted visible object. Besides, one should not forget the range of photographic freedom, the many choices, in this seemingly impersonal automatic method for producing pictures with light. We remember certain photographs of the time more vividly than numberless Salon portraits of the same human types.

In the generation of the Impressionists, the better portrait painters in fashion, like Carolus-Duran (Charles-Emile Duran) and Léon Bonnat, were clever men and worldly connoisseurs of art and manners, who applied the ideas of more original artists with a sophisticated spirit and a surface brilliance that has quickly dimmed. Together with the English portraitists of the late

FIGURE 71.
Jean-Auguste-
Dominique Ingres,
Monsieur Bertin,
1832, oil on canvas,
116 x 95 cm,
Musée du Louvre,
Paris

opposite:
FIGURE 72.
Claude Monet,
*Portrait of a
Seated Man
(Dr. Leclanché)*,
1864, oil on canvas,
46 x 32.5 cm,
The Metropolitan
Museum of Art,
New York

eighteenth century, they were the forerunners of more virtuoso specialists, like Giovanni Boldini and John Singer Sargent, both of whom absorbed some lessons from Monet.

During the decline of portraiture, the Impressionists painted the outstanding examples of their time, though the characterization of individuals was not their central aim. The impression as a softening of appearance through the shift of attention from the hard structure of objects in close view to the airy and luminous in both near and distant fields, together with the effect of high-key color and of directly falling outdoor light on the expression of the face, and the

constant exchange or interaction of its tints with the colors of the surroundings—all these had to reduce the distinctness and hence the force of individual features that are blurred, and even lost, in the prevailing light.

The meticulous scrutiny of faces practiced by the old portraitists was incompatible with the Impressionist breadth of handling. In giving up that ideal of minute veracity, which required somewhat rigid postures for their subjects under an adjusted interior lighting contrived for the effective display of features and the signs of role and rank, the Impressionists introduced a naturalness and ease of confrontation that had been rare in earlier portraiture and that expressed both a genuine trait of the sitters and an ideal of social life. The painters looked in a new way at objects as colorful presences, toned by the light of their surroundings. That new way of looking may be summarized in their positive concept of the impression: in their receptive glances, their informal postures, and their surroundings, the individuals portrayed often reveal corresponding sensibilities and dispositions toward frankness and truth-to-feeling.

A French tradition of portraits stamped by good nature and amiable sociability had existed earlier: the smiling faces of aristocratic and upper-middle-class contemporaries by Quentin de La Tour and other painters of the eighteenth century. Turning from these to the Impressionist portraits, we sense, beside the continuity of manners that are also those of a tempered and urbane hedonistic outlook, the difference arising from the effects of a more open and democratic attitude in the relaxed postures, the outdoor look, and the greater casualness of self-presentation.

In portraying a friend, Monet pictured him standing with his hands in his pockets, a posture generally taboo in the academic portraiture of the time, which was still bound to a ceremonious conception of dignity. That pose appeared, however, in photographs made as calling cards and therefore less subject to the norms of individual painted portraits hanging on a wall. Such cards were especially favored by the freer personalities in the sphere of the arts: painters, musicians, writers, journalists, and others who lived in Paris before the public eye. A photograph of Baudelaire by Nadar has in the posture an evident likeness to Monet's painting; it is the same naturalness and candor but even more striking through the subject's openness to the viewer and the air of familiarity.

For another portrait, Monet's doctor-friend sat with legs crossed, facing us and smoking a cigar, in an attitude of conversation with an accustomed partner, as in daguerreotypes of the time (fig. 72), but also in popular woodcuts of the decades before, illustrating the manners of the studio and the literary *cénacle* with lounging and even sprawling figures, for example that of Jules de Goncourt drawn by his brother Edmond. The life-size portrait of the painter Sisley and his wife by Renoir, with the affectionate arm-in-arm posture that seems a veristic touch, followed a photographer's standard image of a married couple.

Many centuries passed before painters ventured to portray each other or themselves full-length and life-size, as they had represented patrons who belonged to a socially higher class. There were, of course, such figures of artists at the edge of a religious painting, like Luca

FIGURE 73. Peter Paul Rubens, *The Artist and His Wife in the Honeysuckle Bower*, 1609, oil on canvas, 174 x 130 cm, Alte Pinakothek, Munich

Signorelli's representation of himself standing alongside his late predecessor Fra Angelico in the San Brizio Chapel frescoes at Orvieto (1499–1504). Their presence in a monumental cycle of scenes of the Apocalypse and Last Judgment, though not equivalent to an isolated portrait, pointed to the dignity the artist had acquired by that time.

Sir Peter Paul Rubens, conscious of his high rank and culture, which were visible in his worldly life and role at the court, could picture himself, together with his wife, on a lordly scale, in postures of mutual affection and intimacy that would have seemed inappropriate in a double portrait of a king and queen or a noble couple subject to the etiquette of a court (fig. 73).

Not until the later eighteenth and early nineteenth centuries, a time of advancing bourgeois strength and consciousness of worth as well as a widespread militant criticism of aristocratic privilege, did artists begin to present themselves habitually as independent personalities confronting the viewer full-length and life-size, like noblemen, dignitaries, and kings. The smaller self-portraits, focused on the features, retained their interest as occasions of self-assertion and keen self-scrutiny, like the autobiographical and confessional writings that conveyed an author's personality and his virtues of candor, naturalness, and fellow feeling, and spoke directly to the reader without the barrier of a code of manners that stylized human relationships in the regulated world of the court and the salon. Chardin's two pastel portraits in the Louvre are classic examples of that frank self-scrutiny in a painter's image of his own person.[4] Rembrandt van Rijn, a proud artist, never showed himself life-size in full-length; his awareness of the self as an illumined soul with shadowy depths was better realized through a portraiture concentrated on the face. But he did portray himself in a half-length image in the Frick Collection that seems larger than life, as a broad majestic figure enthroned in his seat like a king.

Photographers, too, had conventions of pose, lighting, accessories, and composition, in part borrowed from the painters. But these devices, as in painting, were applied selectively, with discretion, to convey the qualities of the subject. In the early photographs, one can distinguish the stereotypes from the original conceptions, which in time become standard, though not empty, forms.

The aesthetic viewpoint of photographers, often themselves painters who responded to congenial aspects of sites in their unique and arresting actuality, inspired many pictures of the city that remind us of Impressionist paintings. A photograph of a bridge in Paris, reproduced in a newspaper, corresponds amazingly to a picture by Monet, though the painting captures more effectively the stirring, vibrant atmosphere of the changing scene. But the chaos of the painter's city landscape, its crowded and weather-steeped look, which we would not expect in older art, was anticipated by the photograph, a work of about 1860.

In comparison to a photograph, an Impressionist painting has another texture, apart from the difference in color. The brushstrokes, a mosaic of separate touches, reenact for the eye the course of the painter's work, his perceiving, translating, and correcting—and also preserve the characteristic rhythm of his hand. The photographic print, by contrast, is a perfectly regular,

unmarked surface, with a magically effected, often uncanny likeness to its subject. In this respect the photographic print has a striking affinity with Neoclassical paintings, which seem at times astonishingly photographic, despite the idealistic tenor of that style. Ingres's portrait of Monsieur Bertin owes its camera-registered aspect to an absolutely smooth finish, as well as to the unremitting objectivity of the artist's vision of his powerful sitter at the instant of Bertin's turning to the viewer in a revealing, momentary posture (see fig. 71).

Influenced to some extent by an established academic art that combined a pursuit of probing detail with a taste for the solemnity of fixed posture—transmitted in the schools through the study of posed naked models—the early photographers were inclined accordingly to select cleancut forms in a lighting that preserved the clearness of details and contours. This clarity depended also on the material or physical conditions of the photographic art, a *parti pris* that made the print especially attractive to uncultured taste, such as that of the peasant or the philistine, who valued nothing so much in imagery as an minutely veridical likeness.

Different as they are in obvious respects, painting and photography could converge in composition and conception of the subjects, which are so important for imagery. That convergence offers an instructive example of the complexity of artistic development: a style can disclose in the course of time ignored features that are assimilated in a contrary approach. Most remarkable of all is the relation of photography to Impressionist works, an unexpected parallel of a monochromatic technique to an art of color that seemed to so many of its contemporaries perversely untrue or inept as representation, though a few decades later Impressionist painting was being criticized adversely as a purely retinal art. We understand the resemblance today as springing from a common interest in the visible, in the actualities of the individual and the environment, discovered by what was then a liberating refractory sensibility. Photography shared several qualities with Impressionist painting: an idea of picturing of and through light, a direct confrontation with the subject, and a process of rapid exposure and development. In speaking of the novel as an art of impressions, Henry James, we have noted, was to take the photographic eye and plate as an apt metaphor of a true artist's sensibility.

Generalizations about the Impressionist portrait apply less to Degas, who, of all the members of his circle, was the most devoted to both portraiture and photography. Exceptional among them in undertaking very few landscape themes, he was in the earlier years the most frequent painter of portraits; unlike Renoir and Monet, he displays in these works a novelist's temper in the sympathetic comprehension of the fragility, doubts, and solitude of his sitters, especially of the women (fig. 74). They are sensitive, withdrawn personalities whom he sometimes placed in the shadowy part of a light room, turned away from the viewer by their own shy habit, and immersed in thought or music—the opposite of Degas's dancers and jockeys, who are wholly possessed by their arduous physical roles and appear incapable of introspective reflection.

In an early picture, possibly of Madame Paul Valpinçon, the painter placed a woman

brooding in the corner of the canvas with her hand nervously covering her cheek and mouth, beside an immense bouquet of chrysanthemums that seem to crowd her, almost to smother and stifle her with their pungent, saturating fragrance. Degas employed painterly motifs of light and the flicker of small elements—countless petals, the spotted ornament of the table and wallpaper, the twinkling highlights on the glass pitcher—to shape an evocative setting for a subject absorbed by an unspoken malaise (fig. 75).[5]

An essential find in this daring, original composition is the place of the woman so close to the edge of the picture, a willful break with the self-evident rule of portraiture, that centers the sitter on the canvas. It is an early example of what was to be a consistent practice of Degas, developed with ingenious effect in his scenes of ballet rehearsals and performances, the music hall, and the café (and later in his pictures of the bath), where the peripheral point of view

FIGURE 74. Edgar Degas, *Mme. Camus*, 1870,
oil on canvas, 72.7 x 92.1 cm, National Gallery of Art, Washington, D.C.

FIGURE 75. Edgar Degas, *A Woman Seated Beside a Vase of Flowers*, 1865, oil on canvas, 73.7 x 92.7 cm, The Metropolitan Museum of Art, New York

intimates the presence of an undrawn observer whose perspective explains the odd composition of the painting, with its incomplete, intercepted, and bizarre silhouettes.

In the portrait of Madame Valpinçon, her place at the side, like her troubled gesture, is not so much the result of a near viewer's eccentric glance as it is inherent in her uneasy mood and withdrawal from her surroundings. The unusual composition offers a convincing characterization of a subject who felt out of place in her own home or before an observer, or who was seen by an unexpected eye in the privacy of her mood, and looked away. In the course of Degas's art one can discern a progressive shift from the pathos of the estranged self to the objective standpoint of a spectator in a marginal and detached but often physically close position who enjoys the power of the eye to reshape and deform beings who are unapproachable in their normal existence.

FIGURE 76. Edgar Degas, *The Bellelli Family*, 1858-67,
oil on canvas, 200 x 250 cm, Musée d'Orsay, Paris

Madame Valpinçon's mood was foretold in Degas's early portrait of the Bellelli family, where
the contrast of the two sides of the picture conveys a tension between the woman and the man,
related to their contrasted roles in the bourgeois home, although that contrast may also be the
outcome of the artist's own divided self, identified in part with the feminine sphere (fig. 76). The
wife, Degas's aunt Laura, is in black, sharply outlined in an ascetic, puritan silhouette that
envelopes one daughter. She stands at the left in the icy, self-imposed constraint of a martyr and
a solemn guardian of her children. Her husband, Gennaro, sits in an opposite orientation, half
turned and partly in shadow at the right, as if arrested in the course of work by the intrusion of
his wife and daughters, one of whom just fails to reconnect him with his family. On the wall
beside the woman, as an aesthetic analogue to the strictness of her traditional role and her family
pedigree, hangs a small Holbeinesque portrait of her recently deceased father, while next to the

man, more loosely painted, are the opulent material goods of their Florentine exile: a nobly framed modern mirror and the mantle of the fireplace supporting a picturesque clock and other objects. Gennaro's involvement in an 1849 Neapolitan rebellion against the Bourbons had forced the family to leave their home in Naples, where they had been part of a prosperous banking business. The move greatly added to the couple's marital tension, which the picture so richly and subtly reflects.

In a later painting of the 1860s, called *Bouderie* (*Pouting* or *Sulking*) (see fig. 62), a husband has drawn away from his wife in angry isolation at a desk covered with papers that might contain the matter of their disagreement. In a print on the wall behind, steeplechase jockeys visually leap the unbridgeable psychological chasm between the two. However we interpret the

FIGURE 77. Edgar Degas, *Portraits in an Office—The Cotton Exchange*, 1873, oil on canvas, 74 x 92 cm, Musée des Beaux-Arts, Pau

picture, it is an image of conflict in the family, less of passion than of material interests and authority. An episode in a short play by August de Villiers de L'Isle-Adam entitled *La Révolte* (1870) could be the subject of this work: a wife who has slaved for her husband for many years in a loveless marriage that could better be described as a business partnership finally presents him a reckoning of her services and leaves him. The woman victimized by the cold ambitions of an unfeeling husband or brother who lives mainly for worldly success is also a theme of two novels by the de Goncourts, *Mme Gervaisais* (1869) and *Renée Mauperin* (1864).

To Degas, who showed with the Impressionists and shared certain of their new ideas, photography in its aesthetic and material aspects was an exceedingly fascinating art; several of his paintings seem to realize on canvas qualities of a photographic print. His *Portraits in an Office—The Cotton Exchange* (fig. 77), a group scene, was the first picture of a modern office that transmitted, in a dispassionate view and in advance of the photography of the day, the atmosphere of a business milieu of his time: its informality, its sober, methodical bookkeeping, and its cool, dry air of calculation. This image of an American business interior, a surprising theme either for an Impressionist or for a painter with Degas's classicist training and elegance, was conceived in a scale of closely stepped grays, whites, and blacks, with minor subdued tones of light green and flesh; it is all the closer to the aspect of a photographic print because of the uniformly smooth execution. The perspective, too, is reminiscent of a later type of unarranged camera view, with its streetlike convergence in depth and its scattering of figures who appear as separate individuals in a random grouping, each occupied with his own perceptions and thoughts while taking part in the common affair. One feels the cotton and judges it by touch, another lounges, a third reads a newspaper, a fourth is at work in shirtsleeves writing at a high desk. All are in markedly varied postures, hands in pockets, legs crossed, unbent or parallel. In addition to the restricted scale and the harmony of tones, an ingenious deployment of lines establishes the unity of what appears at first sight as an unplanned snapshot, without an obvious embracing scheme or large accents, yet rich in parallels, analogies, and contrasts of neighboring forms, some arising from chance inflections in the clothes and postures of the figures. Degas was an early devotee of the camera and, in his bold experiments with the new medium, anticipated future discoveries in this art.

By the 1870s, photography was already acknowledged as possessing a likeness to an everyday view of things, with all that this implied of the momentary and unposed. A decade earlier the Russian revolutionist Alexander Herzen, comparing his memory of Giuseppe Garibaldi's visit to London in 1864 with the extensive descriptions in the newspapers, wrote: "I do not intend to enter into competition with them, but simply want to give a few of the little pictures I have taken with my camera from the modest corner from which I look on. In them, as is always the case in photographs, much that is accidental is seized and retained: awkward draperies, awkward poses, overprominent details, with the lines of the events left untouched and the lines of faces unsoftened."[6]

The modern note in Impressionist painting as an imagery founded on collective life, whether of the family or convivial gathering, becomes obvious, as with the portraits, in a comparison

with French works of the eighteenth century that have similar themes. An observer in the museums will not fail to note that the Impressionists revive certain features of that old art that abounds in imagery of pleasure and play. Setting a picture of a family meal by François Boucher beside Monet's picture of the same theme (figs. 78, 79) we see that the first is submitted to formalities and a decor that give an air of self-conscious grace to the intimate occasion. Except in the children, the postures strike us as affected and mannered. The well-bred adults turn, twist, and balance themselves through contrasted inclinations of the head and limbs in a framework of elaborate furnishings, richly gilt and with precious materials of high luster and refined workmanship whose sinuous shapes repeat the lines of the figures. In Monet's less formalized composition, with broken, irregular shapes and unstressed lines, attention is directed to the child, with the older persons presented in relaxed converse. The delight in food and drink, and in the comfort of the room, with its caned chairs and other plain furniture, the pleasures of smell, touch, taste, and vision, are expressed with an unaffected simplicity.

One can match the two conceptions of Boucher and Monet with the lifestyles of the aristocracy of the Old Regime and of the French middle class of the 1870s. In these pictures, the aesthetic of the painting corresponds to the mode of existence represented in it and to a taste in forms and colors that shaped the outward aspect of the self and its surroundings. What is Impressionist in the execution of Monet's work has evident parallels in the appearance of the breakfast room and the bearing of the figures. But beyond the differences is discernable a continuity of outlook in the common choice of the subject and in the values that seem to underlie it.

Among the Impressionists, other conceptions of the family group existed, as demonstrated in Degas's early picture of the Bellelli family (see fig. 76), where a hedonistic attitude of pleasure and freedom was altogether absent. The joyless family in its home in exile shows traits of the older, conservative bourgeoisie, though with dissonant notes that betray its already problematic state in the middle of the century. One can further consider the personal contrasts of the figures (as well as of various objects in the decor of the home) in the light of variations within Degas's style at that moment, variations that bespeak the conflicting tendencies not only in the artist— between his inherited ideas and manners on one side and his desire for a freer, more modern approach on the other—but also within that conservative bourgeoisie that must maintain itself in a changing, even threatening situation that has arisen from the uncertainties of the economy and the challenge of the lower classes.

Renoir, who adored French Rococo art, pictured a girl playing the piano, with a friend (or sister) beside her; both scan the sheet of music and listen together in unselfconscious accord (see fig. 63). The girl who watches embraces in her posture the girl who plays; she echoes the other's form. The likeness of the young friends to each other in an intent but unstrained sensing and enjoyment of music renders Renoir's feeling for the human in art as both receptive and active. The story in the painting—the shared moment of pleasure in the trial of music—is the vital counterpart of Renoir's warm, sensuous, easy harmony of colors and shapes.

FIGURE 78.
François Boucher,
The Luncheon,
1739, oil on canvas,
81.5 x 65.5 cm,
Musée du Louvre,
Paris

In *The Music Lesson* by Jean-Honoré Fragonard in the Louvre, we cannot miss the piquant duality of boy and girl; they are opposed as a dark to a light color, as a straight to a curved line of contrasted axis. There is a latent intrigue here, a potential romantic comedy between the pair. The music is a set occasion for an outcome that can be divined in the undrawn relation between the two actors. Such a context existed also in Renoir's time and could furnish a diverting episode for a Salon picture or play. But while Renoir, like Fragonard, was a painter of unabashed erotic feeling, he was free of covert allusions and appeals to the sophisticated viewer's amused understanding. By temperament, and with the support of the intervening growth of social ideals and

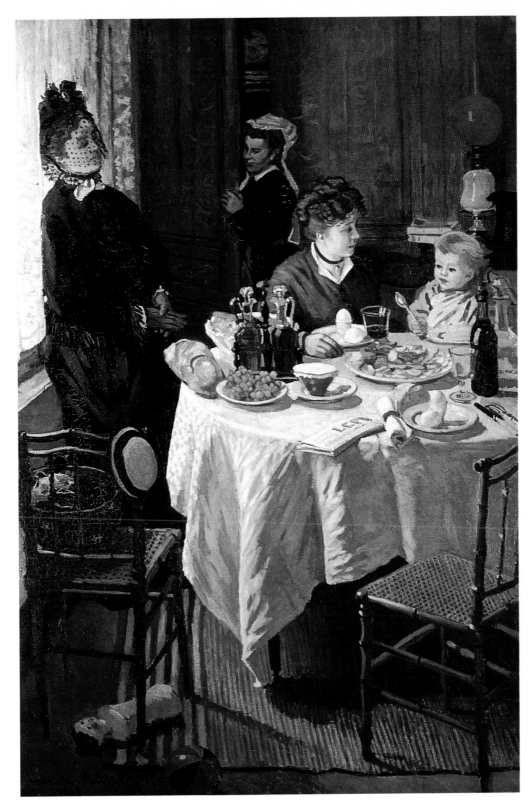

FIGURE 79.
Claude Monet,
The Luncheon,
1868,
oil on canvas,
230 x 150 cm,
Städelisches
Kunstinstitut
und Städtische
Galerie, Frank-
furt am Main

art, he took frank delight in music, youth, and friendship, and found in their spontaneous aspect some congenial themes of his art.

Before Monet's *Déjeuner sur l'herbe*, we are reminded of the lighthearted eighteenth-century pictures of outdoor parties (fig. 80). A painting by Watteau, as much as Monet's own experiences, might have inspired that choice, but we shall not find in Monet's version the courtly gestures, nor the air of make-believe and the erotic intimations of Watteau's *La fête d'amour* (fig. 81). In that older outing a nude statue at one side, of a substance like that of living flesh, blurs the line between artifice and nature at the same time that it declares that artificiality of the whole. Monet's world appears as actually encountered, while Watteau's seems more distant and fanciful, an imaginary space in spite of the fashionable contemporary dress of its inhabitants. As the festive scenes in earlier Venetian art once required the supporting context of a religious or mythological theme, so in this eighteenth-century art the appearance of happiness in nature was represented through a courtly game with idyllic components and allusions or as a masquerade in an imagined theatrical landscape.

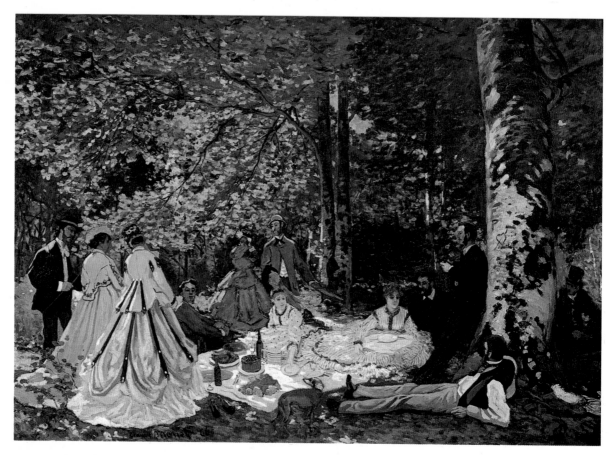

FIGURE 80. Claude Monet, *Déjeuner sur l'herbe*, 1866, oil on canvas, 130 x 181 cm, Pushkin Museum, Moscow

FIGURE 81. Antoine Watteau, *La fête d'amour*, 1717, oil on canvas,
61 x 75 cm, Staatliche Kunstsammlungen, Alte Meister, Dresden

Like certain Dutch works of the seventeenth century, the Impressionist pictures of outdoor enjoyment consistently exclude fantasy and literary allusion. Romantic art had produced many images of the Arcadian dream—those of Adolphe Monticelli and Narcisse-Virgile Diaz de la Peña come to mind—which clothed the picnic in an atmosphere and costume of ancient and medieval idylls. The Impressionists converted this poetic dream into a lived modern actuality, stripping it of all that was fanciful and contrived. The new realistic image is easily read and hardly invites a search for latent or concealed meanings. Here the outdoor pleasures are pictured directly in the figures enjoying a familiar milieu. A single spot or ray of sunshine establishes the natural in the occasion; the casual postures of the figures are evident signs of freedom and

well-being. An attempt by Monet to make of that sketch of a modest weekend diversion a second picture of monumental size was a failure; the ambition was incompatible with an essential character of his art. Yet the ill-chosen format is a revealing sign of the painter's conviction about the importance of his subject, its representative modernity.

With all their differences Monet and Watteau shared a significant theme: society at home in the forest landscape. While for Watteau the depicted play was an assumed role, a collective fiction as in old pastoral poetry with its idealized actors, for Monet it was no game or fantasy but a frequent holiday experience of sensuous impressions, the fulfillment of the desire for a freer outdoor life, a release from habit in a more open environment. We are not surprised that Watteau also represented scenes of the stage, subjects that never attracted Monet as they did Degas, who was indifferent to the everyday picnic as a subject.

The picnic as an actuality of social life had begun to engage the attention of thinkers in the nineteenth century; their observations foreshadow the universal sense of a new concept of the natural in later art. After repeated contact with "savage" peoples, Charles Darwin noted in his *Voyage of the Beagle* (c. 1831) that "the pleasure of living in the open air," like the love of the chase, was "an inherent delight in man—a relic of an instinctive passion . . . it is the savage returning to his wild and native habits."[7] And his contemporary Herbert Spencer, the Victorian conservative philosopher of progress, could say that "the picnic is a reversion to savagery, to barbarism,"[8] where one eats without knives and forks in one's shirtsleeves. Such elements of the primitive in the picnic were lacking in Watteau's idyllic image and move us as the notes of freedom in Monet's conception. They anticipate the exotic taste of Gauguin's vision of Tahiti twenty-five years later and of the explosion of feeling in the naked dancers, lovers, and musicians in paintings by Matisse and the Fauves in the early twentieth century.

In the Rococo ancestors of Monet's scenes the landscape settings—and they were settings in the most literal sense—were conventional types of the forest glade and formal park. The enclosing trees preserve in mass and silhouette the symmetries of Renaissance composition; the color still holds to a fixed tonality that tempers the hues; the touch (as in Watteau) is often wonderfully fresh and delicate, and sometimes spirited. Early Impressionist pictures, where the figures and trees still retain something of the old formality of composition, manifest in many parts an aspect of the encountered, the momentarily seen, especially in the play of light with its irregular spotting on the ground and trees and with high-key shadows. The individual figures are casual in posture. In the *Déjeuner sur l'herbe* one of them leans against a tree trunk with his right hand in his pocket; another, based on the lanky Frédéric Bazille who is recycled twice more in the composition, is stretched out on the grass with long legs straight and parallel. Both appear unaware of their inelegance, which violates the canonical formula of grace, the balance of contrasted limbs in a relaxed figure. In all these features we see physical analogues of the attitude that exalted the "impression" as the mark of the inwardly free, authentic human personality.

More than Monet's early views of the beach, the river, the forest, the park, and the garden,

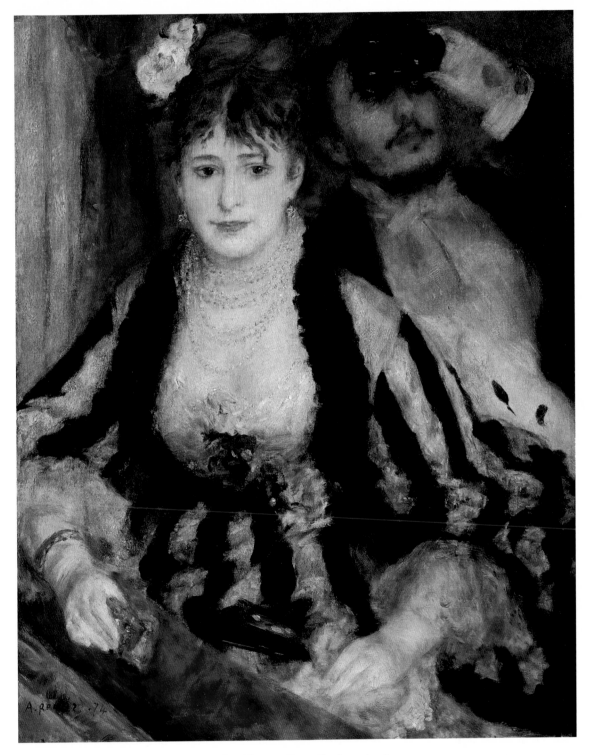

FIGURE 82. Pierre-Auguste Renoir, *The Theatre Box (La Loge)*, 1874, oil on canvas, 80 x 63.5 cm, Courtauld Gallery, London

FIGURE 83. Paolo Veronese, *The Wedding at Cana*, detail. For entire image, see fig. 28, page 81.

Renoir's paintings revived the ethos of pleasure in the Impressionists' city world. No one has realized on canvas as fully as he did an imagery of the innocent recreation of his time—moments of collective joy that have remained perennial goals in our culture. He depicted men and women together as figures of health and charm in shared enjoyment of spectacle, of sport, and of convivial talk: the couple in the loge of the opera (fig. 82), sighting and seen; the picnic; the boating party (see fig. 84); the dance hall; the garden restaurant (see fig. 26). Part of the conception of this last scene is altogether new in painting: the young man, lighting a cigarette at a table with a bright sparkle of cups, grenadine glasses, and a decanter of water, as the beautiful girls look on. Placed behind the two girls, so fully in view, he is subordinate to them. The bright flame catches the attention of Georges Rivière, a writer and friend of Renoir, seated at the far right. The choice of this incidental moment of the luncheon lends to the whole, a public yet intimate outdoor scene, a note of lighthearted, unclimactic enjoyment. The striking of a match, a minute explosion and flash that arrest the conversation and focus the attention of a member of the party, like the piquant touch of a sharper single stroke among the nearly equal values of color, marks

the level of intensity in the brightness and pleasure of the enchanted afternoon. In earlier art, the effacement of the man in such company would have been unimaginable. As the socially dominant figure, he would have been central and would have commanded attention by a more stable and significant pose.

Other artists have inserted in a large painting a small, piquant, attractive object to season the impact of the primary figure—the fallen glove in the life-size portrait of a fashionably dressed woman, the decanter and lemon atop a glass on the table alongside the standing gentleman in outdoor dress. But this carefully placed accidental presence, which stands out both as a sign or as a tactical piece in the strategy of composition, contributes little or nothing to the quality of the whole and by its prominence gives to the painting something of the shallowness of the trivial.

Inspired perhaps by the lower left corner of the immense painting by Veronese in the Louvre, Renoir's ambitious *The Luncheon of the Boating Party* (fig. 84) initially appears unarranged. In

FIGURE 84. Pierre-Auguste Renoir, *The Luncheon of the Boating Party*, 1880-81, oil on canvas, 129.5 x 172.7 cm, The Phillips Collection, Washington, D.C.

fact, it has been thoughtfully composed by a deployment of balancing couples with contrasted features in their color, postures, and costumes, and built up in depth accordingly. The picture retains the casual aspect of a participant's vision, a scene caught in its living actuality; old formalisms of grouping are absorbed or merged in the scattering of profuse elements and suggest the natural positions of spontaneously moving figures in a situation of ideal freedom without a center or climax.

The turn to nature was not just a means of escape from a burdened urban existence, a way to free oneself by flight to a nonhuman and undemanding world of sky, trees, and water, which could isolate the self from a turbulent and grimacing society. Nor was this pastoral inclination, as was remarked so often in the middle of the nineteenth century, a reaction to social disturbances, or a search for peace. In the literature of the time and for authors who shared the viewpoint of the advanced painters, the dwelling in landscape was more often a revivifying experience, a magical, mythical recovery of the instinctive and natural self. Zola's novel *La Faute de l'Abbe Mouret* (1875), for example, was built on the struggle between a need for wholeness of sensuous being and the demands of a sincere religious dedication that suppressed instinct. In the Paradou, an abandoned and overgrown park designed by a nobleman of the eighteenth century, the Abbé Mouret, stricken to the brink of mental collapse by his inner conflicts, regained through naked contact with wild nature an Edenic freshness of feeling and knew the happiness of sensual love. On another level, the painter Fromentin, who belonged to an earlier generation, pictured in his novel *Dominique* the romantic maturation of a young girl through two months of travel in the sun.[9]

During the decades of Impressionism, the regeneration of individuals, especially the sick or convalescent, by exposure to the sun was a recurrent theme of Scandinavian writers—Henrik Ibsen, August Strindberg, Jens Peter Jacobsen, and Hans Henrik Jaeger. More than other Europeans, the Northerners, through their climate and austere Protestant code, felt the attraction of the South as the land of sunlight and of a freer life of the senses. Experienced in repose as a place of pure enjoyment of new sensations and impressions, the outdoor milieu possessed a healing virtue. Succeeding the older metaphysical pantheism, the thinking of that time argued for a therapeutic naturism, a faith in the natural environment and especially in exposure to the sun, as a source of strength and a recharging of the rundown human body and spirit.

The Exemplary Impressionist: Claude Monet

IF MONET IS REGARDED AS THE IMPRESSIONIST par excellence, one must admit that both Degas and Renoir also have their own special qualities. Cézanne, too, merits individual study, although his development in relation to later art seems to set him somewhat apart from the Impressionist movement as a whole. However, when considered with reference to Monet's life and work, the concepts applied in interpreting Impressionist art—in particular, those of the impression, the stroke, the contrast of colors, and the consistency with which the consequences of the Impressionist ideas visible at the beginning of an artist's career are elaborated in the long course of that individual career—make Monet's position central.

By his fellow painters Monet was regarded as a leader, not because he was the most intellectual or theoretically minded or because he was able to answer questions that they could not answer, but because in his art he seemed to be more alert to the possibilities latent in their common ideas, which he then developed in his work in a more radical way than did the others. Considering how all these painters developed their intensely personal manners with respect to the new artistic ideas, we may observe that the new elements appeared most often for the first time in the work of Monet and then were taken over by the other Impressionists, who incorporated them as suggestions or as definite means and applied them in their own ways.

A clear example of Monet's influence can be noted in the change in Degas's art after the middle 1870s, when his color began to approach that of the other Impressionists and he employed techniques, particularly in pastel, that gave to the whole a more granular, broken, and flickering effect—qualities not found in his earlier work. That is true also of Cézanne, Pissarro, and Renoir. Monet showed the way, even if the development of the others seemed to diverge from his.

There is still another reason for Monet's outstanding position as an Impressionist. If we compare his paintings over a short period with the paintings of the others, we see that while the others painted within a restricted range of ideas and even of feelings, so that the Renoirs of the period 1873–76 are characterized by the joyousness in a collective world of recreation described earlier, Monet, with his powerful, ever alert eye, was able to paint at the same time brilliant

pictures and also rather grayed ones in neutral tones. He was more reactive, he had more of that quality that psychologists of that time called "impressionability." That is to say, he was open to more varied stimuli from the common world that for these painters was the evident source of the subjects of their paintings.

Monet could appear variable at any given moment, producing many surprising interpretations of the common matter. He altered his technique according to his sense of the quality of the whole, whether joyous or somber, that he wanted to construct in response to the powerful stimulus from the object that engaged him in the act of painting. Similarly, over the course of years, his art underwent a most remarkable general transformation. The early work of Monet appears as a painting of directly seen objects characterized by great mobility and variety. His art is a world of streets and harbors, beaches, roads, and resorts, usually filled with human beings or showing many traces of human play and activity (see fig. 15). In the late work, however, Monet excluded the human figure. There are practically no portraits and no figure paintings by Monet after the middle 1880s and few between 1879 and 1885. From that period, we can count all his figure paintings on one hand. He also gave up still life and painted no genre groups. He restricted himself to an increasingly silent and solitary world.

When Monet traveled to Venice and London, he pictured those great cities from a distance, in fog or sunlight, without the clear presence of human beings and with no suggestion of their movement through that space. He tended, moreover, to shift from the painting of large to small fields; and, whereas at first the large fields were painted on small canvases, later he painted a small field—water in a nearby pool or a few flowers in his garden—life-size and seemingly larger than life, as if he wished to give a maximum concreteness and the most intimate presence to a small space that, although only a segment, was for him a complete world. He moved in his art from a world with deep, horizontal planes in long perspectives—the paths of carriages and traffic—to a world in which the plane of the water or the ground seen from close by has been tilted upward and has become vertical, like the plane of a picture or mirror. The quality of landscape as the extended human environment, the old traversability of space, has been minimized in the later work.

Monet offers one of the most extraordinary transformations known in the lifework of an artist. But it does relate to an observed trait of many artists in their old age. An attempt has been made to characterize in broad terms a style of old age—what the Germans call an *Alterstil*—as if the late works of Titian, Rembrandt, Tintoretto, and Monet must have something in common. In old age they lived presumably more within themselves than in the "world," and from this tendency of aged artists seems to flow certain characteristics of their art. This theory rests on an arbitrary selection of old artists, however, and one can point to Ingres, whose last pictures, such as *The Turkish Bath*, painted in his eighties, are of an indomitable sensuality and sometimes surprisingly naive and tangible in the voluptuousness of the forms. Or Pissarro, the fellow painter of Monet, who, beginning with idyllic pastoral subjects, painted in his old age streets and

crowds, steamboats, factories, and people, the reverse of the process that we have observed in Monet.

Besides his academic nudes, Renoir began by painting the sociability of his own world—pictures of his artist friends and the pleasures of Paris; but as he grew older, he withdrew from this public world. He still represented human figures, even more passionately than before. But they are completely domestic figures—a child, the nurse, the mistress, the wife, always a figure presented in an intimate relation to the observer or the painter. Monet never painted a nude, and one may suspect that his vast world of nature and the theme of water played in his art the role that the fantasy about women or children or mothers played in the imagination of other artists. All his variety, from the stillness of the lily pond to the awful turbulence of waves beating on the rocks, may have to do with the feelings or passions that in other artists can be recognized in their mythology and subjects or through a fanciful imagery of human figures.

The characteristics of Monet's development can be approached through several questions. We may ask: was this change the result of aging, or was it perhaps the result of a peculiarity of his personality that was always there or was latent in his character and already evident from the beginning? Or was the course of his art a reaction to his surroundings, which he at first accepted and which later ceased to satisfy him, not because he had aged but because society itself had changed and could no longer offer him the pleasure and confidence in human nature and collective life that the open world of the streets had offered him as a young man in the 1860s and 1870s? We ask the latter question because the marked change in Monet from 1860 to the beginning of our own century is paralleled in the development of generations. The younger artists in the 1880s and 1890s and the beginning of the twentieth century more and more turned away from the common world and regarded all that belonged to collectivity, to the social order, as uncongenial or alien; they tried to find elsewhere material or themes that offered a surer support to the individual. Those developments formed part of the reaction against Impressionism and the decline of Impressionism as a leading art in France and other parts of Europe after the late 1880s or 1890s, which will be discussed in the conclusion. Here some related aspects of Monet are considered in a personal historical order; they are connected also to experiences of the man and to new encounters, as well as to his life problems.

In a pair of pictures that range in date from the 1860s to the twentieth century, we can see more readily the great span from the paintings of Monet in his twenties to his work in his sixties, seventies, and even eighties (figs. 85, 86). One of these—a London scene from the early twentieth century—perhaps marks a return to his original excited interest in the city. But London is no longer the former city of promenades with visible strollers and the delight of the summer occasion, with the multiple details of the familiar streets, the windows, chimneys, domes, kiosks, traffic, and carriages—all necessary features for the Parisian's world. Painting cities toward the end of his life, Monet represented London and Venice, but not Paris: he was quoted as saying that he was always unhappy there, even as a young man. Presenting quite a different

FIGURE 85. Claude Monet, *The Thames below Westminster*,
1871, oil on canvas, 47 x 73 cm, The National Gallery, London

impression than that bitter memory suggests, Monet's early pictures present a no less significant manifestation of his attitude toward the people and things around him. Those early paintings may well offer a more reliable testimony than does his subsequent statement, quite possibly made at a time of solitude and despondency.

If there is a far-reaching shift in Monet's approach to his themes, in his choice of subjects for the creation of images, one cannot separate that choice from his lyrical content and artistic conception: there are too many close links between them. Despite the great change in his work, it is possible to point to surprising constancies in his choices and even in his attitude. Compare the two paintings of London, works separated by more than thirty years. You can readily see that the second belongs to the end of his career and the other work to the earlier phase. But common to them is the deep interest in water and the magical quality of life and atmosphere that permeates the world, determining its character, life, and mood.

Many of the same features of landscape recur and fascinate the painter over a career of sixty years; but the concentration of choices, the frequency of a particular object or approach varies: there is a distinct difference between the youthful and the late work. In the early period of the

1860s, the element of movement and play and the allover effect of light and atmosphere depended more on material things, tangible things. The objects themselves determined the complexity of the painted world. Instead of breaking up the field into many small units of color, Monet was attracted by objects that already exhibited in their familiar form a multiplicity and complex subdivision or assembly of parts—with many masts and sails, letters and numbers written out. These elements formed light spots against dark, figures in a boat in alternating rhythms of light and dark, dark and light, water broken by tides or currents, the architecture of boats made up of many small units.

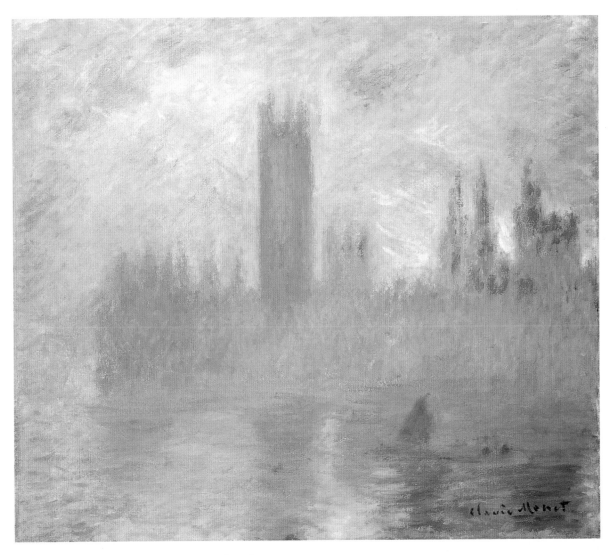

FIGURE 86. Claude Monet, *Houses of Parliament,*
c. 1900/01, oil on canvas, 81 x 92.1 cm, The Art Institute of Chicago

Monet hardly had to invent a technique of division, it was there already in the variegated world that he contemplated, stirring him with the constant flicker of things and their parts. Through steam, smoke, and movement of the human traffic on land and water, the atmosphere was created by man; everything possessed an aspect of motion, even those momentarily stationed things, which were so rich in contrast.

In the 1870s that love of movement, of an animated world, of mechanical power, and also of human traffic, the crowds, gave Monet models, images, and suggestive possibilities for an art of great lyrical intensity, with a free play of repeated elements. His pictures of the railroad station and the streets were not approached in quality until the beginning of the twentieth century by the Fauve painters. A degree of impulsiveness and freedom hitherto unknown in painting, even to the Romantics, was realized through a brushwork that had a correspondingly chaotic air and yet was held together by his firm touch and spontaneous rhythms of execution, which seemed to issue from his conviction and enthusiasm before the human world in movement, the outward life of the city.

Another example of Monet's range of approach is the painting of the street in Rouen on the national holiday with the vivid crowds and flags (see fig. 15). Parallel to these explosive paintings are many with somber tones, with dominant grays. A count of his paintings in the 1860s and 1870s might disclose more with finely neutralized tones than with strong accents of red, blue, yellow, and white. These accents did not come from the search for contrasting colors that is described in chapter 10's dicussion of Impressionism and science, but were based rather on local color, on the actual intensity of the colors of the flags and displays or of the summer sky, which were translated often into a simple equivalent of bright, unmodulated pigment color.

In the late 1870s and particularly in the 1880s, Monet's painting became consistently bright, vigorous, and alive through pure tones (fig. 87). It showed then a characteristic search for contrasted touches in the local color, often losing or submerging local color in the richness of an odd contrast of hues or in some unexpected tone that prevailed over the whole, as an effect of sunlight or atmosphere in which the whole spectrum has been embedded. That spectralizing of color belongs to the late 1870s and 1880s and was the starting point for van Gogh's intense color and the painting of Seurat. If those two had begun to work in Paris five or seven years earlier, they would undoubtedly not have painted as they did. Monet and then Renoir together first introduced the high intensities, the full saturations, which they not only applied to local color but also distributed freely and sometimes in a random, woven manner in colors that themselves might not appear to be rich in their local tint. With that new force of color came an increasingly subdivided stroke, with stronger point contrasts of paired colors—tiny units of red and blue, blue and yellow, yellow and violet, orange and blue, green and orange, woven together or superimposed to make a rich crust with many overlays; the color then no longer coincided with the boundary of an object.

In the same period, however, Monet painted wonderfully subtle scenes of winter, autumn,

FIGURE 87. Claude Monet, *A Field of Tulips in Holland,*
1886, oil on canvas, 65.5 x 81.5 cm, Musée d'Orsay, Paris

and early spring, in a gray or middle key, rarely dark in the prevailing value, though with some areas of darker tones. These pictures were characterized, above all, by extreme finesse in the tiny intervals between one large area and another, like the difference between sky and water, or between the snow on the road and snow on the embankment. Into the more or less spread-out, neutralized tones, Monet worked an immense number of little touches of color that vibrate and enliven the surface, creating distinctive textures that are only vaguely the textures of things and more evidently the grained relief of the pigment and the canvas. These pictures are marvels of virtuoso rendering of atmosphere and depth; they translate through variations of paint the transparencies and different degrees of materiality of the world that has been represented, while creating another order of textures with the brush. Monet approached these very different scenes

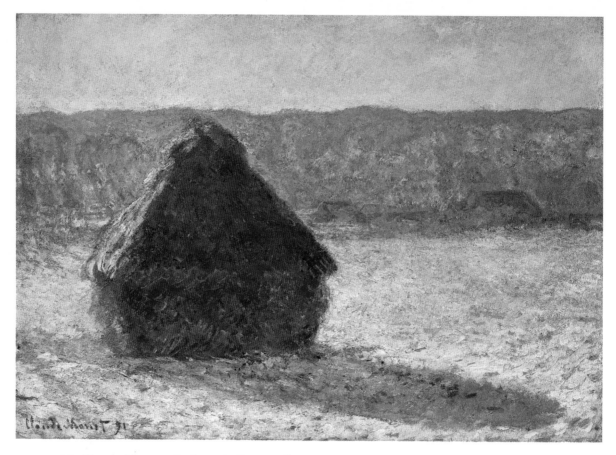

FIGURE 88. Claude Monet, *Grainstack (Snow Effect)*, 1891,
oil on canvas, 65.4 x 92.3 cm, Museum of Fine Arts, Boston

with the same searching conviction and love of the phenomenon, the passionate desire to create a unique harmony from each situation.

In the middle 1880s and 1890s a new concept of what and how objects are depicted in painting appeared. Monet began to paint pictures of the same object in a series, unlike the older canvases in which he undertook to represent a complex world with many different types of objects, near and far, big and small, crowds and isolated things. Now he isolated a single stationary object, which he set in the most intense light or atmosphere and painted repeatedly on separate canvases from nearly the same point of view. He carried a half dozen or more canvases to a chosen spot and set up a different canvas every half hour or hour, returning to complete the picture, when the light was the same, in resolute fidelity to the impression, to the quality of light and atmosphere, and to the subtle changes that appeared in the course of the day. The grain stack is one of the most familiar of these chosen objects, painted in series (fig. 88). We may observe that as the motif becomes more defined as a stationary silhouette, its surface is

more minutely broken, vibrant, and flickering, and more strange in color, unlike our everyday image of the color of a haystack. The ground on which it rests, the distant sky and hillside, are all of endlessly changing hues, so that we cannot identify their constant color, which we know from experience or from older paintings—that color we traditionally named when we wished to describe them.

Two examples of the paintings in his series of the Cathedral of Rouen also show how different the same object may appear from hour to hour (figs. 89, 90). Monet's procedure was not photographic, although it is reminiscent of the beginnings of the cinema, of photography in time. In the 1880s and 1890s inventors were developing the methods that brought into being a practical continuous photographic film, although astronomers and investigators of animal movement had improvised devices for that purpose before. Rather Monet's aim sprang from a lyrical exaltation before these excited harmonies, each bound to a moment in time, each a surprising transformation of the appearance of a stable object. His former pictures had owed a great part of their flicker and randomness to the real mobility and complexity of things in the environment. Now he reversed the relationship, and all the movement is in the appearance of the single object, in the phenomenon, while the object itself, by contrast, remains stable.

In his attitude toward movement, Monet introduced a new conception of the instantaneous or momentary. Artists before him had been interested in the problem of the choice of the moment to paint. Old landscape painters, having to paint from a particular point of view in a definite illumination, nevertheless strove to preserve those aspects of light and shade, of modeling and texture, that support our constant idea of natural forms, our image of an enduring object. The earlier artists who represented figures in action tried to formulate a principle that would guide them in selecting what the German writer, dramatist, and critic Gotthold Ephraim Lessing called the fruitful moment,[1] that point in a sequence of movements that seems pregnant with what follows and that also permits us to see what has produced that momentary state. The great masters of dramatic painting in the seventeenth century staged their figures so that the observer could discern in their relationships a sequence of cause and effect, a significance that gave to the chosen instant a dramatic density with respect to its main components.

In the nineteenth century the idea of the moment changed. Artists were then more interested in the instantaneous as an experience. There are many remarkable efforts to represent it. Baudelaire heard Delacroix say to a young draftsman that if he could not draw a man falling from a fourth-story window before he hit the ground, he would never be able to complete large-scale paintings.[2] Representing a sudden cloudburst, a fall of rain, Daumier showed the crowd, the rain, and the whole atmosphere of the scene, with a new vividness and wit in the perception of the momentary, replacing the old interest in the momentous. Similarly, Manet, in his *Execution of the Emperor Maximilian*, chose a split second, a very specific and crucial instant, with a sudden, startling, but somewhat flat effect. It is no dramatic conception. We do not see conflicting wills or purposes in these motions, but a briefly focused, almost random destructive force

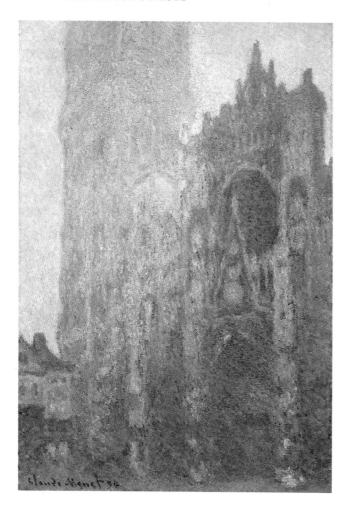

FIGURE 89. Claude Monet, *Rouen Cathedral Façade and Albane Tower (Morning Effect)*, 1894, oil on canvas, 106.1 x 73.9 cm, Museum of Fine Arts, Boston

within the common field, a force that disturbs all the objects and produces this pointless death and disruption.

The realistic art that preceded Impressionism demonstrated an interesting conception of time. In representing crowds, Daumier showed them in the theater, focused on a spectacle that absorbs them, on the road as fugitives, and in the train as passengers impelled toward a common goal (see fig. 39). He was not interested by a particular episodic instant, but by an instant that was recurrent, that had qualities that could be found in many succeeding or preceding moments. The moment in Daumier's pictures is part of a continuous movement, with the same features in many segments of its duration. But in Monet's painting of the crowds in the street there is no compulsion—and no goal. It is not a drama that has an end point in time. The crowd will return, day after day, holiday after holiday; it will distribute itself randomly and always maintain in that randomness the same elements, the same density, filling the streets in the same way. The moment in Monet's pictures is not part of a direct process in time, it has no climax, no explosiveness; and

it requires no interpretation. It does not mark a state or outcome of human will that we have been invited to understand. Nature and man become one through this constant streaming effect of which any moment is practically like any other.

With this new conception of serial painting, certain features of Monet that were apparent earlier but only when his works were considered beside those of Renoir, Degas, and Cézanne or other older landscapists become more striking and much more pronounced. One is that the decorative grouping of objects, those large elements that exist in series, are frequent enough to be counted even if cut by the frame. They include subsets or smaller groups, which can also be enumerated; these have parallel axes, and a certain regularity. The decorativeness of the large elements is accompanied by an intensified richness of minute, random dots of contrasted color; with the tiny units being about the same size, there is again a principle of repetition. Another feature of this phase is the verticality and nearness of things—the vertical plane of the picture is like the vertical plane of what is represented. Even big rocks have been treated as if they were close to

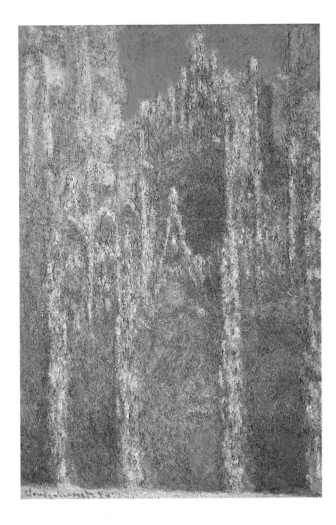

FIGURE 90. Claude Monet, *Rouen Cathedral in Full Sunlight*, 1894, oil on canvas, 100.5 x 66.2 cm, Museum of Fine Arts, Boston

us; the vertical face of a rock is the most interesting and important; and where Monet has painted a horizontal plane like the water, he has tilted it upward, as if he was looking down at it.

The decorative grouping and verticality, which are to some extent observable earlier and can be described as latent in Monet's art when we know what followed, emerge now in a decided way, determining many other peculiarities of his style as well as his choice of objects. In his *Rouen Cathedral Façade and Albane Tower* (*Morning Effect*) (fig. 89), the spotting of blues and yellow, of shadows and lights, has a vague rhythm, but the picture as a whole is not rhythmical like traditional ornament or like the original building itself; it has a created rhythm derived from Monet's brush and his invention of surprising color-pairs and recurrences that are independent of the form of the building. In the same way, the ornamental structure in his *The Four Trees* (see fig. 27) depends on the arbitrary cutting of the field. Monet has isolated and framed a segment of nature, but the result has a remarkably regular ornamental aspect, if not a rigid form.

Monet's earlier work anticipated that later direction. In *Regatta at Argenteuil* (fig. 91), his picture of the resort, the flecking of color in the foreground, which corresponds in part to the actual breaking of the surface of the water in nature, tends toward verticals and horizontals and has been

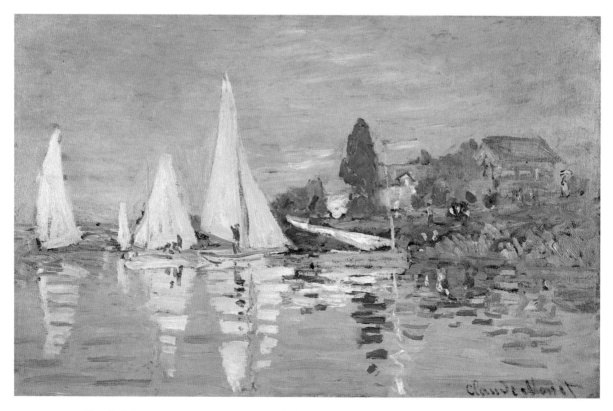

FIGURE 91. Claude Monet, *Regatta at Argenteuil*, 1872, oil on canvas, 48 x 75 cm, Musée d'Orsay, Paris

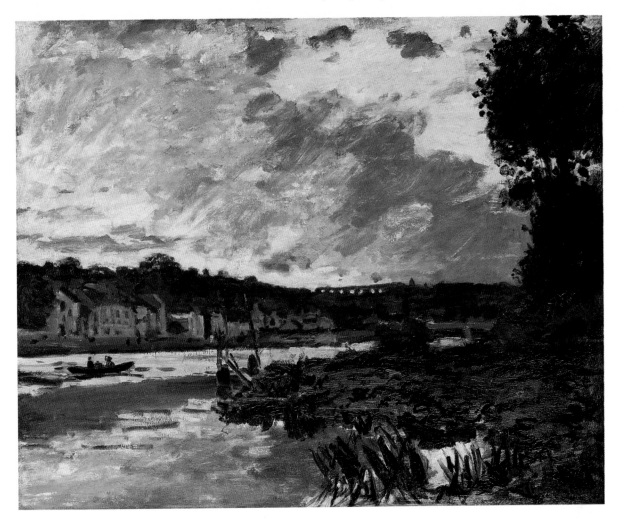

FIGURE 92. Claude Monet, *The Seine at Bougival*, 1869,
oil on canvas, 60 x 73.3 cm, Smith College Museum of Art, Northampton, Massachusetts

made up of units of nearly the same size, with a rhythm of alternating warm and cool, dark and light strokes. But the painting as a whole has not been treated in the same way. In different areas of the picture, Monet wove different patterns of such elements; they have been harmonized and acquire a distinct unity through these rhythms, which seem to arise directly from his technique of painting. In a still earlier painting, the sky and the water form surfaces that are distinctly like ornament but are fabrics of a different type (fig. 92). Here there is so much variation from part to part that none could be interchanged with another, even if made up of the same type of stroke. Always inventive in his response, Monet did not hold to an ornamental nucleus in composing the picture as a whole, like those artists who are essentially decorators and compose by repetition.

Yet there are segments of paintings by Monet in which two neighboring objects of quite

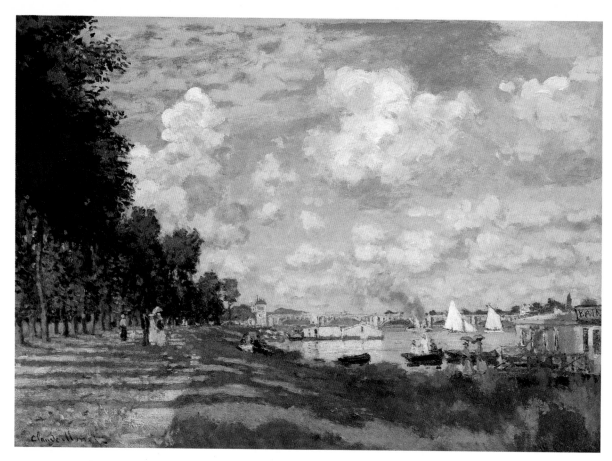

FIGURE 93. Claude Monet, *The Port at Argenteuil*, 1872,
oil on canvas, 60 x 80.5 cm, Musée du Louvre, Paris

different character, vegetation and water, appear as a woven ornament of strokes, though the painting is unlike ornament in its great freshness and conviction. Every touch seems to have been effected with a light hand and a great sureness and playfulness of the brush; the two areas are not only opposed in color but in the pattern of the weave. They are like a montage of different fabrics, matching what the painter has observed in nature, but still unlike the natural object in detail. Approach the picture more closely, and you will begin to discover the immense richness and versatility of Monet's brush as well as his eye.

That decorativeness, which appears in the taste for the impulsive and rhythmical play of the hand—a sort of animal vitality in the execution of the work as well as a delight for the eye that sees it—determined also the devices of continuity in the formation of the larger fields. For example, in an early painting, you can follow an edge, an arabesque, of trees at the left down to the foreground and along to the shore and the figures (fig. 93); you observe then that the typical irregularity and softness, the relatively unstructured and yet oddly repetitious character of that

edge, belong also to the cloud forms. Together they constitute a family of shapes that have a common source, in spite of their seeming formlessness. Paradoxically, they are formless in about the same way and are connected with one another in a distinct order. The same is true of the sails, the buildings, the tree trunks, and the shadows cast by the trunks in the foreground. As a result of this mode of composition, the work has no dramatic character; there is no focus, no concentration, no strong contrast of large, unlike features. All has been assimilated by corresponding processes of repeated and of reduced contrast, yet the whole remains a unique landscape. Never can one part be transposed to another.

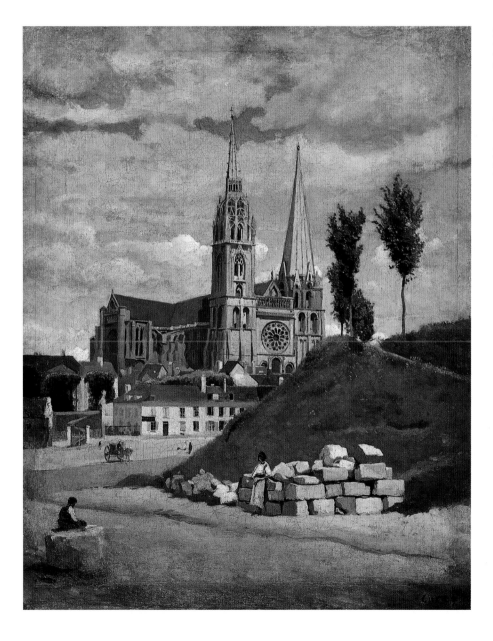

FIGURE 94. Jean-Baptiste-Camille Corot, *Chartres Cathedral*, 1830 (retouched in 1872), oil on canvas, 64 x 51.5 cm, Musée du Louvre, Paris

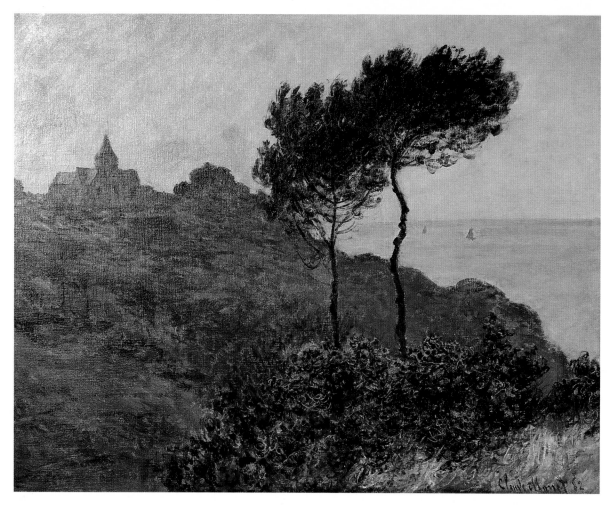

FIGURE 95. Claude Monet, *The Church at Varengeville, Grey Weather,* 1882, oil on canvas, 65 x 81 cm, The J. B. Speed Art Museum, Louisville, Kentucky

That lack of focus or drama leads us to questions about the value of Monet's work beside the painting of other great masters. By comparing him with Corot, we can judge more precisely how Monet's imagination functioned—not the imagination as understood by the Romantics, that power to conceive images of heroes and divinities, but the capacity to imagine coherent forms and to shape new types of structure. Painting *Chartres Cathedral* (fig. 94), Corot was attracted by the two trees in the front of the church. He chose a point of view that would allow him to connect the irregular trees—so different and yet matching one another—to the dissimilar towers with their spires of unequal age and size. He relates them by contrasting their silhouettes and their different attachment to the ground. One spire is like the hillock in the foreground, and the masonry of the tower beneath the spire is like the blocks of unused square stones in the

foreground. There are other very remarkable echoes, adjustments, and metaphorical analogues of parts to one another in this picture by Corot, which looks almost photographically real. Observe how he painted the clouds touching one spire and not the other. His clouds are somewhat formless and in their formlessness similar to the silhouette of the trees, but the clouds are horizontal and the trees vertical, so that a strong contrast is produced in the repetition of the form. The analogous elements are distinct in color and axis and differently related to what is behind and in front. In Corot's construction, the elements of contrast have been powerfully

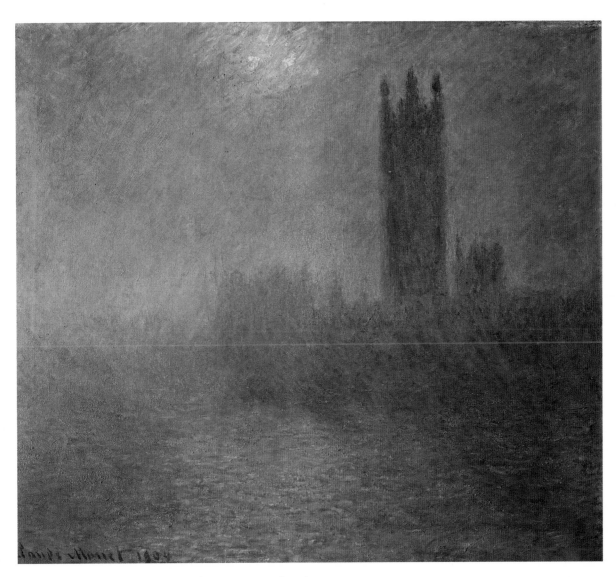

FIGURE 96. Claude Monet, *London, Houses of Parliament*, 1904, oil on canvas, 81 x 92 cm, Musée d'Orsay, Paris

applied in a whole that exhibits at the same time the subtlest proximities of tones and shapes to one another.

In Monet's beautifully painted picture of a church, two trees have merged to produce a large single mass that is repeated in the vegetation below (fig. 95). That form is related in tone to the dark, distant hill reaching up to the church and the two rising promontories. Church, trees, and rock all lack the articulation that is so interesting in Corot's work. While Corot gave distinctness not only to the trees and buildings but also to the entire space, Monet has fused the line of the foreground as a silhouette with a line of the middle distance, and finally with the very distant building. The trees merge as an arabesque with the contour of the hill. In Monet's picture, we see continuity, fusion, reduction, a simplicity of the large whole in which he makes so many fine distinctions. In Corot's painting, the order depends on many elements of independent and individualized contrast, but he has worked with fewer resources of color, relying more on value relationships, on the relative brightness of tones, while Monet has made greater use of intensities, saturation, and contrasts of hue. These two pictures illustrate sharply the shift in the conception of landscape from Corot to Monet, if not for all artists, at least for the advanced painters of that time. But it was Monet who discovered the means by which this shift was accomplished.

Returning to the Thames more than thirty years after he had painted there during the Franco-Prussian War, Monet represented the same water and buildings in a new picture (fig. 96). They fuse into one vast and beautiful silhouette, suspended in a medium through which the light flows, a mist that unites building and river and the distant shores. The earlier picture, which is a highly original poetic vision of fog and blurred forms, retains that sharp definition of foreground, middle distance, and horizon, with the distinct boats and the clear silhouettes of figures against the grayish architecture of the distance (see fig. 85). It has more of the armature of nature's space: the planes of ground, foreground, and distance, the verticals and horizontals, as well as the guiding lines of a perspective are all still perceptible. It is a space in which the human crowd can promenade. The latter picture is more like a mirage. The phenomenal prevails everywhere, fusing the objects into a rare, less articulated substance, but in that fusion it achieves a new quality of color that radiates, blurs, and blends, that is lost and recovered within its own vaporous matter.

Monet's tendency toward surface pattern and decorative repetition and analogy was already evident in his earlier work. Even in the late 1860s and 1870s in small canvases with a few objects, like his still life of fish, he composed in a way that points to the later style (fig. 97). The two fish are turned in opposition—perhaps influenced by the zodiac sign for Pisces—and are set on a white cloth of which the darker lines of the folds are of a tone that is repeated as a shadow color in the fish. But much more interesting is the fact that the uncovered areas of the table are in a soft neutralized orange tone related to the color of the fish, which have the maximal intensity of that color and are whitened in places with a tone like the cloth. With this scale of tones, the middle value, which is also a midpoint in the span of saturations, is set in the corners of the

FIGURE 97. Claude Monet, *Rougets (Red Mullets)*, 1869,
oil on canvas, 35.5 x 50 cm, Fogg Art Museum, Cambridge, Massachusetts

picture; three of these corners are shapes that can be isolated and grouped with the fish and with some of the patterns cut out in the cloth. But that compositional resonance was not conceived in the Cubist sense or in the manner of the Renaissance painters. The whole constitutes a flat vertical pattern rather than a grouping in depth and in the filling of the corners echoes the forms of the fish. Already in this ultrasensitive painting of textures and tones in a scheme from bright to neutral and from white to dark, Monet had designed in cutout fashion, flattening and filling the field with a single type of unit that has been repeated, however adroitly varied by rotation and inversion.

Even when Monet painted a scene that did not seem to lend itself to decorative repetition, the large masses share a close resemblance between the large silhouettes and the quantities of hill, road, roadside, and intervening area; they are also similar in shape, in the gentle rounding, while approaching a straight line. In making a complete composition, neither Cézanne or Renoir would likely have used elements of this degree of analogy or closeness in series. And yet it is not a dull composition: it is simply undramatic as a result of its uniformities. Each area has a unique

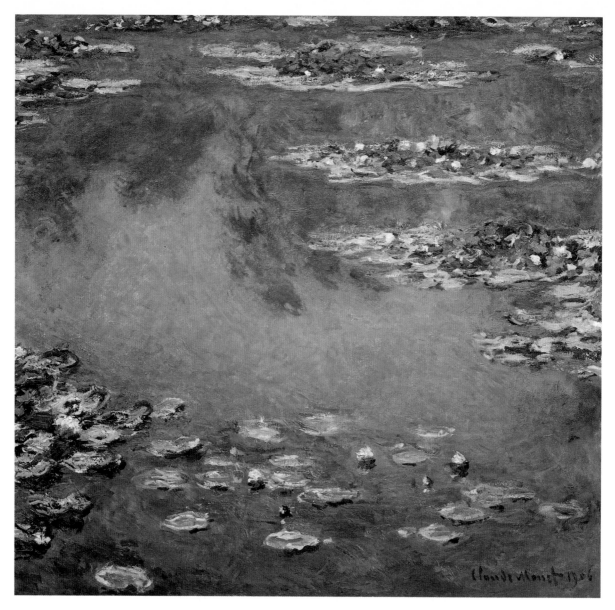

FIGURE 98. Claude Monet, *Water Lilies*, 1906, oil on canvas,
87.6 x 92.7 cm, The Art Institute of Chicago

quality of tone, brushwork, and subsisting natural texture. Each has its own little rhythm, but none is far from the others, even in the fine scale of the filling.

Monet's late phase was distinguished in large part by his water lilies, which he also painted in series (fig. 98). The stimulus for these epic works was in part the commission for the great wall paintings in the Paris Orangerie, a task that took many years and in the course of which, as a preparation and later as a continuing fulfillment, he produced many canvases with the same

theme. Monet's approach was to isolate a small section of a pond and to paint that segment in its actual size, with his canvas almost as large as its subject. This procedure represented a great departure, a kind of realism, an attempt to match the object fully. Yet the result is an image that does not seem to fit conventional ideas of Impressionist reality. Most unusually the object is a horizontal surface that has been treated as a vertical—a wall in which we see reflections of clouds, sky, and the surrounding world. The surface is the plane of existence of plants, which seem to float but have their roots below—passive existence responding delicately and sensitively to the play of light and shadow and the stirring of the water. It is as if Monet, in restricting more and more the space of the painting, made that tiny segment of the admissible world the symbol of the greater world beyond it.

Eloquently and accurately dubbed *Nymphéas, paysages d'eau (Water-lilies, Water Landscapes)*, Monet's pictures became at the same time the equivalent of an eye or mirror, fields that contain the greatest complexities and refinements of his painting of the boundless nature beyond these segments. All these qualities have been preserved in each small segment; what is more, Monet gave to the composite whole a distinctive quality through its floating, passive, reflecting essence. That quality of the pond entailed another, already remarked in Impressionist paintings of the 1870s—their invertibility. Such pictures, when turned upside down, would hardly seem different. We are reminded of the criticism made so often of twentieth-century abstract painting that the artist himself had to label the top on the back of the picture, in order to ensure the proper hanging of the work. That same criticism had already been leveled in the 1850s at the English painter Turner.

The invertible picture owes its character to the fact that there are no definite horizontal planes or that these planes cannot be distinguished from the vertical in the image of nature or that there are no modeled solid objects to guide our response to the gravity of any spatial field in which we recognize bodies and into which we can project our own existence and movements. By spreading out the elements of the picture in this way, by giving to the color an extremely light, diaphanous, translucent character, by rendering all the objects in the picture as unmodeled and floating, and by the predominance of a mirroring surface—the water—the image acquires this air of invertibility. It is not a defect; indeed, it is one of its charms, even a poetic quality, an achievement that depends upon a high degree of consistency in the relations of all the elements of the picture.

This conception of the picture has been described as pantheistic, as belonging to Monet's religious attitude, but more likely it emerged from his feeling for the Impressionist themes and as an expression of his need for solitude, for withdrawal and contemplation into a private sphere that stimulated his sensibility of color but also permitted him to project himself into that world and to identify with certain of its evident qualities. That interpretation is more adequate not just as an intuitive reading of his pictures, which depends on our sympathy with his experiences and feelings, but it is also supported by poems that express a similar mood and were written ten to fifteen years before these paintings were conceived by Monet. Composed by young men, twenty to thirty years younger than Monet, who belonged to the French and Belgian Symbolist move-

ment in the late 1880s and 1890s, these poems, describe precisely just such scenes. André Gide wrote such poems, though rather poor ones, as did his friend Pierre Louys, as well as the Belgian Albert Mockel. But the best are by another Belgian poet, Georges Rodenbach, who was close to the Symbolists in Paris. They are in clusters entitled *L'Ame sous-marine* (The Submarine Soul) and *La Tentation des Nuages* (A Temptation of Clouds), and are from his book *Les Vies encloses* (The Enclosed Lives, 1896). Many of them deal with the reflections and the depths of water:

> *Nous ne savons de notre âme que la surface!*
> *C'est ce que sait, de l'eau, le nénuphar au fil*
> *De cette eau; ce que sait, d'un miroir, le profil*
> *Qui s'y mire: ah! plonger dans l'étang, dans la glace!*
>
> *(What do we know of our soul but the surface?*
> *It is what the lily in the pool knows of the water,*
> *What the mirrored profile knows of the mirror—*
> *Oh, to plunge into the pond, into the looking-glass!)*

These poems are generally melancholy and subdued. In another poem called *Le Règne du Silence* (The Kingdom or Reign of Silence, 1891), Rodenbach wrote:

> *Qu'importe! dans l'eau vide on voit mieux tout le ciel,*
> *Tout le ciel qui descend dans l'eau clarifiée,*
> *Qui descend dans ma vie aussi pacifiée.*
> *Or, ceci n'est-ce pas l'honneur essentiel*
> *—Au lieu des vaisseaux vains qui s'agitaient en elles,—*
> *De refléter les grands nuages voyageant,*
> *De redire en miroir les choses éternelles,*
> *D'angeliser d'azur leur nonchaloir changeant,*
> *Et de répercuter en mirage sonore*
> *La mort du jour pleuré par les cuivres du soir!*
>
> *(What does it matter? in the empty water one sees the entire sky better—*
> *The entire sky that descends into the bright water,*
> *That descends into my life, pacified too.*
> *For, is this not the essential honor*
> *—Instead of the vain boats that were agitated in them before—*
> *To reflect the great sailing clouds,*
> *To repeat as a mirror the eternal things,*
> *To angelize with blue their changing nonchalance,*
> *And to mirror in a sonorous mirage*
> *The death of the day mourned by the copper twilight!)*[3]

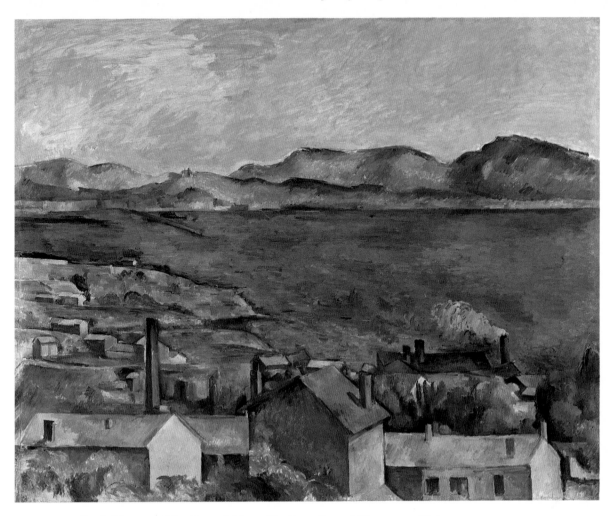

FIGURE 99. Paul Cézanne, *The Bay of Marseille, Seen from L'Estaque*, 1886-90, oil on canvas, 80.2 x 100.6 cm, The Art Institute of Chicago

The mood of these poems depends on the persistent appeal to vision and especially to color, surface, reflections, and the immaterialized quality of phenomena—features that also pervaded paintings of Monet ten to fifteen years later.

The old Monet found a rich relationship between his solitude and his love of pure phenomena, of the floating lilies and the water as a mirror with its extraordinary delicacies, in which, unlike the poet quoted above, he was never wholly passive and despondent; he always approached his paintings with an immense vigor of the brush and a will to produce large wholes rather than tiny units of poetic vision.

Monet's late views of his world of water, rock, building, and cloud compare interestingly with Cézanne's final works. Cézanne, too, was a recluse, particularly in his last years, and for most of his life was attracted to sites that he could contemplate and represent without including human

beings. Where Monet looked for the resemblance of clouds to water, of buildings to the light in the clouds, and of the trees' silhouettes to their reflections and distant horizon, Cézanne generally sought an image of powerful forces in things. He laid down an earth that is itself weighted, stratified, supporting great blocks of architectural construction or trees of accumulating massiveness and strength of light-dark contrast. Water cuts into the land, and land advances into water (fig. 99).

Cézanne's projections produce strong prongs and thrusting forms; and, similarly, they provide powerful connections between the distant jetty and a rising tower. The mountains far off have been built up in a quasi-architectural manner. The contrast of the earth to the sea is of a maximal span of hue—orange against blue, blue against green, and dark blue against light blue; the sky is a light bluish-green against the deep blue of the water, which has some violet in it. If

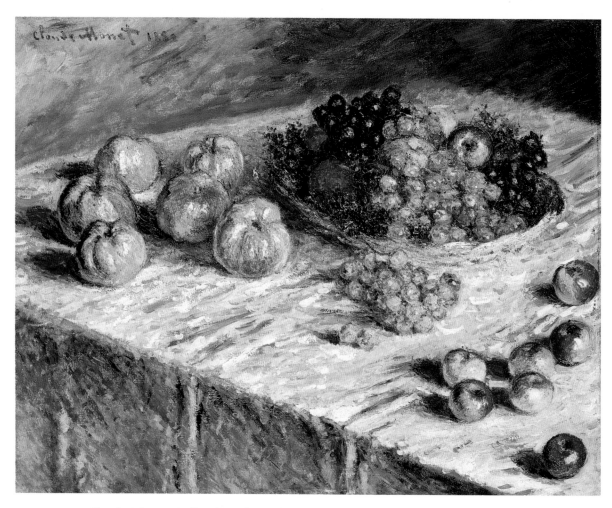

FIGURE 100. Claude Monet, *Still Life with Apples and Grapes*, 1880, oil on canvas, 66.2 x 82.3 cm, The Art Institute of Chicago

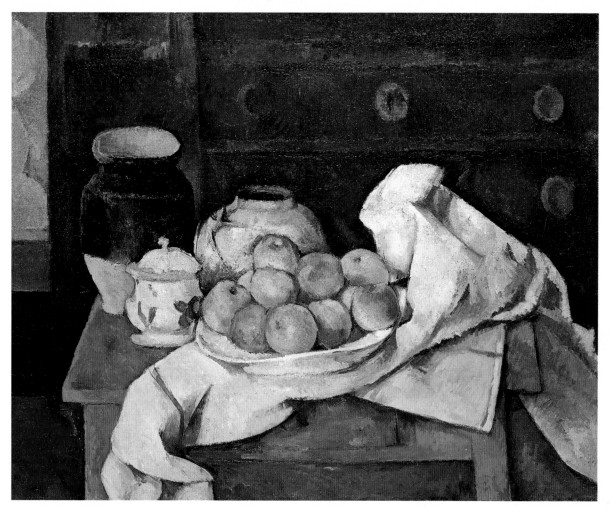

FIGURE 101. Paul Cézanne, *Still Life with Commode*, c. 1883-87,
oil on canvas, 62.2 x 78.7 cm, Fogg Art Museum, Cambridge, Massachusetts

there is a dominant violet and lavender in the distant mountain, there is also an alternation of light and shadow, of straight lines and curved lines, of lines rising to the left and descending to the right. For Cézanne, the approach to landscape always had a quality of dramatic opposition or of the calming and harmonizing of immense forces; whatever has been brought into play has a large coefficient, so to speak, before it.

Monet, on the other hand, sought assimilation and produced a delicate unity that brings all things together through an instantaneous harmonizing of innumerable analogous tiny units. He searched the larger forms for small elements, divisions of tones, that would bring them into accord with other series in the same work—series of which the elements are also tiny and possess a very small charge of color effect.

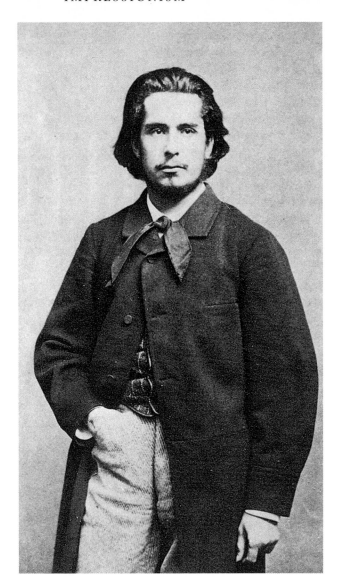

FIGURE 102. Carjat,
Monet at age 20, 1860,
photograph

An opposition of the two artists can be found even in the small segments of their work. Distinguishing between a still life by Cézanne and one by Monet is not difficult (figs. 100, 101). The objects are similar, but Monet's picture has been shaped by an impulse to repeat, to enjoy, and to multiply the typical curve or the relation of orange to blue. In the Cézanne, on the contrary, the greatest interest lies in opposing to an object something unlike itself with which it comes to terms and in building a larger set that has further elements of instability and conflict but that is finally controlled and brought to a point of resolution. This process appears also in the drastic, angular elements breaking the curve of the fruit, while for Monet the curves are broken by wavy elements that are themselves curved segments. Note, too, how in the choice of tones Cézanne's

impulse was toward a continued circulation of contrasts that builds up units of a larger order.

Hence, Cézanne worked in his harmony like a dramatist, while Monet proceeded like a lyric poet. Monet's feeling overflowed, he responded instantaneously to an overwhelming quality of the subject. Every corner of the work has been possessed by the emotion; Monet's hand palpitated and imposed on every stroke, every inch of the canvas, that initial excitement. Forces that were in conflict within his own nature—and we know there were such forces, very deep ones— were not permitted to enter the picture in terms of corresponding oppositions, polarities, or alternatives. On the other hand, the fullness and strength of emotion are manifest throughout in a harmonious and ready way. Few painters in history possessed that capacity for lyrical expression as completely as Monet. But his art is not of the same kind as Cézanne's, which is also lyrical at times, but exploits the diversity of color for a dramatic expression.

Two photographs of Monet as he appeared in youth and in old age help form an idea of the artist (fig. 102; see fig. 70). Monet stood out among the Impressionists and was admired by his fellow painters for his strength of character as well as the strength of his brush. He was known for his intransigence, his stubbornness, his absolute dedication, his willingness to endure every hardship without bending, without giving up his goals—though at one point he was near suicide. He suffered deeply through the loss of his wife, and through other tragedies, but he remained firm in his convictions. He was, besides, a man of extraordinary liberality of temperament— friendly to other artists, always cooperative and ready to speak out for the group as well as for himself, and unwilling to compromise. He was a friend and supporter of Courbet, who was imprisoned and then exiled because of his supposed part in the destruction of the Vendôme Column during the Commune in 1871. Monet was also a friend of Zola and, like the writer, was active in defending Alfred Dreyfus.

Monet's work and his life demonstrate an exceptional independence of spirit and a devotion to goals that he had set himself and that he realized not alone but in association with others. We can see in such striving his dignity, his strength of character, and his independence. These qualities of personal militancy in a struggle for art were part of the heritage of French painting and culture in the nineteenth century and were undoubtedly shaped and sustained by the political and social transformations of France during the two centuries before. Monet was aware of that tradition and always identified himself with what he regarded as the progressive tendency of life. Nevertheless, in his last thirty to forty years, he became increasingly solitary and was pessimistic about public affairs. In that attitude, he showed great integrity and honesty. But we cannot be certain to what extent his work was influenced by the discouraging impact of contemporary events of his time and to what extent his own personality led to the great shift in his painting from the public, social world to a deepened, personal solitude.

X

Impressionism and Science

THE RELATIONSHIP OF IMPRESSIONISM to the science of its time is interesting for both the history of ideas and the judgment of the art. It is well known that Impressionist pictures, when they first appeared, were often decried as untrue to nature and were explained as an aberration of the artist's eye. In reply, the novelist and literary and art critic Edmond Duranty, a friend of the painters, asserted that the color in their pictures would satisfy the most exacting physicist and that their novel art was in line with contemporary developments in science. A few years later in defending the Impressionists, the poet Jules Laforgue declared not only that their work was scientific but also that the strange aspect of Impressionist coloring corresponded to the most advanced sensibility in the evolution of the color sense of the human species.[1] Laforgue knew the argument of an ophthalmologist, Hugo Magnus, much discussed in the 1870s and 1880s, that the color sense of mankind had evolved in historic times from an early state in which only four or five colors were discriminated, as evidenced—he supposed—in the writings of Homer. According to this mistaken theory, our finer discrimination of colors had arisen in the course of the last twenty centuries.

In reply, critics argued that Impressionism was not a true art precisely because it was scientific—science and art being, as the poet Stéphane Mallarmé wrote, "enemy faculties" (though he, as an appreciative and empathetic fellow artist, did not criticize the Impressionists from that point of view). What each of the two domains stood for was held to exclude the other. Science required strict reasoning; it was the source of technical advances and supported an optimistic attitude toward existing society, while artists gave a higher value to feeling and individuality and were more critical of current beliefs about progress. Science and art were often regarded as, in principle, opposed to each other, though the two might be reconciled in the work of a rare personality.

Such, in the advanced painters' circle, was the poet Charles Cros, author of "L'Heure verte" (The Green Hour), an 1868 poem with many Impressionistic qualities.[2] Cros was admired also as the inventor of the phonograph and the author of memoirs on color photography and on

communication with distant planets. Villiers de L'Isle-Adam took Cros as the model for Thomas Edison in his 1886 scientific-philosophical novel *L'Eve future (The Future Eve)*. Edison, Villiers wrote, was a myth already and belonged to mankind and could, therefore, be the subject of a novel.[3] With Cros in mind, Villiers pictured Edison as gifted in both science and art. These were *"aptitudes congénères, applications différentes, mystérieux jumeaux"* (connate aptitudes, different applications, mysterious twins). In a world in which art and science appeared hostile to each other, their union or reconciliation was strange—a mystery.

From another viewpoint, painters of the 1880s like Seurat and Signac, admirers of science, reacted against Impressionism precisely because it was not scientific enough. They aimed at a more up-to-date art by stricter observance of the laws of optics and the perception of color.

Opposing views persisted into the twentieth century, when artists who gave up naturalistic representation belittled Impressionism as a misdirected art that aimed at the faithful imaging of the visible world—a kind of color photography. Like certain academic artists, Impressionist painters had used photographs as an aid in making their pictures. But they had not held strictly to the black-and-white photograph as a model; it suggested possibilities of spotting and composition or reminded them of a site they had actually seen and had attracted them as a subject. Contrary to a widespread opinion, the Impressionists, who were often interviewed, never declared that their goal was scientific. They were scarcely concerned, at least before 1886 (and even then in a quite limited way), with what the scientists had to say about color and light. Yet in their novel works were several challenging features that provoked questions about the connection of Impressionism with science.

By 1875 the Impressionist painters had introduced a coloring with a range and brightness that could well be described as spectral. It was not dominated, like much of older art, by browns or grays or a single hue that was felt as a tonality of the whole, but often displayed the span and seeming purity and luminous effect of the rainbow. In the appearance of the world in Impressionist paintings there is, besides, a filminess that is also characteristic of the spectrum. In color science, the spectrum is a band of hues not identified with a specific object. Appearing in nature in such occasional, striking effects of refraction as the rainbow (and the iridescence of thin films or layers of water), the spectrum was studied by the scientist as an artifact of the laboratory. Since Impressionist painters also decomposed objects—making them appear vague and often indecipherable, and replacing them by a rich play of colors that in their close succession had a spectral appearance—their colors suggested a dependence on a scientific model of light and color.

In paintings by Monet and Renoir, the range of colors deviated from those of the objects represented. In contrasting their efforts with the work of an advanced Realist artist of the preceding generation, Courbet, who also undertook at times to paint landscape in bright sunlight, we recognize the powerful impulse of Impressionist painters to spectralize the color of their landscapes; in doing so, they reminded one of the prism of Isaac Newton.

A feature of their art often cited as the outcome of scientific observation was the use of high-

key blue shadows, especially on snow where they appear more evident under a clear blue sky. Older painters had surely noticed the surprising tints in shadows, but they had not transposed them to the canvas. William James, a most attentive psychologist, wrote that shadows were brown; we can understand why, knowing that he had been a pupil of the painter William Morris Hunt, who taught him to paint them that way, establishing for James a lifelong conception.

The blueness of shadows had been observed long before but had not been rendered in painting.4 Such strikingly colored shadows became frequent in Impressionist art. The new painters were convinced that shadows are not simply the absence of light but darkened areas with a particular coloring that one could approximate in a picture by certain adjustments of the intervals of brightness between light and dark tones—for example, by painting those shaded areas in a key higher than in previous art. This would produce, in turn, a more convincing quality of bright sunlight, a stronger effect of a pervading illumination, than in the more sharply contrasted conventional light and dark. The blue shadows in Monet's picture of the Magpie (see fig. 19) are akin to the local blue color of the roof and become elements of a larger set of tones in which the shadows, the induced colors, and the local colors—all blues, and of the same pigment substance—work in concert.

Another coloristic feature important for the idea of the Impressionists' affinity with contemporary science is the idea of so-called simultaneous contrast. This concept also plays a part in the coloring of shadows but is not identical in principle with that coloring, which depends on both contrast and reflected light. In an Impressionist painting of a gray rock in bright sunlight, which appears somewhat yellowish in its grayness, the yellow note induces an appearance of blue and violet in the neighboring areas. And the blue of the sky and the water causes notes of yellow and orange, corresponding to sensations in the local color of the nearby objects. What we regard as the typical or constant color of an object is modified by many fine, elusive, induced contrasting colors, which the Impressionists were quick to sense and to transfer to the picture, often methodically.

This method included the use of divided color. To represent a local color that was fairly complex, the painters, instead of matching the color on the palette by mixing the appropriate pigment hues, applied on the canvas, side by side, distinctly contrasted notes of color that they supposed would fuse optically in perception. It was believed that such a fusion would produce purer, more intense, and sometimes more delicate tones, as well as greater truth to visual experience, than were obtainable by blending the hues on the palette itself.

Finally, it was observed that in an Impressionist painting built up through many small touches of color corresponding to sensations and also to induced effects of sensation (which might be retinal or central—scientists were undecided), the whole acquired an atomistic appearance. It seemed to be made up not of semblances of the known objects but of tiny arbitrary elements of color, units that flickered and vibrated and gave to the surface of the canvas an effect of perpetual interaction and play.5 This appearance recalled to observers the conception of the physical

world that had been created by physicists of the nineteenth century. In the 1860s and 1870s, there was much talk of atomism. The concept of substance and matter, long questioned by the philosophers as a metaphysical fiction, was regarded as useless, and one spoke instead of forces, fields, and forms. The submicroscopic world of the physics of that time was also conceived as an aggregate of particles—molecules and atoms—in ceaseless rapid motion, with qualities of randomness that could be best described by the new statistical concepts and models. The politician Georges Clemenceau, in a book about his friend Monet, pronounced the physicists' term "Brownian movement" apropos of Impressionist painting.[6]

What was the validity of such comparisons with the science of the time, and to what extent were they justified by the painters' dependence on the scientists? Were there actual connections of the kinds supposed between the new art and science? Was the Impressionists' practice indeed faithful to the scientists' notions? To begin to answer such questions, we must recognize that ever since the fourteenth century, with few interruptions, Western painters have been occupied with the problems of representation in an experimental, investigative spirit. The artists made new observations of the appearances of nature, of its forms and colors, and also devised complex procedures for representing more fully what they believed to be the visible aspect of the bodies they pictured.

Impressionism seemed to be an advance achieved by artists in the knowledge of nature, with reference to that long history of representation as an evolving, accumulative process. There is an important difference, however, between the Impressionists' knowledge of nature (and we are not considering now its source) and the knowledge reached by the Renaissance painters. The latter were occupied mainly with perceived structures or forms that interested the anatomist, the geometer, the zoologist, and the botanist. They wished to create a representation of the visible world that corresponded to the visual image in everyday experience, but in a controlled way. Through a few projective rules and restricted conditions both in sighting the objects and the picture and in choosing a viewpoint and the spectator's distance from the plane of the picture, one could determine mathematically the relative apparent sizes and foreshortenings of the objects in this projective system.[7]

Following the innovations of relief sculptors, the Renaissance painters were pioneers in developing geometrical perspective and in systematizing it mathematically. Further, in order to represent the human figure consistently and adequately for their purposes, they had to observe the form of the body more precisely; and to achieve greater skill in rendering the body in action in narrative painting and sculpture, they studied also the structure of the skeleton and muscles and the mechanics of movement so that with their understanding of that structure, the physical principles of a jointed self-adjusting system, and the laws of equilibrium, they could anticipate on paper or canvas how a body would look and what forms it would display to the eye in its many different positions, in motion or at rest. Perspective and anatomy were scientific fields that the painters cultivated and even developed in a spirit of independent research as part of their

tasks as painters. They not only read books on anatomy and mathematics, they also had to create these for themselves. The sciences of anatomy and perspective owed much to the researches of artists.

These sciences also possessed an aesthetic sense for the artist, since perspective in the framed plane of the picture was itself an ordering principle. In its mathematical relations, it provided a model of a system of coherent forms based on a few simple rules posed in advance. Likewise, the human body, studied in the sense just described, was a model of harmony. It was conceived as an ideal whole that offered a beautiful correspondence of parts, a system of interdependent forms and articulations. The body and its components could serve theoretically minded artists as a model for the order governing a picture as a whole, with its varied human figures, animal forms, and its architectural or landscape setting and elements. Interest in the human figure was accompanied by minute measurement of actual bodies and by attempts to construct an ideal system of proportions and graceful coherent postures. In addition, painters studied the forms of rocks and clouds and built up an empirical natural history that served them in their work.[8] They also cultivated archaeology in order to learn how Romans and Greeks were clothed and what objects surrounded them so that they could produce plausible, consistent pictures of classical subjects satisfying to a scholarly mind. Without sacrificing their artistic aims, Renaissance artists were led to closer observation, more systematic in some fields, less in others, as part of the procedures of painting and sculpture.

In the nineteenth century, the newer painters' response to nature did not pertain so much to sciences that described the structure and movement of bodies or that provided mathematical rules for perspective representation. The Impressionists were interested rather in how things looked in a particular light, how the lights affected one another, how colors interacted, how atmosphere changed local colors, how colors emerged from atmosphere, and how illumination of neighboring fields altered the boundaries of fields and their local color, They also concerned themselves with such matters as the relative filminess of some colors and the more opaque or bodily appearance of others. This optical sphere of knowledge had begun to emerge as early as the Renaissance and the eighteenth century, but it became a field of systematic investigation only late in the nineteenth and twentieth centuries.

The Impressionist painters were forerunners of the phenomenological study of colors, lights, and shapes. In their work, they anticipated observations that were made in the twentieth century, particularly what German psychologists called the *Erscheinungsweise der Farben*—that is, the "mode of appearance of colors." What the Impressionists learned about these properties of color and light was not written down in formal statements or considered under controlled experimental conditions; they were empirical observations applied in a practical spirit according to the artists' idea of how these observations would affect their picture and satisfy a vague but tenaciously held idea of their aesthetic goals in painting. Nevertheless, the scientists of the nineteenth century who pursued physiological and psychological optics were fascinated by the work of the

painters. Hermann von Helmholtz, the author of the classic *Treatise on Physiological Optics* (1867), published a lecture on "Optics and Painting" in which he showed not only what the new science of physiological optics could give to art but also what a scientific investigator in this field could learn from painters. Painting was for Helmholtz an independent experimental field in which certain theories of the physiologist and psychologist could be tested. That was also the attitude of the German physician and physiologist Ernst Brücke, his friend and collaborator, who was the son of an academic Austrian painter and also a teacher of Freud.

Brücke wrote a treatise on color for artists and collaborated with Helmholtz in a book on the scientific theory of the fine arts, dealing with perspective and color. In the twentieth century, German psychologists Karl Bühler, Johannes von Allesch,[9] and David Katz, in writing on the experience of color and the constancies in the local color of objects, and on the modes of appearance of color in relation to surface properties of objects, paid tribute to the subtle observations of painters. Moreover, they referred to art frequently in confirming their own observations and explanations. They showed how one can infer from their theories what will happen if one tries to reproduce an appearance on a canvas under specified conditions.

Indeed, well before our time painters influenced physicists as well as writers on physiological optics. The familiar fact that painters regarded red, yellow, and blue as the primary colors led scientists, including Newton, to isolate these as primaries in the physiological process of perception of colors, and even in physical descriptions. Newton, however, singled out seven hues in the spectrum because of the analogy with the seven tones of the octave, an analogy that he illustrated with a diagram. For a long time it was difficult for scientists to accept the idea of Thomas Young, and of Helmholtz who revived it, that red, green, and violet were physiologically primary; for this view did not agree with the teaching and practice of artists. The art schools taught that red, yellow, and blue were the true primaries. In holding to these hues as the primaries despite Young, the Scottish physicist Sir David Brewster, cited the practice of painters as an argument.[10] The influence of the tradition of painting on science extends further, but not in areas relevant here.

Their connection to the study of perception led the Impressionist painters away from the strict linear contours and the carefully constructed perspective of Renaissance compositions. As mentioned earlier, the Impressionists blurred the familiar outlines of objects, fusing them with each other, immersing them in atmosphere, and breaking them up in light (see, for example, figs. 6, 9a, 13). The replacement of the closed, constant form by variable, unstable forms under the dominance of light and atmosphere was an essential feature in the art of the Impressionists. Those forms were unlocalized and unbounded and pervaded the field as a whole.

As previously discussed, the Impressionist painters favored those colors and devices of coloring that were consistent with the universalized stroke as an equivalent of a sensation or impression. One of the consequences of that approach was the abandonment of traditional perspective. A painting in strict perspective required a preliminary construction of an outline on the surface

of the canvas, a scheme of convergent lines, with a vanishing point and a distinct horizon. Failing to follow such strict perspective did not mean that the Impressionists were unaware of convergences and diminutions according to the laws of perspective. Their direct method of working *alla prima*, that is, commencing a painting without a preparatory drawing, made it impossible to start with a perspective grid. Perspective as a system is not something that we perceive as we sense color. For practical artists, perspective was a theoretical construction, a preliminary consideration, and the Impressionists did not construct in advance. They responded to immediate impressions of large complex wholes for which they sought an immediate, impressing imagery, with properties that reinforced intensely the valued qualities underlying each original chosen subject, its atmosphere and life, and the artist's viewing point.

In Monet's painting of the railroad station (see fig. 13), any attempt to determine the vanishing point would be frustrated by the blurred distance, by the smoke and steam and the locomotive interposed between us and the distant objects. But even the straight lines that might have led us to the vanishing point do not yield a consistent perspective pattern. Nor are the lamps, with their varying ellipses, compatible with a fixed viewpoint of an observer at a definite eye level. The Impressionists improvised directly, upon immediate perception of the object, the forms that were suggestive of the object, but they avoided tracing them precisely. They shunned the rigidity that would result from a planned perspective drawing made in advance. On the contrary, because they were naively committed to the look of things at the moment they painted them, and wished to free the colors from hard, predetermined shapes, they often introduced on the canvas fine deviations from the object-form and from the expected mathematical projection. Certain of these deviations actually occur in laboratory experiments as what are called figural aftereffects— the influence of one shape upon a neighboring shape under special conditions.

As noted earlier, the Impressionists gave up not only strict perspective but anatomy as well. Drawing figures with his brush, Monet was not concerned either with their exact proportions or with the underlying bodies and their precise, outlined articulation in movement. Instead, he applied with force tiny patches of color that were for him "true" to his impression of the subjects and also right for the pattern of the painting on the textured surface of the canvas. His procedure ignored traditional anatomy and perspective without violating, however, the commitment to painting what he saw.

From the scientific point of view, the most important writer on painting in the academic tradition of the nineteenth century was the pioneer organic chemist Michel-Eugène Chevreul. His work serves as a useful reference point in any account of the Impressionists' relation to color science. His book *The Law of the Simultaneous Contrast of Colors* was published in 1839, and his ideas were also known through his lectures on color, which were attended by many young painters. In his work, Chevreul undertook to formulate laws of the interaction of neighboring colors when seen together. He was led to this problem by a challenging experience as the chemist of the Gobelins factories, which produced for the French state tapestries for public buildings. The

painters and artisans who designed and executed the cartoons at the Gobelins and depended on Chevreul for the quality of the dyes employed in the colored threads complained that the blacks he supplied them were not deep or rich enough in effect; they looked weak and dusty. Chevreul asked the artists to show him specimens of a good black, and analyzing these chemically, he found that they were no different in substance from the defective blacks. He was thus led to examine the visual context of the color. Observing that the unsatisfying black was used as a shadow tone on a blue or violet form, he was led to investigate the effect of the neighboring color upon the black.

Chevreul was not the first to have recognized that effect. In the eighteenth century, the fact that neighboring colors influenced each other's appearance was well known. Buffon, who had written about such perturbations, called them "accidental" or "fugitive" colors. If you place a red and a blue patch side by side, the blue will look a little greenish because of an induced yellow-orange and the red will look orangy. These effects had, interestingly enough, already been noticed by Aristotle. In his *Meteorology*, Aristotle credited the observation to the tapestry makers and dyers who spoke of difficulties with black.[11] Over a period of 2,200 years the same problem had been pinpointed twice, and both times sagacious observers had concluded that colors interact when seen together.

Chevreul investigated systematically many effects of colors on each other. He described the reactions of large numbers of paired colors and summarized them in a teleological manner, countering our natural tendency to see neighboring colors as unlike as possible. Chevreul's formulations were significant also for the practical conclusions that he drew from them. For example, he advised artists not to use black as a shadow color for a blue or violet strip (though one could do so with reds or yellows and various tones of those hues). But he was especially concerned with more general principles to help painters. In his book, he counseled artists that if they wished to render properly what they see before them, they should not be faithful to how things look. Painters must know these laws, he advised, in order to be able to remove what is accidental in the color and thus get at the true local color of the object. If a painter looks at two objects that he knows to be blue and red and the blue one looks greenish and the red orangy, the painter will know how much to subtract from each as the result of simultaneous contrast to arrive at the true color.

Chevreul's advice was consistent with his own taste in art. Born in 1786, he was affected by the Neoclassical tradition prevalent in his youth. His favorite painter was David's pupil Girodet, whose work, muted in color, with grays and blacks and dulled tones of the stronger colors, was most notable for its careful finish and striking chiaroscuro. But Chevreul's approach stemmed from a broader attitude in which the perturbing interactions in nature and life, though subject to laws, were not permitted to alter the inherent properties of individuals or to mask an essential constancy or truth. His law of simultaneous contrast seemed to him a principal application in fields other than color. He observed, for example, that when two individuals argued, A did

not hear correctly what B said, nor B what A said, but there was induced in each the complementary or logical contrast to what the other said; which when added to the other's view, colored or deformed it. In order, then, to reach a proper mutual understanding, one must subtract the simultaneously induced contrast occasioned by the confrontation of opposed views in argument.

Chevreul's approach to that psychological problem in terms of a norm of color—the constant local color that he believed the painter must preserve on the canvas—is surprising. Remarkable, too, is the fact that the problem from which Chevreul started was how to produce a good black. The Impressionists, on the contrary, were not at all concerned with the "real" local color of an object; the color of the grainstack (see fig. 88) was for them anything but its constant defining local hue. The light on one side determined a yellowish orange tone; below was a more reddish one; in the shadows, there was much blue, violet, and green; and in the sky, the distant hills, and the foreground were many subtle notes of color that appeared in the course of the painter's intensive scanning of the scene for suggestive colors—fugitive notes that to the older writers were mere phantoms or accidents. In German, they were called *Gespenstfarben*, or "ghost colors." Before the Impressionists, one had to know how to get rid of them in order to render the "true" color, but the Impressionists, truly brought those ghosts to life.

The Impressionists were not interested in black. Part of their program was to eliminate black from the canvas altogether as a nonspectral, therefore antiluminous, color and never to use black as a means of shading or of modeling colors to a lower key. It was, as the scientists had taught, a noncolor and therefore seemed incompatible with the ideal of a natural spectral coloring and luminosity. It is true that Renoir used black as a local color in the 1860s and early 1870s, but his later work was free from it.

It is clear from these facts that if the Impressionist painters had read Chevreul and had been faithful to his teachings, they would not have painted as they did. Impressionist practice may be closely compared with Chevreul's observations on the colors that were induced when we look at objects of bright color next to one another; but the practical conclusions drawn by Chevreul from his observations were not followed by the Impressionists.

There is reason to believe that the Impressionists were not acquainted with Chevreul's writings, or that if they had come upon them, they paid little attention to them. In 1886 when the Impressionists had already emerged as a well-established movement in France and had many disciples abroad, Pissarro wrote to their dealer, Paul Durand-Ruel, telling of a young artist, Georges Seurat, who had made remarkable discoveries in color and devised a new method of painting based on a treatise by a chemist, Chevreul. That year the aged chemist celebrated his centenary, an event which inspired the first photo-interview, with Chevreul discoursing to Nadar on "The Art of Living for 100 years" (fig. 103). Chevreul died three years later. Pissarro's mention of Chevreul was the first in the large surviving correspondence of the Impressionists, and Seurat's approach was, in fact, quite different from that of the Impressionists. He did use simultaneous

contrast but not in the way that the Impressionists had done. The Impressionists' pictures were rarely, if ever, consistent in reproducing induced colors. In some paintings, especially where they wished to create an effect of intense sunlight or where they aimed at a rich crust of color with a maximum of small, subdivided, contrasting tones, they were attentive to whatever would supply them with the notes of color that they could use in their scrutiny of the scene, at the moment of painting the picture. They did not test their chosen colors according to Chevreul's laws, as close study of a segment of Monet's painting of Rouen Cathedral shows (see fig. 10).

'I find here the name of Monsieur Pasteur: that is where I will write my name. Monsieur Pasteur is one of the greatest geniuses of our age because, contrary to his predecessors, he proceeds from the unknown and not from the known.'

'What would you like me to write in your album?'

'I am going to write my first philosophical principle, it was not I who formulated it but Malebranche. I have looked hard, but I have not found a better one.'

'One should strive for infallibility without claiming to have achieved it' (Malebranche).

FIGURE 103. Paul Nadar, photos of Chevreul aged 100 talking to Félix Nadar about "The Art of Living for 100 Years," from *Journal Illustré*, September 5, 1886

Here we see that the amount of yellow and orange in the shadow is not simply a reflection from the yellow on the illuminated parts of the stone of the cathedral—the stone was not really so white—but had also to do with the blue sky and, above all, with the painter's rapture before the sublime phenomenon of the cathedral in sunlight. It also accords with the vision of the novelist Joris-Karl Huysmans, who, in describing the front of the cathedral, wrote that in the sunlight "the yellows hallelujahed."[12] Actually, this quality of the light does not agree with the predominantly orange and red light of the afternoon when the west façade is directly illuminated by the setting of the sun. In the choice of these colors, the painter hardly followed Chevreul as a model, in the way that Renaissance masters followed anatomical norms or applied perspective, with precise measurements. Monet worked in a more spontaneous, lyrical manner, responding to what was immediately given to his eye, and given because he was searching and alert to that quality, which would be absorbed according to an inspired conception of the picture as a colorful whole.

Artists long before had been aware that just such odd manifestations of color appear in bright sunshine and even in less brilliant light; but they had chosen to eliminate them as accidental. In a passage from a standard manual of landscape painting at the beginning of the nineteenth century, the painter-author, Pierre-Henri de Valenciennes, spoke of optical illusions produced by colors that "deceive the eye no less than those produced by lines." He continued: "What is vague in nature ought not to be represented, for even if one succeeded in rendering it with the greatest exactness, one would only have taken pains to represent an illusion and, therefore, a falsity." This warning was taken seriously by most artists.[13]

The Impressionist enterprise flew in the face of such traditional editorial wisdom. The Impressionists' persistent search for vague and supposedly illusory tones in the visual field was not an adherence to scientific teaching—although it was compatible in some features with Chevreul and the spirit of science—or to the conclusions drawn by the scientists as to what a painter should do. Those conclusions depended less on science than on the scientist's taste in art, or on his theory of knowledge, his idea of what a representation ought to be, what one should represent if one wishes to render the so-called real object. It is in such terms that we must read the prescriptions of modern scientists with regard to painting. And the same applies to some psychologists in our time who have written about art.

Concerning color variation, Helmholtz counseled painters that they need not pay attention to the changes of local color in simultaneous contrast, because, if they had such sensations from the objects, they could elicit the same responses in the observer by simply painting the local color.[14] Helmholtz also advised painters about the optimal conditions for producing good representations. He remarked that at noon the sunlight, striking rooftops and the ground with its highest intensity, tended to decolorize, that is, to whiten, objects; in such strong light we would be unable to distinguish the local color and its modifications easily, if at all. He therefore warned painters against the practice of painting at midday.[15]

FIGURE 104. Claude Monet, *St. Germain l'Auxerrois*, 1867,
oil on canvas, 79 x 98 cm, Nationalgalerie, Berlin

That time period, however, was precisely the one the Impressionists preferred. They wished to see objects under conditions that destroyed the familiar stable attributes—local color and shape.[16] Monet painted the Church of St. Germain l'Auxerrois in Paris when the light fell so directly on a rooftop that it was almost indistinguishable in value from that of the sky (fig. 104). The tops of the trees were similarly illumined so as to suppress the obvious green of the foliage. Like the mode of composition, the intensity of light here was a means of replacing what would be the familiar isolating aspects of color by mutations. Together with the complex forms of objects, these create the surprising, stirring appearance of a complicated, unanalyzable world.

Another example of color analysis from Helmholtz's writing, which occurs also in Brücke's, concerns the rendering of the volume of objects. Helmholtz explained, as painters had known

FIGURE 105. Abbott Thayer, *Peacock in the Woods*, 1907, oil on canvas, 116 x 93 cm, National Museum of American Art, Washington, D.C.

since the fourteenth century, that if you wish to represent an object with an adequate effect of relief it had to be illuminated from the side in order to produce a graded shadow at the farther contour and a contrast with the surroundings. The background then is darker against the light side of the object, lighter against the dark side. This was, in fact, the method of modeling in some early Impressionist works, although in the backgrounds one no longer followed that ancient rule.

In the course of his development, Monet came to disregard this principle. He deliberately chose illuminations from behind that isolated objects as flat silhouetted surfaces, much flatter than they appear to us. We are inclined to restore the bulk through our knowledge and through paying more attention to the contours than to the color, while in the original the shadow cast by the haystack fuses with the silhouette of its shadowy surface, and the colors of object and

shadow contain so many similarities and echoes of one another that they seem to be a single continuous surface patch. In the background a luminous haze of phantom color with little range of values in turn sets off the flattened cutout of the object, which becomes even more pronounced, even as it advances toward us. This kind of solution was not a perverse, unscientific choice, but arose from the painter's choice of an effect that was realized no less scientifically than the traditional one. If the artistic problem is to present a haystack with that shadowy, filmy appearance, this is the proper lighting and this is the point of view for the painter to select.

Helmholtz, Brücke, and Chevreul, who had similar views, all drew from their scientific knowledge advice for painters that favored the constancy and distinctiveness of the object's form and color because they were committed to an aesthetic of the scientist—not necessarily an aesthetic of the laboratory phenomenon, but rather of scientific intellectual activity. They found beauty in clarity and simplicity; they sought classifications, invariants, a stability of knowledge, a reduction of the great complexity of things to a compact logical system that allowed them to deal with the variety of phenomena in an economical manner.

Yet a scientist could draw the opposite conclusion from practice. At the moment that these scientists were writing in this vein, a contemporary investigation of protective coloration showed that the coloring of animals in nature depended on relationships of light and dark and of colors that made the animals' contour and color hard to discriminate against its ground. The scientist who first made these observations was a painter, the American Abbot Thayer. He analyzed the pattern and figure-ground relationships that entered into what he called the "obliterative" coloration of animals. For Thayer, nature offered exemplary principles to guide a painter who might have wished to fuse ordinarily distinct forms into a pattern in which figure and ground could not easily be distinguished.

Thayer's own work as an artist, which was in a pre-Impressionist vein, was less advanced than the pictures he made in the 1890s to illustrate a book on protective coloration written by his son. In his painting *Peacock in the Woods* (fig. 105) you can barely discern the bird because the small units of color on its feathers, in contrast with one another, are so like the flickering subdivision of color in the surrounding vegetation. In his preface to the book, Thayer remarked that only a painter could have discovered these laws, because painters alone were truly interested in how things look; the ordinary man was not, and the scientist, too, lacked the proper attitude toward the perceptual world that would have permitted him to discover these laws.[17]

In Monet's painting of a garden (fig. 106), you discover hidden in the lower-left corner a child whose coloring merges with the coloring of the tablecloth and vegetation, as does also that of the female figures in the distance at the upper right. The Impressionists painted such effects independently of scientific aims. They had already discovered in nature and welcomed as beautiful those occasions of light and color in which objects were fused with their surroundings; they devised new methods of painting in order to realize those qualities more fully and harmoniously on the canvas. In one of Pissarro's landscapes, the trees in the foreground cross and cut up the

FIGURE 106. Claude Monet, *The Luncheon (Decorative Panel)*, 1873, oil on canvas, 162 x 203 cm, Musée d'Orsay, Paris

forms of the buildings in the middle distance, so that we cannot easily determine their positions in depth nor trace their precise shapes.

Monet's paintings of the water lilies (see fig. 98) pursued this fusion further. Here the reflections and the observer's perspective have been designed to bring about an allover surface effect offering an instance of the deliberate, consistent effort by the Impressionists to render precisely those aspects of the landscape that became the starting point for pictures in which the familiar properties of things were sublimated, veiled, and transformed.

Another aspect of Impressionism that has been compared with scientific work is the divided brushwork, the breaking up of the color into supposedly pure, elementary spectral components. The Impressionist use of "divided" color was part of the universalizing of the stroke as a distinct

working unit, alike in all parts of the picture, without the spatial hierarchy common in older paintings where distant objects were treated in small flecks but the nearer ones were depicted with smoothly blended brushstrokes that render the texture and surface mode of appearance of objects that are closer to the viewer.

In using their new method, the Impressionists did not apply it in a strict or mechanical way, as was sometimes supposed by writers in the 1880s and 1890s. They employed it freely and imaginatively as the expression of the picture required, in keeping with their taste for flicker and vibrancy and for a tangible pigment surface and texture. They also employed it to effect an air of randomness in the composition, together with a loosening of contours or merging of colors along the edges. These properties were so valuable for the aesthetic of Impressionism that one can describe the choice of colors without referring to a general physical or physiological principle governing their combination. The Impressionists did not break up their surface fabric in order to achieve greater brilliance or purity. Many of their pictures have, on the whole, a subdued or grayish effect. Many tend toward neutral tones, as in the subtle winter paintings of Monet and Pissarro. Besides, the Impressionists could introduce larger unbroken areas in their paintings, which, for the sake of accent, brightness, or contrast, were not as variably flecked or spotted as other parts.

The palettes of the Impressionists did not correspond to a preconceived ideal of pure spectral colors. They employed the contemporary paint manufacturer's usual colors; only certain earth pigments, browns, and blacks were omitted, but the yellows, blues, and reds were not the pure yellows, blues, or reds of the spectrum. The painters at times applied greens directly from their palettes and other times would mix blues and yellows. The unmixed, juxtaposed blues and yellows together did not produce the effect of a green, naturally, but a greenish-gray. Some writers have mistakenly accused the Impressionists of misunderstanding physics and of aiming vainly to produce a sensation of white light by putting a blue and a yellow together, as if the painters imagined they were working with spectral light rather than with pigments.

The Impressionists were unconcerned with a scientific ideal of purity or elementarity of colors; whatever colors they chose they used subtly in an experimental, empirical way, changing their method from time to time, from picture to picture, or even from part to part on the same canvas, according to the imagined possibilities and the qualities arising from these juxtapositions of color. In a Renoir painting, which focuses on a small segment of nature (fig. 107), the flicker and liveliness, the universalized contrast and play, and the marked materiality of pigment subdue the textural quality of the plant forms themselves and permit us to see how far the Impressionists were from the strict, systematic approach of older artists to correct anatomical and perspective forms.

One last type of relationship between the Impressionists and the scientists can be considered: the analogy that has so often been drawn between the Impressionist picture as a totality and the so-called atomistic picture of the world presented by scientists, philosophers, and popular writers on science between 1860 and 1900. There is no evidence so far that the Impressionists

FIGURE 107. Pierre-Auguste Renoir, *The Garden in the rue Cortot, Montmartre*, 1876, oil on canvas, 151.8 x 97.5 cm, Carnegie Museum of Art, Pittsburgh

were acquainted with them, no references in Impressionist literature to the names of such figures or their books.

The attempt to relate Impressionist pictorial structure to the scientific view breaks down for several reasons. The scientific picture of the world is not an image of nature as given to the eye, but a sophisticated theoretical construction. The scientist has conceived a mechanical model of a world that has not been experienced directly in terms of perception but that has certain effects, deduced from the properties of the model and from the laws of mechanics, that may be listed on the level of ordinary observation. Our everyday observations would not by themselves have allowed us to imagine that structure. This fact alone should make us doubtful of the idea of the Impressionists' dependence on physics, particularly since their methods of applying the small strokes of color had little to do with calculation, regularity of control, or uniformity of elements.

The Impressionists' methods do have, however, a sufficiently clear connection with two empirical fields. One is their own practice considered from the point of view of the effects. Here separate colored touches, broken colors, and small units, have replaced the textures of things by the texture of paint. What is represented in this way seems less substantial and more filmy. The small touches are also a means of creating luminosity; light is seen less readily when we are attentive to the unbroken local color that has been illuminated and that is bound to a clear contour defining the object, just as a local color helps to characterize the object. As a practical method rooted in a hundred years of painters' experience, the divided brushstrokes are intelligible without the assumed model of science.

A second source may be found in the conception of the themes of Impressionism, which relate to the moral and social outlook of the Impressionists as well as to their personal temper. These themes constitute a human and natural world in which motion and constant change were valued. The appearance of the whole depends on the individual's movements and attitude in an environmental field with perpetually changing parts and without a fixed center or axis. This world, which was accepted joyously by the painters and was one of their chief subject matters in the 1860s and 1870s (and for others, like Pissarro, persisted into the 1890s), already offered a model of these qualities of the small unit. The great aggregate of random touches contributed to the appearance of mobility and relative informality in the world represented and to its aspect of change and freedom. That general mobility was recognized by the novelists and poets as one of the conditions of individual freedom.[18] The writers of the first half of the nineteenth century (independent of the sociologists and physicists) left us many interesting remarks about these qualities as experienced in Paris. Their view has, of course, something to do with the attitude of social thinkers, who, in the course of the new growth of industry and trade, and the social struggles that accompanied them, formed concepts of dynamics that reflected, in different ways and according to conflicting goals or interests, the experience of the growing city and the developing forms of social and economic life.[19]

In the positive attitude of the painter to his world, we find the grounds of certain tendencies of composition in Impressionist paintings. In the 1830s, well before the Impressionists, Parisians were intensely aware that the modern world was characterized by universal movement and that the individual was a restless unit in a crowd. This conception was a source of Poe's famous story, "The Man of the Crowd," which was translated by Baudelaire and which became a model for novelists in characterizing social groups. The imaginative pictorial and literary atomism and dynamism, like the theory of society, could not be patterned on the physicist's concept of gas and heat as states and types of particle motion but could only come out of a collective social experience, an experience shaped by contemporary values and social perspectives.

In his *Peau de Chagrin*, Honoré de Balzac told of a wild ass's skin that enabled its owner to fulfill his wishes; but with each wish his life was shortened, and the wild ass's skin itself shrank as a material sign of this decreasing power. Balzac offered a poetic model of an irreversible process, the "degradation of energy," but without any pointed reference to "entropy."[20] The owner strove to overcome the fateful shrinking of the skin. He brought it to a physicist whom he asked to stretch his uncanny possession. The physicist applied the most powerful modern machines but could not arrest the process. The skin did not belong to nature; it was a magical, supernatural, object. Philosophizing, Balzac delivered a speech on the nature of motion:

> Everything is movement; thought is a movement; life is based on a movement; death is a movement to which the end escapes us. If God is eternal, you may be sure he is always in motion. God is perhaps movement itself. That is why movement, like him, is inexplicable—like him, profound, without limits, incomprehensible, intangible. Who has ever touched, comprehended, or measured movement? We can feel its affects without seeing them. We can even deny it as we deny God. Where is it? Where isn't it? Whence does it come? What is its principle, its end? It envelopes us, presses us, and escapes us. It is evident like a fact, obscure like an abstraction. Effect and cause all at once. It requires space as we do, but what is space? Only movement reveals it to us. Without movement it is nothing but a word without sense.[21]

Balzac's notion of the skin is a kinematic, not a dynamic, concept of perpetual motion, without a cause, a view that shares certain aspects with Buddhism.

Balzac had described Paris as "*le capital de hazard*" ("the capital of chance"); he had spoken of Paris also as an ocean. This theme of the universality of movement belongs not only to the philosophy of nature at the beginning of the nineteenth century; it appears also in social theory in the notions of historical development and the atomism of society. The French philosopher, journalist, and politician Pierre Leroux, in 1833, at the same time as Balzac, characterized individualism in his society as a reduction of man to atom; it is the same term that Karl Marx used in 1844 when he wrote of a world of "atomized, mutually hostile individuals" in collision and

conflict.[22] This restless, chaotic world, however, was also a ground of liberty, favoring individual initiative and enlarged experience and permitting the pleasurable detachment in which the city dweller felt unconstrained by custom and convention.

The open pattern of society confirmed the urban resident's inner freedom, however problematic, and it encouraged the striving for personal growth and creativeness. That view was expressed in many novels of the nineteenth century. When Maupassant discovered Impressionist art, he was led through the paintings to look at the world with new eyes. He wrote then his passage on the intense perception of nature as the only consolation in a world that had become inhuman and repugnant to a man of his sensibility. Describing nature as seen by the Impressionists, he wrote, "My eyes, opened like a hungry mouth, devoured the earth and the sky. Yes, I have the clear and profound sensation of eating the world with my glance, of digesting the colors as one digests meat and fruit." "All that," he continued, "is new to me and I perceive that never before had I looked."[23] Here that mode of seeing colors rather than objects became the norm of vision as opposed to the traditional approach of Valenciennes, Chevreul, and Helmholtz. Vision is precisely when you don't see things, but when you experience color and movement and flicker as an absorbing universal process.

I have mentioned the railroad as one of the exciting models for the painter at this time. The business world, too, displayed to the artist a model of continuous and random movement. Even where its figures are represented in a precise way bound to a classical norm of drawing, as in the work of Degas, their composition expresses this new vision of social life. Degas was a marginal Impressionist, and not until a later time at the end of the 1870s and 1880s did he begin to use pastel with a chalklike, granular, microstructure of powdery colors that broke up the forms of the living body and objects and replaced them by coloristic effects. In the early 1870s, when Degas painted a picture of the cotton office of his family in New Orleans, he represented the figures with a new veracity (see fig. 77). Their cold black-and-white coloring unites them with the inanimate records and papers, the cotton, and the books; Degas's grouping of these figures is amazingly photographic, but in its sharp, candid revelation of the nature of office activity, anticipates any comparable photograph. The grouping has much of that randomness of the crowd in the streets or cafés or railroad stations; it is the business office as a sober world of ongoing traffic. We see how from experience itself the Impressionists were able to derive features that one might otherwise have credited to the model of scientific thinking at that time.

A confirmation of the Impressionists' independence of science is the reform of their method undertaken by the young Seurat, after 1882. He had read the work of the scientists Chevreul, Helmholtz, Brücke, and the American physicist Ogden Nicholas Rood and wished to reorganize the practice of his art according to their principles. But Seurat was not at all faithful to their prescriptions and Rood himself was later to disavow the use that the Neo-Impressionists made of his writings. In Seurat's work, we see how painting that took seriously the idea of a scientific model came to look in the 1880s. It is related to science not so much in the fact that it attempted

to reproduce strictly the complementary colors and effects of irradiation described in the scientific textbooks of the time, but rather in the notion that the whole picture is a system in which small elements, though not identical in size, are visibly alike, and through their varying color, can evoke the qualities of the visible world. Seurat accomplished that end, moreover, with larger forms and groupings that have an air of precise calculation.

At the same time, nothing in Seurat's paintings seems to have been drawn; all depends on the variable color in the tiny brushstrokes. If there is an outline, it is simply a region on the canvas where the dosage of contrasting colors tends to average out into adjacent fields of color, in which the distribution of clustered points of maximum difference of brightness maps a shape, a contour, or an edge. This conception, then of an order emerging, statistically as it were, through a highly controlled, almost systematic application of color, gives a scientific aspect to Neo-Impressionism. And that quality depended finally on the unique genius of Seurat. His fellow painters, Signac and others, who had read the same texts of physics and physiological optics, were unable to realize a whole as thoroughly imbued with this approach. Seurat possessed what is rare among scientists as well as artists: a genuinely scientific temperament. By its own endowment, his mind was constructive and exacting, with a rare power of imaging formal possibilities and a great strictness in carrying out the consequences of his ideas.

Even for Seurat, science did not entirely provide the models of his art. His scientific knowledge probably did not extend to the advanced physics of the time, which dealt with an imagined world of molecules and atoms and applied to it a subtle and powerful mathematics he would not have acquired in the *lycée*. He was more likely influenced by the rational technology of his time, which also produced great structures made up of many small prefabricated units, assembled in a strict, calculated way and characterized also by spectacular effects of light and airy space. Engineering in France had been based on rational mechanics and on a greater use of mathematical analysis and calculation since the beginning of the nineteenth century, a strong tradition in French thought. With his ideals of order and mastery and his methodical way of working, Seurat was able to achieve his surprising constructive style probably in part through the stimulus of the visible models offered by the new and imposing world of engineers' constructions. In his painting of the *Invitation to the Sideshow* (fig. 108), executed before the Eiffel Tower was completed in 1889, the central figure reminds us of that monument in form.[24] Seurat was one of the few artists to admire the Eiffel Tower, to enjoy and accept it, and even to depict it.

Seurat's sketches for the *Invitation to the Sideshow* reveal a curious resemblance to physical diagrams of fields of force. They suggest magnetic fields, as if the painter had seen the scientific representations of these and had built his composition accordingly. But this is less significant than his debt to rational technology, which provided monumental examples of constructions made of small, uniform elements.

Seurat's scientific bent, his affinity with the methods of physicists and chemists, appeared also

FIGURE 108. Georges Pierre Seurat, *Invitation to the Sideshow*, 1885,
oil on canvas, 99.7 x 149.9 cm, The Metropolitan Museum of Art, New York

in his determination of the price of one of his paintings. He set this price at the cost of his maintenance during the year it had taken him to complete the work. He reckoned this cost at seven francs a day; but he was ready to reduce the sum if he liked the purchaser. He regarded his work as a summation of equal daily units of labor; and he measured the cost of his labor as the cost of his maintenance (food, rent, materials, and so on) during that time, which was also counted as a sum of equal units, as if every part of his effort had the same importance for the final result. He not only held to a classic labor theory of value but also to a classic view of the cost of that labor. To appreciate the distinctiveness of Seurat in this matter one may compare him with Whistler. In suing Ruskin for libel in a famous trial, Whistler was asked by an astonished barrister if he actually charged two hundred guineas for only a few hours work. "No," riposted Whistler, "I ask it for the knowledge of a lifetime."[25] For Whistler, his painting had a value incommensurable with its time of production; for Seurat, it was the result of so many equal units of work.

Factors suggesting a relationship between the Impressionists and the science of their period

227

include the importance of science during the period of the movement, the Impressionist painters' devotion to the visual, to the immediately surrounding world, and to the value of individual efforts in painting; and the artists' initiative in devising new ways, and their attempt to search out the consequences of their ideal of an ordered whole—aspects that remind us of a scientific temper. But such a connection can best be established not through an influence of the scientist on the painter but in their common empirical bent, their enjoyment of the phenomenal world.

In the more popular writings of Helmholtz, John Tyndall, William Kingdon Clifford, Brücke, and many others, the scientists, including those who used mathematical methods and those who experimented in the laboratory rather than observe nature outdoors, revealed themselves as men with a hearty love of nature and a great curiosity about the appearance of things and their effects upon us. In that respect, scientists and artists belonged to the same moment in Western culture and may well have reinforced each others' attitudes. In his letters, journals, and published writings, Helmholtz spoke frequently of paintings. For a lecture in London in the 1860s, he made a small watercolor, since lost, to illustrate a point in optics. In traveling, he constantly sought out works of art and wrote long letters about them to his family. These scientists belonged to a culture in which the visual in nature and the laboratory formed a single whole, with many rapports, many mutual reinforcements.

On the other hand, to try and account for Impressionism through the influence of individual scientific researches on the paintings of the painters can easily lead us astray. In such comparisons we are inclined to think that the scientists who were sufficiently interested in painting to draw conclusions for artistic practice from their scientific observations counseled the opposite of the conclusions drawn by the painters. It does not mean that the painters were unscientific, but rather that the scientists were not yet Impressionists; they were attached to an older taste, a taste in some ways more congenial to their science than was Impressionism because it supported their belief in the stability and simplicity of the laws of nature. The Impressionists, who showed little interest in the new science that was beginning to challenge and destroy the old picture of matter, with its fixed entities and stable properties that fitted objects exactly, were presenting a visual world that in a remarkable way, concretely and metaphorically rather than abstractly, was nearer in some respects to the invisible, constructed, imagined, theoretical world model of the scientists.[26]

There is a sense, however, in which Impressionist painting and scientific atomism come together.[27] For the physicist, objects exist on two levels of experience. They are given as directly observed entities of everyday life and the laboratory. But they are also explained as determined by invisible structures and forces that the physicist has tried to imagine through the form of a model with certain properties from which, with the hold of mathematically framed laws, can be deduced the observable qualities of the objects that the model simulates. Similarly, the Impressionist painter has presented observers with two worlds: from close-up, we see an artificial structure of brushstrokes, each distinct in itself, the whole random and shapeless; from a distance,

these same strokes beget in our perception the familiar world of objects, the recognizable landscape, streets, crowds, people, light, and air.

Common to both scientist and artist was the idea that to represent the world of observation adequately it was necessary to construct a different kind of model, an artifice from which the familiar one can emerge as a qualitative whole. Artists were in this sense imaginative, constructing sensibilities, but their microworld was realized not by calculation, but spontaneously, by noting their sensations of color and adjusting them to each other to form a harmony of tones. One can see how from that point of view might arise the nonrepresentational arts of the twentieth century, in which creation of such structures has appeared as a free activity of the artist unconstrained by any requirements of conformity to the observed world. For many scientists at the end of the nineteenth century, the theoretical picture, the physical model, was a fiction. The reality of atoms and even of molecules was not a serious question; they were arbitrary concepts with the help of which one might explain the visible.[28]

But this analogy between science and art can be carried too far. If scientists and artists shared the practical ideas that the constructed model can be justified by the extent to which it will account for visible phenomena and that many different models were possible, the Impressionists' painted surface was still part of the visible world and retained many traces of the directly experienced appearance under special selected conditions, thus corresponding to the world far more closely than any physical micromodel of their time corresponded to direct observation.

XI

Impressionism in History

THE CONCEPT OF IMPRESSIONISM as a period style is obscure and problematic, for the criteria usually applied in defining a period style do not seem to fit Impressionism well. Besides, another view of Impressionism exists. According to this perception, Impressionism was not a localized phenomenon, restricted in place and time and significant for a specific culture and outlook. It is, rather, a more general type of art, and approach to art, that has arisen at different times and in different places, as the recurring product of tendencies inherent in the nature of image making.

The notion of a period style is normally based on the character of art in relatively homogenous and stable societies, in which the works and forms of painters correspond to well-established, common practices of their place and time. A style is generally intelligible, popular, and adapted to tasks commonly assigned to artists. French Impressionism was mainly the product of only a dozen or so painters[1]—"five lunatics and a woman," according to one acerbic critic—who deviated from the norm during their most active phase. At the time they formed this style they were not appreciated widely or wholeheartedly, except by a few sympathetic minds. To most viewers, Impressionist works seemed strange and even absurd. By 1890, when these painters had come to be admired and their art commonly imitated, other new styles arose that underwent a similar disparagement until recognized as valid a decade or two later. In the period of its formation, Impressionism was an exceptional approach. But the academic art acclaimed at that time is today regarded as relatively unimportant.

Thus Impressionism cannot be described as a conventional period style, because it was not the widespread type of art in its time. It did not satisfy the taste of most contemporary art-minded people or even of most other artists. Discovering popular attitudes to painting requires looking at works that otherwise lack great interest and have little importance for the growth of subsequent art. In studying the history of art as a history of achievement, much of the Salon paintings contemporary with Impressionism can be neglected, even if they possess significance for cultural history. Such works did, however, affect the first stage of the young Impressionists'

careers as students of older painters and did serve as conservative foils, negatively inspiring them to greater heights of conceptual and technical originality.

Terms used repeatedly in the discussion in chapters 1 and 9 of the concept and aesthetic of Impressionism—"light," "perception," and "direct experience"—had a much wider vogue in the field of spiritism. When Impressionism was emerging in around 1868, at least 4 million people in the Western world believed in spirits, ghosts, and occult phenomena, and in communication with the disembodied souls of the dead. This estimate is based on the subscriptions to two Spiritualist magazines, called *Light* and *Banner of Light*. By the mid-1870s the Spiritualist movement had an estimated 20 million adherents. From the point of view of cultural history and social statistics, Impressionism was in its time an extremely limited and insignificant activity of a dozen or so painters, plus a few followers. On the whole, it was unappreciated, except by a few other artists and devotees of painting. But by the 1890s, it had been standardized, copied, and diffused throughout the world. If Impressionism is to be considered a period style, it must be approached from another point of view than that which permits us to speak of Gothic as the style of western Europe in the later Middle Ages or of the Pharaonic style as typical of Egypt during the three millennia before the Roman conquest.

An attempt to isolate a single style of art and connect it with an historic time and region demands other considerations than the obvious ones of date and place of origin of the works. Understanding the peculiarities of French Impressionism and the careers of those few painters involves attending to much that happened between 1850 and 1885 in France. Considering contemporary events in America, Germany or England helps less, though somewhat. Certain ideas that were common in France in the 1850s and 1860s also have to be taken into account, as well as the rejection of those ideas or attempts to modify them in the 1860s and 1870s. The more deeply Impressionist painting is studied, both from the artistic point of view and the point of view of the personal values and experiences of those who created the new art and conveyed in it something of their life attitudes, the more contemporary attitudes and institutions must be examined, as well as parallels in other arts in France during those decades.

Impressionist painting bears striking similarities to concurrent features of the social life and thought of its time and place, similarities more pronounced than in any other art form of its day. Despite its exceptional character, the new art was a particularly significant expression of new and emerging values of its period.[2] Impressionism can be viewed as a period art in the broad sense of the comprehensive historian because of the multiplicity of ties between that painting—so exceptional, and limited to so few people—and a larger complex world of action, events, ideas, and values in the second half of the nineteenth century. In that sense, Impressionism may be called a period style. Such a designation does not permit us to say that if a work was made in France in 1875, it is Impressionist in style, but rather that if it is Impressionist, it must have been done in France during that period, unless it is a product of the old age of the painters who lived into the next century or a belated imitation of their style, a parroting that continues today.

Another concept of Impressionism as a period style arises from our values today. To construct a history-making sequence of works of art—those that were decisive for subsequent art, and in which appeared for the first time the possibilities that were realized in many later works—and to follow the sequence of art like the course of scientific discovery requires us to recognize that, just as in science, only a few highly original minds have been responsible for the basic new ideas, however many workers have contributed to their application and growth or refinement. So also the pictures created by a few Impressionist painters between 1865 and 1885 are the most effective and influential series of works in the succession of new styles of the last two hundred years.

The essential ideas of the new art were realized by the individual originators in quite varied ways, with different weightings of particular aspects of the style. In the next generation, it was possible for painters to build on this art in opposed directions by developing further one or another side of the art and changing thereby the accepted view of Impressionism as a distinct whole. Secondly, what appeared as critical, liberating values on both the personal and social plane soon became unproblematic or even commonplace interests that no longer engaged the individual in a struggle with established values, serving even as a means of accommodation or escape from conflict. So the imagery of the environment and of the spectator and spectacle with the new coloring and brushstroke was absorbed as an agreeable, decorative art in a transparent, now easily intelligible style. The charms of the sights and pleasures of the day as a field of personal freedom could mask the irksome constraints of social life and its deep conflicts.

Impressionism as a creative phase was a short episode in the history of art and French culture. The new style of painting was quickly generalized as a method and copied everywhere. Its technique and imagery became as common as the occasions represented in the pictures. Springing from a situation in which the radical aesthetic values had a liberating and critical function, the originating impulse lost its force soon after for a new generation of artists who had still inherited the Impressionists' personal independence and ideal of sincere perception, their confidence in the expressive power of color and frank execution.

Any attempt to explain the characteristics of Impressionist painting cannot overlook its ancestry. Only a small number of earlier painters contributed directly to this art. In their own time, the Impressionists mainly introduced qualities and ideas important for later art. While there were strong reactions against the Impressionists' works and even repudiations of them as not truly or sufficiently artistic, all later art has absorbed the Impressionists' traits. Besides, the attitude of the Impressionists as inventive, uncompromising artists open to new perceptions but with a decided viewpoint of their own helped form what is today regarded as the modern type of the authentic artist. Though it arose earlier and is now applied to artists for whom seeing is imaginative and constructive rather than devoted to the reflection of an environment, the concept of a personal style as a way of seeing owes much to the Impressionists. In all these respects, Impressionism was not just a historical event localized at a fixed point in time and space, it is also a link

in a continuous line of achievement, a chain that is truly important. Without the Impressionists much that we value in contemporary art would doubtless be missing.

Impressionism was so congenial to a larger culture and to widespread needs and sensibilities that once its distinctive nature was clear it evoked a universal application and repetition and thousands of paintings were created in that style throughout Europe, America, and Japan. But these imitations lack the characteristics that belong to a major discovery, to the first realization of a new possibility—always a difficult and rare leap. Many of the paintings that imitate the French Impressionists can be enjoyed and admired, but they do not hold the viewer as do the original Impressionist works. There is not always a connection between originality in creating a style and a high level of artistic achievement, but this relationship has been the case frequently enough to suggest that a plausible relation between the two often exists. At least that correlation applies to many works in the Western tradition of art, offering one reason why artists of our own century have been so concerned with originality. The striving for originality can be justified pragmatically, though many who sought the new have failed to produce works of enduring interest. Great artworks as original creations have often been the outcome of strong impulses to do what particular individuals alone can do and what they have struggled to realize in spite of all obstacles and risks of failure. Such an effort need not be accompanied by consciousness of originality.

In contrast to the aspects of Impressionist originality are the Impressionist aesthetic and mode of seeing and the Impressionist thematic material and content. Impressionism was not only an achievement of the 1860s, 1870s, and 1880s, but it is also a phase in the universal evolution of styles—a type of style that appears when certain preconditions exist. Those preconditions can be regarded as inherent in art itself or in our way of perceiving. An "impressionist" phase has been observed in Chinese painting, in late Roman painting (where it is called "illusionism"), and in European art of the seventeenth and eighteenth centuries. The writers of the eighteenth century who first saw the works of Chardin and Gainsborough, viewing them against the background of traditional art, described them in a way that seems to us remarkably like later descriptions of Impressionist paintings. Those writers were struck especially by the use of small dots of color. They noted that these painters were not interested in drawing, only in color and sensations, and they observed the looseness of brushwork and the importance of light and shadow. Yet when we turn to a painting by Chardin or Gainsborough, we cannot help noting that these are eighteenth-century pictures and that they are quite different from the works we have called Impressionist (figs. 109, 110). Works by artists like Chardin and Gainsborough can be called "impressionistic" rather than "Impressionist," with the former term used to designate paintings that possess traits resembling some features of the art of the French Impressionists. But such paintings should not be mistaken for works of the Impressionists, who constitute a distinct school.[3]

Why has it been supposed that nearly every great cycle of art includes an impressionistic phase? One reason relates to a judgment of value, namely that all art passes through a cycle beginning with a naive phase of childhood simplicity but in time becomes adult, robust, and

FIGURE 109. Jean-Baptiste Chardin, *Bouquet of Carnations, Tuberoses, and Sweet-peas in a Blue-and-White Porcelain Vase*, 1755-60, oil on canvas, 44 x 36 cm, National Gallery of Scotland, Edinburgh

mature, with strongly modeled naturalistic forms, then overripe, and finally old and in decay.[4] The impressionistic phase was believed to be a stage of decline in which solid forms disappeared and all was dissolved in atmosphere and light, which were less tangible, less stable phenomena, and hence less ordered and less noble as elements in a work of art. Alexandrian culture in late antiquity has been seen as a typical impressionistic phase. Under that category also belongs a style of literature that includes the novel, the amusing lyric poem, and clever, precious light verse. In impressionistic art, form and depth in the grand sense of epic and dramatic poetry have been lost. The impressionistic has also been extended to the European arts of the eighteenth century, as well as to later Chinese art in which can be discovered an aspect of the eccentric and personal that lacked respect for high tradition.

There is another approach to the historical use of Impressionism or the impressionistic, an approach for the most part independent of the value judgments that follow from the acceptance of a classical norm, any deviation from which must appear as a weakening or decay. This approach is rooted in the view that painting, like literature an art of representation, begins with the depiction of distinct objects, just as our discovery of the world in childhood begins with the isolating and handling of things, with exploratory touch and bodily movement as well as seeing. In time, we become aware of all that qualifies things, such as their interactions; their background

FIGURE 110.
Thomas Gainsborough,
*Mrs. Richard Brinsley
Sheridan, née Elizabeth
Linley*, 1785, oil on canvas,
219.7 x 153.7 cm,
National Gallery of Art,
Washington, D.C.

and appearance in different circumstances and perspectives, the void or space that lies between things according to the viewer's position and mood; their modifications by light and shadow and atmosphere; and their changes owing to motion. Two poles are found, then, in our experience of the world.5 One is the tangible, or the tactile or haptic as it is sometimes called, and includes qualities of stability, closure, definiteness, and clarity through the centering of distinct objects in perception and thought. At an opposite pole, the stable, centered, and closed are slighted in favor of the mobile, the changing, the contingent, the more vaguely apparent, the continuous as opposed to the discrete, and the unbounded light and air. Given these two poles in our visual experience and knowledge of the world and their connections with thought, the fact that art begins with the first of these and moves to the second is easy to understand.

The expression of this view in the history of art has been developed early in this century by European art historians, especially by the Austrian Alois Riegl and the Swiss Heinrich Wölfflin, who tried to ground this interpretation on a psychological conception of the latent order in which perception and understanding develop. In attempting to explain the difference between twentieth-century science and its predecessors, thinkers such as British astronomer and physicist Sir Arthur Eddington have pointed to the example of Impressionist painting as an art that is not concerned with things, but with the relations between things, with the fields and motions and point forces. In chapter 10, this approach was shown to be inadequate. Wöfflin's broad approach has a strong appeal, however, through its generality. He brought out the interesting fact that arts that are impressionistic and resemble French Impressionism in important respects have appeared at different times in far-separated cultures between which there is no historical connection, no clear continuity of practice.6 It is as if on the tree of art different branches from the same trunk or even different trees with an independent branching, at certain stages of growth show not only similar forms but, more remarkably, a similar sequence of forms in time. One style of art A, is followed by B, and B by C; in a similar culture, A2 is followed by B2 and C2, and so on. Yet one cannot ignore the fact that the number of such long-range sequences moving from the haptic to the optic with significant resemblance of types is quite small. No more than three stylistic sequences—the modern Western since the Renaissance, the Graeco-Roman, and the Far Eastern—have developed an impressionistic phase that can be likened to French Impressionism. What in these three cultures accounts for the emergence of an impressionistic style, even granting that the type is latent in the conditions of perception or depends on a universal process of development in our way of construing or organizing the visual world? More relevant than psychological factors is the degree of the resemblance of those impressionistic styles to modern Impressionism, not only because that parallel provides a clearer view of such styles but also because it gives a better grasp of the distinctive character of Impressionist works. What an Impressionist painting is becomes clearer if the differences from quasi-Impressionist or impressionistic works of other times and places are taken into account.

A second problem of interest for the understanding of Impressionist painting is how

applicable the concept of Impressionism is to arts other than painting. Writers spoke of certain musicians as Impressionist, but they are figures not known today, such as Federico Mompou. The term was also applied to Richard Wagner and Emmanuel Chabrier, and to Claude Debussy, who rejected it. Renoir, who met Wagner in 1881 in Palermo and painted his portrait, thought the German's music was Impressionist. More recently the concept has been extended as a general category to late-nineteenth-century music as a whole. Moreover, the example of the painters was used as early as 1879 by the critic and historian Ferdinand Brunetière to characterize the new French novel and its innovating syntax. In our century, philologists and statisticians of language, studying the vocabulary and syntax of the French novel and poetry of the period 1860 to 1900, have found in them analogies to Impressionist painting. Already in his own lifetime, Mallarmé was described as a poet whose syntax was fractured and spotted like the forms in an Impressionist picture. Similar remarks were made about the Goncourts,[7] and Nietzsche's famous definition of the decadence of modern culture, which he applied to Wagner, was taken almost verbatim from Paul Bourget's analysis of the richly pictorial prose of the Goncourts.[8] In their art, he noted, the page is more important than the chapter, the paragraph than the page, the sentence than the paragraph, the phrase than the sentence, and the word more than the phrase—the whole page often being a single sentence of patched-together phrases in which subject and predicate cannot easily be discerned. That notion of artistic prose as a complex structure of abruptly juxtaposed, nuancing phrases, with strikingly contrasted small elements, was an ideal of literary style in the 1870s and 1880s.

If the concept of the impressionistic as a type of art found in far-separated cultures seems to make such art a supracultural or transcultural phenomenon, the view of French Impressionism as a style common to different arts of the same time and place gives to this style the essence of a cultural style, a pervasive mode of thought and expression. The psychologist Eric Rudolf Jaensch, reacting against Austrian physicist and philosopher Ernst Mach and his fellow thinkers, asserted that modern science, too, is fundamentally Impressionist and, together with modern philosophy, mainly under the influence of French philosopher Henri Bergson, has been on the wrong track because of its commitment to Impressionist values and outlook combined with a positivist view of sensations as the ultimate experiences on which our knowledge of the world is built. The concept of Impressionism as a style has been extended here beyond the painterly and literary to embrace the whole range of intellectual activity of a historic period, and is treated, in fact, as a lifestyle.

What were the features of these older impressionistic styles and to what extent were they like French Impressionism? The first came in late Roman art. It has been called "illusionistic" because painters were less interested in depicting objects in their bounded linear aspect, a practice that ruled classical art from the sixth century B.C. until the beginning of the Imperial period of Rome or a little before. They represent things, instead, under the effects of light and atmosphere in deep space. When such ancient paintings were discovered in the eighteenth century,

Johann Winckelmann, a scholar with a strong classicistic taste, characterized them as being *"flüchtig wie ein Gedanke"* ("fugitive as a thought"), an eloquent phrase that expresses, in contrast to the sculptural character of classical art, the noncorporeal and airy-phantasmal in this Roman style.[9] It seems to belong to another world than that of the clear architectural Greek forms. Though accessible at Pompeii, Herculaneum, and Rome, such works were little appreciated or studied by classical scholars until after Impressionism had developed in western Europe. The first archaeologists and students of the history of art to examine without the usual prejudice the paintings in that loose, atmospheric style were observers like Franz Wickhoff who were also attracted by the new modern painting.[10] The change in viewpoint is a clear and revealing instance of how a fresh perception of old art can be influenced by the new in one's own time. Sometimes the reverse has been the case. Experience of earlier art may give ideas to and stimulate artists and even inspire them to change their way of working, as happened in the Middle Ages, the Renaissance, and in our century.

An example of ancient illusionism in The Metropolitan Museum of Art comes from Boscotrecase, a site near Pompeii. It is a small picture on a black wall, representing a shrine. That it is a religious site can be judged from the statues, ribbons, and garlands, and the typical tree that arises above a sacred precinct. The figures have a ceremonious air, as if they are performing a ritual. The painting is patterned by light falling on the pictured objects, with bright colors in lively contrast, and, most of all, by the flecking of the brush. The artist has suggested the forms of trees, figures, and statues, not by the outlining of their contours but by the juxtaposition of little touches of color, which fuse in our perception of the whole.

This kind of painting differs from the Impressionists in France in several noteworthy respects. In the first place, the scene is not represented as if beheld from a fixed point in the landscape by an observer who, in sighting it, grasps it as a whole, ordered in its lines and magnitudes with respect to the position of his eye. The lines of the porch—with the roof seen from above—do not agree with the perspective of the tower, whose upper surface cannot be seen, a far more drastic deviation than appears in Monet's excited renderings of a railroad station (see figs. 13, 41, 42). The picture is also quite formal in its grouping of parts, with a large central object and smaller flanking ones. Further, the relationships of light and shadow are inconsistent with a single source of light, and there is no sky or horizon. In this ancient art of landscape, clouds are rarely represented, though often described, by Roman poets. Yet in the far less naturalisitic art that followed, clouds are common, because it is a Christian art and clouds symbolize heaven. They illustrate sacred texts in which God and the angels are placed in the sky or appear on clouds.[11]

The painting from Boscotrecase, with its sunlight and shadow, is clearly not a direct rendering of a scene in nature. The artist has not grasped visual experience as fully as the French Impressionists. He lacked their concept of the far-reaching variety and interaction of natural phenomena and the role and position of the observer in the shaping of the sighted world.

These non-Impressionist features stand out more if the ancient work is compared with a

FIGURE III. Camille Pissarro, *The Crystal Palace*, 1871,
oil on canvas, 47.2 x 73.5 cm, The Art Institute of Chicago

picture by Pissarro of a site that in his time was visited, like the shrine in the Roman painting, by tourists and holiday travelers (fig. III). It shows a street in a suburb of London in 1871, a Sunday sight on the way to the Crystal Palace in Sydenham: a favorite place for weekend excursions. In Pissarro's painting, the space of the scene is continuous with the space of the spectator, who can be imagined in the foreground. The viewer's eye level determines the perspective, and the light of the sky affects the tones of the large foreground and middle distance. Seen on the left, the subject of the title is wholly secular and modern, independent of tradition. An epoch-making, original construction, the Crystal Palace had been designed for the Great Exhibition of 1851 and rebuilt in 1852-54. The exhibition hall had housed works of industry, the newest in the technology, goods, and crafts of its time. It was, therefore, especially attractive to the Impressionist artist, an innovator intensely conscious of modernity's value and its interest to the public. The conception and the features of the building—its pattern based on the greenhouse, its novel and monumental use of glass and iron, its design for optimal light in the display of objects and for the circulation of vast crowds, and even the symbolism of its dimensions, with its length corresponding in measure to the year it was built—all demonstrate an affinity with the content of

Impressionist painting and its general outlook. In contrast, without any such sky or foreground, the Roman artist isolated on a black wall an image of a sacred spot, like a relief or a statue on a pedestal, hallowed by tradition and connected with the supernatural and invisible, though set in bright sunlight.

The Impressionists also rendered scenes of nature without signs of modern life. The cathedral of Rouen, a medieval building, was a favored subject of Monet and Pissarro. But Impressionist pictures of the countryside bring to view the qualities of nature most significant to a city dweller who prizes movement and change and personal spontaneities of perception in his surroundings. Monet represented the cathedral not as it had been done by Romantics and earlier artists, with the goal of creating a religious mood through the mysterious light and shadow of the interior or through the inspired artifice of constructed, mazelike lines or through the depiction of the small houses of the faithful nestling around the ancient house of God which reaches to heaven.[12] In the pictures of churches by Monet, Pissarro, and Sisley—all of them admirers of Gothic art—there is no interest in cult or ritual, no sentiment of grave antiquity or pathos of decay and survival. It is rather the exterior façade in sunlight that catches the eye, with its details obliterated by the intensities of unstable, interacting colors. To see in this choice a spiritual impulse, one must admit that it no longer proceeds from traditional religious beliefs or aspiration, but issues from individual feelings whose ties to religion are more poetic and metaphysical than confessional. In Pissarro's painting *The Rooftops of Old Rouen, Gray Weather*, the cathedral is the site and background of the market, with crowds of merchants and shoppers thronging the public square, like the humanity in his scenes of the Paris boulevards.

The Romans, too, loved travel, scenery, the spectacle of movement in landscape, the pleasures of the seacoast and the river. Both the wall paintings of episodes from the *Odyssey* in broad landscapes and the little pictures of villas and seaside resorts are an expression of that taste. As late as the sixth century A.D., the Ostrogothic king in Ravenna wrote to an official whose health was failing and had asked for leave to visit the baths at Baiae, near Naples:

> Go then. . . . Seek the sun, seek the pure air and smiling shore of that lovely bay, thickly set with harbors and dotted with noble islands. . . . There are long piers jutting out into the sea and the most delightful fishing in the world in the fishponds open to the sky on either side.[13]

Cassiodorus, the Roman statesman and writer who composed this letter for the king, also left picturesque descriptions of Ravenna and the nearby coast, sometimes as seen from a great distance, and noted the changing appearance of the landscape in different seasons and weather. After seeing mosaics from the same period in Ravenna, with their limited, schematic fragments of landscape, Cassiodorus's accounts seem surprising. But even in the first and second centuries when art was more impressionistic, Roman landscape painting failed to render much of what the writers observed in their accounts of the pleasures of nature and the seaside resorts. The many

images of the theater, the circus, and the hippodrome, especially in mosaics in the great villas, rarely present the settings of the spectacle, the crowds and the individual observers, or such phenomena as the changing colorful shadows cast by yellow, red, and purple theater awnings, noted by the Roman poet and philosopher Lucretius.[14]

No landscape painting among those that have survived from the centuries of the Roman Empire is comparable in fullness of painterly perception to the descriptions of the Moselle River by the poet Ausonius. He pictured with rich detail of color and light the reflections of the hills and vineyards in the water:

> [T]he blue stream mirrors the dark hill and the water seems green with the vine-sprouts; what a color in the water when the evening star brings the late shadows and steeps the river with the greenness of the mountain![15]

The outlines of the shadows merge in the stream, and the image of the hill fuses with the water. The poet saw also the sunset and the reflections of the boatmen in the brightened water, with the inverted shadows of the bodies. The sailors enjoyed that mirroring of themselves and viewed with naive surprise the illusory reversals and inversions. As a nurse holds up a mirror before a child for the first time to show the child its own beautifully shaped hair, so, Ausonius wrote, the young sailors contemplated with delight the ambiguities of the false and true in the play of shadows.

The observations of Ausonius or Cassiodorus may not have entered painting because for the painters, a plebeian class from the cities, that mode of enjoyment of the country landscape was not as significant an element in their lives and outlook as it was for the aristocratic poet or statesman, who possessed great landed estates.[16] The boatmen on the river could marvel at the reflections in the water as a part of their working environment; but those phenomena were neither solace of their leisure nor matter for literary expression patterned on established models. Even a marvel of light and movement that must surely have caught the eyes of plebeian spectators in the circus and hippodrome, the stroboscopic effect of rapidly turning wheels, was ignored in Roman paintings of the games, though vividly pictured by the Christian Latin poet Prudentius in likening the sun's movement in its orbit to a chariot on the racecourse: "The glowing wheel flashes as it turns on its flying axle,"[17] a perception that will wait more than twelve hundred years for Velázquez to depict it in his painting of *The Spinners* (see below, fig. 115).

Paralleling literary transcriptions of landscape with Roman paintings of the same epoch demonstrates not only how relatively backward the artists were in exploiting perceptions of color, light, and illusory experience when compared with the writers; the comparison also is of considerable relevance to present-day ideas about the relations of painting and visual experience, to the notion that artists viewed much of aesthetic interest that they did not undertake to represent in pictures. Often, if not always, perceptions that we regard as painterly and credit to the initiative or priority of the artist as a guide and educator of the layman's eye were exercised long

before the painters' depiction of them. Roman painters who represented just such features of the landscape as Ausonius and Cassiodorus described may have existed, only to have had their work disappear. But even their rediscovery would not change our view of the differences between Roman illusionistic and French Impressionist painting. Besides the characteristic features already noted in the analysis of the Boscotrecase landscape, Roman pictorial art lacks a continuous and developing study of light and color comparable to the modern one, with its suggestive, far-reaching technical and structural innovations that entered so deeply into all later art.

In a similar way, the practice of still-life painting by the Roman artists remained an imaging of distinct assembled objects, without a concrete setting or a specific, intimate milieu. Except for some eccentric or uprooted individuals, among them philosophers, the consciousness of individual freedom in the classical world never reached the point of modern bourgeois life, with its sense of an inviolate private domain, and of the self as capable of shaping an individual milieu of its own, altogether independent of religious, communal, family, and state bonds.[18]

Yet if Roman paintings lack the specific features of the modern, they differ also from older Greek art in employing light and shadow and effects of atmosphere to dim and transmute the appearance of things. That taste for light and air probably satisfied Roman travelers and big-city dwellers curious about a world beyond the small Greek *polis*. Typical subjects remained religious and traditional and possessed an air of fantasy, a suggestion of idyll, poetry, and myth. The scholars who have investigated these landscapes have been struck by the frequency and even the predominance of such themes, while the Impressionist painting of the nineteenth century was resolutely secular and founded on the attitudes of the less-traditional urban individual. Antiquity, more specifically the passage from Roman civic cult to Christianity, lacked a fully independent secular life.

To these differences corresponds the fact that Impressionism grew out of the art of the Renaissance, which had applied with rational devices the principles of geometrical pespective, organizing the picture with reference to the eye of a definitely placed observer and a single consistent source of light. While loosening the implicit geometric lines that form the armature of perspective, Impressionism still holds to the idea of an observer with a spatially fixed, though momentary, point of view. That suggested spectator is a more spontaneous observer, whose vision is both an objective encounter and an instant of reactive feeling. The shifting of the viewer's perspective will determine different appearances and qualities of the resulting picture and also varying nuances of mood. The variety of structured viewpoints in Impressionism corresponds to a difference of content. The illusionistic painting of the Romans never reached that stage of consistent perspective organization. Throughout its long history, classical art failed to apply a strict, geometrically organized system, although the theorems of Euclid necessary to implement it were available to artists. Classical art always remained faithful to the concept of composition as a grouping of distinct objects, each with its typical forms and unity, assembled according to general norms of rhythm and balance. Contrary to what some scholars have

supposed, no classical painting known to us discloses a consistent one-point perspective.[19] Ancient art also lacks that wealth of viewpoints, that air of personal and spontaneous encounter that stamps so much of modern representation.

Another important difference lies in the fact that in late classical art the relation of the represented scene to the painter-observer, unlike in an Impressionist picture, has no suggested continuity or direct access. In other words, the subject painted is not continuous with the original spectator's space, either in content or perspective—there are no deep paths, no converging lines, no seeming closeness to or participation in the scene on the part of the viewer. Rather, the representation is isolated, often as in a distant world of the imagination, comparable to that of the most ancient art, in spite of the naturalistic light and shadow and atmosphere.

Contrary to the common view that artists bring to our awareness through their work aspects of nature we might otherwise fail to notice, the phenomena the Impressionists undertook to render in their paintings had always been known. One did not have to wait for Monet in order to perceive the colored light in shadow, its play on foliage and water, and the shimmer or flicker of a surface in bright sunshine. Even in the Middle Ages, when artists engaged in representing imagined supernatural and long-dead figures, ignoring landscape entirely, conceiving light as an attribute of holiness in pictures through symbolic means such as haloes and rays, the light of the sun was frequently noted as a natural presence, illuminating familar objects. To illustrate a theological point by analogy, Saint Bernard of Clairvaux could say: "Who would believe the wall should it boast of having begotten the sunbeam which it received through the window?" In another text, Bernard wrote of light as visibility, and not as the sun. We would be greatly surprised to find a twelfth-century painting showing an interior wall illuminated by sunlight passing through a window—not because the phenomenon had not been noticed but rather because the rendering of that observation lay outside the scope of art, which had other tasks and a conception of imagery remote from any interest in portraying such an appearance. In the Middle Ages, light itself was a phenomenon of the greatest significance and served as a model and metaphor for spirit and understanding and especially for divinity, an association that may have underlain much of the use of gold in medieval painting. One distinguished between the different manifestations of light—the sun, its rays, the illumination of a field, reflected light, and the highlight or lustrous surface—and words were found for all these modalities.

But the painter did not respond to these fine distinctions in representing objects, and one will search in vain for an example of sunlight in a painting before the fifteenth century. Where a Bible text described the luminance of sacred beings in a heavenly vision—"their appearance was like burning coals of fire, and like the appearance of lamps . . . and the fire was bright, and out of the fire went forth lightning. And the living creatures ran and returned as the appearance of a flash of lightning"[20]—the painter who undertook to present this vision was satisfied to show the creatures, the lamps, and the red tongues of fire all as distinct objects, without trying to simulate their flashing, luminous aspect. That the images were abbreviated signs for natural and

supernatural manifestations and that the paintings and the objects they represented were quite different were doubtless widespread, even universal assumptions. The likeness of a Gothic statue to the human face, limbs, and costume was justly admired, but certain beings and phenomena eluded precise representation. In the *Roman de la rose (Story of the Rose)*, where the tale of Pygmalion is recounted—an evidence of the degree to which sculptors had achieved the power of creating an impressive human likeness—the author, describing the beauty of clouds, commented on the inability of both poet and painter to represent their color:

Forthwith they deck themselves in grand
And glorious robes of tints diverse,
More fair than poets can rehearse
Or limners paint, and set to dry
Their fleeces in the sun's soft eye.[21]

But the ordinary tasks of the medieval artist who was charged with the representation of sacred happenings and persons, made him more attentive in his art to the postures, physiognomies, and inflections of body and garment most capable of expressing moral and religious qualities. Though God's creation, landscape remained secondary. Neither to Saint Bernard, who wrote that trees and stones teach us more than do books or professors, that mountains distill sweetness, that from hills flow milk and honey, and that valleys abound in grain, nor to a churchman better disposed to pictorial art, would it have occurred to recommend the painting of landscape as the embodiment of these divine gifts.

It has been a commonplace of criticism that the painters of landscape have taught us to see nature, its varied colors and effects of light, and that for the lay eye it is nature that imitates art. Before James Abbott McNeill Whistler painted his London scenes, one did not, said Oscar Wilde, discern the beauty of fog and mist.[22] Impressionism is credited with opening our eyes to the qualities of natural light and the subtle phenomenon of color in the open air. It is a conception of art and ordinary vision that follows a tendency to ascribe to attitudes and ideas—what is called apperception—a major part in seeing and to artists and poets especially a creative role in shaping everyday vision and thought. That view of the painter's priority and influence on perception existed already in the seventeenth century, perhaps independent of the philosophers, though a Platonizing current appeared then in opposition to empiricist views. In speaking of Rubens's supposed exaggeration of colors and lights around the 1670s, French portraitist and art critic Roger de Piles said of the Flemish master's pictures that "they are more beautiful than Nature which seems to be only a copy of the works of this great man."[23]

Whatever truth exists in the idea that artists' representations have influenced the layman's perception of nature, it is improbable that people first noticed perspective convergence or shadows after they appeared in pictures. For these are features of the visible world that are recurrent, indispensable cues for the perception of distance and volume. During that long period of

European history comprising the various primitive and archaic cultures that did not represent the sky, people certainly looked at it constantly and noted its blue color, its filminess and clouds, and its changing aspect from dawn to twilight. Not only were these features noted in poetry while ignored in painting, but also rather subtle phenomena of light were recorded in literature many centuries before it occurred to a painter to represent them on canvas. A revealing example comes from the biblical story of the Moabites, coming to a pool at sunrise. Seeing it all red, they were emboldened to advance, thinking the water was bloody and taking it as a sign of the imminent massacre of the enemies who had preceded them.[24] But if this misjudgment seems to belong to a culture that has not been instructed by its painters to recognize the reflection of sunlight on water and to distinguish it from the local color of water, it springs, nevertheless, from a naive perception such as a modern painter might value in picturing realistically a river at sunrise or sundown. Even a more sophisticated hero could act upon the same sensations as the Moabites in observing the unexpected phenomenon of a reflected color. In 1830 Stendhal told in *Le Rouge et le noir (The Red and the Black)* how Julien Sorel in church was frightened by seeing as drops of blood the water spilled on the floor at the holy font.[25] The redness was the effect of the morning sunlight passing through the church window and staining the water. It had for Julien in his excited emotional state the significance of a portent, just as the reddened water had had for the ancient warriors.

To excerpt from the literature of the past many observations of the transitory in phenomena—the fugitive, the interacting, the surprisingly changing effects of light and shadow and atmosphere—would be an easy and agreeable task. That these phenomena were indeed noticed without being represented is evident from the painter's handbooks. Around 1800 the French landscape painter Pierre-Henri de Valenciennes counseled artists to ignore such appearances as perturbations of the fixed and characteristic in nature, which should be the true objects of the artist's attention.[26] Certainly one did not attend to these constantly; but for some minds they were indeed fascinating and could serve as metaphors of elusive thoughts and moods. So the "green thought in a green shade" of Andrew Marvell, perhaps inspired by an obscure perception in the poet's garden,[27] anticipated the color mystery of a green-on-green painting by Paul Klee. The richly nuanced account of the shadows and reflections of the boatmen on the river in Ausonius's poem is closer in spirit to observations by Monet or Cézanne than to any Roman landscape of his time.

The universality of visual experience founded on the common sensory and motor system suggests the theory that the development of representation from schematic primitive, forms to styles rich in phenomenal effects and varied viewpoints is latent in the native range of human perception, which at all times and in all lands embraces the near and far, the stable and changing, and assimilates and distinguishes so many variables of the phenomenal world as guiding signs.[28]

In China, landscape painting was carried further than in Rome as a theme of the highest dignity and for its own sake. Throughout its known history, Chinese landscape painting has

possessed a love of the beauty and the emotional suggestiveness of water, mountains, rocks, and trees. As in Impressionist landscapes, and more often than in Islamic art, Chinese paintings feature the contemplative observer, traveler, and promenader, the individual who has left the city in order to enjoy reverie and repose and to receive in these natural surroundings the ineffable intuitions of nature. Chinese painting also is reminiscent of Impressionist practice in its subtle, masterly strokes of the brush. Chinese art is more brush painting than drawing with the brush, as in the earliest styles. In its discontinuity of strokes and monochrome aspect, brush painting also retains a quality of the graphic, like the often related written characters delineated with the brush on blank spaces of the picture field. One conception of Chinese painting is strongly appealing in its openness to nature as a source of refreshment, contemplative calm, and inner harmony—a notion quite similar to a Western one. The pictures are captivating in the easy force of their technique and the finesse of their tiny marks in building a unified, continuous world. Yet a close study of both conception and execution reveals how unlike Impressionist painting this art is in essential respects.

Note the different relationships of the two art forms to their frames. Chinese painting is not a segment of universal space, but a collection of objects in a neutral ground, like a complex, hyphenated word on the blank page. It has some resemblance to Western drawings, with their empty ground, but those are sketches, deliberately incomplete. And in parts of Impressionist paintings the implied surface is air and part of the landscape. From its origin in an archaic style of painting that included separate objects on an untreated ground, Chinese painting retains discontinuities of space, even in the landscapes, with their great vistas of earth, water, and mountains. The openness of the unframed field and the practice of stamping the ground with owners' seals or inscribing them with names and poetic verses are also part of a quite divergent approach to compositional organization.

Far Eastern work is generally or largely monochrome, painted in a gray tonality. Even when brighter, these paintings do not often respond to the actual richness of hues in nature, a receptiveness that gives to so many Impressionist pictures their joyousness, their exhilarating aspect of the luminous landscape under the skies. No sunlight irradiates the Oriental atmosphere. The viewer can scarcely feel, as in front of the French works, the power of a natural lighting that modifies each object and permeates the whole as a boundless element. That universality of light has never been realized in Chinese painting, not even in the later period, when the approach was freest. In the eleventh and twelfth centuries, a great age of Far Eastern landscape painting, the monochrome prevailed, and where color was employed, it is sparse and conventional. So effective in evoking atmosphere, mist, and distance, in creating an atmosphere of reverie, a mystique of unity and order, the subtle monochrome of Chinese landscape painting is believed to have issued from an old tradition of calligraphy. Representation by drawing with the brush and ink was a canonical practice governed by strict rules of execution. The achievement of painting was not simply the outcome of an individual talent that explored possibilities freely, but rested also

246

on a long discipline through which the artist learned the appropriate stroke prescribed for every class of object he wished to render.

The manuals of Chinese painting are admirable examples of the systematizing of the unit strokes that make possible the felt life of things in nature and the vigor and unity of the painting as a whole. Dictated by rules, the stroke of the Sung artists, however fresh or individual it may seem, has a less inventive character than the stroke of the Impressionist painter, which is more naively personal and subject to continual change according to the mood of the moment, to the exciting impact of a new perception of nature, or to the demand of coherence with strokes of dissimilar neighboring objects. The original Impressionists' touch was not, as with Chinese artists, a preformed vocabulary that they knew by heart, or had at their fingertips. It was a constantly re-created stroke, open to new variations even within the same picture.

Chinese landscape painting has another trait that distinguishes it from the Western work, a trait that is more difficult to describe. The Impressionists aimed at a particularly manifest paint substance in their pictures; the surface of the paintings, as distinguished from the surfaces of the objects that they represented, may be experienced both from a close point of view and at a distance, as a crust, web, or layer with its own beauties and finesse, inviting the viewer's attention and intimating the activity of the artist on the canvas. The painting is seen as something made that possesses a substance in its own right—a substance of discrete elements. This fabric, unlike the smooth, unbroken surface of older painting, is more pronounced than the dissolving, immaterial aspect of the pictured substances of cloud and water, air and light, in the represented space of the canvas. Besides that kind of material presence, there is a second: the light, which illumines one part of the Impressionist scene, is felt in all the parts. Even the shadows are high in key—bluish, purplish, orangy—so that we sense the light playing through them. The shadows are themselves phenomena of light, and the contrasts of color in the shadows are due to subjective, induced effects of light. In addition to these are continuities of perspective and continuities of the natural terrain in the passage from foreground to middle ground to distance, which we take for granted but which are no less essential.

In contrast, Chinese painting makes a relatively sparse use of pigment. Some areas have been left bare, and in many areas neither the simulated substance of the represented world nor the substance of the artist's means of representation—the paint—can be discerned. The means used, the monochrome ink itself is a translucent or transparent medium. Its phantom thinness is at the opposite pole from the Impressionists' robust, joyously savored pigment, the incrustation and complex weave of their solid, opaque medium. Hence the greater concreteness of the signs of the "subjective" operative moment in the French painters' creations, the evidence of their process, their manipulation, their hands. All this activity is visible in the work through the qualities of the thick pigment. It is the forerunner of the amazing relief, the sculpturing of the surface in paintings of the twentieth century.

Although Chinese brushstrokes do demonstrate qualities of texture and expressiveness, the artists have employed a rather sparse, dilute medium and tend to follow the rules for rendering

the structure of objects through particular strokes that function like words or smaller units of writing, like the letters in an alphabet. Their painting lacks an essential Western feature, the continuity of the space from foreground to distance in the purely topographic sense. Throughout its history, Chinese painting has remained faithful to its beginnings as a style of art in which figures or elements have been placed, like characters in writing, one beside the other with a neutral or empty ground between them. The idea of a true continuity of the pictured space through a continuous ground is, on the whole, foreign to Chinese painting. It is hinted at; it is approached; it may even appear in some exceptional works; but it does not become a necessary form as in Western painting since the fourteenth and fifteenth centuries, when the gold background was replaced by the sky and horizon. That rendering of nature as being natural through and through, as being visibly ubiquitous with a continuity of objects and their surroundings, in a similar sense to that in which a scientist today thinks of nature and of physical fields, was not practiced by Chinese painters.

Another essential difference that should not be ignored is that this advanced Eastern landscape paintings, with its distant views, its atmosphere and limited light, and the fascinating dance of the brushstroke as a mark of the accomplished individual artist, never became a norm for all painting. It was restricted largely to the special domain of landscape painting—one that was cultivated mainly by gentleman-scholars rather than by artisan-painters working to order. Painting of the landscape was a free activity of the *literati*, men who had the power to change their residence and to live in the country as well as the city, while maintaining the culture of the court and a tradition of rationalism, self-analysis, and knowledge of the past. But while they achieved this mode of painting in landscape, there continued beside it the practice of traditional religious art, which was governed by old canons of outline drawing, symmetry, and centered composition, and an established set of icons and religious themes. The same artist could paint in both manners. Styles of unlike character coexisted, varying with the subject of the work. In Chinese society, as in Chinese painting, besides the advanced modes of poetry and philosophic reflection, there survived even in the same center archaic forms in economy and political relationships. In old China, the freedom that characterized the most advanced culture never succeeded in permeating and transforming the whole of life. In contrast, Western society is distinctive in that the conditions of its material productive system, its industry and economy, impose the ceaseless adjustment and transformation of all fields and their reactions upon one another. That revolutionary dynamism is not inherent in the nature of society as such—for example, it is not visible in the older Chinese and Hindu worlds—but it is particularly characteristic of the West in the last centuries. And since the Western is the most powerful of all societies through its industrial technology that has spread over the entire globe, all human societies will probably in time adopt Western modes of production and will be transformed accordingly, until, having achieved equality in this respect, other cultures will bring into advantageous play, as in past times, their distinctive heritage and situation in the fields of religion, science, art, and philosophy as influences upon the West.

In painting, the Chinese impressionistic style operated on a more limited set of features, bound to the special conditions of the experience of nature possible for the scholar and literate gentleman-painter, with a taste for the writing of poetry, with intellectual occupations, at home in both country and city, and with the freedom to move between them. In Chinese art, there was an individuality of styles but also a persistence of standardized codified ones for particular objects. Unity was attained through the ink quality of monochrome and the brush inflections. Atmosphere in Chinese landscape softens or reduces the palpability of things and marks their distance. It is also an effective ingredient of these landscapes: trees, rocks, and indentations are often suspended in a void, as if in an enveloping mist.

In the seventeenth century, there appeared in China what seemed to be the beginning of a more truly Impressionist style. The master Chu Ta composed his painting freely with large-scale spattering and washing—methods of spontaneity or automatism—as well as with impulsive, energetic touches of color. Yet when his work is examined closely, comparing it with Western works of the sixteenth or seventeenth century, like the drawings of the Alps by Pieter Brueghel the Elder we see that Chu Ta's little dabs represent single elements of trees and rocks and are a personal convention of the artist. He improvised the unit, but only as a repeatable, standardized element without achieving, like the Impressionists, a continuous, dense dotting as a consistent means throughout the work. He used it only where he had to render a particular kind of minutely articulated object. Chu Ta's brushstroke does not belong to the pervasive and formless in visual experience, to light and atmosphere, but to the anatomy of separate objects like trees and rocks, that in places are compact enough as groups to suggest the continuous.

This new Chinese art was associated with a catastrophic situation in Chinese history—the fall of the Ming dynasty and the beginning of the Manchu. The intellectuals and artists loyal to the Ming dynasty retired to the country in order to dissociate themselves from masters whom they could not serve. They cultivated their leisure and privacy by painting, and in this art, in their use of violent, impulsive method, they seem to have given vent to a need for explosive reaction, to feelings of melancholy, of disgust even, or exasperation. In any case, they found in painting an absorbing private field in which the socially withdrawn personality could realize itself in an emphatic note of the brush. While approaching certain manifestations of a nineteenth- or twentieth-century European who reacted in a personal way against what was distasteful in his political and social world, this art is, nevertheless, limited by the perennial tradition of Chinese art. In many cultures what determined the activity of an individual, even in a moment of revolt, was not only his experience and situation, but also that set of habits authorized by centuries of tradition and fixed through preadult learning.

Interpreting this phase of Chinese art, so surprisingly free and modern, we must not be misled by the resemblances to modern Western art in which change is more radical and the new features displace almost completely the long-established forms. Through Brueghel's drawing, we can see how the advanced Chinese painting of that time could approximate the drawing of a

contemporary European artist of high individuality, who is still remote from Impressionism. Comparison with Brueghel's paintings discloses still more essential differences and makes us aware of the complexity of the relationship and of the strong roots of both the Chinese and Flemish master in older non-Impressionist styles. Yet the individuality of Chu Ta, his eccentric position with respect to Chinese life, his freedom of movement, his critical attitude toward the official world of the court, all have their counterparts in Brueghel's career. An exceptionally modern personality in his own time, the Fleming worked in Antwerp, a great port and a financial center, crossed the Alps to Italy, and recorded his travels in detailed pictures of the new landscapes and cities, which as panoramic vistas register his joy of discovery and expanded vision. In Brueghel's native country, he had studied the forms of folk life for their own interest and not simply to satisfy a commission. His many pictures with a satirical content affirm an individual response to the events and ideas of his time. In Europe as in China the advances in the painting and drawing of landscape, out of which was to come the later Impressionism, were several times made by men who, in seeking a new environment, achieved, under conditions of conflict, emancipation from the traditional forms of art and asserted new artistic values.

Chinese art of the seventeenth century also recalls a master of the Netherlands, Hercules Seghers, whose life was marked by a similar eccentricity, around which legend, soon after his death, has woven a tragic story of failure, drunkenness, and debt. This painter and incomparable etcher, a man of astounding originality, was admired by the greatest artist of his time, Rembrandt, who owned eight of Seghers's paintings and ventured to rework one of his etchings after his death. Seghers's strange print of a landscape with two distant steeples (fig. 112) reminds us in a most surprising way of Japanese and Chinese landscape painting with their vocabulary of dots and tiny strokes. But Seghers's use of these elements includes a distinctively Western perspective and continuity with the spectator's space and many fresh observations on the structure of things, in spirit unlike the codified anatomy of trees, buildings, and rocks in the Chinese tradition. If Seghers used dots and short strokes, they are personal inventions that translate the substance of the things he renders more than sensations of color, as in Impressionist work. Here again we see how there may arise convergences of form that are quasi-Impressionist but remain within the boundaries of a pre-Impressionist style. But it is instructive to observe the conditions under which these new forms arose—conditions of individuality and social life that in the nineteenth and twentieth centuries were far more general and persistant than they had been during this period in China or the West.

In the seventeenth century in the West, artists produced surprisingly impressionistic sketches, not completed pictures or oils, but watercolors, drawings in sepia, and penciled notes that appear as anticipations of Monet, Cézanne, or Degas. An especially appealing one is the brush drawing of a tree and mountain by Claude Lorrain (fig. 113) who was a pure landscape painter, in several aspects in advance of his time. Lorrain's tree is so contrived with the brush that we cannot follow its structure throughout as a continuous form. He allowed a stroke to stand by itself, to hang in the air and light. These strokes, so free and spontaneous, are not anatomized as in

ordinary studies of a tree. They are seen as spots of light and dark next to one another. They are genuine impressions of color, translated into those rhythmic little motor traces we call strokes. The mass of the tree is broken and blurred by an atmosphere and lighting that vaporize part of the landscape. Monet's painting of the woman vacationist at Bennecourt (see fig. 12a) possesses an apparently similar composition and conversion of the natural structure of the tree into a rich flicker of dark and light spots. There, however, the darkness of the side of the tree in the shade has counterparts in the intensity of light throughout the rest of the picture. It belongs to a medium that penetrates the whole work, while in Claude's composition we do not feel that the

FIGURE 112.
Hercules Seghers,
*A Road Bordered
by Trees with a Town
in the Distance*,
etching, printed in
black on white paper,
14.1 x 10.5 cm,
Rijksmuseum,
Amsterdam

FIGURE 113. Claude Lorrain, *Landscape*, 1663, pen and ink drawing with chalk, 26.2 x 37.8 cm, Dumbarton Oaks, Washington, D.C.

light and shadow, which have suggested some of the quality of the tree, determine all else in the picture. Not that the work lacks a unity of its own, but it is not a unity based on the persistence of the stroke or disengaged unit as the structural basis for the shaping of the flattened web of the whole picture, as you see it in Monet's canvas. Another important difference lies in the fact that although many of these sketches of Claude were made outdoors as quick notes on what he saw, he could not resist composing them in a formalized way or selecting a scene and a viewpoint that lent themselves to such a form. The big tree at the left arches over and frames the distant mountain, which it resembles in its curve. Below, a mass of shrubbery builds a *repoussoir* between the spectator and the scene, setting off the distance from the nearer ground. As a large rounded shape, the vegetation is similar to the mountain and fits snugly under the mass of the tree. Even the tree is curved like an ideal figure, a human body in *contrapposto*, in the painting of that time. The whole is more formal, more clearly adjusted, with a regulated balance and legibility of large forms, independent of the impressionistic strokes. In Monet's picture, the spotting of the whole

252

distance, foreground and middle ground, is variegated and free. Elements are unified less by the assimilation of lines to each other than through the accords, contrast, and balance of irregular patches of color and through the articulation of a scale of brightness and dullness, intensity and saturation, in tones spread loosely throughout the canvas. Claude's drawing is impressionistic in detail and in certain aspects of vision, but it is not Impressionist in the totality or in a consistent diffusion of the specifically Impressionist elements throughout the picture.

For Claude, his composition was only a sketch. It is a preparation that was to be reworked into a large, more complete picture in which that impressionistic flecking and liveliness of touch, that suggestion of quick and shifting perception, would disappear. The final work would be more like a well-organized park and vista, with a framing of the view and a stricter perspective of converging lines; with middle ground and distance clearly distinguished, and the shapes of leaves, branches, and tree trunks most carefully drawn. Both drawing and final painting belong to an art of object-forms more than to an art of light and atmosphere, though light and atmosphere were beginning to be important. Claude's work is still aristocratic, an art of presentation; it is governed by the formalities of a ceremonious order in life itself, a notion of harmony that is always attentive to the proper framing and centering of things and that precedes the vision of details.

A contemporary of Claude, the court painter Velázquez was able in his figure paintings to loosen drawing, composition, and color to a degee that seems much closer to Impressionism. Velázquez has long been regarded as a true ancestor of the French school and was acknowledged by Manet as a vital source of his own art. Velázquez's pair of sketches of the Medici gardens, probably painted during the second of his two visits to Rome, are marvels of fresh painting. In one (fig. 114) the figures are evoked as pure appearances, phantoms of light. They seem suspended in the atmosphere as in a palpable medium, their edges blurred and in places fused with the surroundings. The trees are broken and flickering in aspect; the forms merge and cannot be disengaged. The distance comes into being through lovely passages of fluid color in which we sense many distinct strokes. In the totality of the painter's works, the two Medici garden landscapes are exceptions, improvised sketchy notes arising from occasions of spontaneity, moments in which Velázquez was more like a nineteenth-century artist, seeking his own impressions, than like the official portrait painter of a great monarch, visiting Rome on a mission. Yet if in this instance of freedom he carried his advanced conception of light and value painting much further than he could in one of his portrait groups or allegorical-mythological pictures, even here he had to adapt to the scene in architecture and symmetry, and to a courtly relation between the two figures. In the center of the scene, he outlined a statue of a reclining figure, with respect to which the standing figures are visibly balanced. The whole is an impressionistic rendering of a highly constructed, formalized site. In any case, it is not typical of Velázquez's work as a whole, an extreme example produced under special conditions that approached those of nineteenth-century art.

There is a detail in one of Velázquez's major works that is often cited as an example of his precocious awareness of Impressionist possibilities, even more prophetic than his discovery of

what was later admired as truth-to-appearance in painting through the delicate rapport of tones. In the picture *Las Hilanderas (The Spinners*, or *The Fable of Arachne)*, a scene in the workshop of the royal tapestries—the court artist could paint weavers and armorers, since the manufacture of tapestry and armor was a royal monopoly connected with the decoration and ritualized life of the palace—he represents a spinner's wheel turning so fast that individual spokes cannot be seen (fig. 115). The true semblance of a rapidly turning wheel is, probably for the first time in history, represented in this painting. In all previous representations of wheels in motion, the painter drew the spokes as if at rest, contrary to the appearance of a spinning wheel. Not that artists and others had failed to observe this phenomenon; they had certainly seen the rotating wheel and noted its surprising look. The Christian Latin poet Prudentius had described it in an account of martyrdom.[29] Yet if Velázquez was proto-Impressionist enough to dissolve the wheel

FIGURE 114. Diego Velázquez, *The Gardens at the Villa Medici*, c. 1650, oil on canvas, 44 x 38 cm, Museo del Prado, Madrid

FIGURE 115. Diego Velázquez, *The Spinners* or *The Fable of Arachne*, c. 1657,
oil on canvas, 220 x 289 cm, Museo del Prado, Madrid

in rendering its apparent motion, the rest of his composition remains non-Impressionist, in spite of the delicacy of the flecked, sketchy painting of the distant part of the scene where visitors contemplate a tapestry based on Titian's *Rape of Europa*—a woven picture within a picture, and therefore all the more susceptible, in the distant view, to that freer treatment. In the painting of the whole, the large forms are clearly stationed, outlined, and massed beside one another; the radical rendering of the wheel is not sustained throughout. The turning wheel is attached to its hub, its center. The machine is stationary, its movement a rotation in one plane. That may serve as a measure of the degree of Impressionist freedom possible for Velázquez. He cannot carry it into three-dimensional space; it is not diffused through the whole work. Bergson, characteristically, regarded Velázquez as the greatest of all painters because he represented motion as negating or overcoming matter—motion as a metaphysical principle was arbitrarily counterposed by the philosopher to inert substance.

Early in the nineteenth century, several artists in England carried landscape painting to a vertiginous summit of freedom, which makes us wonder why the British did not develop Impressionism. The first is the painter John Constable, whose work quite early—he began painting at the end of the eighteenth century, two generations before the Impressionists, and lived into the 1830s—is astonishing in the spontaneity of the brush and his enthusiasm for light and atmosphere. On his many sketches of clouds, Constable indicated in writing, as if he were a scientific observer, not only the time of day, even to the minute, but also the condition of the sky and weather. These little sketches are among the most beautiful notes of a painter's eye that we have from the last hundred and seventy years. In Constable's larger paintings, the composition retains something of Baroque formality and largeness of contrast. There is a clear division into foreground, middle ground, and distance, a *repoussoir* and a balancing from left to right in a simple asymmetrical manner that is traditional rather than Impressionist or even impressionistic. His small sketches are freer in that respect, but they should no more be regarded as Constable's ultimate aim than Claude's sketches are to be seen as models of his final work. They are not artistically less valid but must be considered in relation to the goals and conception of the painter and not simply in terms of his success as an artist.

It has been suggested that Impressionism might have developed in France as early as 1830 if Constable's sketches rather than his more finished paintings had been shown in France along with his *Hay Wain* (fig. 116) in the Paris Salon of 1824, probably stimulating Delacroix to repaint the background of his *Massacre at Chios*. The best response to that "if" is a question: Why did not the English who had seen those sketches, why did not Constable himself, create an Impressionist art? He gave the answer himself when he said, "There will be no more painting in England after I die." His belief that he was the last of his kind indicates that for Constable the growth of painting, like the growth of science and morality, indeed of any ideal values, depends not simply on a technique or on imitation, but on more complex circumstances that affect the morale of artists and above all their will and courage to go beyond what exists, in the face of public indifference and the seductive attraction of an easier success on the conventional paths.[30] The lack of such independence is what Constable had in mind when he expressed his pessimistic view of the future of his art in England.[31] He was keenly and sometimes bitterly aware, as we learn from his letters and lectures, that painting in England then was governed by an attitude of complacent conformity in a milieu that in its cult of the old masters was unfriendly to the new and the strongly individual in art.[32] The habit of looking for these qualities, of welcoming them even if one does not understand them fully, anticipating that in time the best will stand out, was one of the preconditions for the continued growth of original painting in France in the period 1830 to 1880.

Consider a second English painter, J. M. W. Turner, a contemporary of Constable's who outlived him by almost a decade and a half. Turner produced in 1842 the stupendous picture called *Rain, Steam, and Speed* (see fig. 43), representing that new phenomenon the railroad train, after

FIGURE 116. John Constable, *The Hay Wain*, 1821, oil on canvas,
130.5 x 188.5 cm, The National Gallery, London

having painted for thirty or forty years ships and galleons in fantastic scenes of ocean traffic under wondrous skies. Turner represented the train, with its glowing fire, steaming across the bridge over the water, with a tiny boat below; he also showed a second bridge and the immense sky, beautiful in its luminous color and marked by a rich grain of paint. Turner shared a graininess with Constable, who used other means: a vigorous brushwork, more muscular and capricious, that points to Impressionist painting.

Yet when Turner's picture is compared with a painting of a bridge and traffic made less than thirty years later in London by Monet, we can see why Turner's work is not actually Impressionist. Its color holds to conventions of the eighteenth century—blue sky against brown earth, a brownness that comes more from previous art than from close study of sunlight; and the isolation of the earth as another object beside the sky, independent of the character of the illumination. Turner's color is somewhat like the monochrome Chinese colors, like Claude's browns and greens, and Corot's grays—a painter's artifice, beautiful in itself, open to many refinements and

harmonies, but still not the Impressionist's color, which sprang from the discovery that all the colors belong to an ordered matrix of light and atmosphere. That empirical oneness is not given to Turner, who seems, on the other hand, poetical, Romantic, and superbly fantastic in picturing this new world of transport as a grandiose revelation of sky and water, of rain, steam, and speed, while Monet's painting renders the actual scene—given to an observer who is there—not as a dream or fantasy, though he, too, inspires wonder and a poetic musing. Uniformly present, Monet's hand colors all things forcefully, and that color is of the same luminous substance throughout, from the setting sun in the far distant upper-left corner to its light in the lower-right; the shadows and reflections build a common scale. All are distinctions within a single medium. The pigment of Turner is less homogeneous; it is more like what the French call "*cuisine*," or "cookery" in painting, with adroit glazing and scumbling, with thick paint in one place, thin in the other, opaque and transparent, designed to create illusions and phantasmagoric appearances, a sublime transfiguring radiance.

Although the encounter with the English artist's work in London in 1871 is believed by some to have been a generating influence on Monet's luminosity, the painter himself spoke of Turner with some reserve. Study of the year-by-year sequence of Monet's work gives little support to the idea that French Impressionism received a decisive stimulus from Turner. Turner is a branch from the same great tree of painterly style but a branch that grew no further in England. The British painters after Constable and Turner lost the passion and boldness of their predecessors, and the Impressionist art that appeared in England toward the end of the century was based on the French rather than the native tradition.[33]

Yet Turner was admired in France: Baudelaire, Gautier, Huysmans, and the Goncourts all wrote of him with an understanding eye.[34] They saw in him less of the veristic observer of nature whom Ruskin celebrated and more of the poet-visionary. When, in a polemical spirit, Huysmans rejected the naturalism of his own youth and moved away from the Impressionists, he wrote of a painting of Turner exhibited in Paris in 1887:

> As for Turner, he stupefies you at the first approach. You find yourself before an absolute mess of pink and burnt sienna, of blue and white, rubbed with a rag turned sometimes round and round, sometimes flowing in a straight line or in long zigzags. One might say it was a print swept with a bread crumb or a heap of tender colors spread out in water on a sheet of paper which is folded, then smoothed down with a brush; this begets astonishing effects and nuances, especially if one scatters some points of opaque white before folding the paper.
>
> . . . Seen from a distance, all is balanced. Before your incredulous eyes arises a marvellous landscape, a magical site, a river, brilliantly illumined, flowing beneath an iridiscent sunlight . . . a water colored with the spectrum of soap bubbles. . . . These are celestial and fluvial feasts of a sublime nature, which has been divested of its outer shell and rendered completely fluid by a great poet.[35]

We have seen that the other approaches to the impression differ as well in their choice of thematic objects, in the artists' attitude, and in the relationship to the "Impressionist" mode of experience, though the latter by itself does not determine a particular style. Impressionist painting arose in France between the 1860s and 1880s, and is preceded by an earlier line of painters whose work stimulated the new artists. Impressionism, however, did not inevitably follow from any of these conditions. If Constable could say in 1820 that there would be no more painting in England after him,[36] he felt, no doubt, that for the further growth of painting what was needed was a strong individuality, artists with confidence in their own original perceptions. In England, however, the pursuit of art in the period from 1830 to 1880 required also the consent of morality and religion to which the life of the senses was suspect as an inferior and even dangerous indulgence.[37] Many of Turner's paintings hung in young John Ruskin's home, but these were covered with black cloth on the Sabbath, pleasure of the eye being incompatible with the requisite solemnity of the seventh day.[38] Across the Channel in France, Sunday was a spell of happy freedom and recreation, the out-of-doors expeditions that the French painters never tired of representing. Expressed in books more intense and thorough than the writings of any contemporary writer in France, Ruskin's passion for the art of painting could be justified only if the prodigious appetite of his eye served to support the ideal and noble in religion and morals.[39]

The new way of life desacralized the Sunday and other holidays. In recharging the vitality of men and women, it freed them from the habits and constraints of merely routine religious observance and made their leisure time more fully their own. The new way of life asserted the goals of pleasure, happiness, and the exercise of individual sensitivity in contrast to the demands of duty, work and conformity to a superpersonal ethic. Stimulated by the growth of Paris and the railroads, which opened the surrounding country and the Channel beaches to Parisians, the change in France had in its time a pervasive effect on the way of life and on thinking and feeling. Coming together with industrialization and with the pressure of the masses in politics, this change prompted an ambience of freedom and of pleasure. The habitual experience of the beautiful parks, old monuments, and the beaches and boulevards as a public domain opened a breach in the wall between classes in the facilities of pleasure. The commercialized entertainment in the big city was part of this process of liberation from religious framework of festivity in the Old Regime. There were new opportunities for openness of the public space and its enlargement, for democratization. It was not just the facilities for pleasure that changed the aspect of life and people's outlook on happiness, the experience of emancipation from the old forms did also. The new opportunities were a symbol, then, of a newly won freedom and of a dream of the future. It was the bodily, the physiological, counterpart of political and social freedom, and it confirmed the belief of reformers that technical progress and economic growth would bring about the conditions for a better life.[40]

At no point in the festive rambling, sports, and amusements of the holiday did one think of a supernatural sanction of rest from work. By the middle of the nineteenth century the day of

rest was no longer justified by the biblical command and the need to meditate on holy things. It was regarded by social thinkers as a practical apportionment of time, required for greater efficiency during the six days of work. From another, though still secular point of view, the journalist and socialist Pierre-Joseph Proudhon wrote that Moses, by instituting the Sabbath, showed himself to be a great sociologist, setting aside a day of rest through which society could know itself as one by a truly shared use of time.

The new forms of recreation replaced the traditional habits and mood of the religious holiday. They depended on the enlarged size of the community; in villages and small towns, it had been harder to resist the pressure to conform. When devoted to God and the saints those holy days had been occasions of churchgoing, prayer, ritual, sermons, and reflections on the sacred. If, like the old folk festivals in the peasants' cycle of the year, they were celebrated by games, music, and dance, these enjoyments were tied to a religious calendar that reinforced the awareness of a supernatural authority in collective and private life. Religion remained the center and organizing power of festivities, just as birth, marriage, and death—the critical points of the individual's existence—were marked by sacramental rites.

Against the background of this millennial religious system—still strong in the nineteenth century, especially in rural regions and small towns but even in large cities—we recognize the novelty and import of the emerging secular practice. The need to reconcile the aesthetic with moral conscience was strong in England between 1830 and 1880. Yet the same Victorian period produced a powerful original literature, at least in its early stage. But in painting, which was so attached then to the sensuousness of color, creation was inhibited. The British painters of that time appear a strange lot when seen beside the more advanced contemporary ones across the Channel. In France, the artists who grew up between 1830 and 1860 lived through the insurgent movements of Romanticism and Realism in the course of which their readiness for personal initiative and their trust in the feelings were strengthened. These changes in art were paralleled by two political revolutions that aborted and were followed by a conservative reaction. But in the course of that experience, French cultural life became a field for the most intense testing of the concepts of freedom, rules, and necessity in art.

That ferment in French thought was sustained by the mobility of private life in the great center of arts and ideas that was Paris. In that larger context of change, artists passed from a Romantic art in which color stood for instinct, imagination, feeling, and passionate release, as opposed to traditional line and form, which symbolized authority, order, and constraints, to Impressionist painting based on a direct confrontation of reality and on color. In the first half of the century, religious and particularly Catholic writers had condemned color as materialistic and praised line as ideal and spiritual. In the twentieth century, these judgments have been reversed. Line has been described as materialistic and color as the spiritual element in art, line being an enclosing and defining form and therefore tied to matter, while the sensations of color are still unquantifiable in spite of the efforts of the psychologists.[41]

FIGURE 117. Gustave Courbet, *Burial at Ornans*, 1849,
oil on canvas, 315 x 668 cm, Musée d'Orsay, Paris

In any case in the 1830s, color was often identified with individuality and the passions. But
the favored themes of art were still imaginary and drawn from history, literature, and myth. A
typical source for the Romantic painter was medieval legend, which supplied an imagery of hero-
ism, poignant love, suffering, and tragic death. With this subject matter, color had special con-
notations of intensity and passionate feeling. Romanticism was followed in the 1840s and after
1848 by the Realistic painting of Courbet, who said of his *Burial at Ornans* (fig. 117) that it was
the "Burial of Romanticism." Courbet called it a historical painting, though it was the funeral
of an unnamed man, the occasion of whose death was not specified. He probably had in mind
the new conception of history, which recounted the fortunes of ordinary men and the struggles
of the lower classes for equality and rights. In this painting, the community has assembled to pay
its respects to a simple individual who is one of them. The idea of individuality has been detached
from the Romantic image of epic heroism and has become part of a radical democratic ideal that
requires for its fulfillment the mastery of the real world and the freeing of men from illusions.

From that moment, painting became less dependent on previous traditions and on themes
that had to be imagined, explained, and interpreted through literature. All that the painter has
represented is familiar from immediate experience; it refers to sensations, impressions, and per-
ceptions. Its typical objects are those of the everyday sphere, not a sphere of fantasy or mediated
knowledge. The new Realism proclaimed a thoroughgoing empirical attitude, though it seemed
to rest at times on a metaphysics of substance and an imagined social or natural totality. But it
was also a protest, a negation of the Romantic and authoritative Neoclassicist ideas that still

ruled art in the 1840s. The Neoclassical and Romantic arts had been addressed to a larger community of politically minded men, to whom the heroic subjects and the pathos of Romantic feeling were closely tied to the aspiration of the non-artists in the community. Hence David could be a militant Jacobin, Chateaubriand a minister, Géricault a Napoleonic youth, even Delacroix a rebellious subject in the Restoration. Ingres, Gros, and Corot had an official or establishment character. The enhanced status of the artist entailed a certain eminence, as well as opposition to traditional privilege. All these developments in the 1850s and 1860s led to a new focus on private life and pleasures, to culture as an increasingly individual affair, perhaps due to the dominance of economic development over the political. There was a revival of certain aspects of the Rococo as a popular rather than court art.

Manet was the last painter to be political in his art. His *Olympia*, *Dejeuner sur l'herbe*, and the *Execution of the Emperor Maximilian* were the final manifestos of the change: the passage from the mythological to the quotidian. For authority, whether of the Left or the Right, appeals especially to intellectual constructions, to beliefs and systems, to a presumed necessity in ideas, to a rationality that deduces truths from fixed principles and regards its directives for action as following logically from self-evident laws. In shifting from imaginary themes to a familiar given world, with its aspect of chance, change, and individual choice, the Realistic painters gave to color and the brushstroke, as the mark of fresh perception or impulse, a greater force and weight. In the period from 1851 to 1870, however, there took place a most important change. Those who had supported the Revolution of 1848, and to whom Realism appeared as a mode of democratic humanism, in oppostion to the preceding monarchy, had to endure the dictatorial rule of Louis-Napoléon, as Napoleon III, emperor of the French. The censorship and discouragement of independent opinion would have been more disturbing had France not experienced a great prosperity and expansion.

In those years, Paris assumed its present attractive aspect. From the old black Gothic town, it became the "white city," as it was often called at the time. The streets were paved, new boulevards were laid out, and the population almost doubled in a period of twenty years. Paris offered then a new model of attractive urban life as the "capital of pleasure." After the 1851 coup d'état of Louis-Napoléon, Baudelaire wrote, "I am depoliticized. If I had to vote, I could vote only for myself."[42] Many intellectuals, artists, and poets, in 1848, had been republicans, anarchists, socialists or communists in the name of personal freedom. While disenchanted and hostile to the existing regime, they found new goals in the possibility of developing a sphere of art in which the program of Realism tempered its militant critical attitude and made the individual sensation or perception self-sufficient. There was an emphasis on the emancipation of personal life, that is family, profession, love.

The new themes of art were founded on pleasurable experience under conditions of freer movement—through the streets, the railroads, and the resorts—in a changing world that was beginning to show the effects of science on industry and of the energies of ambitious enterprise

in other fields. It was that brief moment in which a radical individualism in the arts inherited not only a political disillusionment and quiescence, but also the preceding insurgent Realism and the significance of color, sensation, and movement as values connected with freedom, rebelliousness, and authenticity in the experiences of nature and the urban surroundings. All these, it appears, were preconditions for the emergence of Impressionism in the 1860s and 1870s. The new art was associated with liberating tendencies in French social life, though men felt disillusioned and constrained and spoke most often with disgust about public affairs and the dictatorial regime. That process may be documented in the statements of the artists, in their correspondence and personal attitudes, though all were not affected alike by these conditions; there were great differences between Degas and Monet, for example, as between Cézanne and Pissarro. And there were different stages within the same Impressionist process.

Just before the new art arose in the years between 1850 and 1865, in landscape as well as figure painting, there was in France an intense, persistent growth of pictorial means, culminating in the Impressionist movement. Landscape painters—Corot, Rousseau, and Daubigny—developed the brushstroke and the fresh depiction of light and atmosphere far beyond the

FIGURE 118. Johan Barthold Jongkind, *Setting Sun, Port of Anvers,* 1868, etching, 15 x 26 cm, The Art Institute of Chicago

preceding art. But they did so as individuals who cultivated nature as a separate ideal world, untouched by new conflicts, experiences, and problems of the day; they passed from an idyllic to an increasingly realistic conception for a while, and vacillated within it under various external and inner pressures.

In Monet's circle, two figures had produced such works in the late 1850s and early 1860s and influenced Monet directly. One was the Dutch painter and etcher Johan Barthold Jongkind, who was working along the Normandy coast when Monet painted there as a young man. In Jongkind's etching of the port of Anvers, the image of the setting sun with its evocative, coherent scribble of lines, so fresh, free, and precise in translating the aspect of the sky in black and white—the bold streaking, the casually rendered quality of the atmosphere, the shaping of a light-dark structure corresponding to it, were an indispensable source for Monet's painting of the sunrise that gave Impressionism its name (fig. 118; see fig. 5). Since the two became close friends and Jongkind was Monet's senior by nearly twenty years, it is easy to see how the native locale and the advancing intervening practice of landscape art provided the young artist with models and a stimulus for his work. Monet's other early influence and his first real teacher was Eugène Boudin, who painted at the Normandy beaches in the 1850s and 1860s and, like Constable, but

FIGURE 119. Gustave Courbet, *The Studio: A Real Allegory Comprising a Phase of Seven Years of My Artistic Life*, 1854-55, oil on canvas, 361 x 598 cm, Musée d'Orsay, Paris

264

FIGURE 120. Frédéric Bazille, *The Artist's Studio*, 1870,
oil on canvas, 98 x 128 cm, Musée d'Orsay, Paris

probably without any awareness of the Englishman's work, pictured the sky, weather, and light in sketches on which he noted in writing the time of day and the condition and direction of the wind. Baudelaire admired Boudin's works as sketches but remarked that they were not yet real paintings—they seemed to him unfinished, lacking the completeness that only the imagination could achieve.[43] Baudelaire had not freed himself from his devotion to Delacroix and Romantic art, even while calling for a painter of modern life. In Boudin's work (see fig. 7) we find not only the typical beach scene later adopted by Monet, with its suggestive quasi-Impressionist context, but also the little brushstrokes that weave a texture anticipating the later style.

In this passage from the pre-Impressionist to the Impressionist view, there was an important shift in the painter's attitude to the community. The change may be illustrated by comparing the portrayal of a painter's studio by two artists of succeeding generations who were sympathetic to each other. In representing himself in his atelier in 1855, Courbet called his grand picture a "real

FIGURE 121. Pierre-Auguste Renoir, *Monet Painting in His Garden at Argenteuil*, 1873-75, oil on canvas, 46 x 60 cm, Wadsworth Atheneum, Hartford, Connecticut

allegory, comprising a phase of seven years of my artistic life." He assembled his friends and acquaintances around himself as a central figure painting a landscape (fig. 119). New to him are a nude model whom he is not depicting, and a child who concentrates absolutely on Courbet's landscape in rapt appreciation; a second child, lying on the floor, scrawls on a scrap of paper, an illustration of the Realists' belief about the innate artistry of the child and the value of naïveté in artistic creation and experience. Uninfluenced by schools and traditions, the child is the exemplar of this conviction. Courbet has placed himself in the center of his complex world. In a letter giving an account of the canvas, he described the left side as the community who suffer, who are poor and deformed, or who engage in a traffic that does not fulfill them. They are the sort of subject matter the painter had dealt with during the seven-year period of the picture's title,

but they do not participate in the world of ideas and the arts represented on the other side of the picture (and the other side of the artist's easel). There Courbet has placed, among others, his patron Alfred Bruyas, the novelist Champfleury, and the anarchist writer Proudhon. In the far corner is seated the poet Baudelaire, near a ghostly pentimento of his mistress Jeanne Duval, who was painted out. As in the thought of several writers of the midcentury,[44] the antithetic form of this society is not that of opposed social classes—the proletariat versus the bourgeoisie, the poor versus the rich—but of the cultured and the uncultured, in Courbet's words: the living and those who, for want of culture, are only half alive. In the center of this society is the artist (identified in the lower left corner by his colossal signature), who binds and unifies the whole by his presence.

Fifteen years later, in 1870, Frédéric Bazille, the Impressionist who died soon after in the Franco-Prussian War, represented his own studio with his artist friends (fig. 120). Like Courbet he is positioned centrally, in front of an easel supporting a painting, but there the similarities end. The single figure of the extremely tall Bazille, leaning on the easel with a palette, was painted by Manet, whom Bazille in turn represented standing before the picture with a maulstick. The studio is not a setting for society as a whole; it is only a painter's workroom. But this painter's space has an air of openness, relaxation, and harmony and, unlike Courbet's picture, is brightened by the light from a great window. The Impressionists were pioneers in creating the modern type of studio apartment or house that communicates with the exterior through large windows and doors to gardens and water. That space announced the possibility of reconciling the contrasts of the closed city world and the open country.

Bazille's painting demonstrates not only a difference of personality but of inner attitudes. Bazille showed the transformation of the artist's idea of his personal environment—it is a community of painters alone—but his image depends on the preceding thought of Courbet, who was a friend of the Impressionists and encouraged them.[45] Henri Fantin-Latour's group portraits gathered artists and writers as a complete, closed community; Courbet was exceptional in assembling a broader group. Neither of them, however, had the naturalness of Bazille's presentation: all of Fantin's figures and many of Courbet's have the stiff quality of official photographs.

When Meissonier, an admired academic painter of the period, wished to represent the painter in his environment, he showed an artist of the seventeenth century, a historical figure. At the easel in his studio stands the patron who cocks his head in contemplation of the picture, while the standing artist, holding palette and brushes, awaits his verdict confidently. Scattered around are portfolios and paintings on the wall, elements that contribute atmosphere and authenticity to historical pictures.[46] Compared with this work, the painting by Renoir of Monet at work outdoors (fig. 121) is an image of unselfconscious candor and simplicity—qualities reflected also in the conception of the setting. We see how in the years between the 1850s and 1870s the artist's notion of himself, like his art, has evolved.

XII

Impressionism and Literature

SINCE EACH ART FORM is a complex whole, matching the two arts of literature and painting is extremely difficult, even if the assumption of such unity allows a superficial ease and arbitrariness in finding correspondences. The broad affinity found in Impressionist literature and painting, as well as the close correspondence of certain details of both their form and content, is not always inherent in contemporary arts or in their social outlook. Several styles of painting have existed without any true parallels in qualities of the literature of the same time and place, for example during the Elizabethan period in England or the nineteenth century in America.[1] The accord of the arts in the period of Impressionism is an achievement of a particular culture. Its investigation is a problem interesting also for the sociology of art.

Romanticism had earlier established significant similarities between French literature and painting of the nineteenth century. Writers and painters were closely associated in a Parisian society of creative sensibilities. Delacroix's circle included Balzac, Alexandre Dumas père, Hugo, Prosper Mérimée, George Sand, and Stendhal, as well as great composers and virtuosi like Frédéric Chopin and Franz Liszt. Romanticism existed as a conscious movement and outlook shared by painters and writers. Even the conservative critic and former pupil of David, Etienne Delécluze, spoke of a new solidarity of artists in all the different arts. In the nineteenth century, painting and literature had an equal and dominant place in French culture, an association unique in world literature at that time and not paralleled in England, the United States, Germany, Scandinavia, or Russia.[2] In France, there was an awareness of style of life and an ardent pursuit of its perfection and its expression in the arts of painting and literature.

What we might mean by an Impressionist style in literature is not perfectly clear. Perhaps it would be more accurate to speak of Impressionist features, proceeding from Impressionist painting as a model or type, and admit that they may appear in styles of very different character. First, one must recognize independent tendencies toward such a style in literature. Impressionist forms, themes, and qualities appeared in the writings of Gustave Flaubert in the 1840s and those of Edmond and Jules de Goncourt in the 1850s. A work of Flaubert that especially shows such

affinities—*Par les champs et par les grèves (Over Field and Shore)*—was written in 1847 but not published until 1886, six years after his death. His Madame Bovary in 1857 acquainted other writers with this style, yet Edmond Duranty in reviewing it then found it defective because of a lack of qualities that today we recognize as Impressionist. By 1864, the Goncourts were already writing in a fully developed Impressionist vein.

When this type of literary art was well established in the 1870s, it was often criticized as Impressionist in the painterly sense by the critics who also rejected Monet and his friends. The paintings were seen as not literary enough, and the literature as too painterly. How keenly aware of painters the writers were is evident from what they wrote about their work. More than English or German writers, the French novelists and poets were attracted by contemporary as well as older art. Théophile Gautier dwelt on this relationship in a chapter of his unfinished Histoire du romantisme (published in 1874, two years after his death), stressing the fruitful reciprocal influences or borrowings between the two arts and tracing them to the 1830s. Gautier comments on how many writers had studied painting and on the influence of painters on the vocabulary of writers. But his account is limited to noting the abundance of color words and allusions to objects of art in Romantic writing; he has nothing to say about syntax or the larger forms of the poem and novel. And he seems unaware of the more recent convergence of the two arts.

To grasp that process of convergence, nothing is so revealing as the study of an extraordinary early work by Flaubert in which this process emerges clearly. *Par les champs et par les grèves* is not a novel but rather a report on Flaubert's sensations, feelings, and reflections during a three-month trip through western France in the company of Maxime Du Camp, another writer, who contributed alternate chapters to their common diary. Both friends were committed to the honest statement of their impressions of a journey that was both a holiday and a search for experience. A few years before, in 1843, Flaubert had made a trip to the Pyrenees with a similar intent:[3] his diary began with a promise to himself to avoid all rhetoric, all embellishment, and simply to record what he saw and felt. This earlier work has some astonishing perceptions but lacks what is so pronounced in the later one: the intense response to nature and the lyrical expansion of the traveler who enjoys with ecstatic delight his liberation from the study and the domestic sphere.

Flaubert was enchanted by the freedom of the fields, the random paths, the ever-changing environment, and the sky and sea. He was tireless in noting the rare colors of the landscape. Like the French painters of the 1870s and 1880s who hiked from place to place in the country and by the sea, looking for sites to paint, he caught the most elusive nuances of light and air. *Par les champs et par les grèves* reads almost like a string of canvases by an Impressionist painter, so rich are its perceptions of color, light, air, subtle contrasts, and movement in the changing landscape. The verbal picture of the ocean and rocks at Belle-Île might have been made from Monet's paintings of the same site more than forty years later:

We began by a path which led to the top of a cliff, then followed its asperities and valleys and continued around the whole island. When we reached places where landslips had obliterated it, we struck out into the country and let our eyes roam over the horizon of the sea, the deep blue line of which touched the sky; then we walked back to the edge of the rocks, which had suddenly reappeared at our side. The perpendicular cliff, the top of which we were treading, concealed the flank of the rocks, and we could onlyhear the roaring of the breakers below us.

Sometimes the rock was split in its entire length, disclosing its two almost straight sides, streaked with layers of silica, with tufts of yellow flowers scattered here and there. If we threw a stone, it appeared suspended in the air for a time, would then strike the sides of the cliff, rebound from the one to the other, break into a thousand bits, scattering earth and pebbles in its course, and finally land at the bottom of the pit, where it frightened the cormorants, which shrieked and took flight. . . .

The tide was going out, but in order to be able to pass, we had to wait until the breakers receded. We watched them approach us. They dashed against the rocks, swirled in the crevices, rose like scarfs on the wind, fell back in drops and sprays, and with one long sweeping liberation, gathered their green waters together and retreated. When one wave left the sand, its currents immediately joined, and sought lower levels. The seaweed moved its slimy branches; the water bubbled between the pebbles, oozed through the cracks of the rocks, and formed a thousand rivulets and fountains. The drenched sand absorbed it all, and soon its yellow tint grew white again through the drying action of the sun.

As soon as we could, we jumped over the rocks and continued on our way. Soon, however, they increased in numbers, their weird groups being crowded together, piled up and overturned on one another. We tried to hold on with our hands and feet, but we slid on their slippery asperities. The cliff was so very high that it quite frightened us to look up at it. Although it crushed us by its formidable placidity, still it fascinated us, for we could not help looking at it and it did not tire our eyes. . . .

In some places were great pools of water, as calm as their greenish depths. . . . On one side was the ocean with its breakers foaming around the lower rocks; on the other, the straight, unrelenting, impassive coast.

Tired and bewildered, we looked about us for some issue; but the cliff stretched out before us, and the rocks, infinitely multiplying their dark green forms, succeeded one another until their unequal crags seemed like so many tall, black phantoms rising out of the earth.[4]

But beyond these intense perceptions of color and light, Flaubert's pages contain an awareness of the self, immersed in the visual aspects of nature, and a lyrical affirmation of the roaming spectator's joy and deep fulfillment in that experience. If there is a philosophy of Impressionism, it comes out fully in Flaubert's travel diary of 1847. But the young writer still had roots in

Romantic poetry and sensibility. Flaubert followed his generation in one regard: he often stopped to admire or assess old buildings. He recalled their history, the scenes of violence that had been enacted in them, curious personalities who had lived in the castles, bits of folklore and legend, and archaeologists' problems of interpretation, dating, and attribution. He dwelt at length on the historical past, on folk life, on the native piety and beliefs, on the fantastic imagined figures, heroes, and monsters of the places he visited. Flaubert's rapture in air and sunlight quickly transformed into a metaphysical exaltation of pantheistic fantasies. There are passages, even a prevailing tone, of exuberance that betray the effect of Romantic poetry. Flaubert was still close to the Romantics; steeped in history and legend, he was attracted by the energies and passions associated with old sites—an interest he pursued until the end of his life.

Flaubert's *Par les champs et par les grèves* is a crucial instance of writing that had Impressionist qualities, such as the importance of sensations, the environment, and the moral content, as well as the importance of freedom in movement and roving perception. Yet Romantic and historical content persisted; Flaubert's imagination was not prepared to subordinate itself to full Impressionist empiricism, sublimated by rare harmonies, as well as by novelty of color and surface.

Meticulous as he was in creating an accurate milieu and action in *Madame Bovary* (1857) and *L'Éducation Sentimental (Sentimental Education)* (1869), both novels of contemporary life, Flaubert applied the same scruples in his writing about the distant past: the novels *Salammbô* (1862) and *La Tentation de Saint-Antoine* (1874) and the shorter tales "La Légende de Saint Julien l'Hospitalier" and "Hérodias"(both 1877). In an early 1843–45 version of *Sentimental Education*, Flaubert's hero, who was undoubtedly a stand-in for the author himself, studied history as a means of overcoming despair at the banalities and frustrations of his own time. The detachment and objectivity of such contemplation of the past also gave this self-absorbed observer and student an imaginative experience of a greater and more poignant totality of human life, thus expanding his vision. Flaubert and his character shared such interests with the Goncourts, who, while writing their novels, engaged also in scholarly study of the women and men of the eighteenth century, of their manners and arts. But the Goncourts' taste for the eighteenth century was largely aesthetic—a love of costume, furniture, bibelots, and the salons, as well as of the painters of that time. They were drawn to this period, as they were attracted to Japan, by the special beauty of a period and place. In time, their taste spread among their contemporaries as a common love of the Rococo, a style that had certain obvious affinities with the early Impressionist outlook, in lightness of touch and perception. In contrast, Flaubert's favored periods and places were the early Christian and medieval cultures—like their artworks, more barbaric, irrational, and frankly romantic in the intensity of the violence and passions associated with them.

Yet Flaubert's conception of art was not only a step toward Impressionist abstraction of the painterly brush and its tone, the rare and exact nuance, but also toward the broader Impressionist vision of a pervading medium and natural forces of light and atmosphere that saturate the whole. His search for the right word as an element, a distinctive unit, led him to sharper

observation of fine differences in both the objects described and the language of description. Often he adopted the contemporary painter's way of seeing and method of representation. Especially in *L'Éducation sentimentale*, when describing a scene, he spoke of objects as spots of color in the distance. He was very much aware of the apparent mutations of a color by contrast with a neighboring hue and certainly owed to his knowledge of painting and painters those descriptions that demonstrate this.

Impressionist form and content are highly developed verbally in Flaubert's *L'Éducation sentimentale*, as seen especially in the personalities of Frédéric, Dambreuse, Rosanette, M. Arnoux, and Mme Arnoux. Exemplifying a typical Parisian sensibility without a goal, Frédéric is portrayed in episodes shaped by impressions, encounters, pleasures; he is the *marchand et editeur d'art* (seller and editor of art). Flaubert employed Impressionist-style devices in his descriptions—colors and "contrast" colors, *taches* ("touches") with the word as unit (*le mot juste*)—and he paralleled Impressionist motifs: the open air, the moving spectators, the boat ride, the railway (trips from Nogent to Paris and from Paris to Creil, with highly visual descriptions of views, buildings, landscapes), the promenade, the racetrack, the streets, the ball, the theater, the pottery works, and the forest of Fontainebleau. Flaubert depicted the Revolution of 1848 and politics more generally as seen in terms of individual perceptions, without including the larger view, such as the portrayal of genuinely political personalities. Later, in *Salammbô*, his opulent literary hymn to Orientalist splendor, Flaubert's crowds and the streets they fill in Carthage were undoubtedly inspired by the writer's experience of Paris.

Although Flaubert's writing has much in common with Impressionist painting, it was probably independent of the Impressionist group. There is little or no reference in his correspondence to contemporary painters. He knew and admired the sculptor James Pradier, and he must have been aware of artists of the 1840–60 period and their ideas. Such interests could account for his language of color and light; but his own powerful originality contributed more and led him further in the same path. The painter Pellerin in *L'Éducation sentimentale* somewhat resembles Manet, but moved back to the 1840s.

Precociously advanced as he was toward the Impressionist vision, Flaubert had at the same time an irrepressible longing for the heroic and magical world of the past that engaged the Romantic travelers, historians, and poets. Like Baudelaire, Flaubert experienced a parallel conflict between the modern and the fanciful-exotic, between the past and the present.[5] In his aforementioned travel book on Brittany, Flaubert gave as much space to the remains of the past as to the natural landscape. We see here the lifelong duality of his career as a writer. Besides the pictures of modern life in his *Madame Bovary* and *L'Éducation sentimentale*, he applied himself to the reconstituted history and exotic passions of the *Saint-Antoine* and *Salammbô*. His short stories about Saint Julien and Hérodias are relivings of a distant world recaptured through reading and the study of old images. Even "Un Coeur Simple" ("A Simple Heart"), though placed in a contemporary setting, recounts the stages of an archaic existence shaped by naive religious faith.

Flaubert's attachment to history, while yielding a most penetrating picture of his contemporary world, was found also in other realistic writers of his generation. He knew and esteemed Eugène Fromentin, who was at once painter, critic, traveler, and novelist. *Dominique* (1862), Fromentin's single work of fiction, is set in France and deals with his contemporaries. A thinly veiled autobiography, it is filled with the beloved landscapes of Fromentin's native Charente, perceived by the eponymous character, as by the author himself, in a receptive, somewhat passive way. Among other things, Dominique registers effects of sunlight, of travel, and of the city. Fromentin's Salon paintings were almost entirely of Algeria and were largely done from memories of his three trips there. A finely tuned recollection of place and atmosphere was the most pronounced characteristic of both his writing and painting. Although quite anti-academic in his pictorial technique and gifted in the specific and atmospheric verbal evocation of place, Fromentin was hostile to the developments represented by Manet and the Impressionists. With regard to his progressive contemporaries, his descriptive writing was more advanced than his critical attitudes.

The Goncourts, Champfleury, Ernest Feydeau, and Duranty, who was somewhat younger, mixed the profession of novelist with that of the documentary historian. Balzac and Stendhal before them had attempted to reconstruct the past in certain of their novels. The example of Walter Scott, an immense literary force on the Continent, may have counted for much in this enterprise of French writers. Major historians of that time, Jules Michelet, Augustin Thierry, and Alphonse de Lamartine, were, in turn, conscious of their craft as storytellers, analysts of character, and narrators of destinies. Leo Tolstoy, in undertaking *War and Peace*, was later a part of the same tradition.

The Goncourts were in literature the Impressionists *par excellence*. Their program of art was painterly, and they were concerned with a "new optic" or way of seeing. The ability of both de Goncourts to draw and paint with considerable skill informed their novel about a French painter, *Manette Salomon* (1867). That novel's style is well described by their own term, "*écriture artiste*" ("artist writing"), since they demonstrated a painterly vision of landscape, color, tones, light, and atmosphere. In another of their novels, *Renée Mauperin* (1864), their descriptive language is expressed in touches or strokes.[6] Although independent of the practice of the Impressionists, the approach of the Goncourts converged with the new paintings through a common background in the art of the 1850s, especially landscapes. As writers, their program was Realist and their goal modernity. Despite their chronically spiteful comments, they were friends with Degas, an artist whose insights into special milieux and their effects on personality paralleled the brothers' own approach. Degas's depictions of the Bourse, ballet, and brothel, as well as the laundry, music hall, racetrack, and toilette, reflect a similar artistic immersion into a particular location, profession, even gender, a quality of accurate observation, projection, and empathy also evident in the English novelist George Eliot.[7]

Published just before Impressionism emerged, *Renée Mauperin*, opens with the eponymous

heroine and a young man conversing while bathing in the Seine and holding to a rope attached to a boat, like figures in Monet's *La Grenouillère* (see fig. 9a). They talk of the theater and the opera as well as of social constraints in their transitional environment: "The country, the outskirts of the city, the suburbs, mingled on the two banks."[8] The picturesque landscape is spotted with poplars, gardens, green shutters, signs, old barrels, bits of white wall, roofs, smoke, shadows, chimneys, a bridge, fishermen, wagons, and factories. It is a painterly view with scattered notes of color that the authors likened to the canvases of a contemporary artist, Adolphe Hervieu. The scene is paradoxically dirty and radiant, miserable and gay, ramshackle and alive. Nature crops out between constructions, work, and industry, like a blade of grass between a man's fingers. Renée finds the view beautiful, but her companion disagrees; he remembers a painting he had seen at an exhibition two years before with an effect of that kind and says he doesn't care for such things. With typical spontaneity she ends the conversation by diving into the water.

Approaching Henry James after having read the French authors he had known in his early years, one can recognize in his stories many of their themes and settings, which manifest the emerging Impressionist sensibility of the 1860s and 1870s. His story of *Daisy Miller* (1879) is indebted to *Renée Mauperin*. It begins with pictures of a summer resort in Vevey—the hotels, the terrace view, the lake, and the tourists. An outspoken child and his candid, innocent, beautiful sister, naively and spontaneously delighted with the surroundings and eager to travel, contrast strongly with their old rich aunt, who is prudish, snobbish, and conventional. James paused to describe the lighting of a cigarette, the drinking at table, the waiter, the garden walk with its flowers, and a parasol, all details familiar to us from the paintings of Manet, Renoir, and Monet:

> There is a flitting hither and thither of 'stylish' young girls, a rustling of muslin flounces, a rattle of dance-music in the morning hours, a sound of high-pitched voices at all times. You receive an impression of these things at the excellent inn of the Trois Couronnes. . . . [A] beautiful summer morning. . . . He . . . was enjoying a small cup of coffee which had been served him on a little table in the garden by one of those waiters who looked like attachés. At last he finished his coffee which had been served to him on a little table in the garden and lit a cigarette.[9]

The dialogue is interspersed with glimpses of landscape and changing effects of color that evoke a pictorial ambience of sensing, receptiveness, and informality. In more than one episode, a figure appears first as unknown, unidentified, vague, and shadowy, until it emerges into the foreground and wins full recognition. James noted how looking at landscape may also be a calculated act, an evasion, an expression of detachment. Daisy's severe aunt disapproves of that life of sights and pleasures, sensations and impressions: "You may be sure she thinks of nothing. She goes on from day to day, from hour to hour, as they did in the Golden Age. I can imagine nothing more vulgar."

The setting of episodes and even whole stories in a distinctly toned landscape and weather was, of course, a common idea of writers long before Impressionism, The setting contributes a ground color as well as nuances. It is the carrier of a mood that prepares and reinforces the action. The poet or novelist may describe the spaces of the story in a language that rivals the painter's gamut of tones. The description remains clearly external, however. It is not a perception by the characters themselves; they do not react to the colors and atmosphere of the surroundings but are occupied only with each other. Such is the picture of the gloomy and sinister aspect of the park where Fyodor Dostoevsky places the episode of Shatov's murder in *The Possessed* (1871). It appears to us conventional, a device borrowed from the Gothic novels where crimes are consummated in dark places or in underground chambers. More subtly Turgenev in *On the Eve* (1860) paints a beautiful picture of Venice—remarkably like Monet's pictures of the city almost fifty years later—in coloristic counterpoint to the action and moods of the story; his description invests the characters with something of the phantom qualities of the medieval city, suspended over water and reflected in it. More distinctively Impressionist is the picturing of the environment in certain pages of Flaubert, the Goncourts, Daudet, and Maupassant, as seen and felt by the character, as a revelation of his or her personality, and as sometimes determining a change in the person, a decision, or a new action. This sense of the surroundings in the novel may appear spontaneously in a novelist of generally non-Impressionist temper, like Charles Dickens in the *Old Curiosity Shop* (1840–41) or Tolstoy in *The Cossacks* (written 1853; published 1862). But most often it is a feature in novels with little plot and quite passive characters, like Fromentin's *Dominique*. Likewise, at the beginning of *Eugénie Grandet* (1833), Balzac described the streets and houses, the physiognomies of the dwellings, to establish the town as a sign of its inhabitants.

Impressionist paintings are often described as "poetic." What is the sense of "poetic" here? Is the landscape of Monet poetic in the same sense as a painting by Giorgione or Odilon Redon? Is a picture by Delacroix with a subject from Dante poetic? Landscape painting has generally been assessed as a poetic art, portraying the temperament of the landscape. The poetic in Impressionist painting obviously does not reside in the choice of a subject from an existing poem, but in a conception of the subject in a spirit that is also that of a contemporary poet and that equals the aesthetic in experience. In the period of Impressionism, a certain view of nature was regarded as the essentially poetic view. It involved the contemplation of color, light, movement, texture, and the experience of their qualities as feeling-charged; they fuse to constitute a mood, a state of mind, a symbol of a complex essence of man and nature. Such an approach can be found in two of the century's greatest writers: Charles Baudelaire and Victor Hugo.

Common to painting and poetry at this moment is the significance of the sensations (of color, light, movement, sound) as feeling-toned essences; and of the poetic substances of language as a parallel supporting fabric of word-sounds and rhythms with a corresponding evocation. The difference from older poetry is in the replacement of action by the impersonal phenomena of the

environment as a spectacle; but this spectacle is characterized by movement, flow, interchange, impulses, and their extinction. Impressionist painting is poetic, then, in two respects, both in accord with the content and style of contemporary poetry. It represents a momentary appearance of the environment as a correlate or source of the spectator's feeling; it weaves an artistic substance of rare but precisely observed tones, like the poet's choice words. The smaller units of the words—the vowels and consonants—and their rhythmical grouping are like the brushstrokes and the decorative silhouettes with vague pulsations or projections that soften the whole and reduce the larger contrasts.

The French poets closest to the painters are Stéphane Mallarmé, Charles Cros, Paul Verlaine, and in the later decades of the century, the young Symbolists who imitated Mallarmé, perhaps even Arthur Rimbaud in some of his poems. But a similar sensibility appears in the novels of Zola, the Goncourts, and Daudet when they described the environment and their characters' perceptions. Maupassant should be included here and, to some extent, Fromentin.

The Impressionist spectacle in certain poetry and prose may be regarded as metaphor. The colors of the landscape, its pervading quality serving as a metaphor for the speaker's or observer's feelings, were, however, unlike classic metaphor, part of a visual experience that is the subject of the picture or poem. When a Greek hero is described as falling like a great tree, the simile is a thought of the narrator, an artifice that is not part of the event described, whereas in Impressionist poetry and prose, the landscape or city spectacle is seen and felt by the subject of the poetic text, whether it is the narrator speaking in the first person or the ideal reader conceived as the viewer of the objective spectacle. Figurative or associative language—metonymy or synecdoche—plays a role in the innovative visual approaches of the writers and can perhaps offer illumination concerning the practice of the painters in Impressionism.

In older painting, the figure of speech could be translated into some feature of a form that evoked the comparison contained in the figure of speech. So in medieval Christian art the crossed faggots carried by Isaac to the Sacrifice were a metaphoric symbol, even a metonymy, of the Crucifixion, recalling Jesus carrying the Cross. Are there such "figures" in Impressionist painting? In the contemporary poems, the metaphorical is not distinguished clearly from the warp of description. Many of the figurative words are common words, especially in description of movement— the sky "descends"; the "death of the day (is) mourned by the copper twilight." These words suggest the intersensory or tertiary qualities of colors and especially of the rare tones that one perceives in terms of another object or a feeling. So to "angelize with blue" refers to the occurrence of a pure, distant-looking blue among terrestrial objects in a particular light. If metaphor is a transfer or transformation of objects, an analogy evoked by a quality common to the object described and to some remote object, whereby that first quality is accented and disclosed more pointedly, then Impressionist painting is a metaphoric style.

But in poetry the evocativeness, depending on the allusive intersensory descriptive words, generates a vague meaning or connotation of the whole, which is toned by the implicit mood of

certain of the object words and the musicality of the rhythmic verses. More figurative than the separate words, then, is that connotation of the whole to which one applies the concept of symbol—an untranslatable feeling or idea. What was expressed distinctly in older poetry by metaphors is evoked in this new art by the pictorial language for sensations of light, color, and movement woven together as a single, emergent, affective whole.

The Impressionist painting, with its double aspect of object and image, seems in a parallel manner to create a passage between the surface of pigment *taches*, or patches, and the represented world, and between that surface and a rare or new state of feeling. A Symbolist poet could, therefore, see the painting as a Symbolist work, though some painters of the next generation, like Gauguin, Bernard, and Paul Sérusier, in assimilating Symbolist poetry—as the Impressionists had not done—thought rather of Symbolist painting as invested with an allusive subject matter, like old religious art. But they retained from the Impressionists the experience of color as a carrier of mood and particular feelings, with the addition of a more decided outline form, of a corresponding capacity for expression of feeling. Thus, there was considerable Impressionist influence on the Symbolists, who inherited, borrowed, or absorbed much from their distinguished predecessors.

The figurative in the poetic sense appears in another aspect of Impressionist painting: the rendering of objects through a few cursive strokes that reduce the manifold form of a tree to a mass of green, a human body to a curved or vertical patch, a face to a spot of pink. Such an approach is like the language of poetry that replaces the boat by a sail, the river by its water, the bird by a wing. This simultaneous association and reduction is metonymy, a general property of language in ordinary as well as artistic speech, which is inventive and expressive in its use of such figures. How important is metonymy in the French poetry of this time? I have not studied the poems from this point of view, but such consideration might yield some interesting examples. A distinction must also be drawn between the reductiveness of the Impressionists and of the younger artists—Gauguin, Bernard, Seurat—with respect to both line and color.

That which is essentially poetic lies in the perception of subtle qualities of the scene that make it strange or unreal in its novelty, a revelation of essences that intimate exquisite forces in objective nature, forces beyond the viewer's power of controlling or naming them or arresting their ceaseless emergence and disappearance. They are like the glimpses of a mysterious microworld in the scientist's laboratory and are no less objective than the latter's disciplined scrutiny of his elusive objects. The poet has devised a language for conveying these rare perceptions as objects of wonder and enjoyment. Though attached to a mood, a personal vision, these descriptions have a large objective component, which is especially evident in painting.

Prior to Impressionism, one found the connection of impressionist-like devices with a particular content, as well as the sporadic appearance of these devices in earlier literature, such as stage-setting descriptions in plays by Victor Hugo. The act of looking, often in modern situations, inspired impressionistic tableaux: in Dickens's *Hard Times* (1854), the account of the

railroad train;[10] in Hawthorne, a window view of sky and weather; in Hugo, travel accounts of the train and carriage, in other words views in movement, and of the cathedral in the mist; in Tolstoy, the mountains of the Caucasus; and in Charlotte Brontë's *Villette* (1853), a momentary view of streets. Yet none of these instances of impressionistic seeing can be used to argue for an overall adoption of Impressionist style.

The rendering of the environment and the spectator are a common root of Impressionist features of style in both literature and painting. The environment is a counterpoint, a background of action. Formerly it bore ominous portents, in works such as Shakespeare's *Julius Caesar* or the Gothic novels. Such brooding atmosphere survived into the nineteenth century, with writers like Dostoevsky, but already a new tendency toward a richer account was seen during the 1840s and 1850s. The character became not a victim or counterpart of the viewed environment but a sensibility responding to it. The growth of realism in the nineteenth century naturally entailed greater importance and scope of the visual as the most informative and detail-bearing sense.

This changing awareness was different from the *milieu* concept of Hippolyte Taine, whose view continued the eighteenth-century idea of racial or national temperament seen in writers like Montesquieu or Winckelmann. It is not a conception of art, but rather the response of Taine and the organic chemist Marcelin Berthelot to the strong contrast of the environments of Galilee and Judea in the *Life of Jesus* (1863) by Ernest Renan. Renan stressed the importance of these different settings in terms of their effect on and their reflection of the two significant phases of Christ's career: the Preaching and the Passion. Such a conception of surroundings is relative, based on opposition; it is pre-Impressionist, since the landscape is not perceived aesthetically or affectively in terms of individual character.

The popular and vernacular elements in both painting and literature are qualities found by Brunetière in Alphonse Daudet, with reference to his use of argot terms. But painting diverged from popular art, which had earlier been an object of interest in the 1850s and 1860s.[11] Impressionism seemed casual, spontaneous, conversational in execution. It appeared inexpert and crude to conservative critics and peers, with its lack of the smoothness, polish, or virtuoso finish of academic art. It was too sketchy for devotees of "classical" styles. Mixed with stylistic innovation were different qualities of the popular. Portraits of common figures, such as Paul Cézanne's cardplayers and smokers, his servant and gardener, harked back to the seventeenth-century realism of the Le Nain brothers. Yet nothing in painting really corresponds to quoted vernacular speech in literature, as in the sailor poems of Tristan Corbière, except for, perhaps, Impressionism's loosened composition, its informality of representation, as seen in the work of Degas. In painting there can be no division between the author's language and that of the characters, though some highly finished pictures have included as convincing accessories and background popular prints, graffiti, or children's drawings, as in Meissonier's painting *Sergeant's Portrait*.[12] For writers like Béranger, the most popular poet of his time, the vernacular offered an enrichment of vocabulary, texture, and character that lacked a pictorial counterpart.

Inherent differences between literature and painting can be revealed by Manet's illustrations for Cros's poem *Le Fleuve* (*The River*). Manet's etchings demonstrate stylistic innovation with their sparse, broken effect, their use of voids to suggest light, their freedom of touch, and their graphic approach to color, light, and space. As creative efforts, Manet's etchings could not date from before the 1870s. In the text, Cros's concept of a river is related to the Impressionist taste for movement, continuity, and human environment. It is an urban and suburban river; it includes industry, humanity, and history. Cros followed it as a moving observer, like a railroad passenger.[13] But Cros was still bound by old restrictions of meter and rhyme. The conventionality of his forms betrayed the innovation of his perspective.

Impressionist or "impressionistic" features continued to appear in later nineteenth- and twentieth-century literature, especially in the works of Marcel Proust and Virginia Woolf. Proust's early writings, such as *Jean Santeuil* (1895–99) reveal an interest in light, in the surroundings as aesthetic objects or occasions, and in the awareness of painting as a model art form, inspired by a love of its themes. But Proust's conception of the painter Elstir and his inspiration derived from the beauty of his wife is non-Impressionist, particularly in his notion of an idealized woman.

Doubtless painters opened the eyes of poets and novelists to qualities of the visible unnoted in previous writing. When Maupassant described the dome of an old Muslim building at Sidi El Hani in North Africa, he saw colors in a way that bespeaks his acquaintance with the contemporary pictures of Monet and perhaps even his conversations with the painter:

Never have I seen the sun make of a dome a more astonishing marvel of color. Is it white? Yes, blindingly white! And the light is decomposed so amazingly on this great egg that one distinguishes in it an enchanting spectacle of mysterious nuances, which seem conjured up rather than apparent, more illusory than real, and so fine, so delicate, so immersed in this snowy white, that you do not see them at once but only after the dazzlement and surprise of the first glance. Then you perceive nothing but them, so numerous, so varied, so strong, and yet almost invisible! The more you look, the more pronounced they appear. Waves of gold flow on these contours, mysteriously extinguished in a bath of lilac as light as a mist, crossed in places by bluish tracks. The immobile shadow of a branch is perhaps grey, perhaps green, perhaps yellow? I do not know. Under the shelter of a cornice the wall below looks violet to me; and I guess that the air is mauve around this blinding dome which seems to me now almost pink, yes pink when one keeps looking at it too long, when the fatigue produced by its radiation mixes all these tones, so subtle and bright that they dazzle the eyes. And the shadow of this *koubba* on the ground, what tint is it? Who can know, who can show it or paint it? How many years must we steep our eyes and our thought in these indiscernable colors, so new for our

organs which have been taught to see the atmoshere of Europe, its effects and reflections, before grasping these, distinguishing and expressing them, and conveying to those who will look at the pictures, in which they will be fixed by an artist's brush, the complete feeling of truth?[14]

The writer has not only begun to see the colors in bright sunlight with a painter's eyes; he understands light and color in a new way and applies in his description the concepts of decomposed light and optical fatigue that the painter has borrowed from the scientist.

A generation earlier, the painter-writer Fromentin, also describing the light and sky of North Africa, had been struck by an essential grayness (like Ruskin in Italy at the same time).[15] He had been overwhelmed by the intense light, once temporarily losing his sight, and he prudently turned away from that spectacle as unsuited to his art—the decomposed colors of the white that Maupassant saw would have been for Fromentin a disturbance of the purity of the dome's true color.[16] In fact, the perceptions of Maupassant and Monet were not illusory; they actually agree with the scientific view and have a certain truthfulness.

While aiming at truth of impression in a pictorial vision of landscape, Henry James was not wholly consistent in his point of view, in the painterly sense. In practice, in a language of juxtaposed, separate phrases, he could depict with words a scene as beheld from a distance through a window and could evoke with precision the colors and atmosphere of an hour and a season, a mosaic of randomly grouped perceptions without a center or an order that might permit one to map the surface of the object. But from the same distant view he noted expressive details, particular objects, substances, and textures, minutely observed. Consider the following passage:

> The western windows of Olive's drawing room, looking over the water, took in the red sunsets of winter; the long low bridge that crawled, on its staggering posts, across the Charles; the casual patches of ice and snow; the desolate surburban horizons, peeled and made bald by the rigor of the season; the general hard, cold void of the prospect; the extrusion, at Charlestown, at Cambridge, of a few chimneys and steeples, straight, sordid tubes of factories and engine-shops, or spare, heavenward finger of the New England meeting house. There was something inexorable in the poverty of the scene, shameful in the meanness of its details, which gave a collective impression of boards and tin and frozen earth, sheds and rotting piles, railway lines striding flat across a thoroughfare of puddles, and tracks of the humbler, the universal horsecar, traversing obliquely this path of danger; loose fences, vacant lots, mounds of refuse, yards bestrewn with iron pipes, telegraph poles, and bare wooden backs of places. Verena thought such a view lovely, and she was by no means without excuse when, as the afternoon closed, the ugly picture was tinted with a clear, cold rosiness. The air, in its windless chill, seemed to tinkle like a crystal, the faintest gradations of tone were perceptible in the sky, the west became

deep and delicate, everything grew doubly distinct before taking on the dimness of evening. There were pink flushes on snow, "tender" reflections in patches of stiffened marsh, sounds of car-bells, no longer vulgar, but almost silvery, on the long bridge, lonely outlines of distant dusky undulations against the fading glow.[17]

There are obviously two spectators here, the experienced writer with his discerning eye, remembering the already registered perceptions of the landscape and its familiar objects, responding to these as an environment anatomized and judged; and the character in his story, an eager young girl, open to new sensation, innocent of evil, decay, and ugliness, and entranced by the beauty of sheer appearance, the landscape as a momentary spectacle of light, atmosphere, and color, nature's unique performance for her delight. And through this double view of the scene, together with his judgment of the poor, the mean, the sordid as recurrent realities of the landscape, its subsisting truth, James also intimates something of the human situation in his story, the contrasts of the shabby real and the shining illusion, the actuality of the world and the agreeable glow of fantasy that veils it.

Note also in James the typical language of Impressionist perception: the windows "take in" the sunsets; the "something" of a quality; the "collective impression"; the scene as a "picture"; the "seeming" effects; the "faintest gradations of tone"; and a frankly acknowledged borrowing from the talk of the studio in the "tender" reflections, a word long current among painters and placed by the writer in quotes. James's concept of Impressionism equates it to an experience of different qualities—the phenomenological equals the aesthetic in the old sense.

Impressionism in the novel is only an aspect, a feature or quality of certain parts rather than a principle of the whole. No great novel is as thoroughly Impressionist as a painting by Monet.[18] While in most writing the Impressionist features of language, perception, and outlook stamp the work strongly enough to determine a new quality of the whole, there remains as a matter irreducible to Impressionist aesthetic the novelists' primary subject: human beings in action with their changing fortunes disclosed in time. The character of these protagonists may be revealed through their responses to their surroundings, their fates may depend on the happenings in the streets and resorts while they pursue pleasure, their sensibility may be cast in an aesthetic rather than moral mold, they may be an organism described through a language of sensations and impressions. But with all these interactions, the interest in the stories lies in the development and outcome of a situation, in an action or in a change of mood brought about by an action.

The concept of Impressionism has, then, less pertinance to the novel than to painting. Poetry at that time was perhaps closer to pictorial art. But among the visual arts, architecture was less fully open to Impressionist forms and attitudes. The Eiffel Tower, with its exposed construction made of hundreds of small units, its flicker of trusses and light voids, its airiness, its seeming weightless mass through which the sky may be seen, is perhaps the ideal Impressionist building.[19] In its original state, the Tower was painted in spectral tones—a brilliant, luminous sight against

the changing color of the sky. Although the Eiffel Tower is an exception to the architecture of the time, it came to be recognized as a pioneer work in a line of engineers' constructions that led to the architecture of the twentieth century.

The gulf between painting and literature is clearest in the life and work of Émile Zola, who of all the writers of his generation was closest to the Impressionist painters. His novels and his relations to these artists illuminate the differences between literature and painting and the problems common to them during his lifetime. A schoolmate and inseparable friend of Cézanne in Aix-en-Provence and in Paris, Zola dedicated to Cézanne in 1867 a book of criticism that established the writer as the champion of Manet and the young Impressionists. Zola dedicated a novel, *Madeleine Férat* (1868), to Manet, and both Manet and Cézanne painted Zola's portrait. Although Zola's judgment of painting was founded more on his admiration for the independent spirit of the artists than on discernment of artistic qualities and was guided by the enthusiasms of Cézanne and other young painters in Paris, he was attracted by their bold color and brushwork and was perhaps as much stimulated by their canvases in his written descriptions of Paris and the countryside as by the richness of color impressions written in the novels of the Goncourts and Flaubert. Zola built his novel *Une Page d'amour* (1878) around five pictures: the changing aspect of Paris at different times, seen through a window.

But this Impressionist sense of the physical environment and color was not central to Zola, as it was to Monet and his fellow painters. From the beginning, Zola's own art was addressed to the passions and fate of human beings subjected to the powerful forces of heredity and social environment. Even before he fixed upon his Balzacian program of the history of a family through several generations as a social epic, his stories were violent to the point of the macabre. In his awareness of society and the fate of individuals, he could not ignore the collective struggles and changes going on before his eyes; his early rebelliousness and hatred of repressive authority were soon channeled into keen sympathy for the workers and other sufferers, as well as into a conception of modernity as a basic stage in the growth of the social order.

With this viewpoint and program, Zola became more and more estranged from his painter friends. What had seemed in the 1860s a common banner of Realism no longer, in his eyes, fit their work in 1880. They appeared now to be insufficiently mindful of social reality and had even managed to win admission, as did Monet and Renoir, to the official Salon. When in 1880, at Cézanne's request, Zola wrote a series of articles entitled "Le Naturalisme au Salon" on the occasion of these painters' acceptance by the Salon, he felt obliged to confess his disappointment: "The great misfortune is that not one artist of this group has realized powerfully and definitively the new formula that they all bring, scattered here in their works."[20] A harsher judgment was embodied in the failure of the fictive Impressionist painter Claude Lantier, a misguided, spoiled talent in *L'Oeuvre* (*The Masterpiece*), Zola's novel of 1886, which was a further and still harsher judgment of the group. The book's publication led to a permanent rupture between Zola and his old friend Cézanne, whom he had once called his brother and a real part of himself. In an

article of 1896, shortly after Cézanne had won more popular recognition and the adoration of several young artists in Paris through a major show of his work, Zola spoke of his former friend as a genius who had failed; and he denounced both the Impressionists and the new generation of advanced painters: Gauguin, van Gogh, Toulouse-Lautrec, and Pierre Bonnard, demonstrating philistine dismay at the arbitrary, unreal coloring of their works.[21] Unlike Tolstoy, who at this time also condemned the new painters in the name of common humanity and the moral mission of art, Zola knew their work well and had once been their defender.

The change in Zola's view of the Impressionists can perhaps be better understood through a consideration of his problems as a writer. A militant, uncompromising Realist, he was disturbed by the trend of their art in the late 1870s and early 1880s. What had been a daring break with tradition and official art in the 1860s and early 1870s now appeared to be an agreeable painting of themes of pleasure, more and more acceptable to the bourgeoisie, while his own increasingly venturesome Realism continued to provoke violent hostility and condemnation. Painters like Cézanne and Monet had left Paris and its suburbs for the solitude of distant provinces. Zola recognized in their art all that could be accommodated to the aesthetic of a bourgeoisie, now as complacent in its corrupt republic as it had been under the empire of Napoleon III.

In coupling his attack on the Impressionists with horror at the avant-garde of the 1880s and 1890s, Zola was also defending his own art from the attacks by the young writers and especially the poets. The Symbolist movement of the mid-1880s and early 1890s was vehement in criticizing Realism as artless and unimaginative. While Zola was acquiring a vast public of devoted readers, especially among the lower classes and radicals of all countries who regarded him as a socialist, he found conservative opinion was mercilessly critical and contemptuous of his art. The abuse of Zola is a model chapter in the social history of taste that shows how far the judgment of literature is directed by a social and political bias. Besides this overtly ideological attack on Zola, there was another, also inspired by ideological positions, though stated in aesthetic terms. Zola was condemned for his limitations as an artist, his wordiness, his excessive descriptions, his repetitious themes, his defects as a poet. The whole trend of the new literature was away from Realism and toward a finely wrought, often precious art of moods and sensations; it was often hermetic, mystical, or religious. The defection of his formerly enthusiastic follower and collaborator Huysmans in *À rebours* (1884) and eventually in novels of a Catholic conversion must have been a severe blow to Zola, a man of resolute secular convictions with an unwavering faith in science and social progress. Mallarmé, who had been close to Manet, stood out among the poets as an admirer of Zola; but Mallarmé's disciples were among the novelist's most scornful critics.

By the 1890s, Impressionism itself was already in question as a naturalistic art, committed to appearances. But among painters, the distinction between the earlier and newer modernism was still vague, and the legacy of Cézanne, Renoir, Degas, and Monet was recognized as an artistic achievement, a greatness of pure art. For Zola, they belonged then with the purists and aesthetes

who had lost themselves and betrayed their original gifts in failing to develop further the essential content of their once naturalistic art.

One difficulty in trying to connect the pictorial in literature to painting is that several verbal effects seem to anticipate the pictorial. A page in Alfred de Vigny's *Stello* (1832) describing the public execution of the poet André Chénier in 1794 is a fully developed example of a dramatic moment presented through the eyes and feelings of a passionately concerned spectator. He follows the action from a high window at a distance and observes also the immense crowd below. The scene is colored and intensified by the changing light and atmosphere of the sunset hour, through which nature seems to parallel the tragic human event, with an equal suspense, climax, and horrible finality:

> That evening weighed upon one. The more the setting sun was hidden behind the
> trees and beneath the heavy blue cloud, the more it cast narrow oblique rays on the
> red bonnets and black hats—sad gleams that gave to this agitated throng the aspect
> of a dark sea spotted with flecks of blood. Confused voices no longer reached
> the height of my windows, closest to the roof, but, like the voice of the waves of
> the ocean and the rumbling of distant thunder, added to this somber illusion. . . .
> In the exaltation of this grand view, it seemed to me that the sky and the earth were
> actors in the drama. From time to time a bit of lightning flashed, like a signal
> from the clouds. The black face of the Tuileries became red and bloody, the two
> great squares of trees fell backwards as if in horror. Then the people groaned, and
> as though in answer the voice of the clouds spoke up and rolled sadly.

Earlier, the narrator, watching from his high window, said, "I was completely outside my window, intoxicated, stunned by the grandeur of the spectacle. I had stopped breathing. All my soul and all my life were in my eyes."[22]

It seems unlikely that de Vigny in this vivid account was inspired by historical painting. He knew Delacroix, a man of his own generation, but an historical painting then would not have placed as prominently in a dramatic scene a spectator responding with such great emotion to the event and the setting. The poet was keenly aware, however, of the pictorial in the situation, perhaps as much as any painter. His spectator, Doctor Noir, walking out afterward among the crowd, remembers the moment of execution as a picture: "All the details of the picture returned, even more brightly colored, before my eyes; I saw again the Tuileries in red, the open square, billowing and black, the heavy clouds, the great statue and the great Guillotine facing each other."

Characteristic of literary Impressionism is the manner of presenting the experiences of the characters as well as the emotional content of these experiences. The Impressionist moments—the promenade, the random encounter, the sensation, the weather, the passive pleasures, the enjoyment of the arts—play a vital part in the story; and the literary form is reconstructed to carry the qualities and perceptions of such occasions. In the first chapter of Flaubert's

L'Éducation sentimentale, Frédéric Moreau sees a woman on a boat ride on the Seine; she drops her veil, and his whole life is determined—a chance visit to a racetrack or a meeting with some Parisian friend can likewise cause serious changes. Similarly, Madame Arnoux discovers her husband's gift to his mistress upon a casual visit to a shop. The accidental nature of these events and their subsequent importance represent a deliberate demonstration of Flaubert's ideas.

Daudet's *Le Nabab* (1877) begins in a fragmented fashion with the visit to the President of the Council who is selecting dress designs, then to a noble, who is at his toilette ("an immense toilette"); to a sculptor's studio (a statue plays a part in the story), then to a photographer's. In the Goncourt's novel *Madame Gervaisais* (1869), the crucial turn of the plot hinges upon the title character's sensations in Rome, where she is converted to Catholicism and dies in religious hysteria. These aspects are due not simply to Realism and to accurate description of the people of the period but also to the writers' values and their conception of experience in which the passive awareness of life is increasingly important. Tolstoy, in describing pleasures, subordinates them to a milieu with new human and social relations and to the willed action of the individual and an historical viewpoint. Zola, who wished to explain everything by the heredity of single individuals, abounds in impressionist detail. Compared with Balzac, he often appears to be as much a landscapist as a novelist of action or society, especially in his books about the department store (*Au bonheur des dames*, 1883) and about artists (*L'Oeuvre*, 1886). Another characteristic of these authors is the ideal of impersonality or detachment they seemed to set for themselves, writing as if they were noting what they saw without emotion, just as things struck their eyes and ears.

The choice of a theme is surely not the ground of a new style, though Flaubert could say that in changing his subject he had to employ a different syntax, a procedure noted also by Proust. A style is shaped gradually and depends on many individual themes and problems, as well as on a ripened attitude, a point of view, a disposition of the personality that is open to more than one type of subject. Yet we can observe in exceptional breaks in a writer's habitual forms the effect of a particular theme. When an exceptional experience appears as a central or typical subject, an unusual form or a new syntax or choice of words will supplant the others and begin to reshape the style. In describing the entry of a train into a station, Dickens, a writer who can hardly be regarded as Impressionist in tendency, adapted his style to the peculiar sensations of the moment and employed another syntax, which anticipated a form more common in later writing:

> The seizure of the station with a fit of trembling, gradually deepening to a complaint
> of the heart, announced the train. Fire and steam, and smoke, and red light; a
> hiss, a crash, a bell, and a shriek; Louisa put into one carriage, Mrs. Sparsit put
> into another: the little station a desert speck in the thunderstorm.[23]

Like Victor Hugo, Dickens perceived the train as a living creature, and considered its sounds as organic reactions. But he was able also to re-create the impact of sudden sensations, the rapidity of movement, and the disconnected, simultaneous impressions, through similarly

disconnected words and phrases, like the juxtaposed brushstrokes of Monet in a complex sentence, without verbs, an array of nouns and nominal phrases like painterly touches, a sequence of sensations. This is not Dickens's usual syntax; it is an exceptional form adapted to the striking poetic situation. Written in 1854, it announces the pictorial prose of the end of the century.

Such simulation of the structure of impressions also appeared in Dickens's picturing of a scene lacking movement in the opening lines of *Bleak House* (1853), which are almost entirely without verbs:

> London. Michaelmas Term lately over . . . Implacable November weather.
> Fog everywhere. Fog up the river . . . fog down the river, where it rolls . . . Fog . . .
> Fog . . . Fog . . .
> Gas looming through the fog. . .[24]

One is reminded of Monet's and Pissarro's paintings of smoke and mist. What is lacking in the novelist's picture is precisely the element of color. Rather than any specific acquaintance with art, Dickens's experience as a court stenographer more likely gave him such flexibility and readiness of graphic notation.

That same year, Nathaniel Hawthorne described in *The Blithedale Romance* (1852) the passive narrator's effort while reading a bad novel to relieve his lassitude and boredom with some fresh seeing, creating an Impressionist situation and picture, with a syntax exceptional in the story:

> At intervals, however, when its effect grew a little too soporific,—not for
> my patience, but for the possibility of keeping my eyes open,—I bestirred myself,
> started from the rocking-chair, and looked out of the window.
> A gray sky; the weathercock of a steeple, that rose beyond the opposite range
> of buildings, pointing from the eastward; a sprinkle of small, spiteful looking
> raindrops on the window-pane. In that ebb-tide of my energies, had I thought of
> venturing abroad, these tokens would have checked the abortive purpose.[25]

Leo Tolstoy's chief interest lay in moral life, in action. By heritage and personality he was far from Impressionism and more, a hater of the cities, contemptuous of the middle class and of Parisian culture.[26] Yet, when he wished to depict a change of mood and a shift to a positive feeling of enthusiastic expectation, induced by a landscape, he hit upon a syntax different from his usual order of words and close to what French writers of the next generation employed in their impressionistic writing.[27]

In *The Cossacks* (1863), Tolstoy's central character Olenin, a young man undoubtedly based upon the author, who is traveling through the mountains, is described as responding like an artist. To evoke his state of mind, Tolstoy devised a special word-structure whereby the shock of impressions has been vividly caught through rapid, repeated touches, with breaks in the sentence

form. We see how a new special content led the writer to reshape his usual narrative and the structure of his language to a syntax of Impressionism. The young hero is changed inwardly by his first contact with the strange environment, and this change is conveyed in a progression from the surprising sights to a new feeling about himself—a feeling of strength and youth, of reawakened vitality, from which the look of the mountain is inseparable:

> The quick progress of the three-horsed cart along the smooth road caused the mountains to appear to be running along the horizon, while their rosy crests glittered in the light of the rising sun. At first Olenin was only astonished by the sight, then gladdened by it; but later on, gazing more and more intently at that snow-peaked chain that seemed to rise not from behind other black mountains, but straight out of the plain and to glide away into the distance, he began by slow degrees to be penetrated by their beauty and at length to *feel* the mountains. From that moment all he saw, all he thought, and all he felt, acquired for him a new character, sternly majestic like its mountains! All his Moscow reminiscences, shame, and repentence, and his trivial dreams about the Caucasus vanished and did not return. "Now it has begun," a solemn voice seemed to say to him. The road and the Térek, just becoming visible in the distance, and the Cossack villages and the people, all no longer appeared to him as a joke. He looked at himself or Vanyúsha and again thought of the mountains. . . . Two Cossacks rode by, their guns in their cases swinging rhythmically behind their backs, the white and bay legs of their horses mingling confusedly . . . and the mountains! Beyond the Térek rises the smoke from a Tartar village . . . and the mountains! The sun has risen and glitters on the Térek, now visible beyond the reeds. . . and the mountains! From the village comes a Tartar wagon, and women, beautiful young women, pass by . . . and the mountains! "*Abreks* (hostile Chechens) canter about the plain, and here am I driving along and do not fear them! I have a gun, and strength, and youth . . . and the mountains!"[28]

Tolstoy's writing mixes the impressions of the character with the objective description of the author. His style, so simple, clear and strong, avoiding all appearance of artifice and verbal bravura, could incorporate that Impressionist description of Olenin's vision of the mountains, because it was for him a "natural" human reaction, even a moment of revelation in which his hero purged himself of the memories of his existence in the city. Here we see and are made to feel in a most vivid way the positive moral sense of new impressions of nature. The impact of the first encounter erases Olenin's old imaginings and self-doubt, his shame and repentence. Permeated by this landscape as a pure aesthetic spectacle, he becomes a new man, demonstrating the transforming power, stimulating and energizing, of impressions.

Among the painterly affinities of this page are the frequent allusions to appearances, to

motion and the play of light, and to the confused impression of the horses' legs. Also notable is its shift from notations to finished description, and the change in tense from past to present as the visual impressions mount in intensity.

Just as Dickens and Tolstoy anticipated an impressionistic syntax in devising expressive mimetic form in a single context to picture the phenomenon of the railroad train arriving and departing or an observer in motion and his elated perception of a new emerging mountain landscape, so in the twentieth century, after Impressionism had become a familiar art style, novelists of other tendencies employ Impressionist language in a detail of their narrative without generalizing it as a governing principle of the whole style, much as a Post-Impressionist painter and even a Cubist applied Impressionist tones and brushstrokes in parts of a strongly outlined or modeled composition.

E. M. Forster, a novelist who was preoccupied with personality and the relations of persons, wrote in the concluding paragraph of *The Longest Journey* (1922): "The whistle of Mr. Pembroke's train came faintly and a lurid spot passed over the land—passed, and the silence returned."[29] Forster was not an Impressionist writer—far from it—though he was aware of Monet and Debussy, to whom he alluded as affinities in evoking the sensibility of a character in an earlier novel. But when Forster had to represent departure as evanescence, as an apparent extinction in the void of distance in which the story ends, he shifted from the language of substance and things to a language of graded, diminishing sound and sight. The train becomes a spot of color, at first distinct and then faint, like the whistle. The repeated verb "passed" is used subtly in two barely distinguished senses, like two almost identical notes of the same color, placed as two strokes, one stronger and the other more delicate, one still distinct and moving in space, the other diaphanous and merging with the surroundings, the silence.

Common to Impressionism and literature is an interest in the surroundings as a factor influencing the characters' moods. The environment is not just a setting of an action, as in the short descriptions by the playwright that instruct the producer how to arrange the stage. Writers describe a landscape of changing weather, moving clouds, rain, wind, moisture, sunlight, shadow, a dappling of colors, a stirring of nature in its totality, chain reactions of the entire landscape to the movement of a simple element; all these effects provide a dynamic counterpoint to the flow of feeling, the contrast of desire, the responses of individuals to changing stimuli, the diffused effects of a sudden shift in awareness. Visible nature, in its unstable, unbounded interactions, is a grandiose metaphor of the unstable and unbounded in the feeling and thought of the inconstant self. Nothing can equal the landscape, with its multisensory impact on the observer—its sounds, colors, odors, pressures, movements, textures—as an analogue of the formless, flowing, and emergent, the endlessly sensitive and responsive in psychic life.

In realizing the depiction of these qualities, painters who had divested themselves of all concerns with motives and action in order to concentrate on the directly visible preceded writers with related interests. The writers recognized in Impressionist painting the originality and subtle human

content of the images no less than they perceived the new artistic approach. Content and method were emulated by novelists, who not only introduced lengthy descriptions or complete pictures as an orchestration and even as the source of the characters' feelings, but also gave to their language and narrative web new forms analogous to the Impressionist surface and design, as with the Goncourts, Huysmans, and Zola, who were all interested in painting. In an 1888 preface to his new play *Miss Julie*, Strindberg said: "As regards the scenery, I have borrowed from Impressionist painting its asymmetry and its economy, thus, I think, strengthening the illusion."[30] The Swedish playwright, who was himself a serious painter, had been excited by his first encounter with the new art in Paris and in a famous letter to Gauguin had described Impressionism as a revelation of modernity in depicting the life of the crowd in the city, its movement, freedom, and randomness.[31] Coming to the metropolis from a stable Scandinavian town, Strindberg had been struck that much more forcibly by the objective world pictured in the themes of the painters as well as expressed in their forms.

In Zola's novel *Une Page d'amour* (1878) the imitation of the painters has become a program; literature has absorbed the lesson of the painters. Written at the high point of the Impressionist movement, it is composed of five sections, each of which ends with a chapter that describes the city as seen from an upper window. It is a series of broadly painted views of Paris at different times, in varying light and weather that represents, like Monet's later series, the same objects in perpetual change. In Zola's descriptions, the sky is a vast field of many colors that alter in the course of contemplation; the buildings and streets, too, require his whole palette. The crowds appear as dense masses of little strokes, the innumerable windows are color touches, the chimneys and roofs are indented lines, objects are converted into traces of brushwork and clouds into shapeless spots of color. For Zola, these restless panoramas of shifting tones are a visual music that accompanies the ebb and flow of his heroine's feeling.[32]

Zola introduces as a solo instrument the poetic Parisian landscape in different keys—different lights, seasons, hours. With sharp insight, he lifts her contemplation of the landscape as a pure phenomenon to the level of the painter's discernment by denying his spectator, the heroine of the story, any knowledge of the city. She cannot identify the buildings, the parks, and the streets spread out below her window. She is a stranger who lives in solitude and responds with feeling to the grandiose richness and mobility of the unfathomed landscape, an immense web of changing colors. She is almost an ideal Impressionist spectator, who receives impressions without knowing what it is that she sees. To her little girl's questions about the distant attractive spots of color, she can only say: "I do not know, my child."

But despite penetrating this important sense of the Impressionist perspective, Zola's vision in the end is not the same as the Impressionists'. Anticipating Monet's idea of painting the same object in series in varying light and weather, Zola is possessed by a Romantic and heroic conception of the landscape. Behind this blaze and glow and gradual extinction of color is the architecture of Paris, which in all its movement remains the constructed city, the eternal setting of its

impassioned dwellers. Unfaithful to his character's ignorant contemplation, he names in each recurrent vision of the city its chief landmarks, monuments, streets, and parks, thus destroying the pictorial surface of his description, the uninterpreted strokes of color, the purity of sensation.

In Zola's pages Impressionism becomes a heavy rhetoric of description, with repeated clichés of color and movement. Zola is a Romantic traveler, and his Paris is Balzac's city rendered with an Impressionist palette, not the city of Monet, Pissarro, and Renoir. Many times we encounter in these poeticized chapters Balzac's phrase: Paris is an ocean. We miss the Impressionist concentration on a single quarter of the city. Zola's image of Paris is like Oskar Kokoshka's immense views of a great modern metropolis, with river and sea and terrestrial setting. Zola's impressions of the city are an artifice of style that has its beauties and poetry, but they are neither complete pictures nor necessary, nor even proportionate accompaniments of the action and mood. The sensibility of the heroine is not the source of the description: it is not she who sees the city, but Zola who has mounted these fantastic spectacles of light and color and atmosphere as a setting for her feelings. Nothing in her behavior recalls the grandiose movement and life of the outward Paris described by Zola.

The Goncourts wrote that the taste for description in the modern novel came from the estrangement of writers from the life around them:

> Perhaps observation, that great quality of the modern man of letters, comes from the fact that the man of letters lives very little and sees very little. He is in this century as if he were outside the world, so that when he enters it, when he perceives a corner of it, this corner strikes him as a foreign country strikes a traveler. In the 18th century, on the contrary, how few novels of observation! The writers of that time lived in their surroundings naturally, as in an atmosphere. They lived, without seeing, in the dramas, comedies, and novels of the world, which habitation kept them from noticing and which they did not write about.[33]

Some writers have perceived in scenes colors or atmospheric qualites that would have made them attractive subjects for Impressionist painters, without, however, shaping their descriptions in a painterly manner. As early as 1855, Turgenev had described varying landscapes of color, change, and movement to accompany the emotions of important episodes in his writing. His picture of Venice in _On the Eve_ (1860) anticipates Monet's vision[34] of the island-city almost fifty years later:

> Everything in it is bright, comprehensible, and everything is enwrapped in a dreamy haze of a sort of love-stricken silence. . . . The huge masses of the palaces and churches stand light and splendid, like the beautiful dream of a young god; there is something fabulous, something enchantingly strange in the green-grey gleam and the silken play of hues of the dumb water in the canals, in the noiseless flight of the

gondolas, in the absence of the harsh city sounds, of coarse pounding, rattling and uproar. . . . Neither Canaletto nor Guardi—not to mention the more modern artists—is capable of reproducing that silvery tenderness of the air, that fleeting and near-lying distance, that wonderful combination of the most elegant outlines and melting beauties.[35]

In documenting the tastes and interests that underlie the Impressionists' choice of themes, I have cited and quoted from novels and poems of the time. The fact that similar qualities, sights, and situations appeared in painting and literature points to the pervasive character of Impressionism as an art rooted in the outlook and experience of the time. The writers pictured the same world as the painters: country sites, the suburbs, resorts, beaches, city streets, and cafés, the spectator and the spectacle, and, long before Monet, even the "purple sunset sky" and "long shadows of the great haystacks."[36] What distinguishes these from older writings with similar perceptions is, first, the role of the spectator and the instance of vision in the development of episode, character, and mood, and, second, the style of narration, with a new syntax analogous to the artistic devices of the painters.

Throughout the nineteenth century in France, literature had a "visual" ideal, one that seemed inherent in naturalism, which gave so great a significance to the surroundings and to human appearance, to the qualities of the outward person, dress, features, and the decor of life, as signs of character and feeling. But this ideal was already evident after 1830 among the writers of the Romantic and post-Romantic schools. Stendhal and Balzac called their books *"Scènes."* The poems and prose of Hugo, who was also a gifted artist, abound in picturesque descriptions of the environment in its colors, light and shadow, and varied forms. The previously noted account of Hugo's first railroad trip is like an advanced Impressionist painting in the vivid images of the colors and the vibrancy of the rapidly changing landscape. In the 1860s and earlier 1870s, painting was taken more deliberately as a model for writing. The Goncourts spoke of their aim as an *"optique nouvelle"*:

> At this hour in literature the important thing is not to create characters whom the public will hail as old friends, not to discover an original type of style; the whole point is to invent an eye-piece with which to show people and things through glasses that have never yet been used, to present pictures in a hitherto unknown light, to create a new optic.[37]

Edmond de Goncourt could formulate this visual program more readily than others because he was himself an amateur of painting; but he affirmed in a more deliberate manner what was already a common tendency among writers. In their first novel *En 1851*, published in the year of its title, the Goncourt brothers displayed their taste for the pictorializing of mood and their vision of the world as color, light, air, and shadow. Gautier named his poems after objects of art: his finest book of poetry is entitled *Emaux et camées* (*Enamels and Cameos*). Verlaine called

one sequence in his first volume "*Eaux-fortes*" ("Etchings"); and, in the generation of the Impressionists, Cros wrote "*croquis*" (sketches), "*pastels*" (pastels), "*pointes-sèches*" (dry-points), an "*acquarelle*" (watercolor), a "*coin de tableau*" (corner of a picture), and a "*chanson des peintres*" (song of the painters).

During the nineteenth century, French painters and writers were closer and more sympathetic to each other than ever before. The painter was so often a hero or character in a novel that Hip-polyte Taine complained the example of these painter-heroes was influencing the young to adopt as a profession an art for which most of them were unfitted and which could hardly keep them alive. Stendhal wrote a history of Italian painting and critiques of two Salons; Merimée was a pioneer student of medieval art; Balzac created several painter personalities: Bixiou (after the caricaturist Henri Monnier), Pierre Grassou, and the tragic Frenhofer of *The Unknown Master-piece*. That great story tells of the conflict between values of line and color, between the sketch and the finished work—it offers a drama based on the struggle to fuse seemingly irreconcilable aesthetic principles. Balzac set within the soul of a single painter the contradictions between classic and Romantic art. Gautier, Baudelaire, Fromentin, Edmond de Goncourt, Champfleury, Duranty, Zola, and Huysmans all wrote about painting and created the modern essayistic art criticism, so personal, independent, enthusiastic, and free.

Flaubert's *Tentation de Saint-Antoine* was inspired by a picture of the same subject, and his story "La Légende de Saint Julien l'Hospitalier" by a medieval stained-glass window. *Salammbô* embodied a firsthand, comprehensive study of the remains of ancient Carthage. The painters, in turn, respected the insight of writers into artists' personalities and problems, in spite of differences of judgment. Degas could say that the modern movement came out of the program of painting first sketched by the Goncourts in 1867 in their novel with a painter-hero, *Manette Salomon*.[38] Cézanne recognized himself in Balzac's Frenhofer; he adored the art criticism of Baudelaire, and he undoubtedly admired the Goncourts as fellow artists, since in one of his last letters he named them among his models: "how wretched not to be able to make many specimens of my ideas and sensations—long live the de Goncourts, Pissarro and all those who have propensities to color that represents light and air."[39]

The Romantics, the Realists, and the naturalists, with their strong feelings for the visual, wrote the most about art. Since vision is the sense *par excellence* of a direct and enlarged momentary experience—an object being given to the eye immediately and in its fullest extension—painting has had an extraordinary fascination for the novelists, writers, and poets who emancipated themselves from the banal by a fresh view of their surroundings and by the culture of the senses. Gautier's well-known quote "My whole value lies in the fact that I am a man for whom the visible world exists" asserts the primacy of vision. In his *History of Romanticism*, published posthumously in 1874, the year of the first Impressionist exhibition, he noted as a feature of the Romantic movement the association of painters and poets, closer than ever in the past and important for the style and imagination of writers, even of those who were inclined to the exotic and fantastic.

In Gautier's poem "L'Art," the work of art in an enduring medium outlives empires and creeds and manifests eternal human values.[40] Writers and painters collaborated often in the decades before Impressionism in that lively genre of the woodcut book devoted to the manners, sights, and human types of Paris—the *Physiologies, Prismes, Tableaux,* and *Almanachs.* Baudelaire wrote satirical verses for an illustrated *Salon Caricatural* and devoted a long essay to the genius of Daumier and Grandville as artists known through their work for the popular press.

To the writers, painting was a model of an artistic art, more purely sensory, more material, and universal, also more evidently dexterous and formative than literature, with its indirect verbal medium. In the poet's concept of *l'art pour l'art,* painting had the role that music was to play for later generations as the example of a pure art.[41] Some critics have suggested that Impressionist qualities in the literature of the second half of the nineteenth century derive directly from paintings. The Goncourts deliberately imitated particular effects of painting and used its terms in formulating their own artistic goals. But those related qualities could have arisen independently in the two arts from common attitudes and the value placed by writers and painters upon the "Impressionist" mode of experience. The underlying content was found in life itself, however much the means or style was a creative discovery of the artist. This content is what gave its freshness to the novel of the later nineteenth century. The "Impressionist" novel, if we may use the term to designate this aspect of naturalism—for it is only an aspect and not a thoroughly consistent form like a painting by Monet—was especially concerned with individual perceptions, how one sees and feels the surroundings and other people, how one appears to them, through what stimuli one as been influenced to act, and by what gestures, movements, and appearances one manifests feelings and thoughts. The plot is tenuous, sometimes an occasion—love, solitude, travel—for refined analysis of character as revealed in perception and moods.[42] A simple action is fragmented into partial situations through which a nuance of sensibility is disclosed, and the environment is presented correspondingly through scattered touches translating sensations of the characters. The importance of the short story, devoted to a brief period of time and a segment of an individual's life or even to a single mood, was in part an outcome of this taste.

In his preface to *Chérie* (1884), said to be a portrait of the painter Marie Bashkirtseff,[43] Edmond de Goncourt proposed a novel of pure analysis without plot, to replace the novel of adventure and bookish intrigue, which, he said, had been exhausted in the first half of the nineteenth century.[44] In the same year Huysmans's *À rebours* was published; it is a novel with little if any plot that simply presents the tastes, ideas, and sensory world of a delicate, cultivated recluse. Finally, in 1886 appeared the first novel written as an interior monologue, *Les Lauriers sont coupés* (*The Laurels Have Been Cut*) by Edouard Dujardin, whose innovative work suggested to James Joyce at least a part of the form of *Ulysses* (1922). The outer world, the conversations, actions, and thoughts of a single day appear in discontinous fragments, as perceived by the main characters. Although these later works seem to break with naturalism, they elaborate and refine its methods in order to apply them to an internalized private sphere.

In this naturalistic writing the "Impressionist" moments—the promenade, the random encounter, the unexpected sensation, the weather, the passive pleasures, the life on the streets and the studios—are a vital part of the story. With every change in the environment, whether of setting or of atmosphere, the individual as a receptive sensibility is at once transformed.

The old, fully rounded, balanced, and perfectly modeled sentence is replaced by sentences fragmented into a series of phrases, or by short, rapid sentences, without conjunctions and often without verbs. The adjectives and verbs are made into nouns, as if the writers recorded only disconnected perceptions and interpreted less in the sense of will, effort, and intention—categories that imply a cause and agent, and require verbal forms. Instead of the traditional "he cried out," we read "there was a cry," the cry being something heard rather than produced. To place the reader in the time of the character, the imperfect tense is used rather than the past definite of traditional narrative. The speech of persons is not given directly but in an indirect discourse, imagined or internalized. It is contemplated by the hearer in thought, as a fact perceived by the speaker, like his actions or impressions. The order of words is increasingly independent of the logical relation and submitted to an affective placing that accentuates the shock and stress of perception. To describe a scene or even an action, the writer has juxtaposed the thoughts, sensations, and speech of a character without verbs of action. The story is told by an accumulation of many touches, little observations, sensations, and feelings, which readers have to fuse and interpret as they go along. To reproduce the turbulence of a scene, writers re-created a chaos of impressions through a disjointed juxtaposition of words and broken sentences. Short phrases, isolated words, were joined without logical connection or relation of cause and effect to give a pictorial impression.

To compare the description of a site by the Goncourts and Stendhal is to observe a change like the change in painting between the first and last third of the nineteenth century. Stendhal described the broad layout and the single buildings in an order that corresponds to the vision of classicistic painting; the Goncourts have registered the perceptions of scattered points, mixing colors, sounds and smells, and movement from place to place without clear transitions. From their account, it is difficult, if not impossible, to reconstruct the site or the individual buildings. They are able, therefore, to suggest the sensory experience of a spot, its existence for the casual observer who sees it for the first time, rather than for the inhabitant who has dealt with it for a lifetime.

Certain of these innovations, which seemed to be bold, illogical inversions, especially in syntax and word order, were regarded by critics as signs of degeneration of both language and civilization. Nietzsche's celebrated definition of the decadence of society through the analogue of decay in a prose that makes the word or the phrase more important than the sentence or the paragraph, is taken literally from the criticism given by Paul Bourget to the Impressionist syntax of the Goncourts; and this judgment had already been made before Bourget by Huysmans in *À rebours* in 1884. For Huysmans, however, decadence was a positive value, the condition of a new spiritual sensibility. These innovative forms are now so common in writing that it is hard for us

to realize the original significance of their invention. It is only when we compare them to the older authors with their well-rounded and clear sentences, their regular formal constructions, that we see the novel modernity of the Impressionist generation.

Paul Bourget and Nietzsche neglected the new order that bound these seemingly chaotic elements. At bottom, their attitude was political. They regarded as true order only a particular system of relationships—and used it as a model by which to criticize modern society as being inherently disordered. They also failed to distinguish between the positive values and the formal changes—they neglected what was forceful and constructive in the new approach.

That literature had become "Impressionist" was recognized already in the 1870s. Observant critics could not help noting the similarities to the new and still disturbing eccentric-looking works of the painters. The most detailed analytic statement of that relationship was an article of 1879 by Ferdinand Brunetière. Brunetière, who was also a scholarly historian of literature, reviewed Alphonse Daudet's new novel, *Les Rois en exil (Kings in Exile)* in 1879, calling his article "L'Impressionisme dans le roman."45 The characters, he remarked, were not created but encountered by the author. Their sensations were the guide to their inner life and psychology. The writer painted, creating a succession of pictures rather than of actions. Daudet strove to evoke sensations and the immediate aspect of things—what Brunetière called the "*tache*" or "spot," the first impression of things—and manifested a particular gift of illusion. Daudet, Brunitière believed, was directly influenced by painters; his approach was a transposition of their style. He rendered the impressions of his characters by decomposing them into component sensations. With each episode the surroundings change. Brunetière undertook for the first time to define what is specifically Impressionist in the structure and language of the new novel. Instead of the past definite tense normal in narrative, the novelist preferred the more pictorial past imperfect to convey the moment of perception and the continuing flow of sensations and perceptions. There are many verbless sentences, phrases without logical connection, and conjunctions were often omitted. Thoughts and feelings are presented as corresponding to sensations or even as sensations. The vocabulary is impure, contaminated by the vernacular and the argot of the streets. These are the traits Brunetière itemized as the essentially Impressionist features of the new novel. Brunetière's negative judgment, his conservatism, was political as well as literary. A traditionalist with classical norms, he was also a monarchist and antimodern.46 Since Brunetière's time, the validity of the concept of the Impressionist novel has engaged the studious attention of linguists, philologists, and historians of literature, especially in Germany,47 with differing conclusions reached.

What Brunetière and others ignored in Daudet's novel is significant: the recurrence of scenes, situations, and viewpoints that are the basic themes of Impressionist painting. The book begins with a view of Paris on a bright summer afternoon from the balcony of the Hotel des Pyramides on the rue de Rivoli. "Five o'clock, and the most admirable day with which the summer of 1872 had yet cheered the Parisians." The queen and her child, exiled from their Balkan kingdom by a

revolt, see with wonder and delight the ever-flowing stream of carriages in "a whirlwind of speed," the light dresses, the crowds in the street, the children, the glitter, the Tuileries Gardens, the sunlight, and trees. Happiness, and a sensation of warmth, "envelops her like a silken web" and restores the queen's color and mood. She is "lost in admiration and pleasure." "The fresh joyousness of a marvelous Parisian summer" gives her hope and encouragement after the political disaster that had driven her into exile from her country. In contrast to this scene, Daudet turned her eyes to her left where she sees the blackened walls of the Tuileries Palace, burned during the recent Commune, a reminder of the queen's loss of her Balkan throne. Later in chapter 7, entitled "Joies Populaires," the queen and her child, on a carriage ride through the Bois de Vincennes, watch the Sunday picnics and luncheons on the grass in the suburb of Saint-Mandé and the boating party on the lake—the "merry disorder" and prevailing gaiety and cordiality of the workmen in their holiday clothes. For the royal mother and child it is a contrast of the wholesome pleasures of the lower classes with the high-life and debauches of the dethroned king. Later they descend from their carriage to visit the circus and the fair.

These pictures are sketched not simply as a background of the action, but as a vivid experience of the leading characters that determines their feelings and brings out by contrast another and opposite mode of life—the source of quite different emotions. The story, dedicated to Edmond de Goncourt, has a political edge. Written at a time during the early years of the Third Republic, when there still existed groups and parties determined to restore a monarch, there was an obvious critical point in the theme of the Balkan king exiled in Paris after a popular revolt and disclosing to plain view the degradation of a royal personality in an idle, dissipated life, without honor and taste. Where formerly the great popular spectacles had been the celebrations and festivities of the royal court and the army, now the queen and her child became the delighted spectators of innocent popular amusement, Sunday recreation, and the life of the streets in a modern democratic republic.

What is called Impressionism in the novel touches only certain aspects: language, the picturing of the environment, the sensations of the characters, and at certain points, the abruptness and fragmentation of narrative. There is also a directness in presenting speech. Dialogue consists of heard voices, with less and less of "she said" and "he replied." Similarly, the stream of thought and daydream, the internalized speech and imagery, flow through without the usual frame of indirection, the enclosure by phrases that identify or describe the thinking and imagining person. But narrative itself remained the essential aim, unlike the Impressionist paintings from which almost all trace of plot has disappeared. Those pictures had themes or episodes in characteristic situations and sites, such as outings, boulevards, cafés, races, promenades, beaches, boating parties, travel, but they lacked stories.

However important are Impressionist elements in the novel—and they are considerable—the novel retains its original character and function as narrative. Even today attempts to create novels without action have not really taken root, and the aims of novelists as the inheritors of epic

and dramatic poetry remain an essential part of our culture. Predictions of the novel's demise have turned out to be premature. Writers still, often autobiographically, detail life experiences and the telling effects they have upon the feelings of one or more protagonist. Themes of action and character, of introspection or reflection on the self still persist.

Painting as an art is distinctive; it has special functions and a relationship to a culture of the senses and depends on the material development of the environment and visual signs as a cultural producer in everyday life and practice. Painting diverges as an art with the intrinsic possibilities of the medium, comparable in certain aspects to the approach of music. The nonmimetic is of major significance in painting, even in the representation of objects through the nature of visual signs, their minimal cues, and the variability of object appearances. The importance of the phonic unit and pattern in poetry has already been compared in the discussion of Monet and Mallarmé to the painter's use of color, light, and atmospheric touches. Perhaps lyric poetry comes closer than fiction to Impressionist painting. Not that such poetry was purely pictorial, but its expression was freed more from the episode. Increasingly it found its substance in the mood or current of feeling intimated or evoked by sensations, juxtaposed in a musical fabric of words suggestive of colors, and other perceptions.[48] Lyric poetry need not be pictorial, but it often is, containing a curve or a flow of feeling. Yet even with this greater affinity to Impressionist painting, the poetry of the same period refers more pointedly to the self, with a wider range of feelings, especially of despair and anguish, than was common in the paintings.

Ultimately the probable influence of Impressionist painting on literature came from its example of radical innovation, helping to loosen literary forms, its democratizing, its personalizing, its greater freedom and informality, and its openness to all perceptions. Impressionism was a stage in a general evolution of visual, intellectual, and historical liberation that had been in process since the eighteenth century. What was the significance of the affinity of the French novel—rather than poetry, in large part tied to fixed forms—and French painting? It helps us understand certain aspects of both, their related themes, outlooks, values, methods, their ideals of art and the artist's way of life. But the impressionistic was only an aspect of literature, not a sufficient root principle. Baudelaire, Champfleury, and Mallarmé offer us incomparable insights into the art of, respectively, Delacroix, Courbet, and Manet; but that close association does not entail a comparable pursuit.

The comparison with literature permits a sharper definition of the specific boundaries of the subjective in the paintings. These belong for the most part to a limited domain of the feelings, though they were of high significance for the attitude of sensitive people of that time and were general enough to enable this art to serve later as the model expression of certain experiences and values, even when its style was no longer viable as the carrier of a new content or outlook. We can see from this comparison that the intimate and subjective in the paintings, with all their radicalism, and their sporadic form, were a release and expression of the enjoying sensibility into a new, expansive way of life, arising in the course of the nineteenth century as a result of both

material and social developments closely bound to one another. This notion has been discussed earlier, in relation to the themes of Impressionism and the concept of the impression as a moral and social value.

Although the next generation reacted strongly against this limited vision of humanity and the environment, the Impressionist discovery of the aesthetic in everyday life remained an important ingredient in later art and literature. Its persisting effect on painting can be traced in the art of those who broke with Impressionism: in van Gogh's more intense feeling for the landscape, for human beings, for flowers, and for sunlight and bright colors (see fig. 132); in Gauguin's festive images of the Tahitian primitive world (see fig. 135), in Toulouse-Lautrec's preoccupation with performers and spectators (see figs. 124, 125); in Cézanne's constructed landscapes, in the "intimist" art of Bonnard and Édouard Vuillard, and especially in Matisse. Even the German Expressionists, whose intensities and distortions seem to be the clearest examples of the denial of Impressionist happiness in the world and its charm of imagery, offer many pictures less strained and emphatic, with a joy in the vivid presence of nature in sunlight.

The Impressionists replaced the story and the prearranged subject of the studio with the personally encountered theme, with *peinture vécue*—"lived" or "true-to-life painting"—in a new sense: not, as in the past, the imaginary theme that calls out deep or extreme emotions, but the actual experience that incites one to paint. Impressionism laid the ground for the general character of modern painting, but it also offers clues to similar developments in modern literature. Impressionism's independence of the set theme or object and its faith in the operations of the art as a human process in which the self is at stake became modernist articles of faith. Impressionism began the struggle with the medium and the striving for self-realization during a time of change in art as well as in social life, defining its great uncertainties, general dissatisfactions, and deep anxieties.

CONCLUSION:

The Reaction to Impressionism

By the mid-1880s the group of Impressionists had begun to lose what cohesiveness it had preserved from the original aims and exhibitions. The year 1886 was the last one in which they showed together under the common name. In 1884, a new society of young independent artists including Seurat, Gauguin, and Paul Signac had been formed. Some of them had painted in an Impressionist manner, but were now moving away from it.

The reaction had appeared among the Impressionists themselves in the early 1880s. In 1882 and 1883, Renoir in particular was uneasy over his failure to win the public and disturbed by difficulties in maintaining the Impressionist approach. There are several reasons for this state of affairs. In the first place, times were hard financially. The great economic crisis of 1873 had been followed by another in the late 1870s; throughout the 1880s and into the middle 1890s the sale of paintings in France suffered from the general depression in western Europe, which struck hard in France. Financial stringency was accompanied by ideological reactions that led to a doubting and sometimes scornful view of the art and implicit ideals of the Impressionists.

In the late 1870s and early 1880s, Renoir began again to submit pictures to the official academic Salon, which had rejected most Impressionist canvases for more than a decade, until those painters had no longer dreamed of acceptance by the jury. This time, however, Renoir gained some success and was eager to reach a larger public audience. He was distressed to find that Impressionism was regarded by the public and above all by the conservatives as politically subversive. Among the important Impressionist practitioners was Pissarro, an avowed anarchist; and certain of its early supporters among the critics—Duret, Zola, and others—had written for leftist papers. Renoir at forty felt he was too old to be involved in radical politics and was embarrassed by the association with his old friends. He did not like certain of the younger painters, particularly Gauguin, who had been attracted to his group and who had taken part in the exhibitions. He was also distressed that public opinion connected the Impressionists with the Commune of 1871. They were even called "communards" because it was believed that they were destroying the tradition of painting. As a later modern art indifferent to politics was to be

attacked as Bolshevist, so Impressionism was regarded as allied in some way with the revolt of 1871, though the new group included an aristocratic, conservative personality like Degas.

In 1883 and 1884, after a visit to Italy, Renoir resolved to change his way of working. He explained that he found maintaining the Impressionist method difficult for technical reasons. Painting outdoor themes directly created problems that could not be solved in the studio. Renoir became attracted by Ingres, Poussin, and other old masters, as well as by French seventeenth-century sculpture. In his large canvas with bathing nudes, painted between 1885 and 1887 (fig. 122), the postures owe their character not to Renoir's perceptions of spontaneous movements of the figures but to a traditional formalism; certain of them were borrowed from lead relief sculptures by François Girardon at the palace at Versailles. Renoir drew his figures in well-defined rhythmical outlines and sculptural forms, in sharp deviation from his Impressionist practice. But he also chose to set the figures in a landscape with the soft, sweet, spectral colors of his previous work. The result, in spite of the admirable qualities of texture and line drawing, is a hybrid picture that is not fully of one piece.

FIGURE 122. Auguste Renoir, *The Great Bathers*, 1887, oil on canvas, 117.7 x 170.8 cm, Philadelphia Museum of Art

Renoir acknowledged the inconsistency a few years later when he gave up that way of painting and returned to some features of his older style; he reached a new solution that was more consistent and yielded remarkable paintings of his highest quality. Consider a work of 1885 beside an earlier grouping of three—*The Luncheon in the Garden*—which is also formalized like many of Renoir's works in his preclassical phase, and you can see the difference in the conception of the subject matter, in the execution, and in the original silhouetting of the figures.

In the reaction against Impressionism in the 1880s, we note two kinds of evidence of the response, its grounds, and its direction. One type of evidence appeared in the writings of the novelists, critics, and painters, and the other in the pictures themselves, which through their new content and execution pointed to what was unsatisfying in the old. Early in the 1880s, Zola, who had been a chose friend of Manet, Cézanne, and Monet, wrote that the Impressionists were no longer true to their original aims. According to Zola, they had begun as intransigent painters (an early nickname was "les intransigeants") distinguished by a radical realism and individuality, in sharp contrast to the banalities of contemporary academic art. Above all, they were men of strong personality, who wished to express what was new and vital in their human surroundings.

By 1880, the Impressionists had become, Zola thought, merely skilled depicters of sunlight and atmosphere, excluding the serious human element; they were indifferent to the harsh experiences of social life and lacked all sense of the great struggles of the time, which Zola himself with a passionate interest was presenting in a new series of novels.[1] The Impressionists were essentially eyes, not minds; they were not even hearts and remained in their paintings unaware of the problematic in their world, rendering only that segment that was neutral to the human condition: nature as a phenomenon of atmosphere and light. That criticism, made in the 1880s, has persisted until recently. At the beginning of this century, it formed the basis of a frequent judgment of the Impressionists as mere color photographers, passive artists who failed to react to life and simply registered the agreeable visual stimuli from the objects around them.

The writer Huysmans, who had begun as a disciple of Zola, published in 1884 a novel, *À rebours* (*Against the Grain*), in which the hero, Des Esseintes, wrote of the Impressionists and Realist art in general as boring and inhuman because of the artists' indifference to inner life. Huysmans himself saw the public world, the visible surroundings and society, as infected with ugliness and mediocrity, the result of the domination of the middle class, with its vulgarity and commercialism. Des Esseintes, an eccentric aesthete who always drew his shades to shut out the exterior world, slept through the day and stayed awake at night; sunlight disturbed him, he preferred artificial light. His favorite artists were men of fantasy, like Odilon Redon and Gustave Moreau; but he also admired certain contemporary inventions, like the locomotive, more than the creations of nature, which were for him completely unassimilable to human needs.

The implicit criticism of Impressionism, which the author disclaimed at the time, admitting it only fifteen years later, was only one aspect of a general reaction against the movement in the 1880s. Another judgment of the art came from painters who, while admiring the Impressionists and

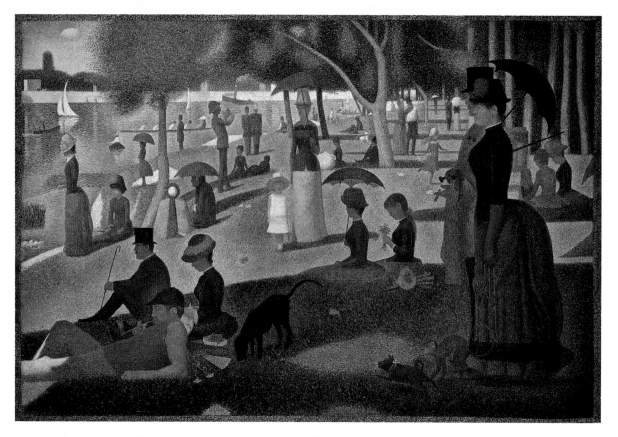

FIGURE 123. Georges Seurat, *A Sunday Afternoon on La Grande Jatte*, 1884-86,
oil on canvas, 207.5 x 308 cm, The Art Institute of Chicago

enjoying their cheerful imagery of spectacle and the environment, believed that their innovations of
color and technique were unscientific, inconsistent in the analysis of light and color, insufficiently
structured, and lacking in rigor of form. Of these dissenters Seurat was the leader. His paintings, for
example, *A Sunday Afternoon on La Grande Jatte* (fig. 123), adopted Impressionist themes: bathers,
the Sunday vacation world of spectacle and amusements, the landscape of beaches, harbors, and
sunny fields. But instead of applying the brush in a free, cursive manner, improvising his strokes and
responding to the effect of a strong feeling for the landscape, Seurat created a systematic method of
elementary unit-strokes governed by strict rules of combination that allowed him to paint by artifi-
cial light what he had seen in daylight and to make the appropriate transformations of the colors.
In Seurat's work, the whole is a fine mosaic of tiny units more homogeneous than Monet's, though
not strictly uniform. Seurat's figures are more evidently organized, a scattered but also contempla-
tive crowd, absorbed in its collective enjoyment of a spectacle and the surroundings. Each protago-
nist has been set in a place clearly allotted to her or him, with a visible role in the structure of the
composition, responding in contour, mass, and color to the neighboring parts.

This critical reaction against Impressionism included the positive idea that Impressionism could be advanced not by further spontaneity, but by a more exacting and deliberate control, through technique, science, measure, and reflection. The artists who shared this aim—Seurat, Signac, and their associates—were also radical in their social views; some were anarchists or held the belief that the development of society and art depended on furthering a rational or scientific approach.

Another type of reaction was that of Toulouse-Lautrec, who built on Degas's art. Toulouse-Lautrec continued the imagery of pleasure and spectacle; but by representing the performer and spectators as sharply characterized individuals and not simply as patches of color embedded in a larger mass of tones, he disclosed their pathos (fig. 124). While before him in the pictures of Monet, Manet, and even of Renoir, a face was either a flecking of distant color or a smiling holiday visage with little individuality and without past or future—a face of pure, joyous sensing, somewhat depersonalized in its happiness or momentary well-being (see fig. 26), Toulouse-Lautrec unmasked the world of pleasure—not in nature but in the city—by portraying more acutely the disenchanted beings in these situations. He often presented them as marked, often stigmatized, individuals distorted by their role in enjoyment and performance. If they are actors, dancers, singers, they are strange in body, crippled or disjointed; or they make of their ugliness an amusing, even caricatural, spectacle. Never expansive or truly carefree, the audience, too, frequently looks melancholy, self-absorbed, cynical, ironic, unhappy, or distracted.

The works of Toulouse-Lautrec uncover with an imagery of disenchantment and indifference the feelings masked or submerged in holiday situations. That world of pleasure rests on the deformation of individuals or springs from a need to sweeten the bitterness of life, to escape its void. Toulouse-Lautrec could not accept his own world or himself fully. Like the performers he depicted, he could only accept himself with irony, practicing his art as the pleasure of the moment, a source of satisfaction to others, but done in full awareness of his own misshapen being.

An example of such ironic visual translation and transformation is Toulouse-Lautrec's picture of the singer Yvette Guilbert (fig. 125), who made of her ugliness a fascinating form, a principle of her dance, her singing, and her speech—in short, a style.[2] As evidenced here and elsewhere, Toulouse-Lautrec's formal originality in his use of line and large patterned form was to prove important for twentieth-century art.

While seeming to reject the values of Impressionism, the reaction still depended on them. It held to and reaffirmed the essential importance of the personal experience and viewpoint of the artist, the painter's freedom in color, drawing, and composition; it explored the affective content of colors and forms, the flux of feeling and phenomena as grounds of imagery, and the visible web of brushstrokes as an expressive surface.

In the 1880s and 1890s, the now so familiar distinction between the Impressionists and those who would later be called the Post-Impressionists was unclear. Van Gogh regarded himself as an Impressionist, though he was aware that he was breaking with their practice in sacrificing nuanced

values to intensity, and in his "abstract" treatment of backgrounds as flat areas of strong color. Yet in criticism during those decades, Monet, Pissarro, Renoir, and Degas were often named together with painters of the younger generation as members of the new avant-garde.

An example of an artist who converted to a different spiritual attitude, while remaining attached to Impressionist taste, is the poet Jules Laforgue, twenty years younger than Monet. Laforgue's writings have already been cited in chapter 10. He wrote exalted pages on Impressionist painting as both an art and a worldview, finding in it a close accord with the scientific ideas of the time and a realization of the most advanced sensibility to color evolved by the human race.

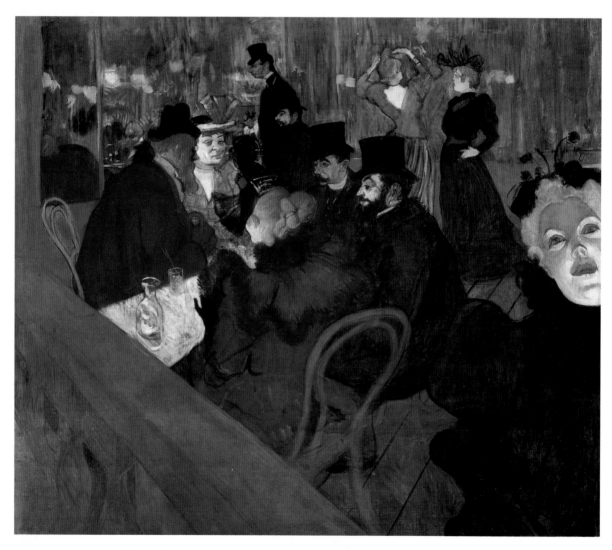

FIGURE 124. Henri de Toulouse Lautrec, *At the Moulin Rouge*, 1893-95, oil on canvas, 123 x 141 cm, Art Institute of Chicago

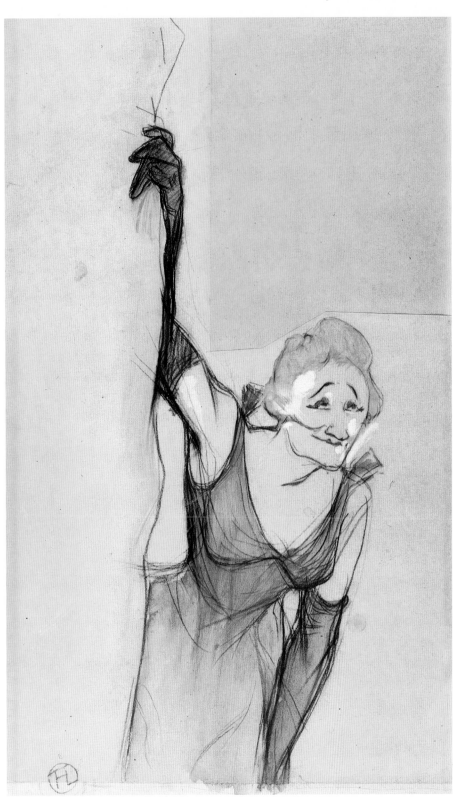

FIGURE 125.
Henri de Toulouse-
Lautrec, *Yvette
Guilbert Taking a
Curtain Call*, 1894,
watercolor with
crayon, 48 x 25 cm,
Rhode Island
School of Design,
Providence

In his poems, Laforgue turned that sensibility against himself; the sources of joy became carriers of anguish and despair. The poetry of this impassioned lover of Impressionist color and science is of a pervasive melancholy, possibly generated by the tuberculosis that caused his early death. But his poems celebrate also the modern, the vernacular, and the new aspect of urban life and the natural environment. A frequent theme is the death of the earth, an idea launched by the physicists who foresaw the inevitable cooling of the sun and announced as a fatal principle the irreversible dissipation of energy, an increasing entropy of heart. Among his poems are a "Marche funèbre pour la mort de la terre," and a refrain: "*Convoi solennel des soleils magnifiques. . . .*" In opposition to traditional associations, sunlight served as a pessimist's symbol or reminder of death.

With this change from the generally cheerful, serene mood of Impressionist painting, Laforgue gave to his rich vocabulary of color new tonalities of meaning. He noted nuances created by modern industry; "*blancs de cold cream*"; but also qualities and associations arising from his moods of despair—"*des lilas noirs et des jaunes pourris*" ("black lilacs and rotted yellows")[3]—tones subtle and complex, like the layered crusts and juxtaposed touches of contrasting color in the world of the Impressionists and their successors. The spectrum that had expressed sunlight and life was conceived by Laforgue with a gloomy symbolism. In his poem about a rose window called "Rosace en vitrail"—written in advance of Monet's Rouen Cathedrals series and Huysmans's novel *La Cathédrale*—he deciphered the symbolism of white, pinks, blues, greens, scarlets, vermilions, and violets as beloinging to different ages from chidhood to death. Three of his thirteen stanzas, tortured and impassioned, reveal the riches of his verbal palette.

> *De ce foyer d'essors, féerique apothéose,*
> *Jaillissent huit rayons, échelle de couleurs,*
> *Où des tons corrompus, mourants, se décomposent,*
> *Symboles maladifs de subtiles douleurs.*

> *Alors, le grand bouquet tragique de la Vie!*
> *Les mornes violets des désillusions,*
> *Les horizons tout gris de l'ornière suivie*
> *Et les tons infernaux des nos corruptions!*

> *Chaste rosace d'or, d'azur et de cinabre,*
> *Va, je viendrai souvent lire en toi, loin du jour,*
> *L'Illusion, plus morne en son chahut macabre,*
> *Et me noyer en toi, crevé, crevé d'amour!*

> *(From this leaping flame, magical, divine,*
> *Springs eight rays, a range of hues,*
> *A cry of tones, corrupt and dying, that decompose,*
> *Sickly symbols of the most subtle sorrows.*

And then, the great tragic bouquet of Life,
The sad violets of disillusion,
The gray horizons of the repeated path,
And the hellish tones of our own corruption!

Chaste rose of gold and blue and red,
Go, I shall often come to read in you, far from the light,
Illusion, so deeply sad in its raggy, macabre dance,
And drown myself in you, heartbroken, heartbroken with love!)

In another poem, "Soir de carnivale" ("Carnival Evening"), Laforgue wrote elegiacally: "*Toute miroite et puis passe*" ("All glistens and then passes away"). And in his poem "Le brave, brave autumn!" ("The Good, Good Autumn"), he left these melancholy but determined lines:

Quand riviendra l'autumne,
Cette saison si triste
Je vais la passer bonne
Au point de vue artiste

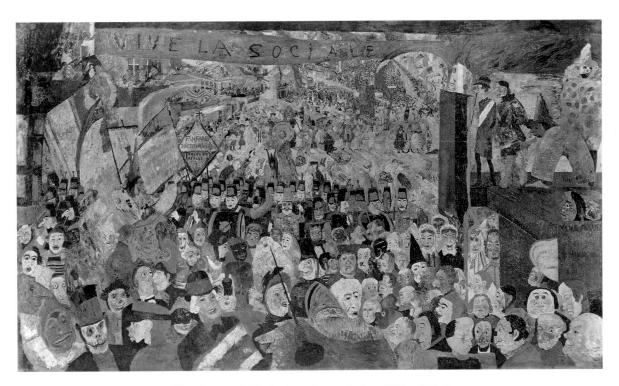

FIGURE 126. James Ensor, *The Entry of Christ into Brussels in 1888*, 1888-89, oil on canvas, 257 x 378.5 cm, The J. Paul Getty Museum, Malibu, California

307

FIGURE 127. Gustave Doré, *Entry of Christ into Jerusalem*, c. 1875, etching, first published in *Die Heilige Schrift Alten und Neuen Testaments verdeutscht von D. Martin Luther. Mit zweihundert und dreissig Bildern von Gustav Doré* by the Deutsche Verlags-Anstalt, Stuttgart, Leipzig, Berlin, and Vienna

(When autumn comes again
That saddest of seasons
I shall spend it well
From an artist's point of view.)[4]

In the 1880s, several other young painters of the new generation, with personalities very different from Toulouse-Lautrec's, repictured the Impressionist urban themes of the city as occasions of stress and suffering, even of violence. Several Impressionist paintings of crowds in the streets and also of the people who made up those crowds at home in their surroundings are reproduced in this volume. In 1887-88, James Ensor, the most gifted Belgian artist

of the period, who had painted domestic subjects with subtle tones in a near-Impressionist vein, represented *The Entry of Christ into Brussels* (fig. 126). It is a strange burlesque of modernity, inspired by a sensational canvas, also adapted as an illustration, of the *Entry into Jerusalem* (fig. 127) by Gustave Doré. In his legible signs on banners and placards, Ensor played on the politics of the time and especially on the rivalry between the Belgian Catholic and liberal parties.

Ensor pictured a carnival crowd wearing masks—some are skulls—not as seen from a

FIGURE 128. James Ensor, *The Cathedral*, 1886, etching, 23.6 x 17.7 cm, The Art Institure of Chicago

distance but as a densely packed humanity viewed close-up in the streets.5 Individuals are possessed by the madness of the crowd or crushed by it; the masks and skulls allow and incite the most brutal expressions of feeling: ferocious, aggressive, and with intimations of death. Through this masking and congestion the whole vast population of a city appears wild, mad, ferocious, and depersonalized. The Impressionist's distant, faceless crowd, the casual urban parade, seen from close-up, has become a mob, with grotesque features, comic and frightening in the release of primitive animal spirits and passions on a religious holiday.

Done several years before Monet's pictures of the great church at Rouen, Ensor's 1886 *Cathedral* etching (fig. 128) presents the old building not as a phenomenon of light but as a huge heap of eroded, disintegrating stone that serves as the support of a wash line from neighboring buildings. In the open square in the foreground is a tremendous throng, more crowded and stifling than the one in *The Entry of Christ into Brussels*. It has been interpreted brilliantly by Wilhelm Fraenger as one of the first authentic images of panic as a modern experience—the feeling of uneasiness and fright in the pressure of a crowd and the sense of the human mass as

FIGURE 129. Edvard Munch, *The Dance of Life*, 1899-1900, oil on canvas, 125.5 x 190.5 cm, National Gallery, Oslo

FIGURE 130.
Edvard Munch,
The Scream, 1893,
tempera and
pastel on board,
91 x 73.5 cm,
National Gallery,
Oslo

a vast, driven multitude with morbid compulsions that overwhelm the individual.[6] Ensor also painted and etched many pictures of cruelty in his scenes of streets, parks, and beaches, of promenades and play, reversing the signs that marked the Impressionist joyousness and freedom in a holiday world. Ensor's view extended Impressionist depersonalization of the crowd, depicting it as random in motion and form but held together by a common, dangerous unity of feeling, essentially destructive, primitive, and instinctive. In the space of a decade, the sunny,

cheerful pictures of crowds by Monet and Pissarro had been converted into uncanny scenes of aggression and fear.

While Ensor was painting in Belgium, the Norwegian Edvard Munch, another young artist of the same generation, who had been in Paris and seen the works of the Impressionists as well as those of Toulouse-Lautrec, transformed the happy imagery of the dance, the child, the promenade, and the pleasures of the table into gripping scenes of anxiety and death. Munch wrote then that he was through with pictures where everyone was secure and happy; he resolved to depict instead the true inner world of suffering and care. Undoubtedly Munch's art owed much to the moral seriousness of contemporary Scandinavian literature that was also beginning to affect the theater in France. But it was from his own fraught experience that he painted the *Dance of Life* (fig. 129), a picture in which dancing is no longer, as it was for Renoir, a carefree occasion of joy in the warm contact of bodies, in rhythmic movement, and the tingling lights and colors of the dance hall, but is rather a chilly, morbid, macabre affair.

Two lonely figures of despair have been placed among frenzied creatures—men and women coupled in a stark nocturnal setting of sky and beach. It is an outdoor scene, without vegetation or sunlight, a cold, barren milieu of the passions. The stylized moon and its long reflection in the water resemble, as silhouetted patterned spots, both the solitary woman and the paired dancing figures. The happy vision of the Impressionist world has been inverted, but not by a return to a pre-Impressionist fantasy. What is pleasurable in the themes of Impressionism—the spectacle and life of the streets, the resorts, and amusements—has become a source of doubt, anxiety, distress, and a disturbing awareness of the human condition. This drastic image, so soon after Renoir's joyous paintings of the dance, betokens an often expressed and mounting dissatisfaction with urban pleasures as symbols of the good life, of progress, and of material well-being.

In *The Scream* (fig. 130), another painting by Munch, the Impressionists' sunset landscape, in which the atmosphere is set by a single rare, entrancing, dominant color, has become, in Munch's own words, a "blood-red evening mood." A great vibration, uncanny in aspect, spreads across the entire scene—an overinterpreted, overwhelming, obsessive rhythm, radiating around a solitary, suffering individual. It is like the primitive fear of the midday demon, each hour of the day being under the control of a spirit that affects the creature under its spell.

This conception of *The Scream* was no invention of Munch; it occurred often in Scandinavian poetry and prose in the 1880s—in the novels of Jacobsen and Jaeger and in the plays and stories of Strindberg. In those years when Scandinavian society was beginning to lose its old, settled aspect, its traditional rustic and small-town life, deep and painful conflicts arose for those who strove to live by the traditional Lutheran beliefs and middle-class morality. Stronger personalities reacted at first by challenging those beliefs in the name of truth and modernity. In time, as the newly developed urban way of life that had been identified with progress and freedom disclosed its own instability and contradictions, writers and painters came to reject an art that represented the world as beautiful, cozy, and untroubled, and humanity as the innocently enjoying

FIGURE 131. Vincent van Gogh, *Wheat Field with Rising Sun*, 1889, black chalk, reed pen, and brown ink on toned paper, 47 x 62 cm, Staatliche Graphische Sammlung, Munich

local community of faith. Behind those formerly unproblematic, domestic themes, they uncovered situations of conflict, suffering, and doubt.

Many typical interests of twentieth-century literature and art were apparent already in the 1880s. If we had to draw a line between our own time and the preceding with respect to outlook and its problems, I believe it would not be in 1900 but in the middle of the 1880s, although there are signs of a new attitude well before then, as early as the 1860s and 1870s, in the writings of Baudelaire, Rimbaud, and Flaubert, and in Germany in Nietzsche's vehement works. Absorbing Impressionism in Paris in 1886-87 after a phase of earnest, compassionate painting in Holland, Vincent van Gogh created a type of landscape in which the elements he borrowed from the Impressionists acquired an unparalleled intensity of feeling, an outlet of his thwarted longing for

FIGURE 132. Vincent van Gogh, *Dr. Paul Gachet*, 1890,
oil on canvas, 68 x 57 cm, Musée d'Orsay, Paris

FIGURE 133. Vincent van Gogh, *Starry Night*, 1889,
oil on canvas, 73.7 x 92.1 cm, The Museum of Modern Art, New York

love and his humane goals, expressed also in his love of objects and his desire for stable entities in the landscape, for a world with a firmer existence than his own uprooted being possessed. His new aims transformed the aesthetic of Impressionism, as his colors and forms became radically more pronounced and intense. In the *Wheat Field with Rising Sun* (fig. 131), the paths or lines in their great oppositions are physiognomic of the whole. The perspective carries you to the left along the plowed furrows, but the source of light is drawn out at the distant right and radiates. The painting has an objective and a subjective center: one from the artist's eye and the other from nature. Each has its own compulsion, fervor, and grandeur. This is not an Impressionist vision of landscape, but corresponds deeply to what we find revealed in van Gogh's wonderful letters about his feelings and desires.

In his portraiture, van Gogh scrutinized the sitters for traits that promised potential friends,

315

brothers, sisters, or lovers. The sense of the human is no longer found in the unreflecting Impressionist joyousness, the casual picnic or dance, but in an intent and fulfilling awareness of the other as a complex human soul, a responding self. Van Gogh portrayed Dr. Paul Gachet (fig. 132)—the flower in his hand is an emblem of the psychiatrist who included among his drugs digitalis, a heart stimulant derived from purple foxglove[7]—as a man who, as he wrote in a letter, "is just as sick as I am,"[8] and seemed to feel van Gogh's problems as his own. The flower here belongs to medicine, to the nerves as much as to nature's beauty. In the 1870s and 1880s, Gachet was a pioneer in developing a type of group therapy by confession. Before treating van Gogh, Gachet had been the physician of the mad etcher Charles Meryon, who was in his care for several years. A painter as well as doctor, Gachet was attracted by suffering artists. Van Gogh's portrait represented him as another self of the painter.

From the historian's point of view, van Gogh's portrayal of the doctor as neurotic is particularly significant, for contemporary writings of the 1880s and 1890s occasionally described neurosis as a principal characteristic of modern man. One published work containing that suggestion was written by the French mathematical economist Augustin Cournot, who, in a book on the philosophy of history published in 1872, predicted that the typical disease of the coming century would be neurosis.[9] This conclusion he inferred from his belief that the development of modern Western society would inevitably create and sharpen conflicts between individuals and society, between their needs and the conditions of work. Cournot foresaw an increasing state of stress, nervousness, and anxiety. Such a view was common among people other than painters. Writers, philosophers of history, historians—among them two Germans, the philosopher-sociologist Georg Simmel and the historian Karl Lamprecht—all used the concept of *Nervösität* to characterize humanity at the end of the nineteenth century and the beginning of the twentieth.

The paintings that followed Impressionism make us see that for a new generation the values that in the 1860s and 1870s had induced a more confident attitude, a feeling of independence, strength, and joy in the environment, had begun by 1885 to seem obstacles to self-knowledge and an understanding of society. Impressionism even became a symbol of the passive, the acquiescent, and the shallow. The Post-Impressionists could not sustain as a fertile ground of art the earlier point of view and mode of experience in a society where the new problems of the state, the economy, of social relationships, and of morality imposed difficult choices for which ordinary individuals were not prepared and with which they could cope only through a militant collective activity, through new laws, institutions, or ways of life that were beyond the power of the single individual to realize.

Artists, honestly groping, were attracted, then, by older ideas about religion and communal forms of life that seemed to promise spiritual security or hope to the individual. A painter as resolutely committed to the everyday world as van Gogh painted a picture like the *Starry Night*, which he described in a letter as an attempt to reach a religious viewpoint without God (fig. 133). God, he wrote, quoting Hugo, was "a lighthouse in eclipse,"[10] though Jesus remained

for van Gogh the greatest of all men. The inadequacy of the positive secular view was more often asserted by artists in the middle 1880s and early 1890s than by the largely agnostic or atheistic Impressionist group in the 1870s. In France, the crisis was felt with a special poignancy. In other countries—especially in the outlying ones that had been conservative in art until then or had advanced only recently to modern industrial society—the artists experienced the changes of the new forms of social life as an even more severe shock, and reacted with intense feeling in their works.

The career of Gauguin is a passion play of the modern artist responding to the new situation. He had begun as an Impressionist amateur painter while employed in a bank. Before that he had been a sailor and traveled around the world, an experience that together with his family's displacement (Paris, Peru, Orléans) during his childhood, gave him the necessary confidence,

FIGURE 134. Paul Gauguin, *The Vision After the Sermon (Jacob Wrestling with the Angel)*, 1888, oil on canvas, 73 x 92 cm, National Gallery of Scotland, Edinburgh

FIGURE 135. Paul Gauguin, *Where Do We Come From? What Are We? Where Are We Going?*, 1898, oil on canvas, 139 x 375 cm, Museum of Fine Arts, Boston

self-reliance, and readiness in his late projects of distant travel and change. Prospering in his job in the 1870s, Gauguin bought Impressionist pictures and made the acquaintance of artists. He lived then in a suburb of Paris with a Danish wife and four children whom he painted in the Impressionist manner, enjoying the scope and charms of his art and acquiring that sensibility so close to an ideal of bourgeois well-being.

When the bank failed during the crisis of 1883, Gauguin quit business and, with the aid of his savings, devoted himself entirely to painting. By 1885 he had abandoned his family, which he could no longer support. After living in undeveloped Martinique and provincial Brittany, he found his insecurity and isolation in urban France increasingly difficult and came to idealize primitive society as superior to the modern European.[11] This Romantic idealization itself may be taken as a sign of the contemporary crisis of the civilized world, in France and elsewhere. In the pictures that Gauguin painted of Tahiti and in those done earlier in Brittany, Impressionist colorism was converted into decorative tapestry-like patterns, with large abstract elements more ornamental and arranged. His themes were often religious, but in their picturesqueness, festiveness, and profusion seem to be exotic equivalents of the Impressionistic outings and sweetness of life in the 1860s and 1870s (fig. 134).

Gauguin in Tahiti saw native life as a fulfillment of at least one part of his positive ideal: a serene enjoyment of nature and community, sustained by a poetic religion and by a social order that assured stability to that native world. In France, the conditions of enjoyment were individuality and freedom of movement and choice within the social group, in other words, surmounting the inertia of "tribal" life. Here is another kind of reversal of human relationships that depended on the Impressionist goals and heritage.

Gauguin could not maintain this view to the end. We see the outcome in a picture with the

FIGURE 136. Jackson Pollock, *Number 1, 1948*, 1948, oil and enamel on
unprimed canvas, 172.7 x 264.2 cm, The Museum of Modern Art, New York

title, "*Where Do We Come From? What Are We? Where Are We Going?*" (fig. 135), where he
undertook to grapple with metaphysical questions about human existence. Lacking a mythology
and a revived pagan tradition like that of the artists of the Renaissance, or a dogmatic religion
as in the Middle Ages, Gauguin could picture those great challenges and answers about the
nature and ends of man only in terms of individual life as a biological process. On one side, he
placed a child; in the middle, a youth—naturally plucking fruit—and at the left figures of brood-
ing old age, memory, and death. It is a picture of the stages of life in its natural course from
infancy to old age, in abstraction from society and history. The "myth" projects an anonymous
individual life, symbolizing the ages of man as seen in old-fashioned popular images, most often
religious, but sometimes ending with burial—a naturalistic note.

The very posing of the unanswerable questions in the title shows that the painting for Gauguin
was not simply an aesthetic enterprise or a means of affirming his strong individuality through devel-
opment of his artistic powers. It entailed also some doubts about himself and his world, questions
hardly conceivable as themes of Impressionist painting, though an Impressionist might have enter-
tained them in thought. The introduction of such themes changed the scope and aims of

FIGURE 137. Claude Monet, *L'Hôtel des Roches Noirs, Trouville*, 1870, oil on canvas, 80 x 55 cm, Musee d'Orsay, Paris

painting. One could not have painted the answers to such questions, or even the questions themselves, in an Impressionist manner. Earlier, van Gogh had said that one could not paint an Impressionist picture of a saint. The appearance of a saint is not a function of sunshine, but of an inner light.

Gauguin, accordingly, introduced clear figurative forms and made them legible as images and symbols of his dream of a lost idyllic happiness in a luxurious, seasonless nature, so different from the weekend and holiday pleasures of the Impressionist spectator, which are a matter of repeatedly renewed individual sensibility. Gauguin had to give to color, texture, and drawing

more stable qualities—deliberate, accented shapes, ornamentation, and an air of the archaic—all alien to Impressionist painting. Much in Impressionism became irrelevant with the change of outlook implicit in his choice of subject.

In terms of the reaction to Impressionism, it is clear from the pictures themselves that the change was not simply a response to problems in painting. No hidden or latent dialectic in painting required that if artists paint with small strokes for a time, they must then paint with large ones, or if painters dissolved clear shapes, they would eventually introduce bounding lines in negation. What happened did not reflect a *Zeitgeist* but a reaction to the presence of circumstances and the conflicts they generated. Specific common attitudes and problems of social life emerged in the 1880s in an acute way, affecting the more self-conscious artists of the next

FIGURE 138. Camille Pissarro, *Place du Théâtre Francais*, 1898, oil on canvas, 72 x 93 cm, Los Angeles County Museum of Art

generation and causing this new art to come into being. A corresponding poetry arose, particularly among the Symbolists, which was critical of naturalism and which restored symbols, religious concepts, and pessimistic reflection upon the self and social institutions.

Impressionist values did not die out, however. Not only did they continue to attract the large public that is relatively uninterested in new painting but enjoys nature, spectacle, holiday pleasures, and recreation; also original painters for the next fifty years continued to use the Impressionists' inventions. It is astonishing to what degree the style's features persisted in the art movements that seem least Impressionist. Among the Fauve painters, the Cubists, the Surrealists, the German Expressionists, and even in abstract painting are traits that come out of Impressionist painting. Four essential aesthetic and technical traits of Impressionism—first, the predominance of the stroke as a building unit of the whole; second, the distinctness of the surface as a weave on the canvas; third, the taste for randomness as a mode of composition in which colors are averaged or brought into harmony; and fourth, the fact of transformation, whereby

FIGURE 139.
Piet Mondrian,
Composition with Lines, 1916-17,
oil on canvas,
108 x 108 cm,
Rijksmuseum
Kröller-Müller,
Otterloo

every canvas by an Impressionist is experienced both as an image and as a painted surface—commonly appear in several of the advanced types of painting in the first half of the twentieth century, and at least three of them can be found in all new art. Impressionism corresponds in a basic way to attitudes and problems of painting that can be discerned in almost all later art.

This point can be illustrated by two works that initially seem entirely non-Impressionist. One is the painting *Number 1, 1948* (fig. 136) by Jackson Pollock, an overwhelming tangle of lines, filaments, and patches of color, with something of the blinding quality of a great snowstorm. In its range from delicacy to roughness, in its detailed forms, it is beyond possible planning or deliberation. In the upper right, the artist has imprinted his hands on the paint to leave a trace, as if to say: a human being has been here, this is the work of an individual who produces as he moves.

Made some seventy-eight years before (fig. 137), a painting by Monet shows a complexity of random touches that build up yet fuse and lose the forms of trees, figures, and buildings as well as a scattering of strokes that are not too distant from Pollock's, though Monet seems to have responded to sensations of the city and Pollock to powerful impulses, to motor activity. The two works are connected visually by the introduction in Monet's picture of figures on a balcony in the upper right looking down at the street. They occupy the same place as the hands in Pollock's canvas. Monet's painting is of what his spectators see and Pollock's is what he has done with his hands. But in both the witnesses and sources are present in the corner of the picture, and this continuity is evidence of the Impressionist attitude to creation. It affirms the artist's presence in his work and the immediacy and tangibility of his result.

In another pair of paintings by Pissarro (fig. 138) and Piet Mondrian (fig. 139), the continuity is no less remarkable. Mondrian's work is without apparent relation to nature or to visible things. It seems nearer to a scientific or technical imagination in which a few types of rectangular unit, restricted in assembly to contact at right angles, have been varied in thickness, interval, and frequency. This conception of a unity with unpredictable relationships of elements, yet integrated and harmonized through the balance of densities, presupposes the randomized type of Impressionist composition, the painting with freely varied, tiny strokes submitted to common unifying intangibles of texture, atmosphere, and light. Without Pissarro's work, this painting of Mondrian would not have been possible.

Impressionism ceased to be a style congenial to a progressive younger generation in the mid-1880s, as became clear in the serious comments on its spiritual inadequacy by certain writers. It was almost forgotten during the revolutionary developments in the art of the early twentieth century. Nevertheless, through its discoveries and qualities, and above all through its concept of art as a free and expressive personal creation submitted to impersonal requirements of aesthetic rightness and wholeness, Impressionism laid an essential part of the foundation of modern painting.

1. Diego Martelli, "Gli Impressionisti," in *Scritti d'arte di Diego Martelli*, scelti a cura di Antonio Boschetti (Firenze, 1952), p. 106. Martelli was an Italian painter and art critic who embraced, in succession, the Macchiaioli painters, the Barbizon School, and finally the Impressionists. He became a friend of Degas and described Monet as "the model of the young modern artist." In a significant 1879 lecture he delivered in Livorno, later reprinted as a pamphlet, Martelli praised Impressionism as not just a revolution in thinking but also a revolution in understanding the workings of the human eye. He called Impressionism "a different mode of perceiving the sensation of light and of expressing impressions," and explained that Impressionist theory followed rather than preceded the painters' observations, that their pictures were "born of the unconscious processes of the artist's eye."

2. Diversity is a factor in the character of the group. If Manet, Degas, and Renoir had not been part of it, the historical impact on contemporary and later art would not have been as great or as decisive. There would have been no Henri de Toulouse-Lautrec, no Paul Cézanne, no Georges Seurat, all of whom were decisive for the twentieth century. Even Paul Gauguin depended on the instinctive linear aspect of Cézanne, Renoir, and Degas (Matisse also, with regard to Renoir, Manet, and Degas). The span of character (artistic, psychological, sociological, even ideological) in the group is perhaps greater than that of any preceding school, such as Realism, Romanticism, Neoclassicism, or the Rococo, in part owing to the fact that it was not formed by a single great teacher or model, but inherited the diversity of Parisian art of the 1840s and 1850s from Delacroix, Ingres, Corot, Couture, Daumier, Courbet, and Barbizon artists like Rousseau, Millet, and Daubigny. Another important factor was the Louvre Museum, which, since the 1820s, had become the open public school of artists, stimulating personal choice in artistic education. That autodidactic relationship corresponded in several ways to the situation in New York in the 1930s and 1940s with the Museum of Modern Art, which was committed to no one school and showed all new work regularly. The diversity of the Impressionists shares similarities with that of the Abstract Expressionists, in which group artists like Rothko and Newman, Pollock and de Kooning were almost opposites with different starting points (see my article on "The Younger American Painters of Today" in *The Listener*, January 26, 1956, pp. 146-47). No single characterization of the group can fit them all, with their different starting points, even of Pollock and de Kooning. In a similar way to Manet and Degas vs. Pissarro, or Cézanne vs. Monet, we see later internal oppositions among Cubist painters, such as Picasso and Braque vs. Gris, Léger, and Delaunay, and, among the German Expressionists, Kandinsky and Klee vs. Nolde, Kirchner, and Kokoschka.

3. The Impressionist painters did not deal with what reviewers of the Salon called "*Les grands sujets.*" Victor Chebuliez in 1876 spoke of Benjamin Constant's gigantic *Triumphal Entry of Mahomet II into Constantinople, 29 May 1453* as "l'art spectaculaire" (*Revue des deux-mondes* 46, 1876, pp. 881–83). See also Delacroix's *Entry of the Crusaders into Constantinople* (Paris, Louvre) and Ensor's *Entry of Christ into Brussels in 1889* (fig. 126).

4. As in literature, dramatic representation in paintings connects to the idea of images as a source of seriousness and life reference, yet forms and colors have a power of their own to stir, evoke, and symbolize feelings.

5. The pleasure in representation (as an imitation) is just as strong today as it was in primitive times. It connects to, among other things, the enjoyment of knowing, of recognizing, and of experiencing in imagination. Representation is a stimulus to imagination, since what we recognize is also something different from the object depicted. It is a simulation, a mimicry. Then there is the interest in the object simulated. The pleasure in a landscape painting is a vicarious satisfaction of an interest in nature and environment. It is more than curiosity; it is an impulse toward new knowledge and new experience.

6. "C'est là tout le secret des beaux-arts: c'est la ménageant des surprises à nos sens, en nous créant de nouvelles manières à voir et d'entendre, que le peintre et le musicien nous ravissent." Maine de Biran, *L'Influence de l'habitude sur la faculté de penser*, Paris, 1803, p. 172.

7. A. D. Blest, "The function of eyespot patterns in the Lepidoptera," *Behaviour,* vol. 11 (1957), pp. 209–256.

8. "[T]oute ma valeur . . . c'est que je suis un homme pour qui le monde visible existe," quoted in the *Goncourt Journal,* Monaco, 1956, vol. 1, pp. 141–42.

9. Gautier's own verbal palette was one of the richest in history. Sainte-Beuve, the greatest literary critic of the century, said that the adjective "indescribable" no longer had any validity, since Gautier had demonstrated the ability to represent worthily anything with appropriate and specific words. C.-A. Sainte-Beuve, *Nouveaux Lundis.* T. VI, Paris, 1883, p. 329 (lundi, 30 novembre, 1863).

10. "Jeanne . . . a little dizzy from the rocking of the waves, looked far away; and it seemed to her that only three things were beautiful in creation: light, space, and water." She described the cliff of Étretat as "a rock of strange shape, rounded and flooded with light, like an enormous elephant plunging its trunk in the waves," and referred to "the pendentives of Étretat, like two legs of the cliff standing in the sea." (". . . un roche d'une forme étrange, arrondie et percée à jour, avait à peu près la figure d'un éléphant énorme enfonçait sa trompe dans les flots. . . . Jeanne . . . un peu étourdi par le bercement de vagues, regardait au loin; et il lui semblait que trois seules choses étaient vraiment belles dans la création: la lumière, l'espace et l'eau . . . les grandes arcades d'Étretat, pareilles à deux jambes de la falaise marchant dans la mer. . .") Guy de Maupassant, *Une Vie,* in *Romans,* Paris, 1959, pp. 37, 38.

11. On the simultaneous appeal of air, sky, and sun to several senses, see the early poem by Constantine Cavafy, "Voice from the Sea":

> *The sea intones for us a tender song,*
> *a song composed by three great poets,*
> *the sun, the air, the sky.*
>
> *She intones it with that divine voice of hers*
> *when summer weather spreads calm*
> *like a gown over her shoulders.*

The Complete Poems of Cavafy, translated by Rae Dalven, introduction by W. H. Auden, New York, 1961, pp. 207-8. Cavafy's poem demonstrates the persistence of Impressionist attitudes in the twentieth century.

12. The notion of the environment was connected to the significance of a mode of attention to the world, as a sign of a sense of self and feelings of dependence, initiative, energy, and confidence. Consider the landscape painter's concept of the "horizon," with its attendent references to goals, projects, or constraints to the openness or closure of self, and finally with its relative sense of freedom, initiative, growth, rigidity, or reactivity defined in terms of the environment. See further chap. 3, "Nature and the Environment."

I. THE CONCEPT OF IMPRESSIONISM
(pp. 21-42)

1. "Le papier peint à l'état embryonnaire est encore plus fait que cette marine-là!" Louis Leroy, *Charivari,* April 25, 1874.

2. Léon Lagrange, *Le Correspondent,* May 25, 1865.

3. ". . . le peintre n'a songé qu'à rendre son impression." *Manet raconté par lui-même et ses amis,* Pierre Cailler, editor, Geneva, 1953, vol. I, p. 135. The foreword was actually written by Zacharie Astruc to reflect what Manet had told him. Astruc, a sculptor, painter, and art critic, was a friend of Manet's and is seated beside him in Fantin-Latour's famous group portrait, *A Studio in the Batignolles Quarter* (Musée d'Orsay, 1870).

4. Thirty years later Antonin Proust, Manet's friend and former fellow schoolboy, flatly denied that the term *"Impressionniste"* came from the title of Monet's picture. It arose, he believed, in the course of Manet's conversation in 1858 (*"Souvenirs," Revue Blanche,* XII, 1897, 427). Proust's recollection was not included in the reprint of his *"Souvenirs"* as a book in 1913. Louis Dimier, who cited the original text, accepted Proust's argument, though it was based on his memory of discussions with Manet nearly forty years before and was supported by no other words of Manet than his statement: "Un artiste doit être spontanéiste" ("Sur l'époque véritable du mot impressionisme," *Bulletin de la Société de l'Histoire de l'Art Français,* 1927, 40-41). Another attribution of the term to a date before 1874 is implied in the story of Victor Hugo's calling Stéphane Mallarmé "mon cher poète impressionniste" in about 1865 (H. Mondor, *Vie de Mallarmé,* Paris, 1941, vol. I, p. 111). But this date is doubted, rightly by D.-H. Kahnweiler, who believed the term was first used in 1874 (*Juan Gris, His Life and Work,* London, 1947, 62, n. 1). Perhaps for Hugo it was the ellipses and untraditional syntax and word order that made Mallarmé appear *"impressionniste,"* a general term then for a radical innovator in the arts. Manet's statement in 1867 was probably an answer to a brutal and blind criticism of his paintings in the Salon des Refusés of 1863 by Castagnary, a man of the Left and ardent defender of Realism: "What do I still see? The artist's lack of conviction and sincerity." ("Que vois-je encore? l'absence de conviction et de sincérité chez l'artiste.") Reprinted in *Salons,* I, 1892, p. 174.

5. Leo Tolstoy, *War and Peace,* translated by Constance Garnett, Book 2, Chapter XVIII, New York, 1931, p. 166

6. *The Dialogues of Plato,* translated into English and introduced by Benjamin Jowett, New York, 1911, vol. III, p. 390.

7. Edgar Allan Poe, *Poetry and Tales*, New York: Library of America, 1984, pp. 1263-66.

8. George Boole, *An Investigation of the Laws of Thought*, ch. 1, 2, New York, 1951, p. 3 (originally published 1854).

9. John Ruskin, *The Stones of Venice*, London, III, ch. II, section xi.

10. ". . . l'on n'entendait plus . . . que froissement vague, innommable et flottant de la neige qui tombe, plutôt sensation que bruit. . ." Guy de Maupassant, "Boule-de-suif" (Butterball), in *Oeuvres Complètes*, Paris, n. d., p. 60, first published as part of *Soirées de Médan* in 1880. *Soirées de Médan* (Evenings at Médan) was a book of Realist stories by Zola and five of his disciples, including Huysmans. Following Zola's tale, which took place during the Franco-Prussian War, the other contributions all had a military setting.

11. Bishop Berkeley, *Works*, ed. Alexander Fraser, vol. I, *Philosophical Works*, 1705-1721, §129, 130, pp. 191-92.

12. Galileo, *Opere*, vol. VIII, p. 692; see also Erwin Panofsky, *Galileo as a Critic of the Arts*, M. Nijhoff, 1954, pp. 6-8.

13. As embodied in Honoré de Balzac's *Le Chef-d'oeuvre inconnu* (*The Unknown Masterpiece*, 1831), the story of Frenhofer, an imaginary seventeenth-century painter with whom Cézanne closely identified. Frenhofer spent nearly all his waking hours on one final, secret work, which gave the story its title. The picture was ultimately revealed as an incomprehensible mass of loose strokes wherein could be glimpsed one perfectly finished foot.

14. "You enter into the room of a king or great lord, or I believe they call it the treasure chamber, where there are countless kinds of glass and earthen vessels and other things so arranged that almost all these objects are seen upon entering. Once I was brought to a room like this in the house of the Duchess of Alba where, while I was on a journey, obedience ordered me to stay because of this lady's insistence with my superiors. I was amazed on entering and wondered what gain could be gotten from that conglomeration of things, and I saw that one could praise the Lord at seeing so many different kinds of objects, and now I laugh to myself on realizing how the experience has helped me here in my explanation. Although I was in that room for a while, there was so much there to see that I soon forgot it all; none of those pieces has remained in my memory any more than if I had never seen them, nor would I know how to explain the workmanship of any of them. I can only say in general that I remember seeing everything. Likewise with this favor, the soul, while it is made one with God, is placed in this empyreal room that we must have interiorly. For, clearly, the soul has some of these dwelling places since God abides within it. And although the Lord must not want the soul to see these secrets every time it is in this ecstasy, for it can be so absorbed in enjoying Him that a sublime good like that is sufficient for it, sometimes He is pleased that the absorption decrease and the soul see at once what is in that room. After it returns to itself, the soul is left with that representation of the grandeurs it saw; but it cannot describe any of them, nor do its natural powers grasp any more than what God wished that it see supernaturally." Saint Teresa of Avila, *The Interior Castle*, "6th Dwelling Place," ch. 4, no. 8, Kieran Kavanaugh, introduction and translation, Mahwah, New Jersey, 1979, pp. 129-30.

15. In a treatise entitled *Principes de Mécanique Cérébrale* (before 1874), poet and physicist Charles Cros, a friend of the Impressionist painters, defined "form" as "a simultaneity of several specific elementary impressions, some alike, some different. . . . An ensemble of different impressions, considered as affecting simultaneously the seats of consciousness, is classified under the category of forms. For example, at a ball, the lights, the invited guests, the music, the sound of voices, the flavor and taste of the ices that you enjoy, and a thousand other impressions, taken together yet at any instant undecomposable by the self, constitute a form, whether experienced in reality or evoked in memory or imagination." ("La *forme* est un simultanéité de plusieurs impressions spécifiques élémentaires, semblables ou différentes. . . Un ensemble quelconque d'impressions différentes considérées comme affectant simultanément les appareils de conscience, se range sous la catégorie des *formes*. Par exemple: dans un bal, les lumières, les invités, la musique, le bruit des voix, le parfum et le goût de la glace que vous prenez, et mille autres impressions prises ensemble, mais dans un instant indécomposable pour le moi, constituent une *forme*, que cette forme soit sentie en réalité, qu'elle soit évoquée en souvenir ou en imagination.") Charles Cros and Tristan Corbière, *Oeuvres Complètes*, Paris, Pléiade, 1970, pp. 531-32.

16. Ernst Mach, *Science of Mechanics*, New York, 1960, p. 579 (original edition *Die Mechanik in ihrer Entwicklung*, 1883).

17. Hippolyte Taine, *De l'Intelligence*, Paris, 1870, vol. I, book IV, ch. III, p. 348ff.

18. Pierre Gratiolet, *De la physionomie et des mouvements d'expression*, Paris, 1865.

19. Pierre Gratiolet, *Zoology for beginners*, Paris, 1835. I am reminded of certain more recent theories of the picture plane as the true field of the painter's attention.

20. Bishop Berkeley, *Works,* op. cit., vol. I, p. 292, section 62.

21. Berkeley, op. cit., I, p. 422.

22. Ernst Mach, *Die Analyse de Empfindungen,* trans. as *The Analysis of the Sensations,* New York, 1959, p. 30, n. 1.

23. *Memoirs of the Life, Death and Burial and Wonderful Writings of Jacob Behmen,* trans. Francis Okeley, London, 1780, p. 8.

24. *The Literary Works of Sir Joshua Reynolds,* with a memoir of the author by Henry William Beechey, London, 1852, vol. 11, "Discourse no. XIV," p. 81.

25. "Quand je te parlerai de vive voix, je te demanderai si ton opinion n'est pas, sur la peinture, comme moyen d'expression de sensation, la même que la mienne," and "en nous n'est pas endormie la vibration des sensations répercutées de ce bon soleil de Provence nos vieux souvenirs de jeunesse de ces horizons, de ces paysages, de ces lignes inouïes, qui laissent en nous tante d'impressions profondes . . ." Paul Cézanne, *Correspondence,* annotated and edited by John Rewald, Paris, 1937, pp. 153-54 and p. 239. Henri Gasquet was the father of the poet Joachim, who wrote an important book on Cézanne.

26. Charles Baudelaire, "Edgar Allan Poe: sa vie et ses ouvrages," in *Oeuvres Complètes,* Paris, Pléiade, vol. II, p. 258.

27. "Il sait bien qu'il faut que tout cela devienne tableau par le moyen de l'impression poétique rappelée à volonté. . ." in "VII. Le Paysage" from the *Salon de 1859,* ibid, p. 665.

28. ". . . quelque chose se dégageait déjà de ma vie extérieur, et qu'il se formait en moi je ne sais quelle mémoire spéciale assez peu sensible aux faits, mais d'une aptitude singulière à se pénétrer des impressions . . . au fond j'étais seul, seul de ma race, seul de mon rang . . ." Eugène Fromentin, *Dominique,* in *Oeuvres Complètes,* Pléiade, Paris, 1984, p. 400.

29. "J'ai une vie intérieure assez active.—J'absorbe surtout énormément par les yeux.—" *Correspondance d'Eugène Fromentin,* edited and annotated by Barbara Wright, vol. I: *1839-1858,* 1995, p. 308.

30. See his *Traité du physique et du moral de l'homme* (1798-99), republished as *Rapports du physique et du moral de l'homme* in 1802.

31. ". . . soumettons-nous à l'impression première. Si nous avons été réelement touchés, la sincérité de notre émotion passera chez les autres. . . ." Etienne Moreau-Nelaton, *Histoire de Corot det ses Oeuvres,* Paris,

1905, p. 172, and idem, *Corot Raconté par lui-même,* vol. 1, Paris, 1925, pp. 105-06.

32. John Ruskin, *Modern Painters,* New York, 1929, vol. 4, part V, ch. 2, sect. 8, 9, 12, pp. 22, 23, 25-26.

33. "Pour faire un portrait faire poser au rez-de-chausée et faire travailler au premier pour habituer à retenir les formes et les expressions et ne jamais dessiner ni peindre immédiatement." P.-A. Lenoisne, *Degas et son oeuvre,* Paris, 1946, vol. 1, p. 100.

34. "Si je pouvais faire ce que je voudrais . . . je ne ferai rien qui ne fût le résultat d'une impression reçue par l'aspect de la nature, soit en paysages, soit en figures." Alfred Sensier, *La Vie et l'oeuvre de J.-F. Millet,* Paris, 1881, p. 130.

II. THE AESTHETIC AND METHOD OF IMPRESSIONISM
(pp. 43-78)

1. Such as the Scottish "common-sense school" founder Thomas Reid. "Common-sense" consisted of self-evident knowledge, embodied in the way in which we understand objects of the external world, objects which we can know in their true sense, and not as copies of ideas.

2. "I remember one day, in front of the slope beyond which rises the Marcil hillside, he pointed out a distant object to me and said, 'Look at that object I have just painted. I don't know what it is.' It was a certain gray shape, which, at a distance, I couldn't identify; but casting my eyes on the canvas, I saw that it was a pile of faggots. 'I don't need to know,' he said, 'I depict what I see without comprehending what it is.' Then (drawing back from his canvas), he added: 'Yes, it's true, they are faggots!'" Unpublished memoirs by Francis Wey, in Pierre Courthion, ed., *Courbet raconté par lui-même et ses amis,* Geneva, 1948, vol. 2, pp. 190-91.

3. William Seitz, *Monet,* New York, 1960, p. 28.

4. "La touche, ou la manière de poser la couleur et de promener le pinceau, est toujours dans le sens de la forme et contribue à décider le relief. Quand le modèle tourne, la brosse de l'artiste tourne dans le même sens . . . En peinture, on ne se préoccupe pas assez de cette logique impérieuse de la pratique; la plupart des peintres mettent au hasard leur griffe sur la toile, contrariant, sans y songer, la structure nécessaire de tous les objets et la géométrie naturelle. On peut bâtir un mur avec des coups de truelle par-ci, par-là; mais on ne caresse pas le visage de sa maîtresse, à commencer par le menton." Théophile Thoré, *Salons,* "Salon de 1847," part III, "Delacroix," Paris, 1893, vol. I, pp. 455-56.

5. Henry James, *The Ambassadors,* introduction by Martin Sampson and John C. Gerber, New York, 1902, p. 62.

6. James, who belonged to the same generation as the Impressionists and lived much in Paris, hardly understood the importance of their work, though he wrote often about art. In a review of their exhibition of 1875, he dismissed them as eccentric painters who lacked the full seriousness of artists. But when he wrote *The Ambassadors,* he had come to appreciate both Monet and Degas as major figures. James's concept of reality as an unsettled play of surface and depth, of appearance and actuality, was perhaps connected to his own evasion of the traditional masculine role, allowing himself a sense of the ambiguities of appearance and reality in normal social life: every object could be read as a part or object of consciousness, as a perception, and as a fact of existence—its own independent existence.

7. Jean-Hippolyte Michon, *Les Mystères de l'écriture,* Paris, 1872.

8. For example, see Monet's *Breakup of Ice, Grey Weather,* 1830, Museu Calouste Gulbenkian, Lisbon, See also Renoir's *Skaters in the Bois de Boulogne,* 1868, Private collection.

9. Guy de Maupassant, "La Vie d'un paysagiste," *Gil Blas,* September 28, 1886 (trans. in Charles Stuckey, *Monet: A Retrospective,* New York, 1985, p. 122).

III. NATURE AND THE ENVIRONMENT
(pp. 79-95)

1. Located in the Musée d'Art et d'Histoire, Lille.

2. "Un port est un séjour charmant pour une âme fatiguée des luttes de la vie. L'ampleur d'un ciel, l'architecture mobile des nuages, les colorations changeantes de la mer, le scintillement des phares, sont un prisme. Et puis, surtout, il y a une sorte de plaisir mystérieux et aristocratique pour celui qui n'a plus ni curiosité ni ambition, à contempler couché dans le belvédère ou accoudé sur le môle, tout ces mouvements de ceux qui partent et de ceux qui reviennent . . ." Charles Baudelaire, "Le Spleen de Paris," "Petits poémes en prose, no. XLI," "Le Port," *Oeuvres Complètes,* Paris: Pléiade, 1975, vol. I, pp. 344-45.

3. Immanuel Kant, "On the quality of the liking in our judging of the sublime," *Critique of Judgment,* trans.Werner Pluhar, Indianapolis, 1987, sect. 27, p. 117.

4. ". . . imitent tous les sentiments compliqués qui luttent dans le coeur de l'homme aux heures solennelles de la vie." Baudelaire, op. cit., "Petits Poèmes en prose, no. XXII," "Le Crépuscule du soir," p. 312

5. C. D. Friedrich, *Mountain Landscape with Rainbow,* 1810, oil on canvas, 70 x 102 cm, Museum Folkwang, Essen.

6. C. D. Friedrich, *Moonrise by the Sea,* 1822, oil on canvas, 55 x 71 cm, Staatliche Museen Preussicher Kulturbesitz, Nationalgalerie, Berlin.

7. "O mer! ta voix est formidable, mais elle ne parviendra pas à couvrir celle de la Renommée criant mon nom au monde entier." Quoted in *Courbet à Montpellier,* catalogue by Philippe Bordes, Musée Fabre, 1985, no. 16, p. 55. The quotation is often associated with *The Seaside at Palavas,* a 1854 painting from Montpellier's Musée Fabre, which shows a figure waving his cap at the gentle incoming breakers of the Mediterranean. The quotation is said to derive from a no-longer-extant letter written the same year to Jules Vallès, a radical journalist whose portrait Courbet painted in the early 1860s. However, Courbet did not yet know Vallès, a younger man, by 1854, and the grandiloquent tone is not the way Courbet normally expressed himself in his letters. Courbet scholar Philippe Bordes doubts that the man doffing his cap in the picture is even the painter, and possibly represents his partron Alfred Bruyas.

8. ". . . quand j'arriverai au sommet des dunes d'où je planais sur l'immensité, il y avait dans le ciel et sur la mer un effet d'argent, que je n'ai jamais revu depuis avec tant d'éclat. La mer et le ciel me semblèrent confondus dans un rayonnement surnaturel. Je me demandais où était la mer. Il me paraissait que j'étais transporté bien au-dessus de la mer et de la terre, dans une sphère plus lumineuse. Je fus saisi d'un enthousiasme expansif qui me serra la gorge. Ne pouvant m'envoler, je me laissai glisser par terre, tout de mon long, pour ne plus sentir mon corps. Ne pouvant crier la gloire de la nature avec la vigueur des tempêtes, je me mis à pleurer doucement, doucement, sans faire de bruit, afin d'entendre la grande voix harmonieuse de l'immensité." Théophile Thoré, op. cit., *Salon de 1844,* "À Théodore Rousseau," vol. I, pp. 7-8.

9. "Et dans la sympathie de cette effusion contemplative, nous aurions voulu que notre âme, irradiant partout, allât vivre dans toute cette vie pour revêtir toutes ses formes, durer comme elles, et se variant toujours, toujours pousser au soleil de l'éternité ses métamorphoses!" Gustave Flaubert, *Par les champs et par les grèves,* Paris, 1979, p. 104; English translation *Over Strand and Field,* in *The Complete Work of Gustave Flaubert,* vol. 7, New York, 1904, p. 49.

10. Note also in Flaubert's diaries his "impressionist" perceptions and his enjoyment of colors and randomness.

IV. THE RAILROAD
(pp. 96-107)

1. "Elle regardait passer les campagnes, les arbres, les fermes, les villages, effarée de cette vitesse, se sentant prise dans une vie nouvelle, emportée dans un monde nouveau qui n'était plus le sien, celui de sa tranquille jeunesse et de sa vie monotone." Guy de Maupassant, *Une Vie,* in *Romans,* annotated by Albert-Marie Schmidt, Paris, 1959, pp. 214-215.

2. "C'est un mouvement magnifique et qu'il faut avoir senti pour s'en rendre compte. La rapidité est inouï. Les fleurs du bord du chemin ne sont plus des fleurs, ce sont des taches ou plûtot des raies rouges ou blanches; plus de points, tout devient raie; les blés sont de grandes chevelures jaunes, les luzernes sont de longues tresses vertes; les villes, les clochers et les arbres dansent et se mêlent follement à l'horizon; de temps en temps une ombre, une forme, un spectre, debout, paraît et disparaît comme l'éclair à côté de la portière; c'est un garde de chemin qui, selon l'usage, porte militairement les armes au convoi. On se dit dans la voiture: C'est à trois lieues, nous y serons dans dix minutes." Victor Hugo, *En Voyage, France et Belgique, Paris,* n.d., p. 92. Hugo's trips date from 1834 to 1844.

3. "Bertall" was the *nom d'artiste* of Albert d'Arnoux. Balzac persuaded him to sign his work with an anagram of his first name.

4. As in his 1843 series of lithographs in Loys Delteil, *Le Peintre-Graveur,* XXII (Daumier III), 16 plates.

5. "Il lui reste à peindre le mastodonte de fer courant sur les rails à travers les arbres, les rochers, laissant de petites villes sur un coteau, passant sur un village par un pont hardi, renâclant, sifflant et suant. . . ." From "Courbet en 1860," reprinted in Champfleury, *Le Realisme,* Paris, 1973, p. 185.

6. "On l'entend souffler au repos, se lamenter au départ, japper en route; il sue, il tremble, il siffle, il hennit, il se ralentit, il s'emporte; il jette tout le long de sa route une fiente de charbons ardents et une urine d'eau bouillante; d'énormes raquettes d'étincelles jaillissent à tout moment de ses roues ou de ses pieds, comme tu voudras, et son haleine s'en va sur vos têtes en beaux nuages de fumées blanche que se déchirent aux arbres de la route . . . il était nuit, notre remorqueur a passé près de moi dans l'ombre se rendant à son écurie, l'illusion était complète. On l'entendait gémir dans son tourbouillon de flamme et de fumée comme un cheval harassé.

"Il est vrai qu'il ne faut pas voir le cheval de fer; si on le voit, tout la poésie s'en va. A l'entendre c'est un monstre, à le voir ce n'est qu'une machine. Voilà la triste infirmité de notre temps; l'utile tout sec, jamais le beau. Il y a quatre cents ans, si ceux qui ont inventé la poudre avaient inventé la vapeur, et ils en étaient bien capables, le cheval de fer eût été autrement façonné et autrement caparaçonné; le cheval de fer eût été quelque chose de vivant comme un cheval et de terrible comme un statue. Quelle chimère magnifique nos pères eussent faite avec ce que nous appelons la chaudière! Te figures-tu cela? De cette chaudière ils eussent fait un ventre écaillé et monstrueux, une carapace énorme; de la cheminée une corne fumant ou un long cou portant une gueule pleine de braise; et ils eussent caché les roues sous d'immenses nageoires ou sous de grandes ailes tombantes; les wagons eussent eu aussi cent formes fantastiques, et, le soir, on eût vu passer près des villes tantôt un éléphant la trompe haute haletant et rugissant; effarés, ardents, fumants, formidables, traînant après eux comme des proies cent autres monstres enchaînés, et traversant les plaines avec la vitesse, le bruit et la figure de la foudre. C'eût été grand.

"Mais nous, nous sommes de bons marchands bien bêtes et bien fiers de notre bêtise. Nous ne comprenons ni l'art, ni la nature, ni l'intelligence, ni la fantaisie, ni la beauté, et ce que nous ne comprenons pas, nous le déclarons inutile du haut de notre petitesse. C'est fort bien. Où nos ancêtres eussent vu la vie, nous voyons la matière. Il y a dans une machine à vapeur un magnifique motif pour un statuaire . . ." Victor Hugo, op. cit., pp. 93-94. In discussing the indifference of the businessman to the poetic in the railroad locomotive, Hugo anticipated the functionalist aesthetic of the twentieth century as a depersonalizing of art, a loss of poetic imagination.

7. Guy de Maupassant, *Au Soleil and La Vie Errante, The Life Work of Henri René Guy de Maupassant,* vol. XII, Akron, Ohio: St. Dunsten Society, 1903, p. 150.

8. See introduction note 10.

9. "Dans ses tableaux, l'eau clapote, les locomotives marchent , les voiles de bateaux s'enflent sous le vent, les terrains, les maisons, tout a, dans l'oeuvre de ce grand artiste, une vie intense et personelle que personne n'avait découverte ni même soupçonnée avant lui. . . . Ces tableaux sont d'un variété etonnant, malgré la monotonie et l'aridité du sujet. . . . Comme une bête impatiente et fougeuse, animée plutôt que fatiguée par la longue traîte qu'elle vient de fournir, elle secoue sa crinière de fumée qui se heurte à la toiture vitrée de la grande halle. Autour du monstre, les hommes grouillent sur la voie, comme des pygmées au pied d'un géant." Georges Rivière, op. cit., pp. 311-12.

10. ". . . elles (Les grandes Halles) apparurent comme une machine moderne, hors de toute mésure, quelque

machine à vapeur . . . gigantesque ventre de métal, boulonné, rivé, fait de bois, de verre et de fonte, d'un élégance et d'un puissance de moteur mécanique, fonctionnant là avec la chaleur du chauffage, l'étourdissement, le branle furieux des roues." Emile Zola, *Le Ventre de Paris* (The Belly of Paris), Paris, 1979, p. 62, first published 1873.

11. "C'était un vrai cataclysme. Éclairs palpitants, des ailes comme de grands oiseaux de feu, babels de nuages s'écroulant sous les coups de foudre, tourbillons de pluie vaporisée par le vent: on eût dit le décor de la fin du monde. A travers tout cela se tordait comme la bête de L'Apocalypse, la locomotive, ouvrant ses yeux de verre rouge dans les ténèbres et traînant après elle, en queue immense, ses vertebres de wagons. C'était sans doute une pochade d'une furie enragée, brouillant le ciel et la terre d'un coup de brosse, une véritable extravagance, mais faite par un fou de génie." Théophile Gautier, *Histoire du romantisme*, Paris, 1874, pp. 371. Champfleury had already remarked "ses grands yeux rouges" in his description of the "iron mastodon" (see this chapter's note 5).

12. Ibid., p. 372.

V. THE CITY
(pp. 108-122)

1. *The Poetical Works of John Milton (Paradise Lost*, part IX, lines 445-451), Cambridge, Mass., 1899, p. 200.

2. Charles Dickens, *The Old Curiosity Shop* (London, *Oxford Illustrated Dickens*, 1951, originally published in 1841). In 1854, Herman Melville made critical remarks about London in his novel *Israel Potter, The Works of Herman Melville*, vol. XI, New York, 1963 (chapter XXII, p. 203): "[F]or solitudes befrend the endangered wild beast but crowds are the security, because the true desert, of persecuted man. Among the things of the capital, Israel for more than forty years was yet to disappear as one entering at dusk into a thick wood. Nor did even the German forest, near Tasso's enchanted one, contain in its depths more things of horror than eventually were revealed in the secret clefts, gulfs, caves and dens of London." And later (chapter XXV, p. 213): "London, adversity and the sea thrice Armageddons, which, at one and the same time, slay and secrete their victims." These writers' attitudes to the city certainly presupposes the economic (and hence social) situation of the individual. The attitude of the Impressionist painters was that of free individuals who felt they were less secure, who enjoyed a perspective of growth, ambition, and expansion.

3. "Série sur la fumée, fumée de fumeurs, pipes, cigarettes, cigares; fumée des locomotives, de hautes cheminées des fabriques, des bateaux à vapeur, écrasement des fumées sous les ponts. . . ." P.-A. Lemoisne, "Les Carnets de Degas au Cabinet des Estampes," *Gazette des Beaux-Arts,* III, 1921, p. 225.

4. Charles Baudelaire, "Peintres et aquafortistes," in *Oeuvres Complètes*, op. cit., vol. 2, p. 740.

5. Charles Baudelaire, "Salon caricatural de 1846," in *Oeuvres Complètes*, op. cit., vol. 2, p. 1338.

6. "Rosanette trébuchait dessus, était désespérée, avait envie de pleurer. Mais, tout au haut, la joie lui revint . . ."; p. 356: "Debout, l'un près de l'autre, sur quelque eminence de terrain, ils sentaient tout en humant le vent, leur entrer dans l'âme comme l'orgueil d'une vie plus libre, avec un surabondance de forces, une joie sans cause; p. 357: "Rosanette détournait la tête, en affirmant qu'ça la rendrait folle' . . . Le sérieux de la forêt les gagnait . . . ils demeuraient comme engourdis dans une ivresse tranquil"; p. 358-59: "Il lui découvrait enfin une beauté toute nouvelle, qui n'était peut-être que le reflet des choses ambiantes, à moins que leurs virtualités secrètes ne l'eussent fait s'épanouir." Gustave Flaubert, *L'Education sentimentale*, in *Oeuvres*, vol. II, Paris, Pléiade, 1952, p. 354.

7. "C'est une oeuvre essentiellement parisienne . . . une page d'histoire, un monument précieux de la vie parisienne, d'une exactitude rigoreuse." Georges Rivière, "L'Exposition des Impressionistes," in *L'Impressioniste*, No. 1, April 6, 1877, reprinted in Lionello Venturi, *Les Archives de l'Impressionisme*, Paris, 1938, p. 309.

8. "[E]ncore aimable, charmant et tel que l'oeil d'un homme jeune et heureux peut le voir. Jamais un pensée triste ne vient désoler le spectateur devant les toiles de ce peintre puissant." Ibid., p. 311.

9. *La Fille aux yeux d'or* (1834–35) was the third and final section of Balzac's *Histoire des Treize* (History of the Thirteen), the first part of his *Scènes de la vie parisienne* (Scenes of Parisian Life). It was dedicated to Delacroix.

10. "Je fus frappé, je m'en souviens, des odeurs de gaz qui annonçaient une ville où l'on vivait la nuit autant que le jour, et la pâleur des visages qui m'aurait fait croire qu'on s'y portait mal." Eugène Fromentin, *Dominique* (1863), in *Oeuvres Complètes*, op. cit., p. 459.

11. Henrik Ibsen, *A Doll's House, Ghosts, An Enemy of the People* (New York, n.d.), act 2, p. 58.

VI. The Performers
(pp. 123-143)

1. "C'est quelque chose de bien beau, en effet, que la probité dans la misère; quelque chose de si beau, que, là seulement, c'est un vertu. . . . Aussi voyez: il raille, il accuse, il insulte les passants et les curieux; et pourtant il fouille à pleins doigts le fumier sur lequel il est établi. . . . Christophe est le chiffonier de l'imagination ou plutôt selon l'imagination. Les artistes, les poëtes et les femmes plus ou moins poitrinaires ne se rêveront jamais autrement. Aussi, malgré sa supériorité incontestable, Christophe est, au moins pour eux, la personnification typique des chiffoniers. Cette élévation naturelle de Christophe lui a valu les honneurs de la peinture. On a fait son portrait, on l'a lithographié . . . On a rangé tout récemment les chiffoniers parmi les classes dangereuses de la ville de Paris. . . . Ils sont pourtant aristocrates et très-aristocrates, je vous jure." "Les Chiffoniers" by L. A. Berthaud, in *Les Français peintes par eux-mêmes, Encyclopédie Morale de dix-neuvième siècle,* vol. IV, Paris, 1841, pp. 335, 343, 344.

2. Victor Hugo, *Les Chansons des Rues et des Bois, in Oeuvres Poétiques,* vol. III, Paris, Pleiade, 1974, p. 67.

3. Charles Baudelaire, "Le Vin," no. CV in *Les Fleurs du Mal,* (1861), *Oeuvres Complètes,* op. cit., vol. I, p. 106. In 1847 a rag picker was the hero of a successful play by a popular leftist writer, Felix Pyat entitled *Le Chiffonier de Paris, Drame en cinque acts et un prologue (douze tableaux),* vastly overrated in its time. The humane, good-hearted, drunken rag picker saved an innocent girl and exposed the crimes of an old chiffonnier who had made a fortune and become a baron. This maudlin work won the applause of Hugo and Heine. As he put scraps in his bag, the rag picker cried: "Love, glory, power: into the bag! All is tatters, shreds, broken glass, old socks, rags!"

4. Monet's picture *The Coal-Dockers* was painted in Argenteuil, on the other side of the bridge that appears in his views of the popular vacation resort (see fig. 57). The painter was capable of looking in both directions in the 1870s.

5. "Quand ça y est, ça y est. Quand ça n'y est pas, on recommence. Tout le reste est de la blague." Antonin Proust, *Edouard Manet: Souvenirs,* quoted in *Manet: A Retrospective,* edited by T. A. Gronberg, New York, 1988, p. 49.

6. "Il nous met sous les yeux, dans leurs poses et leurs raccourcis de grâce, des blanchisseuses, des blanchisseuses . . . parlant leur langue et nous expliquant techniquement le cou de fer appuyé, le coup de fer circulaire, etc." Friday, February 13, 1874, Edmond and Jules de Goncourt, *Journal,* Monaco, 1956, vol. X, p. 150-51.

7. "Elle danse en mourant. Comme autour d'un roseau/D'une flûte où le vent triste de Weber joue,/Le ruban de ses pas s'entortille et se noue./Son corps s'affaisse et tombe en un geste d'oiseau./Sifflent les violons. Fraîche, du bleu de l'eau,/Silvana vient, et là, curieuse s'ébroue;/Le bonheur de revivre, et l'amour sur sa joue,/Sur ses yeux, sur ses seins, sur tout l'être nouveau . . . /Et ses pieds de satin brodent comme l'aiguille /Des dessins de plaisir. La capricante fille/Use mes pauvres yeux à le suivre peinant./D'un rien, comme toujours, cesse le beau mystère./Elle retire trop les jambes en sautant,/C'est un saut de grenouille aux mares de Cythère." P. A. Lemoisne, *Degas et son oeuvre,* vol. I, Paris, 1946, p. 211. The last line translates as "It is the leap of a frog from the ponds of Cythera." There is a variant for the final line that reads "Elle saute en grenouille et je sorts de colère." ("She leaps like a frog and I leave behind my passion.")

8. "Degas lives like a small lawyer and does not like women, for he knows that if he loved them and had sex with them often, he, intellectually diseased, would become insipid as a painter." From *The Complete Letters of Vincent Van Gogh,* Boston, 1978, vol. III, p. 509.

9. For the true popular Parisian sources of Impressionist themes, see Victor Fournel, *Ce qu'on voit dans les rues de Paris,* Paris, 1858, 1867, 2 editions.

10. In a March 1, 1665 letter to Chantelou's brother M. de Chambray, Poussin wrote his famous definition of painting, concluding "sa fin est la délectation." Anthony Blunt, ed., *Nicolas Poussin: Lettres et propos sur l'art,* Paris, 1964, p. 163.

11. P.-A. Lemoisne, op. cit., 1921, pp. 224-228.

VII. The Crowd, the Stroller,
and Perspective as Social Form
(pp. 144-152)

1. Alfred de Vigny, *Oeuvres Poétiques,* Paris, 1978, p. 180.

2. Victor Hugo, *Les Feuilles d'Automne,* in *Oeuvres Poétiques,* vol. I, Paris, Pléiade, 1964, no. XXXV, p. 787.

3. "Les Grecs avaient une expression particulière pour rendre d'un seul mot l'endroit central et important d'un pays ou d'une ville: ophtalmos. N'est-ce pas, en effet, l'oeil qui donne la vie, l'intelligence et la signification à la physionomie humaine, qui en exprime la pensée et séduit par son magnetisme lumineux. Si l'on transporte cette idée de la nature vivante à la nature morte, par une métaphore hardie, mais juste, n'y-a-t-il pas dans chaque ville un endroit qui la résume, où le mouvement et la vie aboutissent, où les traits épars de son caractère spécial

se précisent et s'accusent plus nettement, où ses sou-venirs historiques se sont solidifiés sous une forme mon-umentale, de manière à produire un ensemble frappant, unique, un oeil sur le visage de la cité? Toute grande capitale a son oeil . . . à Paris, le boulevard des Italiens . . . Paris plus parisien . . . dans cet endroit priv-ilégé que partout ailleurs." Théophile Gautier, *Voyage en Italie,* Paris, 1852, p. 338.

4. "Il ne s'agit encore que de paire à l'organe le plus avide et le plus blasé qui se soit développé chez l'homme depuis la société romaine, et dont l'exigence est devenue sans bornes, grâce aux efforts de la civilisation la plus raffinée. Cet organ, c'est l'oeil des Parisiens! . . . Cet oeil consomme des feux d'artifice de cent mille francs, des palais de deux kilomètres de longueur sur soixante pieds de hauteur en verres multicolores, des féeries à quatorze théâtres tous les soirs, des panoramas renaissants, de continuelles expositions de chefs-d'oeuvre, des mondes de douleurs et des univers de joies en promenade sur le Boulevards ou errant par les rues; des encyclopédies de guenilles au carnaval, vingt ouvrages illustrés par an, mille caricatures, dix mille vignettes, lithographies et gravures. Cet oeil lampe pour quinze mille francs de gaz tous les soirs; enfin, pour le satisfaire, la Ville de Paris dépense annuellement quelques millions en points de vue et en plantations." Honoré de Balzac, *Gaudissart II,* in *La Comédie humaine,* vol. VI, Paris, Pléiade, 1950, p. 853. *L'Illustre Gaudissart* (1834) first introduced the title character in one of Balzac's *Scènes de la vie de province* (Scenes from the Life of the Provinces). The hustling salesman reappeared in *Gaudissart II* (1844), one of the *Scenes de la vie de parisienne,* as well as in several of Balzac's other novels, such as *Histoire de la grandeur et de la décadence de César Birotteau* (1837), *Splendeurs et misères des courtisanes* (1838-47), and *Le Cousin Pons* (1846-47).

VIII. PORTRAITURE AND PHOTOGRAPHY
(pp. 153-178)

1. Portrait subjects have been beheld phenomenally, hence not scrutinized in portrait situations that included a careful study of character, but as phenomenal pres-ences like the trees and clouds. This approach was not the same as reduction to still life, as in the works of Chardin, or to mere things, for the things of the Impres-sionists were not indifferent objects, but valued aesthetic moments and essences. The portrait subjects, then, were also the fellow enjoyers, the reflecters of a sensibility like the painter's.

2. Serious portraiture has survived in our time partly as an expression of the personal interest of artists in their friends. There was banal portraiture in the eighteenth

and nineteenth centuries, but David's portraits of lower-class individuals had great strength. The diminution of portraiture was partially due to the separation of the best artists from and their loss of identification with the broader social community. Balzac was still capable of respect and even admiration for certain plebeian types, and Degas's and van Gogh's portraits show an empa-thetic breadth in their embrace of class character.

3. "Double Levelling or a Levelling Which Cancels Itself," *Søren Kierkegaard's Journals and Papers,* edited by Howard and Edna Hong, vol. 4, S-Z, #4230, Bloom-ington, 1975, p. 193,

4. At age thirty-four, 1960: National Gallery, London; at age fifty-three, 1650: National Gallery of Art, Wash-ington, D.C.

5. Although the canvas was originally designed as a flower piece alone and the portrait was added several years later, the final work exists as a coherent whole in which the anomalous position of the added figure has an expressive aptness, perhaps a result of her "sensa-tions," her passive impressibility.

6. Alexander Herzen, *My Past and Thoughts, The Memoirs of Alexander Herzen,* translated by Constance Garnett, London, 1924-7, vol. V, p. 35.

7. Charles Darwin, *The Voyage of the Beagle,* edited by Leonard Engel, New York, 1962.

8. Herbert Spencer, *The Principles of Sociology,* 3 vols., 1876-96.

9. Eugène Fromentin, *Dominique,* in *Oeuvres Complètes,* op. cit., 1984, p. 436.

IX. THE EXEMPLARY IMPRESSIONIST:
CLAUDE MONET
(pp. 179-205)

1. Gotthold Ephraim Lessing, *Laocöon: an Essay on the Limits of Painting and Poetry,* London: Walter Scott Library, n. d., chapter XVI, (originally published 1766): "In its co-existing compositions painting can only make use of a single moment in the course of an action, and must therefore choose the one which is most suggestive and which serves most clearly to explain what has pre-ceded and what follows."

2. "Il disait une fois à un jeune homme de ma connais-sance: 'Si vous n'êtes pas assez habile pour faire le cro-quis d'un homme qui se jette par la fenêtre, pendant le temps qu'il met à tomber du quatrième étage sur le sol, vous ne pourrez jamais produire de grandes machines.'" Baudelaire, "L'Oeuvre et la vie d'Eugène Delacroix," *Oeuvres Complètes,* op. cit., vol. II, pp. 763-64.

"Grandes Machines" (Grand Machines) was a common term for large-scale, dramatic Salon paintings.

3. Georges Rodenbach, *Oeuvres*, vol. II, Paris, 1923-5, pp. 136, 237-38.

X. IMPRESSIONISM AND SCIENCE
(pp. 206-229)

1. "En somme l'oeil impressioniste est dans l'évolution humaine l'oeil le plus avancé, celui qui jusqu'ici a saisi et a rendu les combinaisons de nuances les plus compliquées commues." *Melanges Postumes, Oeuvres Complètes*, vol. 3, Paris, 1902, p. 137.

2. Charles Cros and Tristan Corbière, *Oeuvres Complètes*, op. cit., p. 82.

3. Villers de L'Isle-Adam, *L'Eve future*, in *Oeuvres Complètes*, vol. I, Paris, n.d. pp. 5-6.

4. Fromentin saw blue shimmers on a black Arab horse in the desert. He also saw gold, pink, and scarlet or blood-red mounts. Fromentin, op. cit., 1984, p. 152.

5. Painters before the Impressionists knew of the molecular structure of their pigments and its role in the effects of color. But this knowledge did not suggest to them an analogous fabric of the painting as a mosaic or web of small touches. Writing in 1857 of the loss of richness and brilliance of color in the works of David and his school, with their palette of black, white, and earth colors, Delacroix explained that these artists mixed white and black to obtain a blue, and yellow and black for a green, so that when the picture was seen in shade only the molecules of those dull components reflected the subdued light; while Titian and Rubens, employing strong reds, blues, and greens, produced a far livelier play of tone. ("Il est difficile de dire quelles couleurs employaient les Titien et les Rubens pour faire ces tons de chair si brillants et restés tels, et en particulier ces demi-teintes dans lesquelles la transparence du sang sous la peau se fait sentir malgré le gris que toute demi-teinte comporte. Je suis convaincu pour ma part qu'ils ont mêlé, pour les produire, les couleurs les plus brilliants. . . . David et son école croient les retrouver avec le *noir* et le *blanc* pour faire du *bleu*, le *noir* et le *jaune* pour faire du *vert*, de *l'ocre rouge* et du *noir* pour faire du *violet*, ainsi de suite." *Journal*, November 13, 1857, vol III, p. 147.) Delacroix himself went beyond the old painterly masters in the visible flecking of brushstrokes; he also observed the interactions of neighboring tones and made use of color contrasts to produce vibrancy and brilliance. To treat the whole painting as an apparent system of small units of color did not, however, occur to him.

6. George Clemenceau, *Claude Monet: Les Nymphées*, Paris, 1928 (translated in Charles Stuckey, *Monet: A Retrospective*, New York, 1985, p. 355). George Eliot's *Middlemarch* (1870) contains a surprising reference to the botanist Robert Brown, whose work on the random motion of pollen grains suspended in water (later called "Brownian movement") is read by one of her characters, a physician.

7. Renaissance artists pursued the stable or constant features of sight, cultivating the practical knowledge achieved by the handling of objects, and the movement of the limbs in three-dimensional space, their outlines versus their apparent color. The researches of Alberti, Brunelleschi, Leonardo, and Piero della Francesca demonstrate the impressive, systematic pursuit of that type of knowledge.

8. Agnes Arber in *The Mind and the Eye, A Study of the Biologist's Standpoint* (New York, 1954) discusses the contribution of art to botany and science.

9. In 1931 von Allesch published a book on the German Renaissance artist Michael Pacher.

10. The approach to color of German physiologist and psychologist Ewald Hering, a leading investigator of the 1870s, is interesting as a contemporary parallel to Impressionism. Hering's conception of color was phenomenological, i.e., based on close attention to colors without regard to the objects to which they belonged. His result disagreed in important respects with the beliefs and practices of the Impressionists, which were based on the older scientific classification of colors. Hering included black as a "primary" color, seen, like the chromatic ones, in an illuminated field. He built on that datum a theory of the physiological process of color mixture, while the Impressionists removed black from their palettes, supposing that it was the absence or negation of color. For Hering the primaries, from which all other colors were produced by mixture, were the paired hues: black-white, yellow-blue, red-green. He refused to call colors "sensations" since they were not perceived in or on one's body locally, as were sounds, smells, and tastes, but were seen, not sensed, outside of our eyes; and he denied that there were pure visual sensations without spatial properties. See Ewald Hering, *Outlines of a Theory of the Light Sense*, Cambridge, Mass., 1964.

Also interesting as the reaction of a contemporary scientist to Impressionism was the enthusiastic pamphlet *Science and Philosophy in Art* published by an organic chemist, Helen Abbott Michaels, under the pseudonym Celen Sabbrin (Philadelphia, 1886). Reviewing a show of the Impressionists in New York in the spring of 1886, she wrote of the works of the school

as an illustration of art as one of the highest forms of scientific and philosophical expression. Monet in particular she designated "a genius . . . a master-thinker, who feels the power of the infinite and can reflect it to others. None in art before him has ever approached so near the domain of the philosopher. The inflexible principles of geometry give form to his charming color harmonies." Michaels discovered in the works of the school an underlying basic principle of "triangulation": attention was directed to the hypotenuse as a framework and guide of pictorial composition; lights and darks were always set with reference to a diagonal axis. Yet with this "oblique parallelism," she noted that "in these color idylls, drawing is scarcely present . . . motion is suggested by every stroke of the knife." In pointing to dissymmetry as a principle of Impressionist painting, she cited Pasteur's works on molecular dissymmetry; it was the "basis of organic life, and of the universe, for the cosmic forces are dissymmetrical." Symmetry was equalized force, dissymmetry "unequalized." Michaels concluded with judgments of the moral implications of the paintings and particularly of their dangerous inducement of reverie and dream (see *Who's Who in American Society, Yearbook,* 1904-5).

11. Aristotle, *Meterologica,* translated by H. D. P. Lee, Book III, chapter IV, Cambridge, Mass., 1952, pp. 263-65.

12. "[T]he repeated hallelujah of yellow," *La Cathédral,* Paris, 1937, chapter VI, p. 130 ("l'alléluia répété des jaunes").

13. For a similar awareness of the transitory with a comparable admonition on avoiding it, see William Gilpin, *Remarks on Forest Scenery and other Woodland Views Relative chiefly to Picturesque Beauty, illustrated by The Scenes of New Forest in Hampshire,* two vols., London, 1791, vol. I, Section IX, pp. 236-39: "Sometimes also a good effect arises, when the sky, under the influence of a bleak north-wind, cold and overcast, is hung with blue, or purple clouds lowering over the horizon. If under that part of the atmosphere the distant forest happens to range, it is overspread with a deep blue, or a purple tint from the reflection of the clouds, and makes a very picturesque appearance.—And yet I should be cautious in advising the painter to introduce it with that full strength, in which he may sometimes observe it. The appearance of *blue* and *purple trees,* unless in very remote distance, offends: and tho the artist may have authority from nature for his practice; yet the spectator, who is not versed in such effects, may be displeased. Painting, like poetry, is intended to excite pleasure: and tho the painter, with this view, should avoid such images, as are trite, and vulgar; yet he should seize those only, which are easy, and intelligible. Neither

poetry, nor painting is a proper vehicle for the depths of learning. The painter therefore will do well to avoid every *uncommon appearance* in nature.

"Within this caution however he will spread the prevailing tint of the day over his landscape—over his *whole* landscape. Nature tinges all *her* pictures in this harmonious manner. It is the greyish tint; or it is the blue; or it is the purple; or it is one of the vivid tints of illumination, red, or yellow—whatever it be, it blends with *all* the lights and shadows of the piece. This great principle of harmony, which arises from the reflection of colour, (in some degree, even when the air is diaphanous,) must be observed by every painter, who wishes to procure an effect. His picture must be painted from *one pallet:* and one key, as in music, must prevail through his whole composition. As the air however is the vehicle of all these tints, it is evident that in distances (in which we see through a deeper medium of tinged air) they will prevail most; and of course very little on foregrounds. The painter must observe this rule of nature by bringing his tints regularly forward; and his foregrounds he must compose of such colour (mute, or vivid) as accord best with the general hue of his landscape. Yet still he will be cautious how he spreads even the prevailing tint too strongly. Much error hath arisen from this source; and some painters under the idea of harmonizing, have given us blue, and purple pictures. I know not whether Poussin himself did not sometimes fall into this fault. Nature's veil is always pure, and transparent; yet, tho in itself hardly discoverable, it will still give its kindred tinge to the features, which are seen through it."

14. See Josef Albers, *The Interaction of Color,* New Haven, 1963, and James P. C. Southall, *Helmhotz's Treatise on Physiological Optics,* 3 vols., New York, 1962.

15. See Eugène Fromentin, *Un Eté dans le Sahara,* Paris, op. cit., pp. 162: "Ici, le soleil de midi consterne, écrase, mortifie . . ."

16. Edmond Duranty spoke of decolorizing as a great discovery of the Impressionists. See *La Nouvelle Peinture,* preface and notes by Marcel Guerin, Paris, 1939, p. 39: "La découverte de ceux-ci [the Impressionists] consiste proprement à avoir reconnu que la grande lumière décolore les tons, que le soleil reflété par les objets tend, à force de clarté à les ramener à cette unité lumineuse qui fond ses sept rayons prismatiques en un seul éclat incolore, qui est la lumière."

17. Gerald H. Thayer, *Concealing-Coloration in the Animal Kingdom,* New York, 1909, p. 3. Abbott Thayer's *Peacock in the Woods* is the frontispiece. As the preface to the second edition (1919) explains, the

painter's ideas inspired military camouflaging in World War I.

18. See Walter Bagehot on the newspaper and the city, in "Physics and Politics" in *The Collected Works of Walter Bagehot,* vol. 7, edited by Norman St John Stevas (originally published 1867-72), London, 1974, pp. 34-7, 68.

19. See *Matter and Motion* (1876) by James Clerk Maxwell, the great Scottish physicist, on the dynamics of society as a model of atomic dynamics and statistical approach.

20. The concept of entropy was known in 1824 to Sadi Carnot, the founder of modern thermodynamics and was developed from the late 1840s by Rudolf Clausius and William Thomson Kelvin.

21. "Tout est mouvement. La pensée est un mouvement. La nature est établie sur le mouvement. La mort est un mouvement dont les fins nous sont peu connues. Si Dieu est éternel, croyez qu'il est toujours en mouvement? Dieu est le mouvement, peut-être. Voilà pourquoi le mouvement est inexplicable comme lui; comme lui profond, sans bornes, incompréhensible, intangible. Qui jamais a touché, compris, mesuré le mouvement? Nous en sentons les effets sans les voir. Nous pouvons même le nier comme nous nions Dieu. Où est-il? Où n'est-il pas? D'où part-il? Où en est le principe? Où en est la fin? Il nous enveloppe, nous presse et nous échappe. Il est évident comme un fait, obscur comme une abstraction, tout à la fois effet et cause. Il lui faut comme à nous l'espace, et qu'est-ce que l'espace? Le mouvement seul nous révèle; sans le mouvement, il n'est plus qu'un mot vide de sens." Honoré de Balzac, *Peau de Chagrin,* in *La Comédie Humaine, Etudes Philosophiques,* I, Paris, Pléiade, 1950, p. 198

22. Marx, however, thought the concept of society as an aggregate of self-interested atoms was a fiction, an ideology (but cf. *Kapital* III, 1964 [English], on chance single events and the law in the whole). The members of bourgeois society, he wrote, were not atoms. The atom has no needs; it is self-sufficient, and the world outside it is a void. Contrary to the view that the state is necessary in order to hold the individual self-interested atoms together, it was the state that was held together by bourgeois life. See *Die Heilige Familie,* 1932, ed., I, 383 (ed. S. Landshut and J. P. Mayer). Hegel had remarked in his lectures on the philosophy of history (1822-1831) that colonial North America was "a community arising from the aggregation of individuals as atomic constituents" (*The Philosophy of History,* trans. John Sibree [1857], 1890, p. 88). Democracy, in contrast to feudal and aristocratic social forms was often characterized then as a society of atoms (cf. Mrs. Frances Trollope, *Domestic*

Manners of the Americans, New York, 1904, pp. 284-85, originally published 1832). The notion of the individual in bourgeois society as an atom existed already in the eighteenth century before the French revolution. An example is Tobias Smollett's political satire *The Adventures of an Atom,* published in 1769. Later the social concept of the inherent solitude of the individual in society and of society as a chaos of atoms was a common one. Dickens wrote on the solitude and indifference of people in the streets: "They were but an atom here, in a mountain-heap of misery" (*The old Curiosity Shop, The Oxford Illustrated Dickens,* London, 1951, chap. XLIV, p. 327, first published 1840). Flaubert in a letter of December 1866 spoke of the self as an atom. The model of statistical mechanics (the dynamical theory of heat and kinetic gas) perhaps served Tolstoy as a model of the creation of collective action in history. Several times in the theoretical pages of *War and Peace* he used mechanical analogies as similes in describing human behavior and thought. In the 1880s, Nietzsche wrote: "We are living in a period of atoms, of atomistic chaos" (*Unzeitgemässe Betrachtungen* [Unfashionable Opinions], III, p. 313).

23 Guy de Maupassant, "La vie d'un paysagiste," *Gil Blas,* September 28, 1886, vol. 6, p. 85.

24. In studying these pictures many years ago, I proposed in a lecture that if Seurat's name were not known he might well be called "The Master of the Eiffel Tower" on account of his shapes. Sometime after this suggestion, a previously unknown painting of the Eiffel Tower by Seurat appeared on exhibition.

25. James Abbot McNeill Whistler, "The Action," in *The Gentle Art of Making Enemies,* London, 1892, p. 5.

26. Sir Arthur Eddington wrote: "The artist desires to convey significances which cannot be told by microscopic detail and accordingly he resorts to impressionist painting. Strangely enough the physicist has found the same necessity; but his impressionist scheme is just as much exact science and even more practical in its application than his microscopic scheme." ("Becoming," in *The Nature of the Physical World,* Ann Arbor, 1958, chap. V, p. 103.)

27. There are still other essential differences. The great importance of atomism at the beginning of modern chemistry lay in the discovery that different substances combine in fixed proportions and that all specimens of an element or compound have a constant weight per unit of volume. This discovery gave to chemistry and to molecular and atomic physicists the prospect of finding mathematically exact laws. The concept of atoms existed in antiquity and issued from an acute reflection on phenomena—Democritus explained different qualities

and physical properties by variations in the size and shape of atoms—but classical atomism was wholly qualitative, even in referring to the size and shape of particles, and permitted little or no practical deduction. One observed that sugar and salt dissolved in water, and that different substances could be mixed to form new homogeneous substances, and one inferred from these observations that substances must consist of minute invisible particles. But the ancient atomists had no approach to the distinctive physical properties of these particles beyond some broad speculations as to their constancy (cf. Democritus on sensory qualities as illusory; cf. Swedenborg on molecules as small replicas of molar bodies; cf. Delacroix in his *Journal*: "The particles remained tiny specimens of certain primary qualities of their molar aggregates.") In Impressionism we see little if anything of the spirit of the new scientific atomism, which was experimental but also mathematical, quantitative, theoretical, and deductive. The Impressionists used their brushstroke units freely, varying their size, direction, and color, according to the requirements of a pictorial whole that tends to be vague and loose in effect, while unified through the affinities and contrasts of color and texture. If the rise of modern atomic theory around 1800 was accompanied in art by Neo-Classicism as a style of distinct and regular forms and perfect clarity of elements, Impressionist atomism was at the opposite pole of these appealing intellectual qualities.

28. See George M. Fleck, "Atomism in Late Nineteenth-Century Physical Chemistry" *Journal of the History of Ideas*, vol XXIV. no. 1, Jan-March, 1963, pp. 106-14.

XI. IMPRESSIONISM IN HISTORY
(pp. 230-267)

1. Names most frequently identified with Impressionism in the 1870s as an original art movement include Monet, Renoir, Pissarro, Sisley, Morisot, Manet, Caille-botte, Degas, Bazille, Guillaumin, Cézanne, and Mary Cassatt. Gauguin and van Gogh were certainly Impressionists for a time (see the Conclusion), and lesser-known artists like Eva Gonzalés also clearly reflect the style.

2. In defending the Impressionists in 1877 on the occasion of their third exhibition, their young friend Georges Rivière wrote that no one before them had realized so fully the qualities of contemporary Parisian life. Their paintings were for him truthful documents of modernity as well as artistic achievements. Explanation of their nature must, he argued, be sought in their own time and place.

3. Before Impressionism, artists had spoken of the eye

with wonder and had no doubt longed for a more immediate and complete rendering of the visual. But what they had in mind was a truth to a perception of shapes and colors as set by the practice of their time, a practice that could be modified only if perfected for its own verisitic goal. When, in his 1772 play *Emilia Galotti* (act 1, scene 4), the German writer Gotthold Lessing had his portrait painter say: "Alas! that we cannot paint directly with our eyes! On the long journey from the eye through the arm to the pencil, how much is lost!," he was not conceiving an Impressionist ideal of drawing, even if his notion of an art proceeding as if by a direct reflex from the eye, without the struggle of realization through a laborious, many-staged technique points to a latent impressionistic style. How far Lessing's painter was from such a style appears clearly enough from another remark he made: "Or do you hold, Prince, that Raphael would not have been the greatest of all artists even had he been born unfortunately without hands?" (*Lessings Werke*, Salzburg, 1953, p. 369.) This text gave to the fine critic Julius Meier-Graefe the title "Raphael without Hands" for a chapter in his book on Renoir, which described the old arthritic artist painting with brushes strapped to his wrists and dictating with a similarly attached pointing stick the details of a sculpture to his assistant.

The conception of a direct passage from the eye to the hand, without intervention of thought or memory, perhaps underlies the idea of the biologist Max Verworn (*Zur Psychologie der primitiven Kunst*, Jena, 1907, 2d ed. 1917; *Die Antaugider Kunst*, Jena, 1909; and *Die plastische Kunst*, Jena, 1914) that the art of the cave painters, with their astonishing representations of animals in movement, was a kind of reflex of perception, what he called a "physioplastic" art, in contrast to the analytic and conceptual dimensions in the renderings of later artists, which he termed "ideoplastic." Verworn's idea failed to recognize in that prehistoric work the typical elements of "conceptual" form: the discreteness of parts, the generalized postures, the body in profile yet with hooves and horns turned as if seen from the front. A subsequent attempt of F. Adama van Scheltema, *Die altnordische Kunst*, 1923, to support Verworn's notion with the comparitive example of drawings by a feeble-minded woman, is likewise unconvincing.

4. Such cycles feature in the writings and thought of the Italian philosopher Giambattista Vico, the German classical archaeologist and historian Johann Winckelmann, the German poet/critic/philosopher Johann Herder, the German philosopher Friedrich von Schelling, and the German writer Ludolf Wienbarg.

5. Such poles were discussed by a friend of the Impresssionists, the Italian painter and critic Diego

Martelli, writing in 1879 (*Scritti d'arte di Diego Martelli*, ed. A. Boschetti, 1952).

6. Heinrich Wöfflin was fascinated by art's *Entwicklungen* ("development," "evolution"), a subject that his followers like van Scheltema, and Paul Frankl continued to pursue.

7. Joris-Karl Huysmans in *À Rebours*, chap. 14, Paris, 1977, pp. 309-11 (originally published in 1884), already called the refined style of the Goncourts as reminiscent of "decrepit civilizations," likening it to that of the late Roman poets: Ausonius, Claudian, and Rutilius Namatianus.

8. See also Nietzsche's 1884-85 letter to pianist/organist and writer on music Carl Fuchs about the decadence of Wagner and modern music: "Ambiguity in rhythm, the effect of which is that one does not know and *should* not know whether something is this way or that way round . . . remains a sign of dissolution . . . this is décadence." *Selected Letters of Friedrich Nietzsche*, edited and translated by Christopher Middleton, Chicago, 1969, p. 233.

9. Johann Winckelmann, *Geschichte der Kunst der Alterthums*, Dresden, 1764.

10. Franz Wickhoff, *Die Wiener Genesis*, Vienna, 1895, trans. Mrs. Authur Strong as *Roman Art*, New York, 1900.

11. The absence of clouds in Roman painting and their frequency in early Christian and medieval painting are noteworthy in showing how an extra-aesthetic interest in particulars of nature determines their representation. Elements regarded today as inherent in a naturalistic style of art may be missing in an art that took that approach yet present in an art with an essentially spiritualistic, non-naturalistic outlook. Sometimes in classical art clouds were represented, but only as distinctly outlined objects in a sky of more or less uniform color, in pagan images of Olympus and of other subjects that included figures located in the sky.

12. Note Flaubert's description of Breton churches and the intimacy and harmony of life they suggest in *Par les champs et par les grèves,* op. cit., p. 136: "Un charme singulier transpire de ces pauvres églises. N'est-ce pas plutôt leur pudeur qui ravit? . . . Ces églises ont donc un sens harmonique. . . ."

13. Cassiodorus, *Senatoris Variae*, book 9, p. 6; book 12, pp. 22, 24, 25. Berlin, 1961, pp. 272-73, 278-82.

14. Lucretius, *On the Nature of Things* (*De Rerum Natura*), translated by Cyril Bailey (Oxford, 1910), book 4, p. 155.

15. Ausonius, "Mosella" (The Moselle), Book X, in *Ausonius,* London, vol. I, 1919, pp. 238-241. The original text reads: "Illa fruenda palam species, cum glaucus opaco respondet colli fluvius, frondere videntur fluminei latices et palmite consitus amnis. Quis color ille vadis, seras cum propulit umbras Hesperus et viridi perfumdit monte Mosellam."

16. A major difference between French nineteenth-century and Roman artists was the latter's lack of independence as a class, which limited their readiness to explore the possibilities of their art. Also after c. A.D. 150, there was a general decline of the empire and the resources for art. Yet in architecture, there was a continuing advance in inventiveness and originality between A.D. 200 and 500.

17. Prudentius, *Contra orationem Symmachi,* book 1, line 317 (Loeb Library, vol. 1, p. 375): "emicat ac volucri fervens rota volvitur axe."

18. In Roman painting, the typical subjects remained bound, directly or indirectly, to religion and tradition. In picturing a landscape environment, they possess an air of fantasy, a suggestion of idyll and myth. Other themes stayed small and marginal.

19. Although there are Greek and Roman texts that speak of the convergence of lines to a single point in the visual field and the diminution of the apparent size of an object with increasing distance from the eye, among the thousands of classical paintings that have survived no example has a strict perspective viewpoint or even a close empirical approximation of one. The argument that the surviving works are by lesser artists or copyists and therefore not truly examples of the highest skills and knowledge of the great classical painters is hardly convincing. For if only the works of the minor painters of the Renaissance and copies of the great originals remained, we could still recognize without difficulty that the artists were aware of the principles of central perspective, however imperfectly they might have applied the rules. See Alois Riegl and Gisela Richter on classical perspective, and the authors who maintain an opposite view, such as John White (*The Birth and Re-Birth of Pictorial Space,* London, 1957).

20. Ezek. 1:13–14.

21. *The Romance of the Rose,* by W. Lorris and J. Clopinel, englished by F.S. Ellis, vol. 3, London, 1900, verses 18,794-98. Guillaume de Lorris is supposed to have written the first 4,000 lines of the famous poem in the first half of the thirteenth century, and the remaining 18,000 to have been finished by Jean de Meung, c. 1275-80.

22. ". . . Mr. Whistler . . . spoke of the artistic value of

dim dawns and dusks, when the mean facts of life are lost in exquisite and evanescent effects, when common things are touched with mystery and transfigured with beauty; when the warehouses become as palaces, and the tall chimneys of the factories seem like campaniles in the silver air." Oscar Wilde, "Mr. Whistler's Ten O'Clock," *Pall Mall Gazette*, XLI: 6224, February 21, 1885, pp. 1-2; reprinted in *The Artist as Critic: Critical Writings of Oscar Wilde*, edited by Richard Ellmann, New York, 1969, pp. 14-15.

23. Roger des Piles, *Receuil de divers ouvrages sur la peinture et le coloris*, Paris, 1755, p. 225.

24. 2 Kings 3: 22.

25. The colors of Stendhal's title are, of course, symbolic, representing alternative professions, the black of the church and the red of the Napoleonic armies, that might allow the ambitious young carpenter's son Julen Sorel the two best chances for social advancement.

26. See earlier references to Valenciennes and Gilpin in Chapter 10, note 13. On Valenciennes, see Philip Conisbee, *In the Light of Italy: Corot and Early Open-Air Painting*, New Haven, 1996.

27. "The Garden," stanza 6, line 48, Andrew Marvell, *The Complete English Poems*, Aylesbury, Bucks, 1974, p. 101. The "green shade" echoes Virgil's *Eclogues*, IX, 23: "viridi fontis induceret umbra."

28. See the written observations of Lucretius and Seneca.

29. The difference in artistic styles is reflected in opposing views of Western and Eastern pantheism, with the latter remaining a collection of different objects, not a plenum. The separate approaches also carry over into science. Regarding concepts of the void and plenum in Chinese science, see Joseph Needham, *Science and Civilization in China*, Cambridge, England, 1954.

30. See note 7 in this chapter. See also the observations of Leibnitz and Leonardo da Vinci, who saw a moving luminous point appear as a continuous line of light and a rapidly rotating *tizzone* (firebrand) as a circle of flame.

31. Constable's milieu was not the city; he had no sustaining concept of modernity. As a kind of country gentleman, albeit a far from rich one, he lacked substantial examples of the rising bougeoisie and their new life.

32. On England's failure to develop after Constable, see Prosper Mérimée, who condemned both Turner's art and that of the Pre-Raphaelites in his essay "Les Beaux-Arts en Angleterre," *Revue des Deux Mondes*, October 15, 1852, reprinted in *Etudes Anglo-Americaines*, Paris, 1930, p. 157-184.

33. See the remarks of William Hazlitt on the inadequacy of British art patronage in "On the Catalogue Raisonné of the British Institution," *The Examiner*, November 10, 1816. Reprinted in *The Complete Works of William Hazlitt*, London, 1930, vol. 4, pp. 140-45.

34. In his diary entry of Wednesday, August 9, 1891, Edmond de Goncourt wrote ecstatically of a Turner painting he had just seen at a friend's house that depicted Venice as "une apothéose, couleur de pierres précieuses!" (an apotheosis the color of precious stones). De Goncourt further described Turner as "un Rembrandt né dans l'Inde" (a Rembrandt born in India) and aligned him with the great tradition of Rembrandt, Rubens, Velasquez, and Tintoretto. (*Journal*, op. cit., vol. XVIII, p. 69).

35. "Quant au Turner, lui aussi vous stupéfie, au premier abord. On se trouve en face d'un brouillis absolu de rose et de terre de sienne brûlée, de bleu et de blanc, frottés avec un chiffon, tantôt en filant en droite ligne ou en bifurquant en de longs zigzags. On dirait d'une estampe balayée avec de la mie de pain ou d'un amas de couleurs tendres étendues à l'eau dans un feuille de papier qu'on referme, puis qu'on rabote, à tour de bras, avec une brosse; cela sème des jeux de nuances étonnantes, surtout si l'on éparpille, avant de refermer la feuille, quelques points de blanc de gouache.

"... à distance ... tout s'équilibre. Devant les yeux dissuadés, surgit un merveilleux paysage, un site féerique, un fleuve irradié coulant sous un soleil dont les rayons s'irisent ... une eau qui chatoie, comme savonneuse avec la couleur du spectre coloré des bulles ... ce sont les fêtes célestes et fluviales d'une nature sublimée, decortiquée, rendue completement fluide, par un grand poète." J-K Huysmans, *Certains*, Paris, 1889, pp. 201-2.

36. According to C. R. Leslie, Constable's friend and fellow painter, the decline in English art would come because of public indifference. See *Memoirs of the Life of John Constable*, London, 2nd ed., 1845.

37. See Prosper Mérimée's discussion of the Pre-Raphaelite painter Holman Hunt, op. cit., pp. 163-65.

38. Max Levy's *Der Sabbat in England* (Leipzig, 1933) contains several interesting observations. For example, from pp. 273–75, on the "Promenade": In London in 1781 was founded a "Promenade," a large, enclosed place for music, refreshments, and general conviviality. Entry was three shillings. It was patronized on Sunday by the non-religious. This and other places of Sunday amusement were condemned by an act of Parliament soon after, together with the new societies for debating religious or theological questions. From p. 278: The French Revolution frightened England and strengthened Puritanical religion and Sunday observance there. From

p. 279: During the nineteenth century, and with the industrial revolution and the intensification of factory labor, one looked more often for social hygenic than for religious justification of Sunday rest. A six-day work-week was more productive than a seven-day week. Levy cites Thomas Macaulay, who, in his *Speeches* (1854, p. 449ff), said that without the Sunday observance the English people would be much poorer. Gladstone asserted that the English character owed almost everything to the English Sunday and the English Bible.

From p. 280: Social reformers demanded the opening of museums and parks on Sundays and a culture of travel to the countryside, with cheaper Sunday fares. In the mid-nineteenth century, a national Sunday league was founded. In 1865 a half-holiday on Saturday was instituted, with a gradual overcoming of Sunday restrictions. From pp. 283–84: Legal restrictions on Sunday recreation and amusements (the law of 1781) continued until well into the twentieth century in England. The weekend in the country was still a middle- and upper-class practice as late as 1932 (unlike in France and Germany). The increase of free time after the disappearance of religious observance of Sunday left a great void, which might become a problem in the future.

39. See the observations of Harriet Beecher Stowe on the French Sunday, and of Friedrich Nietzsche on Sunday and work.

40. Consider the role of professional baseball and the World Series in creating an American ethos of community, in contrast to the role of the bullfight in aristocratic Spain (though the matador often came from a peasant or artisan family). Organized festivities in earlier periods usually related to royalty and the church, later to municipal commercialized events like the circus, which allowed individual freedom of movement.

41. Especially psychophysics, that branch of psychology that studies the response to physical stimuli.

42. "Le 2 décembre m'a physiquement dépolitiqué. . . . Si j'avais voté, je n'aurais pu voter que pour moi." Letter of March 5, 1852, to Narcisse Acelle. Charles Baudelaire, *Correspondance,* vol. I, January 1832-February 1860, Paris, Pléiade, 1973, p. 188.

43. Charles Baudelaire, "VII. Le Paysage," in *Salon de 1859,* op. cit., vol. II, p. 665.

44. Flaubert, Baudelaire, Nietzsche, Arnold, and Renan, to name only a few.

45. In 1866, Bazille posed for several different figures in Monet's *Le Dejeuner sur l'herbe* (see fig. 80), and the seated man with a beard has speculatively been identified as Courbet.

46. Ernest Meissonier, *Amateur de tableaux chez un peintre* (Collector in a Painter's Studio), 1860, Musée d'Art et d'Histoire, Lille. The vaguely indicated paintings on the wall are actually contemporary works by Meissonier himself.

XII. IMPRESSIONISM AND LITERATURE
(pp. 268-298)

1. In both periods cited, the literature has been generally perceived as more profound and innovative than the visual art. See the following note, on Russian nineteenth-century art and literature.

2. Few foreign readers of Tolstoy, Dostoevsky, or Turgenev can name a single Russian painter of the same period. Although they did seek to render visual perceptions, the Russian writers pursued comprehensive values, touching on social and moral life.

3. Flaubert later traveled with Du Camp to Egypt. For a colorful, seamless account of their trip, see Francis Steegmuller, *Flaubert in Egypt,* New York, 1972. Du Camp's own later version of their journey to Brittany, and Flaubert's eccentric behavior during it, is contained in his *Souvenirs Littéraires* (1882-83), Paris, 1984, pp. 58-67.

4. "Nous commençâmes par un sentier dans les herbes; il suivait le haut de la falaise, montait sur ses pointes, descendait dans ses vallons et se continuait dessus en faisant le tour de l'île.

"Quand un éboulement l'avait coupé, nous remontions plus loin dans la campagne et, nous réglant sur l'horizon de la mer, dont la barre bleue touchait le ciel, nous regagnions ensuite le haute de la crête que nous retrouvions à l'improviste ouvrant son abîme à nos côtés. La pente à pic sur le sommet de laquelle nous marchions ne nous laissait rien voir du flanc des rochers; nous entendions seulement au-dessous de nous le grand bruit battant de la mer.

"Quelquefois la roche s'ouvrait dans toute sa grandeur, montrait subitement ses deux pans presque droits que rayaient des couches de silex et où avaient poussé de petits bouquets jaunes. Si on jetait une pierre, elle semblait quelque temps suspendue, puis se heurtait aux parois, déboulait en ricochant, se brisait en éclats, faisait rouler de la terre, entraînait des cailloux, finissait sa course en s'enfouissant dans les graviers; et on entendait crier les cormorans qui s'envolaient. . . .

"La marée baissait, mais il fallait, pour passer, attendre le retrait des vagues. Nous les regardions venir. Elles écumaient dans les roches, à fleur d'eau, tourbillonnaient dans des creux, sautaient comme des écharpes qui s'envolent, retombaient en cascades et en perles, et dans un long balancement ramenaient à elles leur

grande nappe verte. Quand une vague s'était retirée sur le sable, aussitôt les courants s'entre-croisaient en fuyant vers des niveaux plus bas. Les varechs remuaient leurs lanières gluantes, l'eau débordait des petits cailloux, sortait par les fentes des pierres, faisait mille clapotements, mille jets. Le sable trempé buvait son onde, et se séchant au soleil, blanchissait sa teinte jaune.

"Dès qu'il y avait de la place pour nos pieds, sautant par-dessus les roches, nous continuions devant nous. Elles augmentèrent bientôt leur amoncellement désordonné; tournées, bousculées, entassées dans tous les sens, renversées l'une sur l'autre. Nous nous cramponnions de nos mains qui glissaient, de nos pieds qui se crispaient en vain sur leurs aspérités visqueuses.

"La falaise était haute, si haute qu'on en avait presque peur quand on levait la tête. Elle nous écrasait de sa placidité formidable et elle nous charmait pourtant; car on la contemplait malgré soi et les yeux ne s'en lassaient pas. . . .

"De place en place immobiles comme leur fond verdâtre, s'étendaient de grandes flaques d'eau qui étaient aussi limpides, aussi tranquilles . . . D'un côté c'était la mer dont les flots sautaient dans les basses roches, de l'autre, la côté droite, ardue, infranchissable.

"Fatigués, étourdis, nous cherchions une issue. Mais toujours la falaise s'avançait devant nous, et les rochers, étendant à l'infini leurs sombres masses de varechs, faisaient succéder l'une à l'autre leurs têtes inégales qui grandissaient en se multipliant comme les fantômes noir sortant de dessous terre." Flaubert, *Par les champs et par les grèves,* op. cit., pp. 97-99. Translation *Over Strand and Field,* op. cit., pp. 42-44.

5. Baudelaire's Spleen poems, published in 1857 in *Les Fleurs du mal,* anticipate Impressionist effects and motifs in much the same way as do certain writings of Flaubert.

6. Especially in the novel's second chapter, where the life history of Renée's father, Charles-Louis, is rapidly sketched in.

7. Among the English writers of her time, George Eliot was perhaps the one most keenly aware of the "new" in both intellectual life and social behavior. In picturing an office in *Middlemarch* (1871-72), she described the businessmen of 1830 in unconventional postures, with hands in pockets, lounging, reading the newspaper, and conversing casually, much as Degas represented them in *Portraits in an Office—The Cotton Exchange* (1873, fig. 77).

8. "La campagne, le faubourg et la banlieue se mêlaient sur les deux rives . . ." *Renée Mauperin,* Paris, p. 14.

9. Henry James, *Daisy Miller, Pandora, The Patagonia, and other tales,* New York, 1937, pp. 3-5.

10. Taine described Dickens as a *painter*-novelist in his *History of English Literature.*

11. See my essay "Courbet and Popular Imagery," first published in 1941, reprinted in *Modern Art:19th & 20th Centuries,* New York, 1982, pp. 47-85.

12. Hamburg, Kunsthalle, no. 56 in *Ernest Meissonier: Retrospective,* Lyon, 1993, pp. 132-33.

13. Charles Cros, "Le Fleuve," in *Oeuvres Complètes,* op. cit., pp. 74-79. Later science would explore the relativistic conception of location, velocities, and distances.

14. "[J]e n'ai jamais vu le soleil faire d'une coupole blanche une plus étonnante merveille de couleur. Est-elle blanche?—Oui, blanche à aveugler! et pourtant la lumière se décompose si étrangement sur ce gros oeuf, qu'on y distingue une féerie de nuances mystérieuses qui semblent évoquées plutôt, qu'apparues, illusoires plus que réelles, et si fines, si délicates, si noyées dans ce blanc de neige qu'elles ne s'y montrent pas tout de suite, mais après l'éblouissement et la surprise du premier regard. Alors on n'aperçoit plus qu'elles, si nombreuses, si diverses, si puissantes et presque invisibles pourtant! Plus on regarde, plus elles s'accentuent. Des ondes d'or coulent sur ces contours, secrètement éteintes dans un bain lilas léger comme une buée, que traversent par place des traînées bleuâtres. L'ombre immobile d'une branche est peut-être grise, peut-être verte, peut-être jaune? Je ne sais pas. Sous l'abri de la corniche, le mur, plus bas, me semble violet: et je devine que l'air est mauve autour de ce dôme aveuglant qui paraît à présent presque rose, oui, presque rose, quand on le contemple trop, quand la fatigue de son rayonnement mêle tous ces tons si fins et si clairs qu'ils affolent les yeux. Et l'ombre, l'ombre de cette koubba sur ce sol de quelle nuance est-elle? Qui pourra le savoir, le montrer, le peindre? Pendant combien d'années faudra-t-il tremper nos yeux et notre pensée dans ces colorations insaisissibles, si nouvelles pour nos organes instruits à voir l'atmosphère de l'Europe ses effets et ses reflets avant de comprendre celles-ci, de les distinguer et de les exprimer jusqu'à donner à ceux qui regarderont les toiles où elles seront fixées par un pinceau d'artiste la complète émotion de la vérité?" Guy de Maupassant, *Au Soleil, Sur l'Eau, La vie errante,* in *Oeuvres Complètes,* Paris, 1969, pp. 480-81.

15. "Le gris, voici l'avènement et le triomphe du gris. Tout est gris, depuis le gris froid des murailles, jusqu'aux gris puissants et chauds des terrains et de végétations brûlées." Algiers, October 4, 1847, *Correspondence d'Eugène Fromentin,* op. cit. vol. I, p. 595; "Le ton local est gris, d'un gris sourd que la vive lumière du matin parvenait à peine à dorer." Eugène Fromentin,

Un Eté dans le Sahara, in *Oeuvres Complètes*, op. cit., p. 157.

16. Ibid, pp. 129-30.

17. Henry James, *The Bostonians* (first published in 1886), reprinted chapter 20, Modern Library, p. 178.

18. If it is possible to speak of a "thoroughly Impressionist" work.

19. In 1883, the newly built Brooklyn Bridge was described by an American critic, Montgomery Schuyler, in similar terms: he was charmed by the tracery of the cables breaking up the view of the city seen through them ("The Brooklyn Bridge as a Monument," *American Architecture Studies*, New York, 1892, pp. 68-85). The Impressionists admired modern metal and glass construction, with its new forms featuring openness, space, and light.

20. "Le grand malheur, c'est que pas un artiste de ce groupe n'a réalisé puissamment et définitivement la formule nouvelle qu'ils apportent tous, éparse dans leurs oeuvres." *Le Voltaire*, June 18-22, 1880, reprinted in Emile Zola, *Mon Salon, Manet, écrits sur l'art*, Paris, 1970, p. 337.

21. "Paul Cézanne . . . grand peintre avorti," in "Peinture," *Le Figaro*, May 2, 1896, reprinted in Zola, ibid, pp. 372-75.

22. "Cette soirée était pesante. Plus le soleil se cachait derrière les arbres et sous le nuage lourd et bleu en se couchant, plus il lançait des rayons obliques et coupés sur les bonnets rouges et les chapeaux noirs: lueurs tristes qui donnaient à cette foule agitée l'aspect d'une mer sombre tachetée par des flaques de sang. Les voix confuses n'arrivaient plus à l'hauteur de mes fenêtres les plus voisines du toit que comme la voix des vagues de l'Océan, et le roulement lointain du tonnerre ajoutati à cette sombre illusion."

"J'étais tout entier hors de ma fenêtre, enivré, étourdi par la grandeur du spectacle. Je ne respirais pas. J'avais toute l'âme et toute la vie dans les yeux."

"Dans l'exaltation où m'élevait cette grande vue, il me semblait que le ciel et la terre y étaient acteurs. De temps à autre venait du nuage un petit éclair, comme un signal. La face noire des Tuileries devenait rouge et sanglante, les deux grands carrés d'arbres se renversaient en arrière comme ayant horreur. Alors le peuple gémissait; et après sa grand voix, celle du nuage reprenait et roulait tristement."

"Tous les traits du tableau me revenaient plus colorés devant les yeux; je revoyais les Tuileries rouges, la place houleuse et noire, le gros nuage et la grande Statue et la grande Guillotine se regardant." Alfred de Vigny, Stello, Paris, 1925, pp. 218, 220, 226.

23. Charles Dickens, *Hard Times*, Book the Second, chapter 11, London, *Oxford Illustrated Dickens*, 1955, p. 213.

24. Charles Dickens, *Bleak House*, chapter 1, London, *Oxford Illustrated Dickens*, 1951, p. 1.

25. Nathaniel Hawthorne, *The Blithedale Romance*, in *Novels*, New York, The Library of America, 1982, p. 761.

26. Both Courbet's *Burial at Ornans* (1849) (fig. 117) and Tolstoy's *War and Peace* (1865-69) offer reflections on the role of every individual in history: the great collective actions are resultants of impulses and individuality of every one, of thousands of actors—there are no "great men."

27. Tolstoy no doubt knew the French novels of the 1850s and 1860s.

28. Leo Tolstoy, *The Cossacks*, transl. Aylmer Maude, New York, 1930, pp. 18-19.

29. E. M. Forster, *The Longest Journey*, New York, 1922, p. 327.

30 *Six Plays of Strindberg*, transl. Elisabeth Sprigge, New York, 1955, p. 71.

31. "I remember my first stay in Paris, in 1876 . . . something was fermenting . . . my young artists had dragged me over to Durand-Ruel's to see something quite new in painting . . . we saw some marvellous canvases, most of them signed Monet and Manet . . . the next day I returned, I did not know just why, and I discovered that there was 'something' in these bizarre manifestations. I saw the swarming of a crowd over a pier, but I did not see the pier itself; I saw the rapid passage of a train across a Normandy landscape, the movement of wheels in the street. . . . Very much struck by these canvases, I sent to a paper in my own country a letter in which I tried to explain the sensation I thought the Impressionists had tried to render, and my article had a certain success as a piece of incomprehensibility." *The Intimate Notebooks of Paul Gauguin*, translated by Van Wyck Brooks, London, 1930, pp. 26-27.

32. Zola's *Madeleine Férat* (1868) contains descriptions of the same landscape in different seasons to parallel the feelings of the characters.

33. Edmond and Jules de Goncourt, *Idées et Sensations*, Paris, 19 , p. 69. *Ideas and Sensations* is a book of aphorisms and reflections from the de Goncourt *Journal*.

34. Monet himself remarked of Venice that it was an Impressionist city.

35. Ivan Sergeyevich Turgenev, *On the Eve*, transl. Isabel F. Hapgood, New York, 1922.

36. "Une large couleur de pourpre enflammait le ciel à l'occident. De grosses meules de blé, qui se levaiet au milieu des chaumes, projetaient des ombres géantes." Gustave Flaubert, *L'Éducation sentimentale*, op. cit., p. 41.

37. "A l'heure qu'il est, en littérature, le tout n'est pas de créer des personnages que le public ne salue pas comme de vieilles connaissances, le tout n'est pas de découvrir une forme originale de style; le tout est d'inventer une lorgnette nouvelle, avec laquelle vous faites voir les choses et les êtres à travers des verres qui n'ont point encore servi, vous montrez des tableaux sous un angle de jour inconnu jusqu'alors, vous créez une optique nouvelle . . ." Edmond and Jules de Goncourt, *Journal*, op. cit. vol. X, p. 172 (end of April, 1874).

38. Perhaps we should allow for Degas's unwillingness to credit his rival Manet with this primary role. The similarity of the names "Manet" and "Manette" may be more than coincidental. Degas elsewhere claimed priority for painting and disturbed Edmond de Goncourt by saying that the novelists followed the painters.

39. Cézanne, *Lettres*, op. cit., p. 281.

40. "Tout passe.—L'art robuste/Seul a l'éternité/Le buste/Survit a la cité," (Everything passes/Powerful art/Alone possesses eternity/The bust/Outlasts the city). Théophile Gautier, *Emaux et Camées,* Lille, 1947, pp. 130-32.

41. George Sand wrote that the new poetry was based upon painting: "The poets of today have changed completely: properly speaking, they are neither classical nor romantic: they are painters. Initiated into the secrets of the studio, they have learned to see Nature in all her details . . . this new school is a progress, like every idea that is thoroughly investigated; but it has one defect—obscurity." ("Aujourd'hui les poëtes ont fait une nouvelle évolution. Ils ne sont plus ni classiques ni romantiques proprement dits. Ils sont peintres. Initié au secret des ateliers, ils ont appris à voir la nature dans son détail, et quand ils la décrivent, c'est avec une richesse d'épithètes qui est toute une gamme de nuances les plus fines et les plus fraîches. Cette école nouvelle est un progrès comme tout notion approfondie en est un, mais elle a un défaut, l'obscurité.") Sand, *Impressions et Souvenirs,* Paris, 1872, chapter XI, p. 231.

42. Flaubert frequently argued that plot was of little or no interest, beginning notably with a letter to his lover and fellow writer Louise Colet of January 16, 1852,

which included an eloquent paragraph projecting "a book about nothing" (*Correspondance*, vol. 2, Paris, Pléiade, 1980, p. 31). A subsequent leter to Colet that following year (*Correspondance*, vol. 2, op. cit., p. 362) suggested related ideas, as does his letter to Amédée Pommier of September 8, 1860 (*Correspondence*, col. 3, Paris, Pléiade, 1991, p. 11). In a later letter of February 2, 1869, to Ivan Turgenev, Flaubert chided Sainte-Beuve and Taine for not sufficiently taking art into account, "the work in itself, its composition, its style, in short what makes the beautiful." (*Gustave Flaubert/Ivan Tourgueniev Correspondance*, Paris, 1989, p. 85).

43. Marie Bashkirtseff, who died of consumption, was an itinerant Russian émigrée. Written in French, her diary is among the most remarkable *journaux intimes* of the nineteenth century.

44. ". . . l'aventure, la machination livresque été épuisée . . . pour arriver à devenir tout à fait le grand livre des temps modernes, c'est de se faire un livre de pure analyse." Edmond de Goncourt, *Chérie*, Paris, 1983, p. iii.

45. Reprinted in *Le Roman naturaliste*, Paris, 1883, pp. 75-102.

46. Yet the Russian critic and political theorist Georgy Plekhanov could similarly criticize Impressionist painting, citing the insufficiency of simply painting light; light for him lacked will, flesh, desire, and bones—the essentially organic in nature.

47. The most systematic treatment is in the book by Georg Lorch, *Historische Französische Syntax*, vol. III, Leipzig, 1934. Lorch regarded the literary form as independent of paintings, a parallel expression shaped by similar attitudes and interests. See also the writings of other philologists and linguists like Elise Richter, Georg Loesch (*Die Impressionistische Syntax der Goncourt*), Leo Spitzer, and Amado Alonso and Raimundo Lida ("El Concepto linguístico del impresionismo," in *El Impresionismo en el lenguaje*, Buenos Aires, 1936, pp. 123-51). Their studies paralleled a corresponding awareness of Impressionist qualities in writing by such major figures as Proust and Maupassant.

48. Paul Verlaine's poem "Impression Fausse" (False Impression) demonstrates with considerable verbal skill and economy a painterly use of contrast. The first stanza reads "Dame souris trotte/Noire dans le gris du soir,/Dame souris trotte/Gris dans le noir"(Miss mouse bustles/Black in evening's grey/Miss mouse bustles/Grey in night's blackness). From *Parallèlement,* Paris, 1889, pp. 42-43.

CONCLUSION:
THE REACTION TO IMPRESSIONISM
(pp. 299-323)

1. The series is called *Les Rougon-Macquart,* conjoining the Rougons, the legitimate family branch dealt with in the cycle, and the Macquarts, the lower class, illegitimate branch. The twenty novels in the series include many of Zola's most famous and finest works, like *L'Assommoir* and *Germinal.*

2. Sigmund Freud wrote a letter to Dr. Max Schiller, Guilbert's husband, that cites her ability to play so many different characters as evidence of her "unusually rich and adaptable psychic life" and traces her repertoire to her childhood. *Letters of Sigmund Freud,* selected and edited by Ernst L. Freud, New York, 1960, no. 260, pp. 405-06.

3. See the palette of James Ensor, who is discussed on pages 308-10 in this volume.

4. On the pessimism of the 1860s and 1870s, see Louise Ackermann on the Parnassians (*Oeuvres de L. Ackermann,* Paris, 1885). All of Laforgue's poems are in his *Poésies complètes,* vols. I & II, edited by Pascal Pia, Paris, 1979.

5. See Mikhail Bakhtin, *L'Oeuvre de François Rabelais et la culture populaire au Moyen Age et sous la Renaissance,* Paris, 1978.

6. William Fraenger, *Zeitzeichen: Streifzüge von Basch bis Beckmann,* Amsterdam, 1996, pp. 186-211.

7. I owe this observation to my wife, Dr. Lillian Milgram.

8. *The Complete Letters of Vincent Van Gogh,* op. cit., vol. III, p. 294.

9. *Considerations sur la marche des idées et des événements dans les temps modernes,* 2 vols., Paris, 1872.

10 *The Complete Letters of Vincent Van Gogh,* op. cit., vol. III, p. 57.

11. During his trip to Morocco on April 28, 1832, Delacroix described the superior appearance of the Arabs in comparision to contemporary Frenchmen: "Ils sont plus près de la nature de mille manières: leurs habits, la forme de leur souliers. Aussi, la beauté s'unit à tout qu'ils font. Nous autres, dans nos corsets, nos souliers étroits, nos gaines ridicules, nous faisons pitié. La grâce se venge de notre science." (They are closer to nature in a thousand ways: their dress, the shapes of their shoes. Thus beauty comes together in everything they do. As for us, in our corsets, our tight shoes, our ridiculous pinching garments, we are pitiful. The graces exact vengence for our science.) Eugene Delacroix, *Journal,* vol. I, 1932, p. 152. Almost fifty years later in 1881, Redon wrote similarly about a troup of "barbares sublimes" (sublime barbarians) visiting from Tierra del Fuego: "Ils ont les signes de notre grandeur; elle éclate en leurs yeux et gestes, avec plus de force que dans l'homme civilizé." (They bear the marks of our grandeur; it bursts out in their eyes and their gestures with more force than in civilized man). Redon contrasted a fancily dressed French financier unfavorably with the near-naked natives: "Est-il laid ce vieux bourgeois, sont-ils beaux ces sublimes enfants de la vie polaie!" (How ugly this old bourgeois is, how beautiful these sublime children of polar life!) *A soi-meme, Journal (1867-1915),* Paris, 1979, pp. 84-85.

LIST OF NAMES

Individuals Discussed in the Text and Notes

Angelico, Fra (c. 1400–1455)
Arnold, Matthew (1822–1888)
Aristotle (384–322 B.C.)
Astruc, Zacharie (1833–1907)
Ausonius (A.D. c. 310–c. 395)

Bacon, Francis (1561–1626)
Bagehot, Walter (1826-1877)
Balzac, Honoré de (1799–1850)
Barrès, Maurice (1862–1923)
Bashkirtseff, Marie (1860–1884)
Baudelaire, Charles (1821–1867)
Bazille, Frédéric (1841–1870)
Béranger, Pierre-Jean de (1780–1857)
Bergson, Henri (1859–1941)
Berkeley, George (1685–1753)
Bernard, Emile (1868–1941)
Bertall (Albert d'Arnoux; 1820–1882)
Berthelot, Marcelin (1827–1907)
Boehm, Jakob (1575–1624)
Boldini, Giovanni (1845–1931)
Bonington, Richard Parkes (1802–1826)
Bonnard, Pierre (1867–1947)
Bonnat, Léon (1833–1922)
Boole, George (1815–1864)
Boucher, François (1703–1770)
Boudin, Eugène-Louis (1824–1898)
Boulanger, Louis (1806–1867)
Bourget, Paul (1852–1935)
Brentano, Franz (1838–1917)
Brewster, Sir David (1781–1868)
Brown, Robert (1773–1858)
Brücke, Ernst (1819–1892)
Bruegel the Elder, Pieter (c. 1525–1569)
Brunetière, Ferdinand (1849–1906)
Bruyas, Alfred (1821–1877)
Buffon, George-Louis Leclerc, Comte de (1708–1788)
Bühler, Karl (1879–1963)
Burckhardt, Jacob (1818–1897)

Cabanis, Georges (1757–1808)
Caillebotte, Gustave (1848–1894)
Carnot, Sadi (1796–1832)
Carolus-Duran (Charles-Emile Duran, 1838–1917)
Cassatt, Mary (1844–1926)

Cassiodorus (A.D. c. 490–c. 585)
Cézanne, Paul (1839–1906)
Chabrier, Emmanuel (1841–1894)
Champfleury (Jules Husson, 1821–1889)
Chardin, Jean-Baptiste (1699–1779)
Chateaubriand, François-René de (1768–1848)
Chevreul, Michel-Eugène (1786–1889)
Chopin, Frédéric (1810–1849)
Cigoli, Lodovico Cordida (1559–1613)
Clairvaux, Saint Bernard of (1090–1112)
Claudian (A.D. c. 370–404)
Clausius (1822–1888)
Clemenceau, Georges (1841–1929)
Clifford, William Kingdon (1845–1879)
Cochereau, Mathieu (1793–1817)
Coleridge, Samuel Taylor (1772–1834)
Condillac, Étienne Bonnet de (1715–1780)
Constable, John (1776–1837)
Corbière, Tristan (Édouard-Joachim Corbière, 1845–1875)
Cordi da Cigoli, Lodovico (1559–1613)
Corot, Jean Baptiste Camille Camille (1796–1875)
Courbet, Gustave (1819–1877)
Cournot, Augustin (1801–1877)

d'Arnoux, Albert (1820–1882)
Darwin, Charles (1809–1892)
Daubigny, Charles-François (1817–1878)
Daudet, Alphonse (1840–1897)
Daumier, Honoré (1808–1879)
David, Jacques-Louis (1748–1825)
Debucourt, Philibert-Louis (1755–1832)
Debussy, Claude (1862–1918)
Degas, Edgar (1834–1917)
Delacroix, Eugène (1798–1863)
Descartes, René (1596–1650)
Deschamps, Antoni (1800–1869)
Desnoyers, Fernand (1828–1869)
Destutt de Tracy, Antoine Louis Claude, Comte (1754–1836)
Dickens, Charles (1812–1870)
Disraeli, Benjamin (1804–1881)
Doré, Gustave (1832–1883)
Dostoevsky, Fyodor (1821–1888)
Dreyfus, Alfred (1859–1935)
Diaz de la Peña, Narcisse-Virgile (1807–1876)
Diderot, Denis (1713–1784)
Dumas père, Alexandre (1802–1870)

Durand-Ruel, Paul (1831–1922)
Duranty, Edmond (1833–1880)
Duret, Théodore (1838–1927)

Eddington, Sir Arthur (1882–1944)
Edison, Thomas (1847–1937)
Eliot, George (1819–1880)
Ensor, James (1860–1949)

Fantin-Latour, Henri (1836–1904)
Feydeau, Ernest (1821–1873)
Flaubert, Gustave (1821–1880)
Forster, E. M. (1879–1970)
Fournel, Victor (1829–1894)
Fragonard, Jean-Honoré (1732–1806)
Friedrich, Caspar David (1774–1840)
Frith, William Powell (1819–1909)
Fromentin, Eugène (1820–1876)

Gachet, Paul (1828–1909)
Gainsborough, Thomas (1727–1788)
Galilei, Galileo (1564–1642)
Gasquet, Joachim (1873–1921)
Gautier, Théophile (1811–1872)
Gavarni, Paul (1804–1866)
Géricault, Théodore (1791–1824)
Gérôme, Jean-Léon (1824–1904)
Gide, André (1869–1951)
Gill, André (Louis-André Gosset de Guiness, 1840–1885)
Giorgione (c. 1477–1511)
Girardon, François (1628–1715)
Girodet-Trioson, Anne-Louis (Anne-Louis Girodet de Roucy, 1767–1824)
Goethe, Johann Wolfgang von (1749–1832)
Goncourt, Edmond de (1822–1896)
Goncourt, Jules de (1830–1870)
Grandville (Jean-Ignace-Isidor Gérard, 1803–1847)
Gonzalés, Eva (1849–1883)
Gratiolet, Pierre (1815–1865)
Guillaumin, Armand (1841–1927)

Halévy, Ludovic (1834–1908)
Hawthorne, Nathaniel (1804–1864)
Hegel, Friedrich (1770–1831)
Helmholtz, Hermann von (1824–1891)
Herder, Johann (1744–1803)
Hering, Ewald (1834–1918)
Hervier, Adolphe (1818–1879)
Herzen, Alexander (1812–1870)
Hill, David Octavius (1802–1870)
Hugo, Victor (1802–1885)
Hunt, William Morris (1824–1879)
Huysmans, Joris-Karl (1848–1907)

Ibsen, Henrik (1828–1906)
Ingres, Dominique (1780–1867)

Jacobsen, Jens Peter (1847–1885)
Jaeger, Hans Henrik (1854–1910)
Jaensch, Eric Rudolf (1883–1940)
James, Henry (1843–1916)
James, William (1842–1910)
Jongkind, Johan Barthold (1819–1891)
Joyce, James (1882–1941)

Kant, Immanuel (1724–1804)
Katz, David (1884–1953)
Kelvin, William Thomson (1824–1907)
Kierkegaard, Søren (1813–1855)
Klee, Paul (1879–1940)
Kokoshka, Oskar (1886–1980)

Laforgue, Jules (1860–1887)
Lamartine, Alphonse de (1790–1869)
Lamprecht, Karl (1856–1915)
Laplace, Pierre-Simon (1749–1827)
La Tour, Maurice Quentin de (1704–1788)
Leibnitz, Gottfried Wilhelm (1646–1716)
Leroux, Pierre (1797–1871)
Leroy, Louis (1812–1885)
Lessing, Gotthold Ephraim (1729–1781)
Liszt, Franz (1811–1886)
Locke, John (1632–1704)
Lorrain, Claude (Claude Gelleé, 1600–1682)
Louis-Napoléon (1803–1873; as Napoleon III, emperor of the French, 1852–1871)
Louys, Pierre (1870–1925)
Lucretius (c. 99–c.55 B.C.)

Mach, Ernst (1838–1916)
Macaulay, Thomas (1800–1859)
Maine de Biran, François-Pierre (1766–1824)
Malebranche, Nicolas de (1638–1715)
Mallarmé, Stéphane (1842–1898)
Manet, Édouard (1832–1883)
Martelli, Diego (1838–1896)
Marvell, Andrew (1621–1678)
Marx, Karl (1818–1883)
Matisse, Henri (1869–1954)
Maxwell, James Clerk (1831–1879)
Meilhac, Henri (1831–1897)
Meissonier, Ernest (1815–1891)
Mérimée, Prosper (1803–1870)
Michelet, Jules (1798–1874)
Millet, Jean-François (1814–1875)
Milton, John (1608–1674)
Mockel, Albert (1866–1945)
Mompou, Federico (1893–1987)

Mondrian, Piet (1872–1944)
Monet, Claude (1840–1926)
Monnier, Henri (1805–1877)
Montesquieu (1689–1755)
Monticelli, Adolphe (1824–1886)
Moreau, Gustave (1826–1898)
Morisot, Berthe (1841–1895)
Munch, Edvard (1863–1944)

Nadar (Gaspard-Félix Tournachon, 1820–1910)
Namatianus, Rutilius (fl. A.D. c. 417)
Nanteuil, Céléstin (1813–1873)
Newton, Isaac (1642–1727)
Nietzsche, Friedrich Wilhelm (1844–1900)

Piles, Roger de (1635–1709)
Pissarro, Camille (1830–1903)
Plato (c. 428–348 or 347 B.C.)
Poe, Edgar Allan (1809–1849)
Pollock, Jackson (1912–1956)
Poussin, Nicolas (1594–1665)
Pradier, James (1792–1852)
Proudhon, Pierre-Joseph (1809–1865)
Proust, Marcel (1871–1922)
Prudentius (born A.D. 348)
Pyat, Felix (1810–1899)

Redon, Odilon (1840–1916)
Reid, Thomas (1710–1796)
Renan, Ernest (1823–1892)
Renoir, Pierre-Auguste (1841–1919)
Reynolds, Sir Joshua (1723–1792)
Rodenbach, Georges (1855–98),
Rood, Ogden Nicholas (1831–1902)
Rousseau, Jean-Jacques (1712–1778)
Riegl, Alois (1858–1905)
Rimbaud, Arthur (1854–1891)
Rivière, Georges (1855–1943)
Ruskin, John (1819–1900)

Sainte-Beuve, Charles-Augustin (1804–1869)
Sargent, John Singer (1856–1925)
Schiller, Max (1860–1952)
Scott, Walter (1771–1832)
Seghers, Hercules (1589/90–c.1638)
Sérusier, Paul (1865–1927)
Seurat, Georges (1859–1891)

Signac, Paul (1863–1935)
Signorelli, Luca (c. 1450–1523)
Simmel, Georg (1858–1918)
Sisley, Alfred (1839–1899)
Spencer, Herbert (1820–1903)
Stendhal (Marie-Henri Beyle, 1783–1842)
Strindberg, August (1849–1912)

Taine, Hippolyte (1828–1893)
Thayer, Abbot (1849–1921)
Thierry, Augustin (1795–1856)
Thoré, Théophile (William Bürger) (1824–1869)
Tintoretto (Jacopo Robusti, c. 1578–1594)
Titian (Tiziano Vecelli, c. 1495–1576)
Tolstoy, Leo (1828–1910)
Toulouse-Lautrec, Henri (1864–1901)
Traviès de Villers, Charles-Joseph (1804–1859)
Turgenev, Ivan Sergeyevich (1818–1883)
Turner, Joseph Mallord William (1775–1851)
Tyndall, John (1820–1893)

Valencienne, Pierre-Henri de (1750–1819)
Vallès, Jules (1832–1885)
van Eyck, Jan (c. 1395–1441)
van Gogh, Vincent (1853–1890)
van Rijn, Rembrandt (1606–1669)
Verlaine, Paul (1844–1896)
Veronese (Paolo Caliari, 1528–1588)
Vico, Giambattista (1668–1774)
Vigny, Alfred de (1797–1863)
von Schelling, Friedrich (1775–1854)
Vuillard, Édouard (1868–1940)

Wagner, Richard (1813–1883)
Watteau, Jean-Antoine (1684–1721)
Whistler, James Abbott McNeill (1834–1903)
Wickhoff, Franz (1853–1909)
Wienbarg, Ludolf (1802–1872)
Wilde, Oscar (1846–1900)
Winckelmann, Johann (1717–1768)
Wölfflin, Heinrich (1864–1945)
Woolf, Virginia (1882–1941)

Young, Thomas (1773–1829)

Zola, Émile (1840–1902)

LIST OF ILLUSTRATIONS

1. Edgar Degas, *Portrait of Diego Martelli*, 1879, oil on canvas, 110 x 100 cm, National Gallery of Scotland, Edinburgh. Photo: Art Resource/Bridgeman.

2. Édouard Manet, *Le Déjeuner sur l'herbe*, 1863, oil on canvas, 208 x 264 cm, Musée d'Orsay, Paris. Photo: Art Resource/Giraudon.

3. Édouard Manet, *Portrait of Émile Zola*, 1868, oil on canvas, 146 x 114 cm, Musée d'Orsay, Paris. Photo: Art Resource, New York.

4. Claude Monet, *The Manneporte, Étretat I*, 1883, oil on canvas, 65 x 81 cm, The Metropolitan Museum of Art, New York. Bequest of William Church Osborn, 1951 (51.30.5).

5. Claude Monet, *Impression, Sunrise*, 1872, oil on canvas, 48 x 63 cm, Musée Marmottan, Paris. Photo: Art Resource/Giraudon.

6. Claude Monet, *Rouen Cathedral: The Portal in the Sun*, 1894, oil on canvas, 100 x 65 cm, The Metropolitan Museum of Art, New York. Theodore M. Davis Collection, Bequest of Theodore M. Davis, 1915 (30.95.250).

7. Eugène Boudin, *Approaching Storm*, 1864, oil on panel, 36.6 x 57.9 cm, The Art Institute of Chicago. Mr. and Mrs. Lewis Larned Coburn Memorial Collection, 1938.1276.

8. Pierre-Auguste Renoir, *Claude Monet Reading*, 1872, oil on canvas, 61 x 50 cm, Musée Marmottan, Paris. Photo: Art Resource.

9a. Claude Monet, *La Grenouillière*, c. 1869, oil on canvas, 75 x 100 cm, The Metropolitan Museum of Art, New York. Bequest of Mrs. H. O. Havemeyer, 1929. The H. O. Havemeyer Collection (29.100.112).

9b. Fig. 9a, detail.

10. Fig. 6, detail.

11. Claude Monet, *Boating on the River Epte, Blanche and Marthe Hoschedé*, 1890, oil on canvas, 133 x 145 cm, Museu de Arte, São Paulo, Brazil. Photo: Art Resource/Giraudon

12a. Claude Monet, *River Scene at Bennecourt*, 1868, oil on canvas, 81 x 100 cm, The Art Institute of Chicago. Potter Palmer Collection, 22.427.

12b. Fig. 12a, detail.

13. Claude Monet, *La Gare Saint-Lazare*, 1877, oil on canvas, 75 x 100 cm, Musée d'Orsay, Paris. Photo: Art Resource/Giraudon.

14. Claude Monet, *Vétheuil in Summer*, 1880, oil on canvas, 60 x 100 cm, The Metropolitan Museum of Art, New York. Bequest of William Church Osborn, 1951 (51.30.3).

15. Claude Monet, *The Rue Montorgueil, 30th of June, 1878*, 1878, oil on canvas, 80 x 48.5 cm, Musée d'Orsay, Paris. Photo: Art Resource/Giraudon.

16. Claude Monet, *Le Boulevard des Capucines*, 1873-74, oil on canvas, 80 x 60 cm, The Nelson-Atkins Museum of Art, Kansas City, Missouri. Purchase: the Kenneth A. and Helen F. Spencer Foundation Acquisition Fund.

17. Camille Pissarro, *The Red Roofs in the Village, Winter Effects*, 1877, oil on canvas, 54.5 x 65.6 cm, Musée d'Orsay, Paris. Photo: Art Resource/Giraudon.

18. Jean-Baptiste-Camille Corot, *Ville d'Avray*, 1870, oil on canvas, 54.9 x 80 cm, The Metropolitan Museum of Art, New York. Bequest of Catharine Lorillard Wolfe, 1887. Catharine Lorillard Wolfe Collection (87.15.141).

19. Claude Monet, *The Magpie*, 1869, oil on canvas, 89 x 130 cm, Musée d'Orsay, Paris. Photo: Art Resource/Giraudon.

20. Claude Monet, *The Beach at Sainte-Adresse*, 1867, oil on canvas, 75 x 101 cm, The Art Institute of Chicago. Mr. and Mrs. Lewis Larned Coburn Memorial Collection, 1933.439.

21. Claude Monet, *The Church at Vétheuil, Snow*, 1878-79, oil on canvas, 53 x 71 cm, Musée d'Orsay, Paris. Photo: Art Resource/Eric Lessing.

22. Claude Monet, *Bordighera*, 1884, oil on canvas, 64.8 x 81.3 cm, The Art Institute of Chicago. Mr. and Mrs. Potter Palmer Collection, 1922.426.

23. Claude Monet, *Water Lilies (I)*, 1905, oil on canvas, 89.5 x 100 cm, Museum of Fine Arts, Boston. Gift of Edward Jackson Holmes, Courtesy of Museum of Fine Arts, Boston.

24. Gustave Caillebotte, *Boulevard vu d'en haut*, 1880, oil on canvas, 65 x 54 cm, Private collection, Paris.

25. Claude Monet, *Windmill at Zaandam*, 1872, oil on canvas, 48 x 73.5 cm, Ny Carlsberg Glyptothek, Copenhage. Photo: Art Resource/Eric Lessing.

26. Pierre-August Renoir, *Ball at the Moulin de la Galette*, 1876, oil on canvas, 131 x 175 cm, Musée d'Orsay, Paris. Photo: Art Resource/Giraudon.

27. Claude Monet, *The Four Trees*, 1891, oil on canvas, 81.9 x 81.6 cm, The Metropolitan Museum of Art, New York. H. O. Havemeyer Collection, Bequest of H. O. Havemeyer, 1929 (29.100.110).

28. Paolo Veronese, *The Wedding at Cana*, 1562-63, oil on canvas, 666 x 990 cm, Musée du Louvre, Paris. Photo: Art Resource/Eric Lessing.

29. Eugène Delacroix, *Murder of the Bishop of Liège*, 1829, oil on canvas, 91 x 116 cm, Musée du Louvre, Paris. Photo: Art Resource/Giraudon.

30. Jean-Léon Gérôme, *The Rug Merchant*, 1887, oil on canvas, 83 x 65 cm, The Minneapolis Institute of Arts. The William Hood Dunwoody Fund.

31. Claude Monet, *Garden at Sainte-Adresse*, 1867, oil on canvas, 98 x 130 cm, The Metropolitan Museum of Art, New York. Purchased with special contributions and purchase funds given or bequethed by friends of the Museum, 1967 (67.241).

32. Caspar David Friedrich, *Monk Before the Sea*, 1808-10, oil on canvas, 110 x 171.5 cm, Schloss Charlottenburg, Berlin. Photo: AKG London.

33. Gustave Courbet, *Marine, The Waterspout*, 1870, oil on canvas, 68.9 x 99.7 cm, The Metropolitan Museum of Art, New York. Gift of Horace Havemeyer, 1929. The H. O. Havemeyer Collection (29.160.35),

34. Claude Monet, *The Jetty at Le Havre in Rough Weather*, 1867, oil on canvas, 50 x 61 cm, Private collection. Photo: Art Resource/Bridgeman.

35. Claude Monet, *Rocks at Belle-Ile*, 1886, oil on canvas, 60 x 73 cm, Ny Carlsberg Glyptothek, Copenhagen.

36. Camille Pissarro, *Lordship Lane Station, Dulwich*, 1871, oil on canvas, 45 x 74 cm, Courtauld Gallery, London.

37. Édouard Manet, *Saint-Lazare Station*, 1873, oil on canvas, 93.3 x 111.5 cm, National Gallery of Art, Washington, D.C. Gift of Horace Havemeyer in memory of his mother, Louisine W. Havemeyer.

38. Edgar Degas, *A Gentleman's Race, Before the Start*, 1862, partly repainted in 1882, oil on canvas, 48.5 x 61.5 cm, Musée d'Orsay, Paris. Photo: Art Resource/Eric Lessing.

39. Honoré Daumier, *The Third-Class Carriage*, 1863-65, oil on canvas, 65.4 x 90.2 cm, The Metropolitan Museum of Art, New York. H. O. Havemeyer Collection, Bequest of Mrs. H. O. Havemeyer, 1929 (29.100.129).

40. William Powell Frith, *The Railway Station*, 1862, Royal Holloway & Bedford Collection, New College, Egham, Surrey, Great Britain. Photo: Art Resource/Bridgeman.

41. Claude Monet, *Saint-Lazare Station, the Normandy Train*, 1877, oil on canvas, 59.5 x 80 cm, The Art Institute of Chicago. Mr. and Mrs. Martin A. Ryerson Collection, 1933.1158.

42. Claude Monet, *Arrival at Saint-Lazare Station*, 1877, oil on canvas, 82 x 101 cm, Fogg Art Museum, Harvard University Art Museums, Cambridge, Massachusetts. Bequest from the Collection of Maurice Wertheim, Class of 1906.

43. J. M. W. Turner, *Rain, Steam, and Speed: The Great Western Railway*, 1844, oil on canvas, 91 x 122 cm, National Gallery, London. Photo: Art Resource, New York.

44. Edgar Degas, *Before the Races*, 1869-72, oil on canvas, 46 x 61 cm, Musée d'Orsay, Paris.

45. Claude Monet, *Quai du Louvre*, 1867, oil on canvas, 65 x 92 cm, Gemeentemuseum, The Hague.

46. Jean-Baptiste-Camille Corot, *Rome: The Forum from the Farnese Gardens*, 1826, oil on paper mounted on canvas, 28 x 50 cm, Musée du Louvre, Paris.

47. Jean-Baptiste-Camille Corot, *Le Beffroi du Douai*, 1871, oil on canvas, 46.5 x 38.5 cm, Musée du Louvre, Paris.

48. Camille Pissarro, *Boulevard des Italiens, Morning, Sunlight*, 1897, oil on canvas, 73.2 x 92.1 cm, National Gallery of Art, Washington, D.C. Chester Dale Collection.

49. Anonymous, caricature, *Le Mardi-Gras sur le Boulevard*, from *Le Salon caricatural*, Paris: Charpentier, 1846.

50. Philibert-Louis Debucourt, *Tuileries Garden*, "*La promenade publique*," 1792, colored copper engraving, 35 x 58 cm, Musée de la Ville de Paris, Musée Carnavalet, Paris. Photo: AKG London.

51. Édouard Manet, *Music at the Tuileries*, 1861, oil on canvas, 76 x 118 cm, National Gallery, London. Photo: Art Resource/Bridgeman.

52. Édouard Manet, *The Rag Picker*, c. 1869, oil on canvas, 193 x 130.5 cm, The Norton Simon Foundation, Los Angeles.

53. Pierre Zaccone, *The Rag Picker*, etching from *Les Rues de Paris*, 1844, #205.

54. Édouard Manet, *The Tragic Actor (Philibert Rouvière as Hamlet)*, 1866, oil on canvas, 187.2 x 108.1 cm, National Gallery of Art, Washington, D.C. Gift of Edith Stuyvesand Gerry.

55. Édouard Manet, *Bar at the Folies-Bergère*, 1881-82, oil on canvas, 96 x 130 cm, Courtauld Gallery, London.

56. Jean-Auguste-Dominique Ingres, *Countess d'Haussonville*, 1845, oil on canvas, 132 x 92 cm, The Frick Collection, New York. Copyright The Frick Collection, New York.

57. Claude Monet, *The Coal-Dockers*, 1875, oil on canvas, 55 x 66 cm, Musée d'Orsay, Paris. Photo: Art Resource/Eric Lessing.

58. Gustave Caillebotte, *Floor-Scrapers*, 1875, oil on canvas, 102 x 145 cm, Musée d'Orsay, Paris. Photo: Art Resource/Giraudon.

59. Edgar Degas, *Dancers Practicing at the Bar*, 1876-77, oil colors freely mixed with turpentine, on canvas, 75.6 x 81.3 cm, The Metropolitan Museum of Art, New York. Bequest of Mrs. H. O. Havemeyer, 1929. The H. O. Havemeyer Collection (29.100.34).

60. Edgar Degas, *Mlle LaLa at the Cirque Fernando*, 1879, oil on canvas, 116.8 x 77.5 cm, National Gallery, London. Photo: Art Resource.

61. Honoré Daumier, *The Laundress*, 1863, oil on wood, 48 x 32 cm, The Metropolitan Museum of Art, New York. Bequest of Lizzie P. Bliss, 1931.

62. Edgar Degas, *Pouting* or *Sulking*, 1869-71, oil on canvas, 32 x 46.5 cm, The Metropolitan Museum of Art, New York. Bequest of Mrs. H. O. Havemeyer, 1929. H. O. Havemeyer collection (29.100.43).

63. Pierre-Auguste Renoir, *Young Girls at the Piano*, c. 1889, oil on canvas, 56 x 46 cm, Joslyn Art Museum, Omaha, Nebraska.

64. Pierre-Auguste Renoir, *At the Milliner's*, 1878, oil on canvas, 32.4 x 24.5 cm, Fogg Art Museum, Harvard University Art Museums, Cambridge, Massachusetts. Bequest of Annie Swan Coburn.

65. Isidore Grandville, *View of the Vendôme Column*, 1844, etching from "Un Autre Monde."

66. Camille Pissarro, *Place du Théâtre Français*, 1898, oil on canvas, 72 x 93 cm, Los Angeles County Museum of Art. Mr. and Mrs. George Gard De Sylva Collection (M 46.3.2).

67. Isidore Grandville, *Caricature of gigantic eyes*, 1844, etching from "Un Autre Monde."

68. Honoré Daumier, *The Melodrama*, c. 1860, oil on canvas, 97.5 x 90.4 cm, Neue Pinakothek, Munich. Photo: Artothek.

69. Edgar Degas, *The Ballet from "Robert le Diable,"* 1871, oil on canvas, 66 x 54.3 cm, The Metropolitan Museum of Art, New York. Bequest of Mrs. H. O. Havemeyer, 1929. H. O. Havemeyer collection (29.100.552).

70. Paul Nadar, *Portrait of Claude Monet*, 1899, photograph.

71. Jean-Auguste-Dominique Ingres, *Monsieur Bertin*, 1832, oil on canvas, 116 x 95 cm, Musée du Louvre, Paris. Photo: Art Resource, New York.

72. Claude Monet, *Portrait of a Seated Man (Dr. Leclanché)*, 1864, oil on canvas, 46 x 32.5 cm, The Metropolitan Museum of Art, New York. Gift of Mr. and Mrs. Edwin C. Vogel, 51.32.

73. Peter Paul Rubens, *The Artist and his Wife in the Honeysuckle Bower*, 1609, oil on canvas, 174 x 130 cm, Alte Pinakothek, Munich. Photo: Art Resource/Eric Lessing.

74. Edgar Degas, *Mme. Camus*, 1870, oil on canvas, 72.7 x 92.1 cm, National Gallery of Art, Washington, D. C. Chester Dale Collection.

75. Edgar Degas, *A Woman Seated Beside a Vase of Flowers*, 1865, oil on canvas, 73.7 x 92.7 cm, The Metropolitan Museum of Art, New York. The H. O. Havemeyer Collection, Bequest of Mrs. H. O. Havemeyer, 1929 (29.100.128).

76. Edgar Degas, *The Bellelli Family*, 1858-67, oil on canvas, 200 x 250 cm, Musée d'Orsay, Paris. Photo: Art Resource/Eric Lessing.

77. Edgar Degas, *Portraits in an Office—The Cotton Exchange*, 1873, oil on canvas, 74 x 92 cm, Musée des Beaux-Arts, Pau.

78. François Boucher, *The Luncheon*, 1739, oil on canvas, 81.5 x 65.5 cm, Musée du Louvre, Paris. Photo: Art Resource, New York.

79. Claude Monet, *The Luncheon*, 1868, oil on canvas, 230 x 150 cm, Städelisches Kunstinstitut und Städtische Galerie, Frankfurt am Main. Photo: Art Resource, New York.

80. Claude Monet, *Déjeuner sur l'herbe*, 1866, oil on canvas, 130 x 181 cm, Pushkin Museum, Moscow. Photo: Art Resource, New York.

81. Antoine Watteau, *La fête d'amour*, 1717, oil on canvas, 61 x 75 cm, Staatliche Kunstsammlungen, Alte Meister, Dresden. Photo: Art Resource/Eric Lessing.

82. Pierre-Auguste Renoir, *The Theatre Box (La Loge)*, 1874, oil on canvas, 80 x 63.5 cm, Courtauld Gallery, London.

83. Fig. 28, detail.

84. Pierre-Auguste Renoir, *The Luncheon of the Boating Party*, 1880-81, oil on canvas, 129.5 x 172.7 cm, The Phillips Collection, Washington, D.C.

85. Claude Monet, *The Thames below Westminster*,

1871, oil on canvas, 47 x 73 cm, The National Gallery, London.

86. Claude Monet, *Houses of Parliament*, c. 1900/01, oil on canvas, 81 x 92.1 cm, The Art Institute of Chicago. Mr. and Mrs. Martin A. Ryerson Collection, 1933.1164.

87. Claude Monet, *A Field of Tulips in Holland*, 1886, oil on canvas, 65.5 x 81.5 cm, Musée d'Orsay, Paris. Photo: Art Resource/Eric Lessing.

88. Claude Monet, *Grainstack (Snow Effect)*, 1891, oil on canvas, 65.4 x 92.3 cm, Museum of Fine Arts, Boston. Gift of Misses Aimée and Rosamond Lamb in Memory of Mr. and Mrs. Horatio A. Lamb. Courtesy Museum of Fine Arts, Boston.

89. Claude Monet, *Rouen Cathedral Façade and Albane Tower (Morning Effect)*, 1894, oil on canvas, 106.1 x 73.9 cm, Museum of Fine Arts Boston. Tompkins Collection. Courtesy Museum of Fine Arts, Boston.

90. Claude Monet, *Rouen Cathedral in Full Sunlight*, 1894, oil on canvas, 100.5 x 66.2 cm, Museum of Fine Arts, Boston. Juliana Cheney Edwards Collection. Courtesy Museum of Fine Arts, Boston.

91. Claude Monet, *Regatta at Argenteuil*, 1872, oil on canvas, 48 x 75 cm, Musée d'Orsay, Paris. Photo: Art Resource/Giraudon.

92. Claude Monet, *The Seine at Bougival*, 1869, oil on canvas, 60 x 73.3 cm, Smith College Museum of Art, Northampton, Massachusetts. Purchased 1946.

93. Claude Monet, *The Port at Argenteuil*, 1872, oil on canvas, 60 x 80.5 cm, Musée du Louvre, Paris. Photo: Art Resource/Giraudon.

94. Jean-Baptiste-Camille Corot, *Chartres Cathedral*, 1830 (retouched in 1872), oil on canvas, 64 x 51.5 cm, Musée du Louvre, Paris. Photo: © RMN, Paris.

95. Claude Monet, *The Church at Varengeville, Grey Weather*, 1882, oil on canvas, 65 x 81 cm, The J. B. Speed Art Museum, Louisville, Kentucky. Bequest of Mrs. Blakemore Wheeler, 64.31.20.

96. Claude Monet, *London, Houses of Parliament*, 1904, oil on canvas, 81 x 92 cm, Musée d'Orsay, Paris. Photo: Art Resource/Giraudon.

97. Claude Monet, *Rougets (Red Mullets)*, 1869, oil on canvas, 35.5 x 50 cm, Fogg Art Museum, Harvard University Art Museums, Cambridge, Massachusetts. Gifts of the Friends of the Fogg Art Museum.

98. Claude Monet, *Water Lilies*, 1906, oil on canvas, 87.6 x 92.7 cm, The Art Institute of Chicago. Mr. and Mrs. Martin A. Ryerson Collection, 1993.1157.

99. Paul Cézanne, *The Bay of Marseille, Seen from L'Estaque*, 1886-90, oil on canvas, 80.2 x 100.6 cm, The Art Institute of Chicago. Mr. and Mrs. Martin A. Ryerson Collection, 1993.1116.

100. Claude Monet, *Still Life with Apples and Grapes*, 1880, oil on canvas, 66.2 x 82.3 cm, The Art Institute of Chicago. Mr. and Mrs. Martin A. Ryerson Collection, 1993.1152.

101. Paul Cézanne, *Still Life with Commode*, c. 1883-87, oil on canvas, 62.2 x 78.7 cm, Fogg Art Museum, Harvard University Art Museums, Cambridge, Massachusetts. Bequest from the Collection of Maurice Wertheim, Class of 1906.

102. Carjat, *Monet at age 20*, 1860, photograph.

103. Paul Nadar, photos of Chevreul aged 100 talking to Félix Nadar about "The Art of Living for 100 Years," from *Journal Illustré*, September 5, 1886.

104. Claude Monet, *St. Germain l'Auxerrois*, 1867, oil on canvas, 79 x 98 cm, Nationalgalerie, Berlin. Photo: AKG London.

105. Abbott Thayer, *Peacock in the Woods*, 1907, oil on canvas, 116 x 93 cm, National Museum of American Art, Smithsonian Institution, Washington, D.C. Gift of the Heirs of Abbott Thayer, 1950.2.11.

106. Claude Monet, *The Luncheon (Decorative Panel)*, 1873, oil on canvas, 162 x 203 cm, Musée d'Orsay, Paris. Photo: © RMN, Paris.

107. Pierre-Auguste Renoir, *The Garden in the rue Cortot, Montmartre*, 1876, oil on canvas, 151.8 x 97.5 cm, Carnegie Museum of Art, Pittsburgh. Acquired through the generosity of Mrs. Alan M. Scaife, 65.35.

108. Georges Pierre Seurat, *Invitation to the Sideshow*, 1885, oil on canvas, 99.7 x 149.9 cm, The Metropolitan Museum of Art, New York. Bequest of Stephen C. Clark, 1960 (61.101.17).

109. Jean-Baptiste Chardin, *Bouquet of Carnations, Tuberoses, and Sweet-peas in a Blue-and-White Porcelain Vase*, 1755-60, oil on canvas, 44 x 36 cm, National Gallery of Scotland, Edinburgh.

110. Thomas Gainsborough, *Mrs. Richard Brinsley Sheridan, née Elizabeth Linley*, 1785, oil on canvas, 219.7 x 153.7 cm, National Gallery of Art, Washington, D.C.

111. Camille Pissarro, *The Crystal Palace*, 1871, oil on canvas, 47.2 x 73.5 cm, The Art Institute of Chicago. Gift of Mr. and Mrs. B. E. Bensinger, 1972.1164.

112. Hercules Seghers, *A Road Bordered by Trees with a Town in the Distance*, etching, printed in black on white paper, 14.1 x 10.5 cm, Rijksmuseum, Amsterdam. Photo: AKG London.

113. Claude Lorrain, *Landscape*, 1663, pen and ink drawing with chalk, 26.2 x 37.8 cm, Dumbarton Oaks, Washington, D.C.

114. Diego Velázquez, *The Gardens at the Villa Medici*, c. 1650, oil on canvas, 44 x 38 cm, Museo del Prado, Madrid. Photo: Art Resource/Giraudon.

115. Diego Velázquez, *The Spinners*, or *The Fable of Arachne*, c. 1657, oil on canvas, 220 x 289 cm, Museo del Prado, Madrid. Photo: Art Resource.

116. John Constable, *The Haywain*, 1821, oil on canvas, 130.5 x 185.5 cm, The National Gallery of Art, London.

117. Gustave Courbet, *Burial at Ornans*, 1849, oil on canvas, 315 x 668 cm, Musée d'Orsay, Paris. Photo: © RMN, Paris.

118. Johan Barthold Jongkind, *Setting Sun, Port of Anvers*, 1868, etching, 15 x 26 cm, The Art Institute of Chicago. Gift of Mrs. Morris Woolf, 1941.44.

119. Gustave Courbet, *The Studio, a Real Allegory Comprising a Phase of Seven Years of My Artistic Life*, 1854-55, oil on canvas, 361 x 598 cm, Musée d'Orsay, Paris. Photo: © RMN, Paris.

120. Frédéric Bazille, *The Artist's Studio*, 1870, oil on canvas, 98 x 128 cm, Musée d'Orsay, Paris. Photo: © RMN, Paris.

121. Pierre-Auguste Renoir, *Monet Painting in His Garden at Argenteuil*, 1873-75, oil on canvas, 46 x 60 cm, Wadsworth Atheneum, Hartford, Connecticut. Bequest of Anne Parrish Titzell, 1957.

122. Pierre-Auguste Renoir, *The Great Bathers*, 1887, oil on canvas, 117.7 x 170.8 cm, Philadelphia Museum of Art. Mr. and Mrs Carroll S. Tyson Jr. Collection.

123. Georges Seurat, *A Sunday Afternoon on La Grande Jatte*, 1884-86, oil on canvas, 207.5 x 308 cm, The Art Institute of Chicago. Helen Birch Bartlett Memorial Collection, 1926.224.

124. Henri de Toulouse-Lautrec, *At the Moulin Rouge*, 1893-95, oil on canvas, 123 x 141 cm, Art Institute of Chicago. Helen Birch Bartlett Memorial Collection, 1928.610.

125. Henri de Toulouse-Lautrec, *Yvette Guilbert Taking a Curtain Call*, 1894, watercolor with crayon, 48 x 25 cm, Rhode Island School of Design, Providence. Gift of Mrs. Murray S. Danforth.

126. James Ensor, *Entry of Christ into Brussels in 1889*, 1888-89, oil on canvas, 257 x 378.5 cm, The J. Paul Getty Museum, Malibu, California.

127. Gustave Doré, *The Entry of Christ into Jerusalem*, c. 1875, etching, first published in *Die Heilige Schrift Alten und Neuen Testaments verdeutscht von D. Martin Luther. Mit zweihundert und dreissig Bildern von Gustav Doré* by the Deutsche Verlags-Anstalt, Stuttgart, Leipzig, Berlin, and Vienna. Photo: *The Dover Bible Illustrations*, Dover Publications, 1974.

128. James Ensor, *The Cathedral*, 1886, etching, 23.6 x 17.7 cm, The Art Institure of Chicago. Joseph Brooks Fair Fund, 1953.268.

128. Edvard Munch, *The Dance of Life*, 1899-1900, oil on canvas, 125.5 x 190.5 cm, National Gallery, Oslo. Photo: Art Resource, New York.

130. Edvard Munch, *The Scream*, 1893, tempera and pastel on board, 91 x 73.5 cm, National Gallery, Oslo. Photo: Art Resource, New York.

131. Vincent van Gogh, *Wheat Field with Rising Sun*, 1889, black chalk, reed pen, and brown ink on toned paper, 47 x 62 cm, Staatliche Graphische Sammlung, Munich.

132. Vincent van Gogh, *Dr. Paul Gachet*, 1890, oil on canvas, 68 x 57 cm, Musée d'Orsay, Paris. Photo: Art Resource/Eric Lessing.

133. Vincent van Gogh, *Starry Night*, 1889, oil on canvas, 73.7 x 92.1 cm, The Museum of Modern Art, New York. Acquired through the Lillie P. Bliss Bequest.

134. Paul Gauguin, *The Vision After the Sermon (Jacob Wrestling with the Angel)*, 1888, oil on canvas, 73 x 92 cm, National Gallery of Scotland, Edinburgh. Photo: Art Resource/Bridgeman.

135. Paul Gauguin, *Where Do We Come From? What Are We? Where Are We Going?*, 1898, oil on canvas, 139 x 375 cm, Museum of Fine Arts, Boston.

136. Jackson Pollock, *Number 1, 1948*, 1948, oil and enamel on unprimed canvas, 172.7 x 264.2 cm, The Museum of Modern Art, New York. Purchase.

137. Claude Monet, *L'Hôtel des Roches Noirs, Trouville*, 1870, oil on canvas, 80 x 55 cm, Musee d'Orsay, Paris. Photo: © RMN.

138. Camille Pissarro, *Place du Théâtre Francais*, 1898, oil on canvas, 72 x 93 cm, Los Angeles County Museum of Art. Mr. and Mrs. George Gard De Sylva Collection (M 46.3.2).

139. Piet Mondrian, *Composition with Lines*, 1916-17, oil on canvas, 108 x 108 cm, Rijksmuseum Kröller-Müller, Otterloo. Photo: AKG London.

INDEX

For illustration titles see the List of Illustrations, p. 348.

aesthetics: in everyday life, 298; Impressionism, 43, 87–88

The Analysis of Sensations and the Relation of the Physical Psychical: Mach, Ernest, 37

Aristotle: *Meteorology,* 213

Arnoux, Albert d', 330 n. 3

"L'Art": Gautier, Théophile, 292–293

artist (as subject), 160, 162; *The Artist and His Wife in the Honeysuckle Bower* (fig. 73), 162; *Monet Painting in His Garden at Argenteuil* (fig. 21), 267

artists in old age, theory of, 180–181

artist studio. *See* studio (themes)

Ausonius, 241

Bacon, Francis, 25

Balzac, Honoré de: *La Fille aux yeux d'or,* 121; *Gaudissart II,* 150, 152; *Peau de Chagrin,* 224; *The Unknown Masterpiece,* 292

Barrès, Maurice, 38

Bashkirtseff, Marie, 343 n. 43

Baudelaire, Charles, 39, 110, 116–117; "Le Vin des chiffonniers," 126

Berger, Louis, 124–125

Bernard, of Clairvaux, Saint, 243, 244

Bertall, 99, 330 n. 3

Bleak House: Dickens, Charles, 286

The Blithedale Romance: Hawthorne, Nathaniel, 286

Bonington, Richard, 65

Boole, George, 27

Boscotrecase, 238

Boucher, François: portraits: *The Luncheon* (fig. 78), 169

Boudin, Eugène-Louis, 39, 41; and Monet, Claude, 264–265; seascapes: *Approaching Storm* (fig. 7), 265

Boulanger, Louis, 65

Bourget, Paul, 237, 295

"Le brave, brave autumn!": Laforgue, Jules, 307–308

Brazille, Frédéric: studio (themes): *The Artist's Studio* (fig. 120), 267

Brewster, David, 211

Brooklyn Bridge, 342 n. 19

"Brownian movement": Clemenceau, Georges, 209

Brueghel, Pieter (the Elder), 249, 250

Brunetière, Ferdinand, 237, 295–296

brushstroke, 50–52, 60–61, 220–221, 223, 226; *Le Boulevard des Capucines* (fig. 16), 62; and modeling, 50–57; and paint texture, 51–52; and surface texture, 53

brushstroke and color, 71–72; *Boating on the River Epte, Blanche and Martha Hoschedé* (fig. 11), 55–56; *Bordighera* (fig. 22), 72–73; *The Church at Vétheuil, Snow* (fig. 21), 71; *La Gare Saint-Lazare* (fig. 13), 58–59; *La Grenouillière* (fig. 9a), 53; *River Scene at Bennecourt* (fig. 12a), 56, 58, 70–71; Rousseau, Théodore, 68; *Saint-Lazare Station, the Normandy Train* (fig. 41), 104–105

Buffon, George Louis Leclerc, 213

Cabanis, George, 40

Caillebotte, Gustave, 133

Cassiodorus, 240–241

Cézanne, Paul, 31, 50, 123, 201–202, 278, 282, 292; color: *The Bay of Marseille, Seen from L'Estaque* (fig. 99), 202–203; landscapes: *The Bay of Marseille, Seen from L'Estaque* (fig. 99), 202–203; still life: *Still Life with Commode* (fig. 101), 204–205

Champfleury (Jules Husson), 102

Les Chants modernes: Du Camp, Maxime, 106, 107

Chardin, Jean-Baptiste, 50, 162, 233

Chevreul, Michel-Eugène, 212–214; *The Law of the Simultaneous Contrast of Colors,* 212

Chinese painting, 245–250; Impressionist style, 246, 249

Chérie: Goncourt, Edmond de, 293

Chu Ta, 249, 250

La Cigale: Halévy, Ludovic, 120; Meilhac, Henri, 23, 120

city (themes), 111; *Le Beffroi du Douai* (fig. 47), 113–114; *Boulevard des Italiens, Morning, Sunlight* (fig. 48), 115–116; *Chartres Cathedral* (fig. 94), 194–196; *The Crystal Palace* (fig. 111), 239–240; Impressionist view, 117–118; *London, Houses of Parliament* (fig. 96), 196; *Mardi Gras on the Boulevard* (fig. 49), 116–117; *Quai du Louvre* (fig. 45), 110, 111–113; *The Red Roofs in the Village, Winter Effects* (fig. 17), 62–63; *Rome: The Forum from the Farnese Gardens* (fig. 46), 111–113; *The Rooftops of Old Rouen, Gray Weather,* 240; *Rouen Cathedral: The Portal in the Sun* (fig. 10), 215–216; *Rouen Cathedral Façade and Albane Tower (Morning Effect)* (fig. 89), 190; *The Rue Montorgueil, 30th of June, 1878* (fig. 16), 115–116; *St. Germain l'Auxerrois* (fig. 104), 217; *View of the Boulevard des Capucines about 1810,* 111. *See also* urban (themes)

city (themes, Impressionism), 108–122

classical art, 242–243

classical art (influence), 242

Clemenceau, Georges: "Brownian movement," 209

clouds: 338 n. 11

Cochereau, Mathieu: city (themes): *View of the Boulevard des Capucines about 1810,* 111

color, 47–50, 207–209, 212–221, 225–226, 260–261, 334 n. 5; *The Bay of Marseille, Seen from L'Estaque* (fig. 99), 202–203; *The Beach at Sainte-Adresse* (fig. 20), 69–70; *The Garden in the rue Cortot Montmartre* (fig. 107), 221; *Invitation to the Sideshow* (fig. 108), 226; *London, Houses of Parliament* (fig. 96), 196; *The Luncheon (Decorative Panel)* (fig. 106), 219; *The Magpie* (fig. 19), 208; *Rouen Cathedral: The Portal in the Sun* (fig. 10), 215–216; as signs, 47–48; *St. Germain l'Auxerrois* (fig. 104), 217

color and light, 30–31, 210

color and optics, 210–211

color (meaning), 48

color (primary), 211

color (tones), 66–67; *The Magpie* (fig. 19), 68; *Ville d'Avray* (fig. 18), 67

color (uninterpreted), 50; and sensations, 49

color (use of), 48, 63–73; *The Red Roofs in the Village, Winter Effects* (fig. 17), 62–63; *Rouen Cathedral: The Portal in the Sun* (fig. 10), 53, 55; *A Sunday Afternoon on La Grande Jatte* (fig. 123), 302

common-sense school, 328 n. 1

composition: *Ball at the Moulin de la Galette* (fig. 26), 76–77; *Chartres Cathedral* (fig. 94), 194–196; *The Church at Varengeville, Grey Weather* (fig. 95), 196; *The Crystal Palace* (fig. 111), 239–240; *The Port at Argenteuil* (fig. 93), 192–193; *Portraits in an Office—The Cotton Exchange* (fig. 77), 225; *Windmill at Zaandam* (fig. 25), 75

composition (Impressionism), 73–78

composition (spectator): *See* spectator (composition); portraits; group scenes

Constable, John, 256, 339 n. 31; Impressionistic qualities: *Hay Wain* (fig. 116), 256

Corot, Jean-Baptiste-Camille, 41

Corot, Jean-Baptiste-Camille (city [themes]): *Le Beffroi du Douai* (fig. 47), 113–114; *Chartres Cathedral* (fig. 94), 194–196; *Rome: The Forum from the Farnese Gardens* (fig. 46), 111–113

Corot, Jean-Baptiste-Camille (color [tones]): *Ville d'Avray* (fig. 18), 67

Corot, Jean-Baptiste-Camille (composition): *Chartres Cathedral* (fig. 94), 194–196

Corot, Jean-Baptiste-Camille (landscapes): *Ville d'Avray* (fig. 18), 67

Corot, Jean-Baptiste-Camille (spectator [composition]): *Le Beffroi du Douai* (fig. 47), 113–114; *Rome: The Forum from the Farnese Gardens* (fig. 46): 111

The Cossacks: Tolstoy, Leo, 286–288

Courbet, Gustave, 47; nature (sea): *Marine, The Waterspout* (fig. 33), 90–91; Realism: *Burial at Ornans* (fig. 117), 261; studio (themes): *The Studio: A Real Allegory Comprising a Phase of Seven Years of My Artistic Life* (fig. 119), 128, 265–267

Cournot, Augustin, 316

Cros, Charles: "L'Heure verte," 206

crowds, social aspects, 147–152

crowd scenes: *Boulevard des Italiens, Morning, Sunlight* (fig. 48), 115–116; *Mardi Gras on the Boulevard* (fig. 49), 116–117; *Place du Théâtre Français* (fig. 66), 145; *The Rue Montorgueil, 30th of June, 1878* (fig. 16), 115–116; *View of the Vendôme Column* (fig. 65), 145–146

dancers: *Dancers Practicing at the Bar* (fig. 59), 140

Darwin, Charles: *Voyage of the Beagle,* 174

Daudet, Alphonse, 61–62; *Le Nabab,* 285; *Les Rois en exile,* 149, 295–296

Daumier, Honoré, 84, 187, 188; group scenes: *The Melodrama* (fig. 68), 152; railroads: *The Third-Class Carriage* (fig. 39), 101; seeing (themes): *The Melodrama* (fig. 68), 152

Degas, Edgar, 42, 109–110, 179, 273, 332 n. 8, 333 n. 5; monotypes, 140; and photography, 168; themes, 143; women as subjects, 135–140

Degas, Edgar (composition): *Portraits in an Office—The Cotton Exchange* (fig. 77), 225

Degas, Edgar (dancers): *Dancers Practicing at the Bar* (fig. 59), 140

Degas, Edgar (group scenes): *The Ballet from "Robert le Diable"* (fig. 69), 152; *Dancers Practicing at the Bar* (fig. 59), 140; *Portraits in an Office—The Cotton Exchange* (fig. 77), 168

Degas, Edgar (portraits): *The Bellelli Family* (fig. 76), 166–167, 169; *Bouderie* (fig. 62), 167–168; *Portraits in an Office—The Cotton Exchange* (fig. 77), 168; *A Woman Seated Beside a Vase of Flowers* (fig. 75), 163–165

Degas, Edgar (seeing [themes]): *The Ballet from "Robert le Diable"* (fig. 69), 152

Degas, Edgar (segmentation): *Place de la Concorde,* 77–78

Delacroix, Eugène, 38, 42, 50, 187, 344 n. 11; spectator (composition): *Murder of the Bishop of Liège* (fig. 29), 82

De l'intelligence: Taine, Hippolyte, 31

de Piles, Roger, 244

Deschampes, Antoni, 110

Desnoyers, Fernand, 120

Dickens, Charles, 108, 285–286; *Bleak House,* 286

Dominique: Fromentin, Eugène, 39–40, 121–122, 178, 273

Doré, Gustave: frontispiece for *Histoire des environs du nouveau Paris,* 120; urban (themes): *Entry of Christ into Jerusalem* (fig. 127), 309

Dostoevsky, Fyodor: *The Possessed,* 275

Du Camp, Maxime: *Les Chants modernes,* 106, 107

Dujardin, Edouard: *Les Lauriers sont coupés,* 293

Eddington, Arthur, 236 *L'Education sentimentale:* Flaubert, Gustave, 118–119, 271, 272, 284–285

Eiffel Tower, 281–282

Eliot, George, 341 n. 7

En 1851: Goncourt brothers (Edmond de and Jules de), 291

Ensor, James, 308–312; urban (themes): *The Cathedral* (fig. 128), 310–311; *Entry of Christ into Brussels in 1888* (fig. 126), 309–310

environment, 20; described, 79; and Impressionism, 79–80, 288–291; and literature, 288–291. *See also* landscapes; nature; seascapes

Erscheinungsweise der Farben, 210

Eureka: Poe, Edgar Allen, 27

L'Eve future: Villiers de L'Isle-Adam, August de, 207

Execution of the Emperor Maximilian: Manet, Édouard, 187–188

La Faute de l'Abbe Mouret: Zola, Émile, 178

La Fille aux yeux d'or: Balzac, Honoré, 121

Flaubert, Gustave, 94, 100, 268–272; *L'Education sentimentale,* 118–119, 271, 272, 284–285; *Madame Bovary,* 269; *Par les champs et par les grèves,* 269–270, 271; *Salammbô,* 272; *Tentation de Saint-Antoine,* 292; "Un Coeur Simple," 272

form (impression), 327 n. 15

Forster, E. M.: *The Longest Journey,* 288

Fragonard, Jean-Honoré: portraits: *The Music Lesson,* 170

Les Français peints par eux-mêmes, 126

Friedrich, Caspar David: seascapes: *Monk Before the Sea* (fig. 32), 88–89; spectator (composition): *Monk Before the Sea* (fig. 32), 88–89

Frith, William Powell: railroads: *The Railway Station* (fig. 40), 101–102

Fromentin, Eugène, 280; *Dominique,* 39–40, 121–122, 178, 273

Gainsborough, Thomas, 38–39, 50, 233

Galileo Galilei, 30

Garrick: Reynolds, Joshua, 128

Gasquet, Henri, 39

Gaudissart II: Balzac, Honoré de, 150, 152

Gauguin, Paul, 317–321; group scenes: *Where Do We Come From? What Are We? Where Are We Going?* (fig. 135), 318–320

Gautier, Théophile, 17–18, 98–99, 106–107, 149, 269, 326 n. 9; *Histoire du romantisme,* 269, 292; "L'Art," 292–293

Gespenstfarben (ghost colors), 214

Ghosts: Ibsen, Henrik, 122

Goncourt, Edmond de, 137, 160, 268; *Chérie,* 293

Goncourt, Jules de, 121, 268

Goncourt brothers (Edmond de and Jules de), 271, 290, 294; *En 1851,* 291; *Madame Gervaisais,* 285; *Manette Salomon,* 273, 292; *Renée Mauperin,* 273–274

Grandville, Isidore: crowd scenes: *View of the Vendôme Column* (fig. 65), 145–146; seeing (themes): *Caricature of gigantic eyes* (fig. 67), 152

Gratiolet, Louis Pierre, 35

grouping of objects: *The Four Poplars* (fig. 27), 190; *Regatta at Argenteuil* (fig. 91), 190–191; *Rouen Cathedral Façade and Albane Tower (Morning Effect)* (fig. 89), 190; *The Seine at Bougival* (fig. 92), 191

group scenes: *Ball at the Moulin de la Galette* (fig. 26), 76–77; *The Ballet from "Robert le Diable"* (fig. 69), 152; *Bar at the Folies-Bergère* (fig. 55), 129–130, 131–132; *Dancers Practicing at the Bar* (fig. 59), 140; *Déjeuner sur l'herbe* (fig. 80), 172; *La fête d'amour* (fig. 81), 172; *Invitation to the Sideshow* (fig. 108), 226; *The Luncheon of the Boating Party* (fig. 84), 177–178; *The Melodrama* (fig. 68), 152; *Portraits in an Office—The Cotton Exchange* (fig. 77), 168; *Where Do We Come From? What Are We? Where Are We Going?* (fig. 135), 318–320. *See also* portraits; spectator (composition)

Halévy, Ludovic: *La Cigale,* 120

Hawthorne, Nathaniel: *The Blithedale Romance,* 286

Helmholtz, Hermann von, 216, 217–218; *Treatise on Physiological Optics,* 211

"L'Heure verte": Cros, Charles, 206

Histoire des environs du nouveau Paris, Frontispiece for: Doré, Gustave, 120

Hugo, Victor, 97–98, 102–103, 148; "Jour de fête aux environs de Paris," 126; "Les Soleils Couchants," 147

Hume, David, 25, 35

Huysmans, Joris-Karl, 216, 258; *À rebours,* 293, 301

Ibsen, Henrik: *Ghosts,* 122

illuminate, 218–219

illusionism, 237–238, 240, 242

illustrations: *Le Fleuve* illustrated by Manet, Édouard, 279

impression, 21–42 passim, 25–26, 28–30, 31, 32, 37–42, 43; defined, 26–27, 28, 43–45; term usage, 27. *See also* perception; sensation

impression (in titles): Monet, Claude: *Impression, Sunrise* (fig. 5), 22

Impressionism: and atomism, 337 n. 27; characteristics, 322–323; comtemporary attitudes, 231; cultural style, 237; development of, 45, 46–47; imitators, 233; originators, 9. *See also* Cézanne, Paul; Degas, Edgar; Manet, Édouard; Monet, Claude; Pissarro, Camille; Renoir, Pierre-Auguste; Sisley, Alfred; poetic view, 275–276; politically subversive, 299–300; precondition, 262–264

Impressionism, influences: *Composition with Lines* (fig. 139), 323; *Number 1, 1948* (fig. 136), 323

Impressionism and literature, 237, 269, 297–298. *See also* writing (impressionist qualities)

Impressionism and music, 237

Impressionism and nature, 90–93 passim, 95

Impressionism and science, 207, 216–217, 227–229. *See also* Chevreul, Michel-Eugène; Helmholtz, Hermann von; Seurat, Georges Pierre

Impressionism (criticism of), 301–303

Impressionism (reaction against), 301–303

Impressionism (sketchiness), 78

Impressionism (techniques), 46–78

Impressionism (term usage), 21–42 passim, 22–23

Impressionism (themes), 19–20, 80, 84, 223

Impressionism (use of color), 63–73

Impressioniste, 326 n. 4

L'Impressioniste; journal d'art, 103, 121

impressionistic qualities: *Hay Wain* (fig. 116), 256; *The Spinners* (fig. 115), 254–256

impressionistic seeing, 277–278

impressionistic style, 237–238, 246–249; environment, 278

impressionist painting, viewing of, 52

Impressionists: attitudes, 232, 331 n. 2; color theory, 65–66, 67–69; diversity, 325 n. 2; as a group, 11; list of, 337 n. 1; objects, choice of, 12; passive artists, 301; and perception, 15; and science, 216–217. *See also* Cézanne, Paul; Degas, Edgar; Manet, Édouard; Monet, Claude; Pissarro, Camille; Renoir, Pierre-Auguste; Sisley, Alfred

impressionist writing, 286–298 passim, 295–297; themes, 291. *See also* writing (impressionist qualities)

individual as atoms, 336 n. 22

individual in history, 342 n. 26

Ingres, Jean-Auguste-Dominique: photography: *Monsieur Bertin* (fig. 71), 157, 163; *The Turkish Bath,* 180

inner world (theme): Munch, Edvard: *The Dance of Life* (fig. 129), 312; *The Scream* (fig. 130), 312

innovations (writing), 294–295

Jaensch, Eric Rudolf, 237

James, Henry, 52–53, 163, 274, 280–281, 329 n. 6

Jean Santeuil: Proust, Marcel, 279

Jongkind, Johan Barthold: and Monet, Claude, 264

"Jour de fête aux environs de Paris": Hugo, Victor, 126

Kant, Immanuel, 26

Klee, Paul, 245

Labédollière, Emile de, 120–121

Laforgue, Jules, 132, 304, 306–308; "Le brave, brave autumn!," 307–308; "Rosace en vitrail," 306–307

landscape painting, Chinese, 245–250

landscapes: *The Bay of Marseille, Seen from L'Estaque* (fig. 99), 202–203; *The Beach at Sainte-Adresse* (fig. 20), 69–70; *Déjeuner sur l'herbe* (fig. 80), 174; *The Four Trees* (fig. 27), 190; *Garden at Sainte-Adresse* (fig. 31), 85–86; *The Gardens at the Villa Medici* (fig. 114), 253; *Grainstack (Snow Effect)* (fig. 88), 186–187; *Landscape* (fig. 113), 250–253;

landscapes: *(continued)*
 The Port at Argenteuil (fig. 93),
 192–193; *River Scene at Bennecourt*
 (fig. 12a), 56, 58, 70–71; *A Road
 Bordered by Trees with a Town in
 the Distance* (fig. 112), 250; *The
 Seine at Bougival* (fig. 92), 191;
 Starry Night (fig. 133), 316–317;
 Ville d'Avray (fig. 18), 67; *Water
 Lilies* (fig. 98), 220; *Wheat Fields
 with Rising Sun* (fig. 131), 315;
 Windmill at Zaandam (fig. 25), 75.
 See also environment; nature;
 seascapes
Laplace, Pierre-Simon, 147–148
La Tour, Maurice Quentin de, 160
Les Lauriers sont coupés: Dujardin,
 Edouard, 293
*The Law of the Simultaneous Contrast
 of Colors:* Chevreul, Michel-Eugène,
 212
Leibnitz, Gottfried Wilhelm, 25–26
Leroux, Pierre, 224
Lessing, Gotthold Ephraim, 187, 337 n. 3
light, 244, 247
light and color, 210
light (themes): in literature, 244–245
light (use of): *The Gardens at the Villa
 Medici* (fig. 114), 253; *River Scene at
 Bennecourt* (fig. 12a), 251–253
literary Impressionism, 284–285
literature: metaphoric style, 276–277
literature and Impressionism, 286–298
 passim
local color, 65
Locke, John, 30
London scenes: *Houses of Parliament*
 (fig. 86), 181–182; *The Thames
 below Westminster* (fig. 85), 181–182,
 196
The Longest Journey: Forster, E. M.,
 288
Lorrain, Claude: landscapes: *Landscape*
 (fig. 113), 250–253; sketches,
 Impressionistic: *Landscape* (fig. 113),
 250–253
lyric poetry: impressionist qualities, 297

Mach, Ernest: *The Analysis of Sensations
 and the Relation of the Physical
 Psychical,* 37
Madame Bovary: Flaubert, Gustave,
 269
Madame Gervaisais: Goncourt brothers
 (Edmond de and Jules de), 285
Madeleine Férat: Zola, Émile, 282
Maine de Biran, François-Pierre, 12
Mallarmé, Stéphane, 237

Manet, Édouard, 11, 123–124,
 127–132, 133–134; *Execution of the
 Emperor Maximilian,* 187–188;
 illustrations for *Le Fleuve,* 279
Manet, Édouard (artists and lower class
 as subjects), 127–128
Manet, Édouard (group scenes): *Bar at
 the Folies-Bergère* (fig. 55), 129–130,
 131–132
Manet, Édouard (political paintings), 129
Manet, Édouard (portraits): *Portrait of
 Émile Zola* (fig. 3), 128
Manet, Édouard (portraits [spectator]):
 Bar at the Folies-Bergère (fig. 55),
 129–130, 131–132
Manet, Édouard (railroads): *Saint-Lazare
 Station* (fig. 37), 96
Manet, Édouard (spectator
 [composition]): *Bar at the Folies-
 Bergère* (fig. 55), 129–130, 131–132
Manette Salomon: Goncourt brothers
 (Edmond de and Jules de), 273, 292
"The Man of the Crowd": Poe,
 Edgar Allen, 224
Mardi Gras on the Boulevard (fig. 49):
 city (themes), 116–117; crowd scenes,
 116–117
Martelli, Diego, 325 n. 1
Marx, Karl, 224–225
Maupassant, Guy de, 225, 279–280;
 and Monet, Claude, 65; *Une Vie,* 19,
 97, 103
Medieval art, 243–244
Meilhac, Henri: *La Cigale,* 23, 120
Meissonier, Jean Louis Ernest, 267,
 340 n. 46
Melville, Herman, 331n. 2
Las Meninas: Velázquez, Diego, 130
Meteorology: Aristotle, 213
Michaels, Helen Abbott, 334 n. 10
Michon, Jean-Hippolyte, 61
Middle Ages: art, 243–244; writing,
 243–244
Millet, Jean-François, 42
Milton, John: *Paradise Lost,* 108
Miss Julie: Strindberg, August, 289
Mondrian, Piet: Impressionism,
 influences: *Composition with Lines*
 (fig. 139), 323
Monet, Claude, 10–11, 96, 107, 109,
 115–116, 141, 179–205, 207, 216;
 anatomy, 212; and Boudin, Eugène-
 Louis, 264–265; character, 205;
 crowds, 188; decorative repetition,
 179–198 passim; ice scene, 62;
 influence, 179–180; and Pollock,
 Jackson: *L'Hôtel des Roches Noirs,
 Trouville* (fig. 137), 323; Rouen

Cathedral, 240; serial paintings,
 186–187, 198; technique, 180–181,
 183–184; time, view of, 188–189;
 Venice, views on, 62; water lilies
 (fig. 98), 198–199
Monet, Claude (brushstroke and color):
 *Boating on the River Epte, Blanche
 and Martha Hoschedé* (fig. 11),
 55–56; *Bordighera* (fig. 22), 72–73;
 The Church at Vétheuil, Snow
 (fig. 21), 71; *La Gare Saint-Lazare*
 (fig. 13), 58–59; *La Grenouillière*
 (fig. 9a), 53; *River Scene at
 Bennecourt* (fig. 12a), 56, 58, 70–71;
 *Saint-Lazare Station, the Normandy
 Train* (fig. 41), 104–105
Monet, Claude (brushstrokes), 61, 62,
 108; *Le Boulevard des Capucines*
 (fig. 16), 62
Monet, Claude (city [themes]): *London,
 Houses of Parliament* (fig. 96), 196;
 Quai du Louvre (fig. 45), 110,
 111–113; *Rouen Cathedral: The
 Portal in the Sun* (fig. 10), 215–216;
 *Rouen Cathedral Façade and Albane
 Tower (Morning Effect)* (fig. 89),
 190; *The Rue Montorgueil, 30th of
 June, 1878* (fig. 16), 115–116; *St.
 Germain l'Auxerrois* (fig. 104), 217
Monet, Claude (color), 65–66, 184–186,
 258; *The Beach at Sainte-Adresse*
 (fig. 20), 69–70; *London, Houses
 of Parliament* (fig. 96), 196; *The
 Luncheon (Decorative Panel)*
 (fig. 106), 219; *The Magpie* (fig. 19),
 208; *Rouen Cathedral: The Portal in
 the Sun* (fig. 10), 215–216; *St.
 Germain l'Auxerrois* (fig. 104), 217
Monet, Claude (color [tones]): *The
 Magpie* (fig. 19), 68
Monet, Claude (color [use of]), 49;
 *Rouen Cathedral: The Portal in the
 Sun* (fig. 10), 53, 55
Monet, Claude (composition): *The
 Church at Varengeville, Grey
 Weather* (fig. 95), 196; *The Port at
 Argenteuil* (fig. 93), 192–193;
 Windmill at Zaandam (fig. 25), 75
Monet, Claude (crowd scenes): *The Rue
 Montorgueil, 30th of June, 1878*
 (fig. 16), 115–116
Monet, Claude (grouping of objects),
 189–192; *The Four Trees* (fig. 27),
 190; *Regatta at Argenteuil* (fig. 91),
 190–191; *Rouen Cathedral Façade
 and Albane Tower (Morning Effect)*
 (fig. 89), 190; *The Seine at Bougival*
 (fig. 92), 191

Monet, Claude (group scenes): *Déjeuner sur l'herbe* (fig. 80), 172
Monet, Claude (impression [in titles]): *Impression, Sunrise* (fig. 5), 22
Monet, Claude (landscapes): *The Beach at Sainte-Adresse* (fig. 20), 69–70; *Déjeuner sur l'herbe* (fig. 80), 174; *The Four Trees* (fig. 27), 190; *Garden at Sainte-Adresse* (fig. 31), 85–86; *Grainstack (Snow Effect)* (fig. 88), 186–187; *The Port at Argenteuil* (fig. 93), 192–193; *River Scene at Bennecourt* (fig. 12a), 56, 58, 70–71; *The Seine at Bougival* (fig. 92), 191; *Water Lilies* (fig. 98), 220; *Windmill at Zaandam* (fig. 25), 75
Monet, Claude (light [use of]): *River Scene at Bennecourt* (fig. 12a), 251–253
Monet, Claude (London scenes): *Houses of Parliament* (fig. 86), 181–182; *The Thames below Westminster* (fig. 85), 181–182, 196
Monet, Claude (nature, sea): *The Jetty at Le Havre in Rough Weather* (fig. 34), 91; *Rocks at Belle-Île* (fig. 35), 91
Monet, Claude (perspective): *La Gare Saint-Lazare* (fig. 13), 212; *Water Lilies* (fig. 98), 220
Monet, Claude (portraits), 160; *The Luncheon* (fig. 79), 169; *Portrait of a Seated Man (Dr. Leclanché)* (fig. 72), 160
Monet, Claude (railroads): *Arrival at Saint-Lazare Station* (fig. 42), 105; *La Gare Saint-Lazare* (fig. 13), 58–59; *Saint-Lazare Station, the Normandy Train* (fig. 41), 104–105
Monet, Claude (recreation [themes]): *Boating on the River Epte, Blanche and Martha Hoschedé* (fig. 11), 55–56; *La Grenouillière* (fig. 9a), 53; *Regatta at Argenteuil* (fig. 91), 190–191
Monet, Claude (segmentation), 199; *The Four Trees* (fig. 27), 78
Monet, Claude (series): *Grainstack (Snow Effect)* (fig. 88), 186–187; *Rouen Cathedral Façade and Albane Tower (Morning Effect)* (fig. 89), 187; *Rouen Cathedral in Full Sunlight* (fig. 90), 187; *Water Lilies* (fig. 98), 198–199
Monet, Claude (space): *Vétheuil in Summer* (fig. 14), 59
Monet, Claude (spectator [composition]): *Garden at Sainte-Adresse* (fig. 31),

85–86; *River Scene at Bennecourt* (fig. 12a), 85, 89
Monet, Claude (still life): *Still Life with Apples and Grapes* (fig. 100), 204–205
Monet, Claude (surface pattern): *Rougets (Red Mullets)* (fig. 97), 196–197
motion: *The Spinners* (fig. 115), 254–256
movement, society, 223–225 passim
Mrs. Siddons as the Tragic Muse: Reynolds, Joshua, 128
Munch, Edvard, 312; inner world (theme): *The Dance of Life* (fig. 129), 312; *The Scream* (fig. 130), 312
music and Impressionsim, 237

Le Nadab: Daudet, Alphonse, 285
"Le Naturalisme au Salon": Zola, Émile, 282
naturalist writing, 294
nature, 335 n. 13; described, 79; themes, 94, 95. *See also* environment; landscapes, seascapes
nature and Impressionism, 90–93 passim, 95
nature (sea), 92–94; *The Jetty at Le Havre in Rough Weather* (fig. 34), 91; *Marine, The Waterspout* (fig. 33), 90–91; *Rocks at Belle-Île* (fig. 35), 91. *See also* seascapes
Nietzsche, Friedrich Wilhelm, 237, 294
nudes: *The Bathers* (fig. 122), 300

L'Oeuvre: Zola, Émile, 282
On the Eve: Turgenev, Ivan Sergevich, 290–291
optics, 211

painting, academic: themes, 82–84
pantheism, 92–93, 339 n. 29
Paradise Lost: Milton, John, 108
Paris: growth, 262; in literature, 120–122
"Paris": Vigny, Alfred de, 146–147
Paris Orangerie, 198
Par les champs et par les grèves: Flaubert, Gustave, 269–270, 271
Peau de Chagrin: Balzac, Honoré, 224
perception, 45–46; term usage, 27. *See also* impresionism; sensation
perceptive, 27
period styles, 231–232; Impressionism, 230–232; contemporary attitudes, 231; impressionist phase, 233–236

perspective, 209–210, 211–212, 338 n. 19; *La Gare Saint-Lazare* (fig. 13), 212; *Water Lilies* (fig. 98), 220
photography, 168; and Impressionism, 162–163, 207; Ingres, Jean-Auguste-Dominique: *Monsieur Bertin* (fig. 71), 163; and portraits, 155, 157
Pissarro, Camille, 133, 141, 180–181, 219–220, 240
Pissarro, Camille (city [themes]): *Boulevard des Italiens, Morning, Sunlight* (fig. 48), 115–116; *The Crystal Palace* (fig. 111), 239–240; *The Red Roofs in the Village, Winter Effects* (fig. 17), 62–63; *The Rooftops of Old Rouen, Gray Weather*, 240
Pissarro, Camille (color [use of]): *The Red Roofs in the Village, Winter Effects* (fig. 17), 62–63
Pissarro, Camille (composition): *The Crystal Palace* (fig. 111), 239–240; *The Rooftops of Old Rouen, Gray Weather*, 240
Pissarro, Camille (crowd scenes): *Boulevard des Italiens, Morning, Sunlight* (fig. 48), 115–116; *Place du Théâtre Français* (fig. 66), 145
Plato, 25
Plekhanov, Georgy, 343 n. 46
Poe, Edgar Allen: *Eureka*, 27; "The Man of the Crowd," 224
Pollock, Jackson: Impressionism, influences: *Number 1, 1948* (fig. 136), 323; and Monet, Claude, 323
Portrait of Giovanni Arnolfini and His Wife: van Eyck, Jan, 130
portraits, 158, 160; *The Bellelli Family* (fig. 76), 166–167, 169; *Bouderie* (fig. 62), 167–168; *Dr. Paul Gachet* (fig. 132), 316; *La fête d'amour* (fig. 81), 172; *The Luncheon* (fig. 78), 169; *The Luncheon* (fig. 79), 169; *The Music Lesson*, 170; *Portrait of Émile Zola* (fig. 3), 128; *Portraits in an Office—The Cotton Exchange* (fig. 77), 168; *A Woman Seated Beside a Vase of Flowers* (fig. 75), 163–165; *Young Girls at the Piano* (fig. 63), 169, 170, 172; *Yvette Guilbert Taking a Curtain Call* (fig. 125), 303. *See also* group scenes; spectator (composition)
portraits (poses): *Portrait of a Seated Man (Dr. Leclanché)* (fig. 72), 160
portraits (spectator): *Bar at the Folies-Bergère* (fig. 55), 129–130, 131–132

portraiture, 158, 160, 333 n. 2; decline, 155, 157; Impressionism (characteristics), 153–154; Impressionism (choice of subjects), 123–143; and photography, 155, 157; at picnics, 174; poses, 160
The Possessed: Dostoevsky, Fyodor, 275
Post-Impressionists, 316
Poussin, Nicolas, 87, 143
protective coloration: *Peacock in the Woods* (fig. 105), 219
Proudhon, Pierre-Joseph, 260
Proust, Marcel, 84; *Jean Santeuil*, 279
Prudentius, 241

rag pickers, 332 n. 3; themes, 124–126
railroads: *Arrival at Saint-Lazare Station* (fig. 42), 105; *La Gare Saint-Lazare* (fig. 13), 58–59; Manet, Édouard: *Saint-Lazare Station* (fig. 37), 96; *The Railway Station* (fig. 40), 101–102; *Rain, Steam, and Speed: The Great Western Railway* (fig. 43), 257; *Saint-Lazare Station, the Normandy Train* (fig. 41), 104–105; *The Third-Class Carriage* (fig. 39), 101
railroads (influence of), 96–107
railroads (reaction to), 99–100
Realism: *Burial at Ornans* (fig. 117), 261
A rebours: Huysmans, Joris-Karl, 293, 301
recreation (themes): *Ball at the Moulin de la Galette* (fig. 26), 176–177; *Boating on the River Epte, Blanche and Martha Hoschedé* (fig. 11), 55–56; *La Grenouillière* (fig. 9a), 53; *The Luncheon of the Boating Party* (fig. 84), 177–178; *Regatta at Argenteuil* (fig. 91), 190–191; *A Sunday Afternoon on La Grande Jatte* (fig. 123), 302
reductionism, 277
Rembrandt van Rijn, 162, 250
Renaissance, 242
Renaissance artists, 334 n. 7; and science, 209–210
Renaissance influence (Impressionism), 242
Renée Mauperin: Goncourt brothers (Edmond de and Jules de), 273–274
Renoir, Pierre-Auguste, 42, 53, 142, 154, 181, 184, 214, 299–301; winter scene, 62
Renoir, Pierre-Auguste (artist [as subject]): *Monet Painting in His Garden at Argenteuil* (fig. 121), 267

Renoir, Pierre-Auguste (color): *The Garden in the rue Cortot Montmartre* (fig. 107), 222
Renoir, Pierre-Auguste (composition): *Ball at the Moulin de la Galette* (fig. 26), 76–77
Renoir, Pierre-Auguste (group scenes): *Ball at the Moulin de la Galette* (fig. 26), 76–77; *The Luncheon of the Boating Party* (fig. 84), 177–178
Renoir, Pierre-Auguste (nudes): *The Bathers* (fig. 122), 300
Renoir, Pierre-Auguste (portraits): *Young Girls at the Piano* (fig. 63), 169, 170, 172
Renoir, Pierre-Auguste (recreation [themes]): *Ball at the Moulin de la Galette* (fig. 26), 176–177; *The Luncheon of the Boating Party* (fig. 84), 177–178
Reynolds, Joshua, 38–39; *Garrick*, 128; *Mrs. Siddons as the Tragic Muse*, 128
Le Règne du Silence: Rodenbach, Georges, 200–201
Riegl, Alois, 236
Rivière, Georges, 84, 103, 121
Rodenbach, Georges: *Le Règne du Silence*, 200–201; *Les Vies encloses*, 200
Les Rois en exile: Daudet, Alphonse, 149, 295–296
Roman art and literature, 240–242
Roman artists, 338 n. 16
Roman de la rose, 244
Roman paintings, 241–243, 338 n. 18
Romanticism, 268
"Rosace en vitrail": Laforgue, Jules, 306–307
Rouen Cathedral: Monet, Claude, 240
Rousseau, Théodore: brushstroke and color, 68
Rubens, Peter Paul, 244; artist (as subjects): *The Artist and His Wife in the Honeysuckle Bower* (fig. 73), 162
Ruskin, John, 30, 41, 49, 259; *Stones of Venice*, 27–28
La Révolte: Villiers de L'Isle-Adam, August de, 168

Sainte-Beuve, Charles-Augustin, 65
Sand, George, 343 n. 41
science and art, 206–229 passim. *See also* Chevreul, Michel-Eugène; Helmholtz, Hermann von; Seurat, Georges Pierre
science and Impressionsim, 207, 227–229
seascapes: *Approaching Storm* (fig. 7),

265; *Monk Before the Sea* (fig. 32), 88–89. *See also* nature (sea)
seeing, 12–14, 15, 18
seeing (themes), 149–150, 152; *The Ballet from "Robert le Diable"* (fig. 69), 152; *Caricature of gigantic eyes* (fig. 67), 152; *The Melodrama* (fig. 68), 152
Seghers, Hercules, 250; landscapes: *A Road Bordered by Trees with a Town in the Distance* (fig. 112), 250
segmentation, Impressionism, 77–78, 199; *The Four Trees* (fig. 27), 78; *Place de la Concorde*, 77–78
sensation, 23–24, 25–26, 28, 31, 32, 34–37, 43, 48–49; color, 33–34; defined, 26; Impressionism representing, 46; term usage, 27. *See also* impression; perception
sensations, uninterpreted: and color, 49
sense impression, 25–26; signs, 32–33. *See also* impression; sensation
series: *Grainstack (Snow Effect)* (fig. 88), 186–187; *Rouen Cathedral Façade and Albane Tower (Morning Effect)* (fig. 89), 187; *Rouen Cathedral in Full Sunlight* (fig. 90), 187; *Water Lilies* (fig. 98), 198–199
Seurat, Georges Pierre, 50, 207, 214–215, 225–227; color (use of): *Invitation to the Sideshow* (fig. 108), 226; *A Sunday Afternoon on La Grande Jatte* (fig. 123), 302; group scenes: *Invitation to the Sideshow* (fig. 108), 226; recreation (themes): *A Sunday Afternoon on La Grande Jatte* (fig. 123), 302
Signac, Paul, 207
Signorelli, Luca, 160, 162
simultaneous contrast, 208
Sisley, Alfred, 133, 141, 240
sketches, Impressionistic: *Landscape* (fig. 113), 250–253
social custom, changes in, 259–260
Socrates, 25
"Les Soleils Couchants": Hugo, Victor, 147
space: *Vétheuil in Summer* (fig. 14), 59
spectator (composition), 80–84; *Bar at the Folies-Bergère* (fig. 55), 129–130, 131–132; *Le Beffroi du Douai* (fig. 47), 113–114; *Garden at Sainte-Adresse* (fig. 31), 85–86; *Monk Before the Sea* (fig. 32), 88–89; *Murder of the Bishop of Liège* (fig. 29), 82; *River Scene at Bennecourt* (fig. 12a), 85, 89; *Rome: The Forum from the Farnese Gardens* (fig. 46): 111. *See also* group scenes; portraits

Spencer, Herbert, 174
The Spinners (fig. 115): Velázquez,
 Diego, 241, 254–256
Stello: Vigny, Alfred de, 284
Stendhal, 294, 339 n. 25; *Le Rouge et
 le noir,* 245
still life: *Still Life with Apples and
 Grapes* (fig. 100), 204–205; *Still Life
 with Commode* (fig. 101), 204–205
Stones of Venice: Ruskin, John, 27–28
Strindberg, August: *Miss Julie,* 289
stroke. *See* brushstroke
studio (themes): *The Artist's Studio*
 (fig. 120), 267; *The Studio: A Real
 Allegory Comprising a Phase of
 Seven Years of My Artistic Life*
 (fig. 119), 128, 265–267
styles, 14–15
subject, choice of (Impressionism),
 19–20, 80–84, 123–143, 153, 223.
 See also city (themes); group scenes;
 landscapes; portraits; railroads;
 recreation (themes)
Sunday activities, England, 339 n.
 38
surface pattern: *Rougets (Red Mullets)*
 (fig. 97), 196–197
Susanna and the Elders: Tintoretto, 139
Symbolists: and Impressionism, 277

Taine, Hippolyte, 34, 36, 122, 292;
 De l'intelligence, 31
techniques (Impressionism), 46–78
Tentation de Saint-Antoine: Flaubert,
 Gustave, 292
Thayer, Abbott: protective coloration:
 Peacock in the Woods (fig. 105),
 219
Teresa of Avila, Saint, 31, 327 n. 14
Thoré, Théophile, 50, 93–94
time (view of), 187–189
Tintoretto,: *Susanna and the Elders,*
 139
Tolstoy, Leo: *The Cossacks,* 286–288;
 War and Peace, 24
Toulouse-Lautrec, Henri de, 303;
 portraits: *Yvette Guilbert Taking a
 Curtain Call* (fig. 125), 303
Treatise on Physiological Optics:
 Helmholtz, Hermann von, 211
triangulation, 335 n. 10

Turgenev, Ivan Sergevich: *On the Eve,*
 290–291
The Turkish Bath: Ingres, Jean-Auguste-
 Dominique, 180
Turner, Joseph Mallord William, 41,
 64, 107, 199, 256–258, 339 n. 34;
 railroads: *Rain, Steam, and Speed:
 The Great Western Railway* (fig. 43),
 257

"Un Coeur Simple": Flaubert, Gustave,
 272
Une Page d'amour: Zola, Émile, 282,
 289–290
Une Vie: Maupassant, Guy de, 19, 97,
 103
The Unknown Masterpiece: Balzac,
 Honoré, 292
urban (themes): *The Cathedral* (fig. 128),
 310–311; *Entry of Christ into
 Brussels in 1888* (fig. 126), 309–310;
 Entry of Christ into Jerusalem
 (fig. 127), 309. *See also* city (themes)

Valenciennes, Pierre-Henri de, 245
van Eyck, Jan: *Portrait of Giovanni
 Arnolfini and His Wife,* 130
van Gogh, Vincent, 184, 313–316;
 landscapes: *Starry Night* (fig. 133),
 316–317; *Wheat Fields with Rising
 Sun* (fig. 131), 315; portraits: *Dr.
 Paul Gachet* (fig. 132), 316
van Rijn, Rembrandt, 162, 250
Velázquez, Diego, 127; *Las Meninas,*
 130
Velázquez, Diego (Impressionistic
 qualities): *The Spinners* (fig. 115),
 254–256
Velázquez, Diego (landscapes): *The
 Gardens at the Villa Medici* (fig. 114),
 253
Velázquez, Diego (light [use of]): *The
 Gardens at the Villa Medici* (fig. 114),
 253
Velázquez, Diego (motion): *The
 Spinners* (fig. 115), 241, 254–256
Venice, 62
Les Vies encloses: Rodenbach, Georges,
 200
Vigny, Alfred de, 121; "Paris,"
 146–147; *Stello,* 284

Villiers de L'Isle-Adam, August de:
 L'Eve future, 207; *La Révolte,* 168
"Le Vin des chiffonniers": Baudelaire,
 Charles, 126
visual experience (Impressionism),
 16–18
Voyage of the Beagle: Darwin, Charles,
 174

Wagner, Richard, 338 n. 8
War and Peace: Tolstoy, Leo, 24
Watteau, Jean-Antoine: *Gilles,* 128;
 group scenes: *La fête d'amour*
 (fig. 81), 172; portraits: *La fête
 d'amour* (fig. 81), 172
Whistler, James Abbott McNeill, 227,
 338 n. 22
Wölfflin, Heinrich, 236
work images, 133, 134
writers: art, view of, 292; and
 impressionist features, 268–298
 passim. *See also* writing
 (impressionist qualities)
writing (impressionist qualities),
 268–298 passim, 271; Daudet,
 Alphonse, 61–62, 149, 285,
 295–296; Flaubert, Gustave, 94, 100,
 118–119, 268–272, 284–285, 292;
 Fromentin, Eugène, 39–40, 121–122,
 178, 273, 280; Goncourt brothers
 (Edmond de and Jules de), 271–274
 passim, 285, 290–294 passim; Hugo,
 Victor, 97–98, 102–103, 126, 147,
 148; Huysmans, Joris-Karl, 216,
 258, 293, 301; James, Henry, 52–53,
 163, 274, 280–281, 329 n. 6;
 Maupassant, Guy de, 19, 65, 97,
 103, 225, 279–280; Tolstoy, Leo, 24,
 286–288; Vigny, Alfred de, 121,
 146–147, 284; Zola, Émile, 103,
 178, 282–284, 289. *See also*
 Impressionism and literature;
 impressionist writing

Young, Thomas, 211

Zola, Émile, 103, 282–284; *La Faute
 de l'Abbe Mouret,* 178; "Le
 Naturalisme au Salon," 282;
 L'Oeuvre, 282; *Madeleine Férat,* 282;
 Une Page d'amour, 282, 289